The publisher gratefully acknowledges the generous support of the Art Endowment Fund of the University of California Press Foundation, which was established by a major gift from the Ahmanson Foundation.

EARTH SOUND EARTH SIGNAL

Earth Sound Earth Signal

Energies and Earth Magnitude in the Arts

DOUGLAS KAHN

UNIVERSITY OF CALIFORNIA PRESS

Berkeley Los Angeles London

University of California Press, one of the most distinguished university presses in the United States, enriches lives around the world by advancing scholarship in the humanities, social sciences, and natural sciences. Its activities are supported by the UC Press Foundation and by philanthropic contributions from individuals and institutions. For more information, visit www.ucpress.edu.

University of California Press
Berkeley and Los Angeles, California

University of California Press, Ltd.
London, England

Library of Congress Cataloging-in-Publication Data

Kahn, Douglas, 1951–.
 Earth sound earth signal : energies and earth magnitude in the arts / Douglas Kahn. — 1 [edition].
 p. cm.
 Includes bibliographical references and index.
 ISBN 978-0-520-25780-1 (cloth : alk. paper)
 ISBN 978-0-520-25755-9 (pbk. : alk. paper)
 ISBN 978-0-520-95683-4 (ebook)
 1. Sound in art. 2. Radio noise. I. Title.
 NX650.S68K24 2013
 700.1′08—dc23 2013014804

22 21 20 19 18 17 16 15 14 13
10 9 8 7 6 5 4 3 2 1

Contents

Illustrations

Acknowledgments

The support of friends, colleagues, correspondents, and institutions has made this book possible. A 2006 Guggenheim Fellowship provided dedicated time to research the historical discovery of natural radio; a 2008 Arts Writers Grant from Creative Capital | Warhol Foundation supported work on the book overall; and Vice President and Deputy Vice-Chancellor of Research Les Field at the University of New South Wales enabled me to take up my position at the National Institute for Experimental Arts (NIEA), affording time to complete the book. A grant from the College of Fine Arts, UNSW, provided assistance with manuscript preparation and image rights.

Interviewees, associates, families, and archivists are acknowledged in the book's footnotes for their kind assistance. The book's foundations were laid years ago at Wesleyan University, with my teachers Alvin Lucier and Ron Kuivila, and more recently through interactions with Peter Blamey, Robert Brain, Paul DeMarinis, Frances Dyson, David Haines, Stefan Helmreich, Linda Henderson, Hannah Higgins, Joyce Hinterding, Zita Joyce, Timothy Morton, Gordon Mumma, Hillel Schwartz, Blake Stimson, David Suisman, and James Tenney. Edmond Dewan was very informative and for me transformative. He passed away after a long and productive life, while I was finishing the book; I thank his son Brian Dewan for all his assistance. Jill Bennett and Ross Harley at the NIEA helped me think through many of the late stages of the project. My thanks also go to the readers who made helpful suggestions for improving the manuscript and to Mary Francis, Kim Hogeland, Julie Van Pelt, and Chalon Emmons at the University of California Press for their patience and expertise.

Particularly helpful were University of California at Davis physics professor Tony Tyson for his own experience as a telegrapher and for the Karl Jansky material he rescued; Oliver Staadt for physics and electronics

lessons on country roads at 20 miles per hour; Jesper Olsson's assistance with locating and translating Karl-Birger Blomdahl materials; Margaret Fisher for her work on Pino Masnata and Italian Futurist radio; Ken Sitz's expert guidance through atomic culture; Thomas Patteson's insights into early electronic music; Chris Schiff's encyclopedic knowledge and bloodhound skills for obscure documents; Ben Holtzman for checking my footing in the seismological; and Manfred Kerchoff and other members of the Yahoo Natural Radio VLF Discussion Group. And thanks also to Larry Austin, Luciano Chessa, Sean Cubitt, Bruce Clarke, David Dunn, Dieter Daniels, Raviv Ganchrow, Daniel Gethmann, Oliver Grau, Heidi Grundmann, Erkki Huhtamo, Chris Kubick, Julia Kursell, Adam Lucas, Roger Malina, Stephen McGreevy, Margaret Morse, Marko Peljhan, Simon Sadler, Fred Turner, and Elizabeth Zimmermann, who may or may not have known they were helping me with this project.

The ideas in the book have been developed and tested in classrooms and academic events, but mostly at media arts, experimental music, and eco-arts festivals and events organized by individuals who create crucial opportunities for and contribute to dialogue among practitioners, audiences, and writers. To Arie Altena, Lucas van der Velden, and others at Sonic Acts in Amsterdam; Armin Medosch, Rasa Šmite, Raitis Šmits, and others at RIXC in Riga; Honor Harger in her capacity at the A/V Festival and then at the Lighthouse in Brighton; Sarah Last and the Australian Network of Art and Technology; Su Ballard, Julian Priest, and others at the Aotearoa Digital Arts Network; Sophie Jerram and others at Now Futures in New Zealand; Holly Herndon and others at Gray Area Foundation of the Arts in San Francisco; and Pia van Gelder and others at Serial Space in Sydney—this book is indebted to the energies at the grassroots.

Introduction

RADIO WAS HEARD BEFORE IT WAS INVENTED

Radio was heard before it was invented. It was heard before anyone knew it existed. It was heard in the first wireless technology: the telephone. The telephone served two major purposes: it was a scientific instrument used to investigate environmental energy, and it was an aesthetic device used to experience the sounds of nature. The telephone would also find success in the field of communications. The first person to listen to radio was Thomas Watson, Alexander Graham Bell's assistant. He tuned in during the early hours of the night on a long metal line serving as an antenna before antennas were invented. Other telephone users listened to radio for two decades before Guglielmo Marconi or anyone else invented it. Some heard music and others heard sounds that were out of this world. As time passed, radio fled into the wilderness, a place where nature once existed, and was forced from technology, a place where nature could not be found. Scientists, soldiers, and generals listened until the 1960s, when musicians, artists, and their audiences rediscovered radio. And now, as the wireless of old meets the wireless of new, many people listen.

If the story told in the previous paragraph seems unnatural, it is because the radio is natural. Radio is not always a technological control device supplied with energy from a battery or a plug in the wall; sometimes it is the energy. Unlike other forms of nineteenth-century media that developed upon a tried-and-true base of writing and storage, the sphere of telecommunications technologies of telegraphy, telephony, and wireless resonated with energetic environments and received signals from terrestrial and extraterrestrial sources. Thus, receiving radio may mean that someone is listening but not always that anyone is sending. Communications technologies change old ways and provide tantalizing glimpses into the future,

1

but the mistake is to think that they are always about communications. They do not always default to infrastructural business ventures upon which humans converse or exchange information with one another; communications technologies also belong among scientific investigations, aesthetic engagements, artistic activities, and environmentalist possibilities. Individually and collectively, communications have hosted communes in the tendentious house of nature.

The idea that media might have proximity to nature is certainly counterintuitive; but a merging of recent green media analyses and histories into "the nature of power" promises greater accuracy, wider-ranging political action, and artistic possibility.[1] Mentioning nature and communications in the same breath would have been easier during the nineteenth century, when the earth was regularly put in-circuit with communications technologies (i.e., when aspects of the earth were as integral to the operation of the overall apparatus as the bona fide technological devices and infrastructure). Telegraph and telephone signals were returned through the earth, and a ground meant the ground underneath people's feet; information was underground information. Earth currents associated with auroral display and storms on the sun were sensed on telegraph lines and heard on the telephone. Pairing nature and communications would also have been better tolerated late at night in the 1950s and 1960s, when distant, phantomlike radio stations faded in and out due to a drifting ionosphere, when communications were still under diurnal influence, when there was a night and day to speaking and listening.

The idea that nature might have proximity to media would not seem so strange had the history of communications been written from the perspective of sidekicks, not genius inventors, dominant functions, and victorious business models. We know Watson from Bell's legendary boss-man instructions: "Watson. Come here I need you." Bell's instructions made Watson the first name in modern telecommunications and one of history's most famous sidekicks. But when it comes to telecommunications, nature is more of a sidekick, even though it has always been the biggest broadcaster, bigger than all corporations, governments, militaries, and other purveyors of anthropic signals combined. In fact, nature was broadcasting globally before there was a globe. Radio was heard before it was invented, and radio, before it was heard, was.

Telephony was a new day for sound, not just for talking. The reality and idea of phonography contributed to the surge of sound thinking and auditory imagination during the same period (the latter half of the 1870s), but the way people talked about telephony was different. The telephone was

celebrated for its unprecedented sensitivity in rendering incredibly small amounts of energy audible, just as its associated technology, the microphone, zoomed into a new universe of sounds, real and imagined, like a microscope with ears peering all the way down to a molecular level. And, unlike the phonograph, which relied on old forms of transport to move sounds over great distances, the telephone, for all intents and purposes, paved its own way at the speed of light.

Telephone lines were prefigured by telegraph lines, not only in the distance that a signal could traverse in the time of a tiny spark, but also in the way they resonated with a larger energetic environment, both atmosphere and underground. It was in this latter capacity that the telephone took on its wirelessness, sensing earth currents and receiving musical programs that were not being transmitted on the same line, what I call *inductive radio* (see chapter 5). The capacity of long lines to sense environments alive with unbounded regional or cosmic energies led to a propensity to think big.

The telephone produced plenty of noises and odd sounds when it was first tested from one room to the next, but the types of sounds Watson heard during his off-hours on a line that stretched a half mile down the street were different. He did not seek to eliminate them because they interrupted nothing. They were curious and captivating enough to keep him up into the early hours listening. He may have been a sidekick in the history of communications, but in the history of electromagnetism he was most likely the first person on earth to listen to radio. All Bell did was invent the telephone.

Watson heard electromagnetic waves a decade before Heinrich Hertz empirically proved their existence and two decades before Guglielmo Marconi was credited with inventing wireless telegraphy. The cult leader Pythagoras is reputed to have been the first person to imagine a mythical acoustical cosmos of the *music of the spheres,* but the sidekick Watson was the first to listen to the sound of electromagnetic waves that actually course through the cosmos, irrespective of the silent vacuum of outer space, and he, as of this writing, has no cult.

Watson did not mention a musical character, but others listening to natural radio associated the sounds with music and with gradations that slurred music with noise. It was not necessary for music to be invoked for aesthetics to come into play, of course, since sounds and noises themselves could be experienced in the same way. Whether telephone operators or investigators in the ranks of radio science, listeners heard the raucous and mellifluous sounds of natural radio and some listened aesthetically. Like many naturalists before them and after, they could more easily listen aesthetically and

associate the sounds with music the more distant the sounds were from the dominant institutions and discourses of music. Today, for many reasons, such sounds encounter fewer impediments.

The telephone listening sessions of Thomas Watson were a conjunction of wireless reception prior to wirelessness, engagements with an electromagnetic cosmos prior to scientific investigation, a noisy aesthetics of sound before the avant-garde, and electrical sound before electronic music. Watson did have a personal sense of prescience in his job description as an "electrical engineer," a term that would grow in legitimacy during his own lifetime, but he might find it strange to be playing a role in this book. However, Bill Winternitz, Watson's grandson, did not find these topics strange when we talked, he from his home in Alabama and I stopped by the side of a cycle path in California, on the telephone.

ENERGETIC ARTS

I first encountered natural radio while trying to understand compositions from the 1960s by the American composer Alvin Lucier and artworks from the 1990s by the Australian artist Joyce Hinterding that, although very different, had natural radio as a common element.[2] Their work posed specific questions, but also very large ones that required rethinking cultural engagements with electromagnetism, the histories of telecommunications, the history of electronic music and, ultimately, energies and earth magnitudes in the arts, spanning many decades. My attempt to respond to their work started as a paper and ended as this book.

Before we begin, let me say that the topic here is necessarily interdisciplinary. This book is rooted in the histories of the arts—primarily the media arts, experimental music, and the so-called visual arts—but it branches out to the history of telecommunications and the history of science and veers into media theory and other issues. Readers who may at times find themselves in unfamiliar terrain, however, should be assured that discussion will soon return to more recognizable ground.

The natural radio that Lucier and Hinterding engaged artistically in the second half of the twentieth century was heard aesthetically by Watson in the last quarter of the nineteenth century. All of them were drawn to it by their respective vocations in sound: Watson as a telecommunications engineer, Lucier as a composer in the Western classical tradition, and Hinterding as an artist using sound. The three stand as signposts in the structure of this book: it starts with Watson in the last quarter of the nineteenth century, is centered on Lucier in the 1960s, and ends with the recent work of Hinterding.

Alvin Lucier began to explore electromagnetism as artistic raw material, first as brainwaves and immediately thereafter as natural radio. He was not alone in feeling that electromagnetism per se was viable material for the arts. Experimental music, given its proximity to electronics and the palpable energetic transfer between sound and signal, was conducive to material being immaterial. This idea could also be found in the visual art of James Turrell, where light was understood electromagnetically, and in the conceptual art of Robert Barry, who observed that visual art occupied but a tiny patch (visible light) of the electromagnetic spectrum and that the rest of the spectrum was open to artistic possibility.

By the 1990s, when Joyce Hinterding took an interest in natural radio, there had been substantial developments in sound in the arts, DIY and hardware hacking, amateur communities, science and the arts, and an intensifying ubiquity of communications with a wireless backbone. She is now among a growing number of artists, media artists, and musicians who move along the electromagnetic spectrum and through energetic environments as easily as those energies move through them.

Despite the pervasiveness of electromagnetism in nature, electrical generation and motors, telecommunications and electronic media, physics, and so on, there has been very little written on such phenomena in the histories and theories of the arts. It was not that long ago that the same condition pertained to that other major energy: sound. There are similarities: the way that electromagnetism has received attention among practitioners in the last decade resembles the way practitioners engaged "sound" in the 1980s. Indeed, some of the same individuals are involved.

The exception to the paucity of scholarship is Linda Henderson's *Duchamp in Context,* a meticulous treatment of science, technology, and the occult in the early twentieth-century visual and antiretinal arts.[3] The present effort can be read as an extension of Henderson's chapter 8—"The Large Glass as a Painting of Electromagnetic Frequency"—as I take up additional questions of the cultural incursion of electromagnetism in its relation to communications media and during different periods in the arts and music.

Early in my research, the artist and media archaeologist Paul DeMarinis directed me to a passage in Thomas Watson's autobiography where Watson described listening to natural radio when the newly created telephone was first tested on a half-mile iron line.[4] It took digging into historical documents and talking with a number of radio scientists and engineers to confirm that what Watson listened to was, in fact, a form of natural radio. Once that was established, it was clear that there was an important historical thread consisting of the sounds of natural radio stretching from the

aesthetic listening of Watson to the artistic activities of Lucier and Hinterding in the second half of the twentieth century.

It became necessary to step back a quarter century from Watson to reconsider the activities of Henry David Thoreau, who listened to the sounds produced by the wind on the outside of telegraph lines: Aeolian sounds of a type that had been heard since antiquity, in nature and on Aeolian harps and other purpose-built instruments. Thoreau heard the music of nature on what he called the *telegraph harp,* a piece of the latest technology acting in an ancient manner. Instead of hearing the sounds of nature formed on the outside of the lines of telecommunication, Watson heard sounds from the inside.

Telegraph and telephone lines were in many respects interchangeable; wind could produce Aeolian sounds on either; and, if a telephone receiver was hooked up to a telegraph line, given proper conditions natural radio could be heard. So why were the sounds created by the wind granted musical and aesthetic status through the category of the Aeolian, while the sounds created by the natural electromagnetic activity were not, even though they were heard musically and aesthetically, could occur on the same line, and were produced in the same environment? Since there is no good reason, I have coined the term *Aelectrosonic.*

Where the Aeolian operates between nature and music in acoustics, the Aelectrosonic does the same for electricity and electromagnetism. The character of the sounds in the Aelectrosonic has implications for the history of music, especially avant-garde and experimental music. The Aelectrosonic can certainly provide a footing in nature for electronic music, which has long been trapped under a sign of technology and marched through history in a procession of technological/instrumental devices. It is also a means to understand how energies move across distinctions of music and not-music, nature and technology, as prefigured in the winds moving through manifestations of the Aeolian itself.

Some of the natural sounds that Watson and others heard in the telephone were perceived as musical, especially short sliding tones and whistling glissandi. Indeed, the term *musical atmospherics* later became common in scientific quarters, and researchers in the early 1930s described atmospherics along a continuum of *musical, quasi-musical,* and *nonmusical.* In the musical and artistic avant-garde, the *quasi* middle ground was negotiated primarily in terms of an accommodation of *noise,* first formalized in Italian Futurist Luigi Russolo's *Art of Noises* manifesto from 1913 and echoed in John Cage's call in "For More New Sounds" in 1942. During the 1920s and 1930s, the science of whistlers and the musical avant-garde

shared a similar tolerance and delectation for the plasticity of what was and what was not musical sound; and it can be said that Watson too was listening to the types of noises and odd sounds that would become amenable to the avant-garde almost four decades later.

Listening to problematically musical sounds in nature has a long history with its own debates (see chapter 3). The disposition to listen to the environmental sound aesthetically and as music can be read throughout Henry David Thoreau's writings, as Cage himself acknowledged, and in the writings of other naturalists. Indeed, Russolo's achievement can be characterized in one sense as having moved auditory naturalism downtown to an urban and industrial context (in his essay "Noises of Nature," Russolo's naturalism can be found in its natural habitat) and Cage's achievement as having broken through the inertia of Western art music with regard to a wider world of sound and aesthetic listening. In fact, much of what Cage finds in his notion of *indeterminacy* can be found in the turbulent torque of Aeolian performance that, as Thoreau knew, is an earth sound that originates on a planetary and heliospheric scale.

The Aelectrosonic became evident when telephones were put in-circuit with the telephone lines, telegraph lines, and submarine cables interacting with the naturally occurring energetic environment. However, just as Aeolian sounds were produced by the wind blowing across naturally occurring rock formations and plants, not merely human-made technologies (Aeolian harps, telegraph lines), so too could the Aelectrosonic occur in the sounds of the polar auroras and atmospheric electricity high in the mountains. All that is required to transform an electrostatic or electromagnetic state to sound is the proper transducer, and transducers can be both naturally occurring and anthropic (technological).

The movement from one energy state to another, either within or between larger classes of energy (mechanics or electromagnetism), is called *transduction.* Audible sounds and other acoustical phenomena belong to mechanics: all sound is mechanical in this sense. Just as the wind blows across distinctions of naturally occurring and human-made, of nature and technology, so too does energy move across states as transduction. Energetic movement is in this way a continuation locatable at transformation, the position of transducers. The Aeolian is a mechanical music in that the actions of the wind, vibrating strings, and the resulting sound are of the same class of mechanics.

In contrast, the Aelectrosonic moves from electromagnetism to sound, that is, from the class of electromagnetic energy to the class of mechanical energy. That electromagnetic fields and waves require technology for transduction

into sound means that they have been occluded by mechanisms of control. Electronic music pioneers in the first half of the twentieth century were more interested in technological control than in what was being controlled. As music began to be produced through electrical conductors, one could still see the ghost of symphonic music past. The performances using the Theremin, besides being intent upon replicating existing classical repertoire, consisted of the detached gestures of orchestral conductors, wielding sticks in the ethereal air. Nevertheless, because acoustical and electromagnetic energies are classical in terms of Newtonian and Maxwellian physics, music associated with them could be called classical music.

The instrumentality of electronic music during the period had much to do with this music's reliance on engineers, but it happened to be a prominent engineer, Alfred Norton Goldsmith, who in 1937 reminded the modern music community what it was that was being controlled. The electricity driving new instruments, he said, was just as natural as anything the larger world of music could muster, even as he described this electricity somewhere along a spectrum between the static of cat fur and a bolt of lightning.

As the century progressed, or at least transpired, criticism against using *new means for old sounds* grew along with the avant-garde and experimental precept of *new sounds by any means*, although neither grew as exponentially as the use of electronic technologies to mimic existing musical sounds. Openness to phenomena is at the root of the meaning of *conductor*— something that allows energies to flow through itself, assembles them, coaxes and draws from them. This is no doubt present among symphonic conductors, whereas many experimentalists made an ethic out of it.

Alongside developments *for more new sounds,* electronic music itself became a conductor *for more new signals* (see chapter 10). By the 1960s, composers and artists began considering electromagnetism per se as raw material for their craft, with Alvin Lucier working with what he called *natural electromagnetic sounds,* stretching from brainwaves to outer space; and by 1975, the composer Gordon Mumma could identify what he called an *astro-bio-geo-physical* trend within the ranks of live electronic music, tied to a plenitude of signals culled from scientific investigations of natural phenomena. It is an important distinction: electronic and experimental music did not merely *use* scientific signals; such music was already *conducive* to them. Whether because of DIY or a high level of technical sophistication or both, this generation of composers, musicians, and artists increasingly paid attention to energies rather than immediately defaulting to mechanisms of control. As a result, the world became a more energetic place, both acoustically and electromagnetically.

The challenge of this book is to think energy; however, earth sounds and earth signals are privileged over human corporeal energies. Brainwaves are discussed because they are electromagnetic activity that create what Alvin Lucier called natural electromagnetic sounds, a concept that led to his next composition, *Whistlers,* based on the sounds of natural radio; these electromagnetic sources combined to describe an electromagnetic spatiality from brainwaves to outer space. What Lucier did not do was bring the body and (transcendent) subject into play to construct the countercultural figure of "inner and outer space," although that did occur in many brainwave works by others who followed suit later in the 1960s and 1970s.

A parallel track in this book relates energies to the scales of the earth—from sound at local and long distances, to the effects of electrical atmospheres, to electromagnetic activities occurring at the speed of light at earth magnitude. Rather than the hieratic *music of the spheres,* this book concentrates on the terrestrial *arts and music of the sphere,* from the *sphere music* of Henry David Thoreau to the *sonosphere* of Pauline Oliveros. The grand historical sweep from the nineteenth century to the present, scaled up to the size of the earth, is grounded in detail derived from the anecdotal record, essays and journalism, engineering and scientific literature, the crafted experiences of the arts, and interviews with scientists, technicians, artists, and others involved.

LIVED ELECTROMAGNETISM

A capacious and concentrated attention toward raucous, pulsating, buzzing, crackling and subtle, mysterious little sounds not only goes into an evening's entertainment in the twenty-first century but also acts as an indispensible heuristic device in historical investigation. As Hillel Schwartz's *Making Noise* makes abundantly apparent, if such sounds are filtered out by taste or written off as noise or interference, then much will be underheard and overlooked.[5] This is certainly true for the nineteenth century, during which electromagnetism was experienced through odd sounds in telecommunications systems and the environment.

At its most basic, *Earth Sound Earth Signal* is an account of the trade between two classes of energy: acoustics (mechanics) and electromagnetism. I emphasize electromagnetism for the simple reason that nature *sounds* are familiar while nature *signals* are not: birds sing but most people have not heard the magnetosphere whistle. Also, electromagnetism itself is not very well understood; few of the common understandings of scientists and engineers have assumed vernacular status in the broader culture. The

physicist Richard Feynman did sum up *why* one might wish to know, in his own, inimitable way:

> In this space there is not only my vision of you, but information from Moscow Radio that's being broadcasted at the present moment and the seeing of somebody from Peru. All the radio waves are just the same kind of waves only longer waves. And then the radar from the airplane, which is looking at the ground trying to figure out where it is, is coming through this room at the same time. Plus the x-rays, and cosmic rays, and all these other things, the same kind of waves, exactly the same waves, but shorter, faster, or longer, slower, exactly the same thing. So this big field, this area of irregular motions of an electric field of vibration contains this tremendous information, and IT'S ALL REALLY THERE, that's what gets you! . . . So all these things are going though the room at the same time, which everybody knows, but you've got to stop and think about it to really get the pleasure about the complexity, the INCONCEIVABLE nature of nature.[6]

Feynman also said that it was both more understandable and required less imagination to have the room one inhabits populated with invisible angels or jelly (ether) than with electrical and magnetic fields: "I have no picture of this electromagnetic field that is in any sense accurate. . . . So if you have some difficulty in making such a picture, you should not be worried that your difficulty is unusual."[7]

There has simply been insufficient time, in historical years, for electromagnetic vernacular to emerge. Millennia stocked with amber and lodestones passed until the nineteenth century, when electrical and magnetic forces fused into the fields and waves of Ørsted, Faraday, and Maxwell, and electromagnetism became a recognizable force. It really was not that many generations ago. Acoustical phenomena have been commented on since the birth of commentary: Aristotle had plenty to say about sound but never tuned in to radio. Twentieth-century philosophers, if electromagnetism is invoked, leapfrog over lived experiences of electromagnetism and head straight to theoretical physics and the observably limited behaviors of quantum realities. While understandable in motive, this predilection for cosmology and subatomic physics has left everyday *lived electromagnetism*, from communications to the sun, to others.[8]

Lived electromagnetism is a messy practice resulting from an asynchronous amalgam of perceptual experiences, developing vernaculars and discourses, technologies, and scientific knowledge. For our purposes, lived electromagnetism has its historical basis in such things as rainbows, electric motors, and telecommunications, from which are derived the spectrum, the

correlation of electricity and magnetism, and the speed of light and its global and cosmological manifestations.

Gradients (i.e., a spectrum) of light have long been rendered accessible through comparison of musical pitch with color; such ideas survive today in various understandings of sound color, synesthesia, and how color and sound might physically or metaphorically correlate through frequency. One hundred and thirty years ago, an editorial appeal was made by the respected electrical engineering journal *The Electrical World* (1883), citing Sir Isaac Newton's comparison of "the seven colors of the prismatic spectrum to the average tones of the diatonic scale" as one "correlation of forces" that could extend to an exploration between "light and electricity." The telegraph and telephone had primed the possibility for "telephotoscopy—the vision of objects at a distance," and perhaps the transmission of other senses, smell and touch, the editorial speculated, since electricity and nerves share a common energetic sensibility.[9]

The messiness expressed in *The Electrical World* was understandable, given that the piece was written within an environment of telecommunications but just a few years before Heinrich Hertz empirically demonstrated the existence of electromagnetic waves (the Hertzian waves of radio) beyond visible light, as theorized by Maxwell. Many people still think that light and radio have nothing in common with one another; nevertheless, rainbows and old radio dials are among the best everyday materializations of frequencies along a spectrum.

Although human perception favors the visible light portion of the electromagnetic spectrum, one of light's most salient features, its speed, is not perceptible. It is as though freeways were always, not just occasionally, mistaken for parking lots. Nevertheless, by the mid-nineteenth century the perceptible length of telegraph lines and the distances traversed led to an understanding of a qualitatively different speed, even as conceptual models struggled with notions of electricity flowing through wires like water through pipes (this survives today in the notion of *streaming* media on the Internet). Telecommunications since telegraphy remains at the center of lived electromagnetism. A public model of electromagnetism and the electromagnetic spectrum was extended at the turn of the twentieth century with radium and X-rays, expanded considerably with radio in the 1920s, and resolutely reached the end of the spectrum at gamma with the atomic bombs in 1945. The spectrum was completed with the specter of complete annihilation.

Thus, chronologically located between the old wireless devices and the new wireless gadgets of today was the harshest lesson in electromagnetism:

the *gadgets*, as the first atomic bombs were called. In their wake, the cognizance of radiation became quotidian and global and, along with the dissemination of journalistic tropes, the isotopes that circulated in the wind served as markers for the global spread of other toxins, as genocide moved to ecocide over the following decades.[10] Long-distance radio signals coursing invisibly through the air annihilated space and time, and *Sputnik* and other delivery systems stigmatized the skies, promising a different annihilation during the Cold War. These two systems of annihilation joined on the domestic front in the United States in CONELRAD, the name of the emergency broadcasting station, whose acronym stood for *control of electromagnetic radiation*.

CONELRAD was the radio station to tune to when nuclear attack was imminent or had occurred. It was a concession in the control of electromagnetic radiation, because no ultimate control over the larger field of radiating gadgets was economically or politically viable. Broadcasting stations, domestic appliances, professional instrumentation, and commercial equipment had the potential to be redirected into communicating with the enemy and acting as homing devices for targeting. That is, once electricity started to flow through objects designed for purpose and convenience, the radiations had the potential not only to interfere with radio reception and become a nuisance but also to turn an object into an enemy. Not only were objects collaborators, for and against, so too were the accumulated radiating mass of objects, communications, and heat sinks of cities.

The Cold War moved to the Warm War. The punctuated apocalypse of nuclear warfare, of unleashing the sun on earth, as President Truman put it hours after Hiroshima, moved to the slow burn of today, the sun setting on the species. Just like *Sputnik*, global warming has stigmatized the sky: what used to be a moving star became a delivery system; what used to be the weather is now a vengeful climate. The radar that tracks enemy incursions also tracks clouds. The collaborating objects that provide convenience and transmit media now plug in to complicit fossil fuel grids and patch in to voracious server farms. From the mid-nineteenth century to the mid-twentieth, lived electromagnetism was primarily conducted on the spectrum on technological grounds, from telecommunications to nuclear weaponry, whereas now it consists of ubiquitous global communications with a backdrop of earth-scale environmental disaster. Just as messy as other practices of lived electromagnetism, the relationship between a plethora of telecommunication devices and the nature of the sun has yet to be reconciled.

Since the nineteenth century, naturally occurring electromagnetism-as-nature has been overridden by purely anthropic notions of technological

transformation. Electromagnetism had nothing less than the historical misfortune among forces of nature to be disclosed at the moment of its industrialization. It was ushered quickly into telegraph lines that only under certain circumstances demonstrated their resonance and reception of energetic environments. Instead, telecommunications controlled nature as never before: without a pre-existing nature. It was as though rivers had never existed before being harnessed for mills or dammed for hydroelectric production. For electromagnetism, there was no temporal split from culture, society, or technology within which "nature" could be overcome.

On the physical cusp of the sensory, making sense is difficult because the human body is audiovisually skewed. Unaided human perception is restricted to the tiny patch of light where the eye is entranced by a rainbow but oblivious to the vast analogous sweep of the spectrum on either side. The perceptibility of visual light, however, is overrated, given that humans cannot see light's constant movement. Electromagnetic effects are felt in other ways: the warmth on the skin of infrared, the sunburn of ultraviolet. The civilians of Hiroshima and Nagasaki saw the "noiseless flash" of the atomic bombs dropped by the United States and felt the gamma radiation delayed in the deadly pain of gross cellular damage. Three weeks earlier, a blind woman saw the Trinity test, the first atomic explosion.[11]

Unlike the eye, the ear is not a dedicated electromagnetic apparatus. Although the inner ear eventually excites electrochemical impulses in nerves to the brain, its initial sensitivity is to the vibratory movements of acoustical energy. As elephants and dogs let us know, the human ear only gets excited by a certain range of the sound spectrum; flanked on either side are infrasonic and ultrasonic events.[12] With enough energy, sounds beyond the normal human audible range can be felt or their effects heard—earthquakes come to mind—but most all simply escape notice.

Both seeing and hearing intersect in different ways with the electromagnetic spectrum. What vision is to visible light, hearing is to the range of frequencies known as *audio frequency range*.[13] The Very Low Frequency (VLF) range of natural radio that Watson heard is in the audio frequency range. Like all electromagnetic waves, those in the audio frequency range travel at the speed of light; but because the waves are exceedingly long, they end up oscillating in the range of human hearing. These are the sounds we would hear if we could hear electromagnetic waves unaided. To hear natural radio, there needs to be transformation from one state of energy (electromagnetic) to another (mechanical/acoustical). The movement of energies from one state to another, whether or not it happens with or without the anthropic artifacts known as technology, is called transduction. The

long waves of VLF take a long-wave antenna to hear. If ears had been evo-
lutionarily designed to tune in to long electromagnetic waves, the burden
of our physiological antennas would probably mean that we would be all
ears and prone to be serpentine.

Watson heard natural radio when the long iron telephone test line
acted unwittingly as a long-wave antenna. This was before anyone knew
what an antenna was or, for that matter, what electromagnetic radio
waves were. Watson had an intuition about how they might have been
generated but absolutely no way of knowing. The only reason that
Watson was the first person to accidentally hear these sounds was due to
his privileged proximity to the right type of transducer: the telephone.
Because the transduction was occurring within the audio frequency
range, there was no need to step-down shorter electromagnetic waves
into longer waves of human hearing in the process that we now know
through the device of radio. A primitive telephone connected to a long
iron line would suffice.

There are different types of natural radio. In *Earth Sound Earth Signal*,
I focus on *whistlers and related ionospheric phenomena*, as the title of
Robert Helliwell's classic book on the subject reads.[14] Many people now
know of whistlers thanks to Stephen P. McGreevy's *Auroral Chorus: Music
of the Magnetosphere* (2001) and his other efforts, some of the most stun-
ning recordings ever made. Others of an earlier generation know them
thanks to Cook Recordings' LPs *Out of This World* (1953) and *Ionosphere*
(1955). The Internet has made it possible to listen to natural radio from dif-
ferent parts of the world live, potentially hearing the sound of opposite
hemispheres interact with one another.

Whistlers are but one form of natural radio, but their musical character
and quasi-musical and sonic appeal have attracted the attention of many
people. Heard amid complex fields of noisy activity and often barely distin-
guishable from them, whistlers are mysterious or at least curious in origin,
and they have the ability to captivate one for a very long time. Listening to
them can be similar to sitting entranced by tiny flashes of sun and noises in
the rush and crackling of a creek, not knowing, perhaps, whether certain
flashes are the backs of small silvery fish, that is, as if the creek were ionized
and fish swam thousands of kilometers into the magnetosphere and back.

Whistlers are generated primarily by the powerful, full-spectrum elec-
tromagnetic bursts of lightning. Lightning strikes globally between 100 and
200 times a second, releasing enormous amounts of energy that are teased
out into signals traveling at the speed of light over great distances. They
bounce between the earth and ionosphere and at times catch a ride into

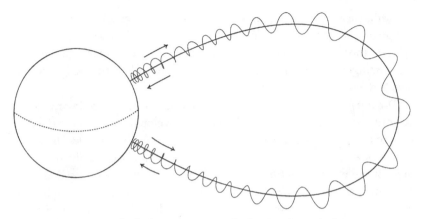

Figure 1. Trajectory of a lightning-generated whistler through the magneto-sphere. Illustration by Pia van Gelder.

outer space on magneto-ionic flux lines before descending back to earth in the opposite hemisphere. Arching over the equator, whistlers are globe-trotting signals, earth signals in the truest sense. The way the frequencies from the initial burst of lightning are spread out into a glissando is not dissimilar from how light is refracted and spread out into a rainbow. Along the electromagnetic spectrum, both ears and eyes are attracted to their respective rainbows.

Yet, it is not merely the aesthetic delectation of whistlers that is important. They have stood like a Greek chorus chiming in at key moments on the stage of the history of telecommunications, science, and the military. Not long after Watson listened out of curiosity and pleasure, scientists tried to figure out what whistlers were and where they came from. Signal corps members in the killing fields of World War I heard whistlers, prompting scientific research during the 1920s that itself was associated with verifying the existence of the ionosphere and mapping its features. During the 1950s, whistler research was aligned with the discovery of the magnetosphere and was present during atmospheric nuclear testing of so-called rainbow bombs, named for how they lit up the night sky. And, with Alvin Lucier, whistlers were present as electromagnetism was taken up as artistic material and as an important alliance between the arts and science was forged in the 1960s.

Whistler science evolved out of the military communications of World War I and, along with the geophysical sciences, its biggest advances were tied to the funding largesse of the Cold War's militarized science. New

scientific means of sensing physical phenomena at a geophysical scale contributed to an understanding of the energetic states of the earth at the same time as those understandings were directed toward military monitoring and intelligence, targeting, and command and control. Cutting-edge science was both sword and ploughshare.

For musicians and artists in the United States who were interested in scientific knowledge and new technological developments, the material culture of militarized science was as integral as it was unavoidable. The cultivation of earth signals in the arts necessarily took place, if only at the far edge of the margins, within fleeting formal, institutional interactions and informal, casual friendships among artists, scientists, and engineers. Whereas the scientists were closer to the crumbs falling from the military funding table, artists worked where dust might occasionally waft off a crumb. In this environment, sounds and signals emanated from a deep noise floor of barbarism. Indeed, following Walter Benjamin's dictum that there is no document of civilization that is not at the same time a document of barbarism, there are no transmissions in which signals are not mixed.

Whistlers were emissaries of earth magnitude. As whistlers arced over the equator, people heard storms in the opposite hemisphere. Although this fact was not understood until the 1950s, one scientist in the early twentieth century was sure the noises of atmospherics heard in England were produced from storms in Africa. Yet by the time Alvin Lucier used natural radio in his music, he was well aware that whistlers were produced by electromagnetic activity of lightning hurling signals far out into the magnetosphere, in the vacuum of space, and back to earth on the other side of the equator as gossamer sounds.

Given the sound of whistlers, the question still arises of how Lucier might have felt licensed to make music with earth-scale phenomena. Modern composers had looked to the expanses of the earth, planets, stars, and universe to inspire and organize sounds rather than for the sounds they made; composers had often channeled these expanses symbolically through the visual inscriptions of notation, rather than conducting energetic fields and waves that actually fluctuated and vibrated dynamically. Lucier, on the other hand, had the example of his friend and collaborator Gordon Mumma, who made music with the globe-trotting signals of seismic activity: earthquakes and underground nuclear testing. Experimental music in the 1960s brought the music of the cosmos back down to earth.

In a late nineteenth-century contest to sense the scale of the earth, the main contenders were acoustical: the booming sound of Krakatoa was heard

thousands of kilometers away and the seismic signals from an earthquake in Japan shook seismographs in Germany. Teleseismological signals were regularly transmitted under the horizon more than a decade before Marconi's wireless "S" made its way over the horizon from England to Canada. Both were means to sense the "whole earth" long before the silent, reverse astronomy of surveillance aircraft, high-altitude balloons, and the "earthrise" and "blue marble" photographs of the 1960s and 1970s. Now that nature has defaulted to earth magnitude, there are many ways to listen live and laterally sense the planet without leaving it.

THE NATURE OF MEDIA: INSCRIPTION, TRANSMISSION

While this book is held together with a running stitch of glissandi formed by whistlers, a global view of energy informs these pages, grounded in an abiotic nature associated with the physical sciences and with a materiality often assumed to be immaterial. For obvious reasons, ecological discourse has largely been framed in terms of the biotic (endangerment and extinction of human, animal, and plant life). Only fairly recently has a discursive presence of the abiotic been rendered routine, with carbon and chemical interactions with the solar terrestrial environment and with the live energy systems (solar, wind, wave) necessary to reach a survivable, dynamical homeostasis on the earth. The solar terrestrial environment is many things, not least the electromagnetic presence of the sun.

It is much easier to empathize with creatures with eyes and limbs (sentience and technics), or with objects (e.g., those that maintain proscribed bounds, occupy fairly stable locations, and especially those consumer electronic objects that themselves take on creature characteristics), than it is with ever-moving nondescript energies. Only when mythological energies assume an oddly evacuated, godlike omniscience may anachronistic forces be with you; but when energies are granted nominal entity status without being grand entities, they are most often relegated to relations, durations, and processes. Keeping things, bodies, subjects, and the like at bay for too long is, of course, impossible: the *lived* in *lived electromagnetism* signals that from the outset. I am simply saying that the rhetorical fields of matter and energy are historically predisposed to the former, yet it is not enough just to be moved by the nonlocality of energy; how this occurs requires demonstration. Thus, my attempt in these pages to persist in positions of energy, to assert a moving materialism of energy, entails nothing more than a bending of the *matter-energy* shtick the other way in order to listen to the piezoelectric stress effects.

This raises the question of the vernacular status of the term *nature*. Invoking nature was once a way to keep things at bay from "society," but this does not work as well as it once did. People increasingly accept that the term *nature* helps destroy the very thing it wishes to protect. If this was not obvious before, then anthropogenic global warming makes abundantly clear that there is no longer any "nature" untouched by human hands and that a finite planet constrains myths of separation. If anything, nature is all over. Even the "nature" of *natural radio* has been skewed, given that whistlers are associated with thunderstorm activity, the patterns and severity of which have been transformed by global warming. To hear such sounds, one would have to listen statistically, at least until the anomalous becomes routine for a moment. The only "nature" left in weather is space weather in the heliosphere, but that is in a wilderness environment not amenable to the biotic.

However, I am not ready to throw the nature baby out with the rising bathwater. There is great variability in the use of the term *nature;* on theoretical terrain the use has been site-specific, and in the vernacular the word has proven capacious and malleable, even in stricter readings. But more important for the present study, the old-school separation of nature and society is simply not operative in telecommunications media, because the dominant notion has been that media have no nature. We will see that this notion is historically situated, with less traction in the past and losing traction in the present. Media have never been monopolized by a separate wilderness and it is too late to start now.

Recent ecotheory and political ecology have critiqued the term *nature*, yet never in relation to where the word has never been used: the ostensibly pure sociality that is media. Thus, I am hanging on to a notion of nature (in effect, *natures*) as a means to introduce it to where it has long since been abandoned. Instead of the capital-N Nature that has served to mask machinations of capital, the question of nature in media actually opens political and ecological investigations rather than closes them down. I am hanging on to the term not only for vernacular purposes but also discursive ones at certain sites of analyses, because, most notably, it has been absent in histories of communications technologies, historical media theory, and the history of electronic music.

The ease with which ubiquitous media gave rise to global *communities* with no natural habitat seems absurd from a generational perspective and may or may not prove to be absurd again. The deep redundancy of the term *social media* goes without notice amid an absence of anything resembling a "natural media." The truly odd place that media assume in ecological

discourses is exemplified in the term *media ecology,* a field in which writers, as Ursula Heise puts it, "generally waste no words on the state of the natural environment."[15] The natural habitat of this ecology consists of media as its own species of content. It is more urgent to ask what a deeper media ecology would be.

Nature is embedded more deeply in media than nature programming, as has been detailed by "green media" research on resource extraction, environmental destruction for infrastructure, carbon neutrality, pollution of workers and the environment, obsolescence and waste, and the huge demands put on electrical generation by the spreading acreage of server farms. The global breadth of any single transmission has already been trafficked in the transportation of materials, labor, and goods, within which innumerable energies are expended at every point in the process. In minerals, fossil fuels, and manufacturing alone, the materiality of any contemporary communications device spreads to the four corners of the earth, mirroring its messaging. Green media analyses have had formidable tasks without accounting for aesthetics or poetics, although that too has begun.[16]

To the extent that this book involves media evolving from the nineteenth century, it concentrates on modern telecommunications technologies (telegraphy, telephony, and wireless) rather than storage media (photography, phonography, and cinema). The former are characterized by transmission, whereas the latter are characterized by inscription (although I will later project cinema onto the field of transmission).[17] Inscriptive media precipitate phenomena onto surfaces (pages, scores, screens, memory devices, etc.) and are associated with recording and storage awaiting revivification, reproduction, repetition, and more storage. Transmissional media (in my usage) are inseparable from electricity and electromagnetism; they differ from inscriptive media through basic physical states of energy (mechanics, electromagnetism) and are thus historically very recent when compared to the antiquity of inscriptive media. Telecommunications technologies like telegraphy, telephony, wireless telegraphy, radio and television broadcasts, and the Internet are transmitted "live," even when they transmit recordings.

One consequence is that transmission should, at a certain level, not be confused with diffusion or dissemination; doing so ignores the speeds involved, the effects of and on distance, and the historical accelerations that have accompanied them, such as colonial and imperial expansion. Word gets out fast, but inscriptive media have been closely tied to metabolic speeds, whereas the electromagnetism underpinning transmission aspires to the speed of light. The metabolic energies and speeds of word of mouth,

postal carriers, horses, and trains differ qualitatively along the biotic and abiotic from the energies of modern telecommunications that began with telegraphy. Whereas diffusion has always existed, transmission is first of all "modern," developing once optical telegraphy moved toward telegraphy.[18] Although these broad distinctions (inscription, transmission) came together in telegraphic code (even switching relays), then merged more significantly with electronic sound recording and the radio broadcast of recordings, and finally became inextricable with digital technologies, they remain operative nonetheless.

Communications systems are thought to be where people or their proxies communicate or otherwise exchange information with one another, whereas I prefer not to let such notions override actual technological functioning. That telegraph and telephone lines were used for aesthetic and scientific purposes means that communications were neither always, nor do they have to be, for communications alone. It is so deeply engrained to equate communications technologies with communications—it is, unfortunately, locked in the word—that variability defaults to the counterintuitive. Nevertheless, we need to understand communications as a *variable technology* that, for the purposes of this book, constitute an interrogative function leading to experiential (aesthetic/artistic), scientific, and communicative areas.

These three classes are not equally proportionate, of course; nor are they autonomous (that is the whole point); nor do they exhaust categorical possibilities (an argument could be made to include the military) or inhibit broader elaboration (the atomic bomb was a seismological instrument). Because the three classes can happen on the same device at the same time (differing from the distributed functions examined in variantology), it seems important not to radically separate them out, as has been done in the closed-circuit sociality informing media history and theory. Ideally, such inquiry can provide a field of historical precedent for how contemporary media devices are composed of multiple purposes.

The most familiar piece of variable technology in the history of communications is the telescope. As an aesthetic and experiential device, it was used for stargazing; as a scientific instrument, it was used in astronomy; and in long-distance communications, it was used in optical telegraphy. Scientifically, the telegraph was used to research magnetic storms associated with sunspots and auroral activity, with the data gathered on a distributed, geophysical scale sent to a central collection point on the same system; all the while, along the telegraph's lines, Thoreau and others listened to the strains of the Aeolian. The telephone, all parts of it, had numerous scientific

uses, while Watson and others listened to its Aelectrosonic strains, and the same was true for wireless technologies.[19] In this way, a closer examination of media technologies uncovers a technological indeterminism.

My attention to technologies is commonplace in my usual disciplinary sphere of media arts history, due in large part to the influence of the writings of Friedrich Kittler, who has mistakenly been called a media theorist when in fact, among other capacities, he was a historical media theorist. While I consider the research here complementary to Kittler in many respects, differences need to be drawn. Most obviously, in his best-known works Kittler chose to concentrate on inscriptive media rather than attending to transmission media and telecommunications. He is correct in showing how telegraphy veering from the railroad separated transportation from information (a separation codified in wireless), but he does not veer from a presumed primacy of inscription over transmission. The title of one of his books is *Gramophone, Film, Typewriter*; it contains three technologies that epitomize the systems of inscription *(Aufschreibesysteme)*, which is, in turn, the title of another (translated as *Discourse Networks*).[20] The inscribed surface of a gramophone disc is etched with a stylus much like a pen on paper, or struck and molded in the manner of a printing press or a typewriter on a page; in contrast, cinema has two surfaces, the filmstrip and the screen, between which the energies serve time.

Kittler argued that "media determine our situation," that is, media constitute an informational situation that subsumes, in their broad bandwidth, literature, philosophy, the production of discourse, and much more. Within this field of exchange, scholarship traditionally conducted in relation to the page and archives reverse engineers in Kittler's work a predominantly inscriptive notion of contemporary media. That is, inscriptive practices determine where media are situated. Inscriptive media cover quite a bit, quite of few bits, and Kittler's theory is capable of fusing long histories and significant continuities and periodizations in a telos toward a Mammon of computation. Scripts, alphabets, and mechanized Gutenbergian effects are continuous with computer code and printed circuits, and Kittler has processed them with an unparalleled integration, much like a microchip itself. However, there remains a basic level at which privileging inscriptive media comes at the expense of transmissional media.

In his historical teleology, Kittler vaults over an engagement with transmission at a place that, coincidentally, gave rise to dedicated whistler research: among the signal corps in the fields and trenches of World War I. He cites the leaky lack of privacy of wireless transmission as rationale for coded communications, and he follows the coding through the Enigma

machine and its decoder, Alan Turing, and in turn to Turing coding computational machines.[21] This specific focus meant that other issues in the trenches were not mentioned.

First of all, other forms of telecommunications were also leaky during World War I: the inductive fields of telegraphs and telephones could be tapped without the lines being cut, and the earth circuits for telegraphy and dipole field telephones meant that the ground too, not just the air, was a font of stray messages. While using a grounded surveillance device for eavesdropping on enemy communications, the German Heinrich Barkhausen also heard whistlers amid a buzzing electromagnetic sea of signals, and he would write the first significant scientific paper on whistlers immediately after the war.

Moreover, during World War I there were two major units in the signal corps; one was for coding and decoding messages, upon which a history of inscription can be built, and the other was for locating the direction from which signals were transmitted. The latter was called the direction-finding (D/F) unit. Thomas L. Eckersley was a member of the D/F unit in the British signal corps when he heard whistlers, and he would be the other major whistler scientist after the war. D/F antennas were already in use before the war for purposes of navigation and can be understood as the ancestors of GPS, but not before playing a role in locating radio at the center of our galaxy and making a guest appearance in James Joyce's *Finnegans Wake*. At minimum, D/F should remind us that wireless telecommunications have always been concerned with positions as well as messages.

Whereas signal corps code makers and breakers exercised their craft on paper much as would a scholar, those in D/F units focused live on the spatially fluctuating movements of transmitted signals. Some of these signals, as Eckersley presciently understood, were misleading because they had to be interacting with what was later known as the ionosphere. Indeed, whistler research in the years after World War I played a significant part in establishing the existence and understanding the behavior of the ionosphere, that part of nature that was, during the 1920s, brought into circuit of wireless telecommunications systems and would remain there for decades to come. Whistlers and the ionosphere have, in this respect, helped determine our present media situation.

Friedrich Kittler's basis in engineering compels media theory to a place where machines increasingly talk to one another at such accelerated speed in minutely localized microcircuitry that space no longer matters, and where what he calls "so-called Man" has been excluded from the conversation. In a practical sense, this scenario can be seen operating in financial

trading, where algorithms converse and manipulate the fate of nonmachines in microseconds. Certain humans figure in, of course, especially mathematicians and politicians, as do other infrastructural items purchased by the financial industry for generating and regulating its activities, but creatures with the old souls once recognizable to the humanities have certainly been excluded.

Souls of nature writers have rightly come under critique in ecotheory, but that does not mean that Kittler's machines are conversant with what he calls "so-called Nature." Media and nature would have more to say to each other with a grounding in physics rather than engineering and in transmission rather than inscription. Kittler limits his discussion in this regard by stopping at voltage differences in microcircuits, which if he followed the potential flows would lead through the power outlet on the wall to green media and a politics of energy, and to a global architecture of ubiquitous media founded on transmission.

. . .

Just a few more words on this book. The chronological expanse combined with the level of detail requires an episodic structure. Since many episodes include new concepts and historical information, or are unfamiliar because of disciplinary cross-traffic, there is a need to step back intermittently to provide context. To understand Watson's fascination with new sounds in the telephone, I have included a discussion of how the microphone, itself a part of the new telephone technology at the time, piqued an unheard-of imagination for sounds. To demystify the act of hearing nature in the lines of communications technologies, I step back to Henry David Thoreau and others who heard the Aeolian music of nature in telegraph lines and, before that, to the longer history of the Aeolian, with its questioning of whether nature had any talent for music. And, given that the natural sounds (if not music) of the Aeolian occurred in the absence of purpose-built technologies, what were and are the commensurate energy-filled fields of technological absence for presence of the Aelectrosonic?

The book's focus on Alvin Lucier derives from his early use of natural radio in a composition and his notion of natural electromagnetic sounds, among other factors, one of which may be that, in full disclosure, I was his student in graduate school and an admirer of his work several years prior to that and every year since. To discuss Lucier's natural radio music, it is necessary to introduce him and the physicist Edmond Dewan and then to investigate their engagement with the natural electromagnetic sounds of brainwaves. Only then is it possible to describe an electromagnetic

spatiality, from brainwaves to outer space, constituted between Cold War and counterculture.

Then it is possible to step back yet again and describe how the constitution of an electromagnetic plenitude was already underway during the twentieth century in the realm of sound synthesis, and how it related to notions of nature, control, and relinquishment of control in modernist and experimental electronic music as "more new sounds" became "more new signals." Both naturalist and modernist plenitudes of surround sound became urban, terrestrial, and extraterrestrial environments of energetic fields and waves, as more objects took on currents, cities were saturated, and reception broadened. The expanse from brainwaves to outer space thus serves as an allegory for the points, sweeps, and scattering of electrical and electromagnetic energies wherever they occur, from the microtemporal voltage differences in digital circuits, back in time to the cosmic corners of the universe, many of them audible in more new sounds and ways of listening.

Throughout, it is very important to keep in mind that the focus on certain artists and musicians is only on select works that intersect the themes of this book. No extrapolations to bodies of work or representations of careers are necessarily inferred. Only a few works initially motivated this book, and what I hope to show is that the integrity of specific works may present provocation and require critical labor in equal measure.

You will notice certain dispositions; for example, I include scientists in discussions of art and science interactions where scientists' concrete roles are too often overlooked. I also acknowledge the popular, amateur, and independent practices that form the third leg of the stool that is art-amateurism-science. I have a predilection for specifying location, which may appear to be unnecessary detail but is rather an accumulation of locations that render earth magnitude a little more palpable. I also choose to invoke sounds, describing them at length in an older form of sound recording provided by words; a book that has sound as a topic should contain sound in a skewed audiovisuality of reading.

1 Thomas Watson

Natural Radio, Natural Theology

The legend of radio begins in the 1890s with Guglielmo Marconi leading the procession of successful great men and Nikola Tesla among the great men unfairly treated. Although some would win in the courts of law and aficionado opinion, Marconi held sway in the popular imagination. Marconi's early device was actually wireless telegraphy, not "radio" as it came to be known with commercial broadcast in the 1920s. It did not transmit voice, music, and other sounds, only the make-and-break dots-and-dashes of telegraphic code. Purpose-built inventions that carried voice and music appeared around 1906 to 1910 and were linked to the names of Reginald Fessenden, Lee De Forest, and Marconi himself, among others, although, as we shall see, non-purpose-built devices had wirelessly carried voice and music through "inductive radio" three decades earlier.

Understanding the physical basis of electromagnetic waves is attributed to James Clerk Maxwell, who, continuing the work of Michael Faraday, theorized electromagnetic waves in 1864, and to Heinrich Hertz, who, two decades later, empirically demonstrated their existence. Still, as Charles Süsskind has stated, "Observations of electromagnetic-wave propagation from man-made electrical disturbances have been made probably for as long as there have been means for producing moderately large sparks."[1] One such observation occurred in 1780 when "Luigi Galvani observed that sparking from an electro static generator could cause convulsions in a dead frog at some distance from the machine."[2]

What kept radio from being heard on the tail end of sparks, apart from the wet slap of a dead frog? Historical incidents of transmissions or possible transmissions are studied in the niche topic of "pre-Marconi wireless."[3] They fall into two general classes: the first contains examples of induction, the disturbances of electromagnetic fields known to Hans Christian Ørsted

and Michael Faraday; and the second contains likely examples of transmitted electromagnetic waves associated with Maxwell and Hertz. The principles of induction were understood in the last quarter of the nineteenth century, so when people were confronted with inexplicable incidents of transmission prior to Marconi, such incidents were simply dismissed as being nothing more than forms of induction.

When the telephone came along in 1876, its lines interacted with the electromagnetic fields of telegraph and telephone lines and "earth currents" and received naturally occurring electromagnetic waves. That is, the telephone acted as a wireless device in both senses of induction and the reception of transmission. Those listening certainly knew what Morse code, music, and voices sounded like, so when they heard them when no one was sending them from the other end of the telephone, they knew they had unexpected company from other lines. In this way, Morse code was heard without wires when Marconi was a toddler, and voices and music were heard when Fessenden was ten years old. However, unlike Morse code, when people listening on the telephone heard natural radio they could not know what it was, so its sounds were a matter of mystery and speculation.

In 1876, when Alexander Graham Bell demonstrated his "articulating" telephone, there were already a number of telephones in existence. They worked on the "make-and-break" currents of the telegraph, an appropriate term given the commercial viability of communications systems, and some telephones were designed to transmit fixed musical pitches. Bell's device, on the other hand, used "undulatory" currents conducive to the dynamics of the voice, as well as to a greater range of musical sounds. However, if a telephone was attached to a telegraph or telephone line, sounds were heard before anyone started speaking or performing. Some were associated with the device itself, that is, with the complete grounded circuit of two or more telephones connected by a line. Some were sounds produced by currents that had long been known to exist more crudely on the telegraph. Other sounds were the result of interactions of inductive fields from nearby lines, and still others resulted from the fact that the line seconded as an antenna. Bell spoke about these sounds during the first few years of the telephone:

> When a telephone is placed in circuit with a telegraph line, the telephone is found seemingly to emit sounds on its own account. The most extraordinary noises are often produced, the causes of which are at present very obscure. One class of sounds is produced by the inductive influence of neighboring wires and by leakage from them, the signals of the Morse alphabet passing over neighboring wires being audible in the telephone; and another class can be traced to earth currents upon the

wire, a curious modification of this sound revealing the presence of defective joints in the wire.[4]

The role of the telephone in the history of wireless technology has not gone unnoticed, but the last full treatment was in 1899. John Joseph Fahie's book *A History of Wireless Telegraphy: 1838–1899* was written a few years after Marconi's invention, yet it required over three hundred pages to detail the many claims, attempts, and realizations at sending messages over distances without wires or, as it was known then, space telegraphy.[5] Fahie divided the history into periods in the evolution of the technology, the first being characterized by good ideas and unsubstantiated claims, followed by the second, *practicable* period, which occurred once the telephone was attached to telephone and telegraph lines. Fahie, however, overlooked Thomas Watson, the person who first attached a telephone to a telephone line.

Alexander Graham Bell and Watson, his assistant and chief machinist, were the first to "talk by telegraph" because of their unique access to the device.[6] Once Watson's workday came to a close and no one was on the other end of the line, he listened to sounds other than voices. Environmental energies had long been ever-present in the telegraph system, but the transductive capability of the telephone made them audible as never before. The sensitivity of the device that made it possible to hear voices also made it possible for Watson to hear natural radio.

Watson heard radio once the telephone was hooked up to an outdoor telephone test line because the line acted as an unwitting long-wave antenna. The other lines coursing through Boston were telegraphic and there were no widespread sources of electrical interference. Most telegraphers closed shop at the end of the business day, meaning there was even less interference during the night when Watson listened to the sounds on his line. Writing in his autobiography fifty years after the fact, Watson reminisced:

> At this time, early in 1876, there was but one outdoor telephone line in the world. It was the iron wire about half a mile long, grounded at each end, that connected the Exeter Place laboratory with Williams' shop [in Boston]. This No. 12 galvanized wire was run for us by some of Williams' men over the housetops very soon after work in the new laboratory was started. There were no trolley car or electric light systems to send their rattling current-noises into our wire and the only other electric circuits in constant use were the telegraph wires, the currents in which, being comparatively weak and easily recognized as the dots and dashes of the Morse code, did not trouble us. This early

silence in a telephone circuit gave an opportunity for listening to stray electric currents that cannot easily be had today. . . .

A few years later these delicate sounds could no longer be heard, for they were completely drowned out when electric light and power dynamos began to operate. I used to spend hours at night in the laboratory listening to the many strange noises in the telephone and speculating as to their cause. One of the most common sounds was a snap, followed by a grating sound that lasted two or three seconds before it faded into silence, and another was like the chirping of a bird.[7]

What Watson described as "a snap, followed by a grating sound that lasted two or three seconds," was probably a lightning strike followed by a "hissy" or "swishy" whistler, rather than a pure tone whistler and, in any case, the duration was probably overestimated. The bird chirping was probably a so-called tweek caused by the electromagnetic burst of a lightning strike, its energies stretched out over hundreds of kilometers bouncing between the earth's surface and ionosphere into a short sliding tone.[8] If it sounded like a flock of birds chirping, then it could have been a *dawn chorus* or, less likely, an *auroral chorus,* the former associated with the sunrise and the latter with auroral activity. The aurora borealis was not commonly observed with any strength at the lower latitudes of Boston; nevertheless there were numerous sightings listed in the monthly weather reports in the annual report of the United States chief signal-officer. Auroral display was but one form of "atmospheric electricity"; "meteorology" at the time was dedicated to anything that moved in the air and, in fact, also to when the ground moved with earthquakes and when plants budded and bloomed.

There would have been many possible times for Watson to hear natural radio associated with auroras, but he may have been referring to mid-1877. That was when William Channing reported that John Peirce, a professor at Brown University in Providence, Rhode Island, and contributor to the early development of the telephone, saw the aurora and heard sounds in the telephone at the same time: "The sounds produced in the Bell telephone by the auroral flashes or streamers were observed here by Prof. John Peirce in May or June."[9] As the chief signal-officer's report described for the month of May 1877, auroras "have been more numerous and brilliant, and more extensively observed, than for some years past," with May 28 being especially notable.[10] Many telegraph systems were affected by ground currents and "the electric disturbance on telegraph-wires was sufficient to interrupt ordinary business between New York, Buffalo, Baltimore, Montreal and Washington."[11] Since auroral display is associated with solar storms that, in turn, produce a flurry of natural radio phenomena, Watson may have been

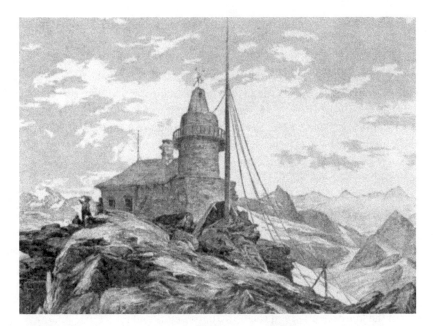

Figure 2. Sonnblick Observatory. A. Heilmann, *The Observatory in the Beginning*, 1886. Image courtesy of Archive Sonnblick-Verein/ZAMG and Bernd Niedermoser.

listening at a particularly good time. He was not only at the right place at the right time with respect to the invention of the telephone; he happened to start listening during a solar maximum conducive to natural radio.

That the iron test line could have acted as an antenna is supported by the sustained scientific observation that occurred twelve years later at the dramatically positioned Sonnblick Meteorological Observatory, a high-altitude (nearly 10,200 feet, or 3,300 meters) meteorological station in the Austrian Alps. The isolated peak was "connected with the post office by a long and free telephone line in a north-south direction," rising 2 kilometers over a distance of 22 kilometers. The observatory was built in 1886 and "immediately after completion" of the telephone line, "Professor [Josef Maria] Pernter often observed a whistler of variable intensity in the line and Professor [Wilhelm] Trabert evaluated the observations" during a continuous six-year period from 1888 to 1894.[12] Further proof of lines becoming antennas comes from a Bell Labs paper from 1933: "A twelve-mile telegraph line free from power interference has been found a satisfactory antenna, and with a telephone receiver between the line and the earth, swishes of remarkable clearness have been observed. Tweeks have been heard with the same equipment."[13]

Back in Boston in 1876, Watson had a few ideas about the source of what he heard: "My theory at the time was that the currents causing these sounds came from explosions on the sun or that they were signals from another planet. They were mystic enough to suggest the latter explanation but I never detected any regularity in them that might indicate they were intelligible signals. They were seldom loud enough to interfere with the use of the telephone on a short line."[14] Neither of these speculations was unreasonable for their time and, in any case, he was not committed to the task of identification. Watson's speculation that the "sounds came from explosions on the sun" was well within the experience of telegraphers. Disturbances on the sun had been correlated to auroral displays, which had in turn been correlated to the magnetic storms that famously wreaked havoc on telegraphic transmissions.

This was probably on the mind of a journalist from the *Lawrence American* newspaper in Massachusetts who reported on a telephone lecture and demonstration that Bell and Watson conducted during May 1877. Although they failed to establish communications along the "rusty-jointed telegraph wires," the article reported that at around 10:00 P.M. Watson had heard the *loose electricity* of the "Northern Lights and found his wires alive with lightning."[15] So, although Boston was too far south for all but exceptional auroral activity, the association was legitimate to an electrical mechanic like Watson in terms of sunspots, auroras, magnetic storms, and the conductivity of telegraph lines. Indeed, as we shall see, Alexander Graham Bell later marshaled his favorite invention, the photophone, to listen to the sounds of storms on the sun.

Any speculation that these might be signals from another planet was based on a confident lack of knowledge about the presence or absence of extraterrestrial life in the solar system. Given the new conversations happening because of the miraculous long-distance telecommunications capabilities earlier in the nineteenth century, reaching other creatures at far-flung locations was first of all a technical matter. Lunar life might be hailed using Charles Fourier's sidereal telegraph, a large-scale version of the semaphore messaging that had worked well in systems of optical telegraphy, or it might be possible to communicate with Martians using powerful wireless signals as later suggested by Nikola Tesla.[16] Indeed, during 1924 on the occasion of the close proximity of Mars to Earth, a National Radio Silence Day was proclaimed, with cooperation from military communications and corporate broadcasters, just in case any intelligent lifeform might be transmitting.[17]

Watson's ruminations about what he heard on the telephone were not too dissimilar from those offered by W. H. Preece, the prominent engineer

and chief technical officer of the British General Post Office, during a talk he gave in 1894 at the Wimbledon Literary and Scientific Society.

> Strange, mysterious sounds are heard on all long telephone lines when the earth is used as a return, especially in the calm stillness of the night. Earth-currents are found in the telegraph circuits, and the aurora borealis lights up our northern sky when the sun's photosphere is disturbed by spots. The sun's surface must at times be violently disturbed by electrical storms, and as oscillations are set up and radiated through space, in sympathy with those required to affect telephones, it is not a wild dream to say that we may hear on this earth a "thunderstorm" in the sun. . . .
>
> If any of the planets be populated with beings like ourselves, having the gift of language and the knowledge to adapt the great forces of Nature to their wants, then, if they could oscillate immense stores of electrical energy to and fro, in telegraphic order, it would be possible for us to hold commune by telephone.[18]

Watson was more earnest, but the possibility of life on another planet was perfectly consistent with the evolutionary logic of his own natural theology; and, in turn, the eventual means to communicate was consistent with the quickly developing technological revolution that he was at the center of.

In his self-published tract, *From Electrons to God: A New Conception of Life and the Universe*, Watson reasoned that, just as the earth had been thrown off the sun as a fiery ball and cooled into an environment amenable to evolutionary progress, so too other worlds would be thrown off from the infinity of stars in the universe. He assured his religious friends who might have thought that God's sole creations were earthbound that "we should be glad we are not alone in the grand procession and that we may hope some time to be able to exchange helpful messages with our sister planets and still further speed up our [evolutionary] progress to higher planes."[19]

Whatever his speculations when he first listened in 1876, writing in the mid-1920s he was still unaware of the true sources of the sounds—although solar storms were not too far off the mark—and he was unsure whether anyone knew: "I don't believe any one has ever studied these noises on a grounded telephone line since that time, for they could not be so studied today unless a wire were run in some wilderness far from an electric light or power station."[20] He was correct in thinking that listening would need to be conducted outside the ambient electromagnetic din of cities and extensions of the electrical grid, and he thereby placed the sounds within a trope of polluted cities versus pristine wilderness. He was incorrect in thinking that studies had not been conducted; such studies had begun with six years

of observation from 1888 to 1894 on the long telephone line at the Sonnblick Meteorological Observatory in the Austrian Alps and had developed significantly after World War I through the 1920s at the time of his writing.

Watson heard natural radio on a telephone that acted like a wireless device when the line turned into a long-wave antenna. During the 1920s, with the contemporary experience of the wireless device of the radio at his fingertips, he wrote, "These currents were probably from the same sources as the static that afflicts the modern radio, and the difference in their sound may have been due to the fact that they were not amplified in the telephone then as static is now in a radio receiver. I, perhaps, may claim to be the first person who ever listened to static currents."[21] The term *static* here has some latitude. It could mean the type of erratic or undifferentiated noise that we associate with static electricity and static on a radio, but during Watson's lifetime it was also a general term in electrical engineering parlance for radio interferences that could range from this type of static to the type of sounds that Watson described. The salient question is why, in 1876, as a young man in his early twenties, would he listen for hours at night to such sounds? Attempts at identification could not sustain such prolonged attention; clearly Watson was engaged aesthetically with these sounds, but there was also a state of wonderment about what he would eventually call *earth's divinity* that overtook him.

As a boy Watson could not accept the idea of a stern god who used thunderstorms to convert people and drowning to consecrate them; instead, he imagined a benevolent deity manifested within a serenity of nature. He found a place on the roof of the stable and sat "alone in the twilight with a delightful feeling of being part of the sky and on good terms with God," and later in life he took long nature walks and would "lie half the afternoon in some quiet nook, miles from home, in a rapturous dream."[22] Thus, he described a predisposition toward the night sky and the patience to listen for hours to the sounds emanating from it.

He formalized his thoughts late in life in a series of related writings: *From Electrons to God: A New Conception of Life and the Universe* and the typescripts "The Religion of an Engineer" and "The Earth, A Vast Orchestra."[23] In them he outlined a vitalistic natural theology bearing the influence of the socialism of Edward Bellamy, the evolutionism of Charles Darwin, the spiritualist diffusion of Hindu cosmogony in the United States, and the mystical side of German psychophysicist Gustav Fechner, especially *The Little Book of Life after Death*.[24] In these writings, Watson applied

energetic principles of vibration, atomistic electricity (electrons), and musical metaphors to the cosmos:

> Every electron and every atom of the earth, from its center to the farthest limits of its atmosphere, is alive and sings its part in earth's stupendous music.[25]
> The universe is made of a single eternal substance, eternally vibrating in an infinite range of frequencies. Everything we know is something vibrating: the universe is like a vast orchestra playing an eternal music of millions of octaves combined into an infinite variety of melodies and harmonies. These vibrations are the universal Life, all under the control of a single eternal Law which causes harmonic vibrations to unite. From every union of vibrations under this Law something new emerges. From this Law, which I call Harmonic-Union-Creation, acting on the universal Substance everything in the Universe from electrons to God has emerged.[26]

Although the cosmos that Watson developed in his writings was musical, he did not talk about natural radio in terms of music. His cosmos was one that proceeded from noise to music, from the vibratory electrical energies of "primeval stuff of the universe partially organized into electrons and the like, all vibrating with an innumerable range of frequencies, which was the manifestation of the earth's now separate life and mind," to a grand, evolved harmony.[27] For Watson, music was related to revelation, whether it was the technical problem-solving revelations he had experienced early in his life while working as a machinist for Alexander Graham Bell, or the mystical, oceanic revelation he experienced during which the unity of everything became apparent to him. Watson's aesthetic engagement with natural radio, on the other hand, was related to a comfort of not being able to know. Something presented itself but nothing was revealed.

2 Microphonic Imagination

The mysterious sounds that Thomas Watson heard belonged to a larger class of sounds, real and imagined, opened up by the actual telephone and the idea of the telephone. The phonograph was good at storing and repeating the realm of already existing sounds, but the telephone specialized in new unheard-of sounds. The atmospheric energies and earth currents influencing telegraph lines had been registered by the perturbations of needles, in the clicking of the telegraph key, and by the occasional sparking of the equipment in telegraph offices under the influence of powerful magnetic storms. Once a telephone receiver was put into circuit with the line, a new, raucous, and subtle array of sounds could be heard.

The telephone technology of the microphone opened a larger universe of small sounds. The microphone was not, as we think of it today, an autonomous piece of technology, a discrete component at the end of a cord that plugs into audiophonic systems. It was an integral piece of telephone technology, one that amplified real and imaginary, natural and unnatural worlds of small sounds, much as the microscope had revealed and conjured up tiny parallel universes existing below the threshold of vision.

The small sounds of microphonia eventually fed into the arts, forming the krill in the baleen of musical and artistic experimentalism from John Cage to the sonocytological and nano arts. Some of the most miniscule small sounds can be heard played back through the stylus of atomic force microscopy, but people in 1878 were already listening closely for molecules and atoms: "Mr. Chandler Roberts, F.R.S., has made an interesting application of the microphone to the phenomenon of the diffusion of gases. By its means he is enabled to hear the patterning of the atom shower of gases diffusing through a porous spectrum. The noise is said, without exaggeration, to resemble the rush of a tropical rain-squall through a forest. It must be

very gratifying to Professor Tyndall to know that he may yet listen to the clash of atoms and the melee of molecules."[1]

The analogy of the microphone as microscope had been made as early as the seventeenth century: "As microscopes or magnifying glasses, help the eye to see near objects, that by reason of their smallness were Invisible before; which objects they magnify to strange greatness: so microphones and microacoustics, that is, magnifying ear instruments may be contrived after that manner, that they shall render the most minute sound in nature distinctly audible, by magnifying it to uncommon loudness."[2]

Modern microphony, however, began with the unprecedented sensitivity of the telephone, as John Joseph Fahie stated: "The introduction of the telephone in 1876 placed in the hands of the electrician an instrument of marvelous delicacy, compared with which the most sensitive apparatus hitherto employed was as the eye to the eye aided by the microscope."[3] The telegraph was a blunt instrument compared to the sensitivity of the telephone, which could detect currents "a thousand million times less than the currents used in ordinary telegraphic work," as James Clerk Maxwell himself pointed out in his 1878 Rede Lecture on the topic of the telephone.[4]

The galvanometers that electricians had used for minute registrations of electrical currents could not compare with the subtlety of the telephone. Galvanometers going back to Luigi Galvani had relied on a frog's leg that, in turn, produced an audible click in the telephone in 1878 when electrodes were attached to its gastrocnemius muscle.[5] However, physiology was failing electrical research: the French physician and electrophysiologist Jacques-Arsène d'Arsondal listening in the "silence of the night" determined that the telephone was "at least a hundred times more sensitive" than any animal nerve.[6]

In early discussions of the microphone, the electrical clicking of convulsing frog legs was accompanied by the cadence of a fly's footsteps. The sound can be tracked back to the 1878 paper in which D. E. Hughes discussed his use of Alexander Graham Bell's new telephone to investigate "the effect of sonorous vibrations upon the electrical behavior of matter."[7] Hughes's experiments led to a device with an ability to "magnify weak sounds" that would do "what the microscope does with matter too small for human vision"; he called the device a *microphone,* a gateway for small sounds.[8] "The movement of the softest camel hairbrush on any part of the board is distinctly audible. . . . If a pin, for instance, be laid upon or taken off a table, a distinct sound is emitted, or, if a fly be confined under a table-glass, we can hear the fly walking, with a peculiar tramp of its own."[9] Moreover, small sounds could then be transmitted over telephone lines great distances, such

that "the beating of a pulse, the tick of a watch, the tramp of a fly, can thus be heard at least a hundred miles distant from the source of sound."[10] The microphone's integration with the telephone produced transmission as a projected amplification, an auditory form of the microscope and telescope combined.

It is doubtful that many people actually heard flies walking around, but that is not the impression one gets from the journalism at the time. The *New York Times* reported on a demonstration by a gentleman in Lawrence, Massachusetts, who separated Hughes's microphone from Bell's telephone with 600 feet of wire: "Then a small wire cage, containing two common house flies, was placed on the instrument, and to the listening ear, 600 feet away, distinctly came the soft and irregular patter of the tiny feet, as the flies walked over the board, and as they flew from one side of their cage to the other, the sound as they struck against the fine wire was heard with a sharp metallic ring, altogether like that of the hammer of a boiler-maker, as he rivets the bolts in the iron cylinder."[11]

The well-known scientist William Crookes compared the sound of a fly enclosed in a box to the kicking of a horse; the *New York Times* compared "the prancing of a fly on a metallic disk with all the distinctness of a horse cantering over a bridge to the meter of Virgil's famous line, *Quadrupendante putrem sonitu quatit ungula campum*"; then it was not merely the fly's footsteps but rather "the mere breath of the fly is heard almost like the trumpeting of an elephant"; or, more precisely, "the insect's respiration may be clearly heard like the wheezing of an asthmatic elephant"; or, more cruelly, as the *Christian Advocate* revealed, "a fly's scream, especially at the moment of death, is easily audible"; and another description, "the sensation of a horse's tread and even a fly's scream at the moment of death"; and finally, as noted in a competing camp by Thomas Alva Edison's associate Francis Jehl, the fly was reincarnated in the sound of "the footfalls of a tiny gnat [that] sounded like the trap of Rome's cohorts."[12] All this time, Hughes had merely invoked the fly's footsteps to speak of a lightness of being that was absent from the human voice: "for a man's voice the surfaces must be under a far greater pressure than for the movements of insects."[13]

James Clerk Maxwell echoed Hughes in his Rede Lecture when he stated, "When a fly walks over the table of the microphone the sound of his tramp may be heard miles off." Noting also that London physicians were already "performing stethoscopic auscultations on patients in all parts of the kingdom," Maxwell had a suggestion for the Entomological Society: "Perhaps a long microphone, placed in a nest of tropical scorpions, may be connected up to a receiver in the apartments of the society, so as to give the

members and their musical friends an opportunity of deciding whether the musical taste of the scorpion resembles that of the nightingale or that of the cat."[14]

Littell's Living Age reported that, whereas "the stethoscope only collected the sound, the microphone will amplify" small sounds and thus will disclose "new sounds now inaudible. . . . It should be possible to hear the sap rise in the tree, to hear it rushing against small obstacles to its rise, as a brook rushes against the stones in its path; to hear the bee suck its honey from the flower; to hear the rush of the blood through the smallest of the blood-vessels, and the increase of that rush due to the slightest inflammatory action."[15] With the microphone attached to the "throat by an India-rubber band, the faintest trill or whisper is audible," and with it attached to the arm "it transmits the muscular sound from a powerful biceps."[16] One Professor Hueter of Germany, having adapted Edison's microphone to a *dermatophone*, "proved that we can not only hear the rush of blood through the capillaries of the skin (dermatophony), but also the sounds of muscular contraction (myophony), of tendinous extension (tendophony), and of the vibration of the long bones when percussed (osteophony)."[17]

All these flies, scorpions, and internal bodily sounds should not distract from the tick of a watch that Hughes heard, or from others listening closely to "the grinding of the wheels, the sonorous ring of the spring and the minutest tick of the gearing," and, just possibly, "molecular movement."[18] After all, Hughes was using the telephone for a study of the electrical behavior of matter that departed from technological approaches based on membranes and the body. Sound remained in physics rather than being imported into the physiology of stethoscopes and electrophysiology of frog legs.

Hughes placed a wire "under strain" to determine the influence on a current flowing through it, much as a musical string would increase in pitch the more tightly it was drawn. But nothing happened until the wire was pulled so tightly that it broke and he heard a "rush" sound. In his attempt to duplicate the moment, he pressed the broken ends together and obtained unprecedented results. Hughes had found that, unlike the inventions of Johann Philipp Reis, Bell, Edison, and others, "the diaphragm has been altogether discarded, resting as it does upon the changes produced by molecular action."[19]

The rushing sound that Hughes heard was also reported as "shh," a sound that usually implores silence.[20] It was the last attempt to keep quiet a new universe of small sounds. The real poetics of the invention, however, resided in something performing better when broken. Hughes had found a delicate new device in what among electricians was known as nothing more

than a loose contact. This act of turning defect into asset was counterintuitive and at the time produced its own Manichaean elaboration: "Electricians have long had sore reasons for regarding a 'bad contact' as an unmitigated nuisance, the instrument of the Evil One, with no conceivable good in it, and no conceivable purpose except to annoy and tempt them into wickedness and an expression of hearty but ignominious emotion. Professor Hughes, however, has, with a wizard's power, transformed this electrician's bane into a professional glory and a public born. Verily, there is a soul of virtue in things evil."[21]

That a gap of a loose contact could amplify a legion of small sounds led to speculation of other, larger environmental sounds rushing in: "Even the cut ends of wires and the splicings of a telephone line are said to act as small transmitters, and to receive and forward the natural sounds which may be produced around them, such as the singing of birds or the croaking of frogs."[22] In 1882, when a manager of a telephone company reported hearing "the croaking of frogs and the singing of birds [on a wire that] passes through dense wood and along large streams," he thought the sound might have been induced into the electromagnetic field of the wire by the conductive properties lent by the surrounding "damp atmosphere." *Scientific American* had another explanation: a bad splice in the wire or loose contact. "The more perfect the joint the less perfect the microphone, and *vice versa*," reported the journal. "The line in question had at some point near the locality where the frogs were croaking and the birds were singing in the morning an imperfect joint, which was affected by the noises in the vicinity, and its resistance accordingly varied. . . . This effect might be aided, and probably was, by the damp atmosphere referred to."[23]

Such speculation by a reputable scientific journal was typical for a time in which defects could give rise to new devices and communications technologies were already in a complex commune with natural energetic forces. Moreover, the journal's speculation belonged to a time when the telephone and microphone were greeted with an uncanny poetics of popular imagination. The following passage forms a chronological bridge between the Romantic commune of Goethe's *Young Werther* and someone patched in to contemporary consumer electronics:

> We are assured that we shall be able, not only to listen to the tramp of
> the tiniest insects, but to hear the growing of the grass and the ripple of
> the sap ascending beneath the bark of the tree. The seething of the
> magic alchemy in the laboratory of the leaves, as they transmute the
> grossness of earth and air into forms of beauty, and all the bravery of
> the Summer's green shall become audible as the clatter of a common

workshop. Then will be the dreaming poet, as he lays him down in the woods or field to feel the thrill of nature's voices surround himself with batteries, disks, and wires, and bring to his ears the clash and roll, the hum, the ripple, and the clang of a Titanic orchestra.[24]

This appeared in 1878 in a *New York Times* article titled "The Phones of the Future," a lighthearted piece about the technological possibilities in an era when the *-graph* was ceding to the *-phone*, in our own parlance, a difference between inscription and transmission.

Given the sensitivity of the telephone, the transmissive *tele* now stretched from the imperceptibly small to the unimaginably distant, while the *phone* rendered audible the myriad "voices" of things within a new sonic plenitude. Thus, to the microscopic focus of microphony was added a full telescoping of distant hearing in telephony. While Goethe's head was in the grass filled with bugs, the stars belonged to Shakespeare, with one "phone of the future" aimed toward the heavens to render audible "the music of the spheres, the voice of the smallest star that 'in his motion like an angel sings/still choiring to the young-eyed cherubins' [*The Merchant of Venice*, Act 5, Scene 1]." It was a meeting of great literature with an aesthetic science on the ground of telecommunications. Music was not far behind: "The voices of earth and heaven may perchance unite in one tremendous symphony through the agency of the *symphone* that is yet to be invented."[25]

In a letter to the editor of the *New York Times*, one P. C. B. was a little less lighthearted. He acknowledged that the speculations in the article were not only amusing but also "profoundly philosophical." His name was Porter Cornelius Bliss, a journalist who was planning to write a biographical sketch of Edison and listed his address as Menlo Park, New Jersey, the site of Edison's laboratory. In the letter, Bliss predicted that, although Edison had not yet invented the *symphone*, he was sure to establish the technological means for "a new science of kosmical proportions, and which may well receive the name of Kosmophonics."

Mr. Edison has already (with his assistant, Mr. Batchelor) listened to the sounds of molecular vibrations, and is thus the first mortal who has removed the veil of Isis from one of the innermost shrines of nature's temple. For this instrument of magnification promise I propose the name of kosmophone. . . . The new science of kosmophonics will have several subdivisions of striking originality and interest. For the graphical registry and subsequent study of the voices of the animate creation we shall have the zoophone and its corresponding science of zoophonics. For the registry of the sounds of the "vegetable kingdom"

we shall have the phytophone, for the sounds of inorganic nature the physiophone. All these names which now appear in print for the first time will doubtless be as familiar to the rising generation as telegraph and photograph are to our contemporaries.[26]

Some of the most compelling speculation appeared in *Littell's Living Age,* the Boston-based literary magazine, in an article titled simply "The Microphone":

> The new instrument may enable us not merely to see, but to *hear* light. It is quite conceivable that by the use of the microphone the chemist who is trying to analyze the spectrum of a star may be enabled to *hear* the first ray of the star strike upon his spectroscope, and to listen to the gentle rain of rays which follows while the spectroscope is exposed to that star, and then to exchange that gentle sound for that of the torrent which would follow when he exposed his instrument to the moon instead of the star. We may find that the rippling of the light from Sirius has a sound quite different in character from the rippling of the light from Arcturus or the Polar Star; and all of these onsets of starry light, if they can be heard at all, must make a sound as inferior to the cataract which rushes from the sun, as the dash of a brook is inferior to the roar of Niagara. It may be, too, that the sound made by the different prismatic rays, as they strike a surface, will produce a harmony as delightful and as susceptible of indefinite variation as the prismatic colors themselves, so that the most exquisite musical instruments might be produced by merely opening the ear to the sounds (at present too slight for any ear to perceive) corresponding to the colors of the rainbow, and varying the combinations at the discretion of the musician. Wagner, in one of his great works produced in this country, has, we believe, a "Rainbow Chorus," which was generally admired, but which did not, without help from the words of the libretto, suggest to the audience that association with a rainbow which he had imaginatively ascribed to it. May it not be possible, with the help of the microphone, to give us a true rainbow music—a music really caused by the sound of the same waves which, in their effect on the optic nerve, produce the vision of the rainbow? But one of the most delightful results of great discoveries like this, is that it fosters so much a dreaming power not quite divorced from possibility, and therefore not quite of a kind to discontent us with the world in which our actual duties lie.[27]

The desire to hear light was neither entirely exotic nor fanciful, as we shall see in Alexander Graham Bell's development of the photophone. And, less than a century later, radio astronomy listened to stars on many parts of the spectrum, not just light.

3 The Aeolian and Henry David Thoreau's Sphere Music

The telephone amplified and expanded the audible world of nature, both real and imagined, from the tiniest sounds inside and immediately surrounding people, out to distant reaches of the cosmos. Circulating within this new world were musical sounds and sounds that otherwise engaged aesthetic attention. Yet nature had long produced its own music—the Aeolian—arising from the wind. This music is as old as the myth of Aeolus and the Aeolian Islands and everywhere else that sentient beings have heard the sounds of the wind among the trees, plants, and rock formations. One legend has it that a music arose from wind streaming through the stringy desiccated guts of a dead tortoise that had baked in the sun, resonating in its shell.

The Aeolian was partially personified in Orpheus, with his sweetly forceful voice that could resonate rocks and trees into song and dance, which would have made him one of the first rock singers. However, the Aeolian would stand as an expression exceeding human embodiment and mediation, at times blowing back to resonate the human soul. Most important for our purpose is the way that winds blow across categorical guts of organology, determinations of what is and what is not music, and, finally, what is and what is not nature or technology.

Aeolian effects cross the musical instrument categories of strings, wind, and percussion. A storm can blow through a bamboo stand and produce wind music or can break bamboo and then blow across it like a flute. Or bamboo can be crafted specifically to produce Aeolian sounds and music. As Carl Engel notes, on windy days on the Malay Peninsula one could hear "the languishing bamboo" or "the bamboo of the storm," an Aeolian flute 30 to 40 feet long carved with holes or slits. Elsewhere, slit bamboo was suspended in trees, and bundles of smaller bamboo exposed on one end formed naturally sounded pan pipes.[1]

Whether nature could in fact make music was in dispute. Engel, in his scholarly account of the Aeolian from 1882, stated, "Perhaps most musicians will be of opinion that the wild and mysterious sounds of nature . . . ought not to be called *music*, since they do not emanate from the human heart. However, as long as musicians disagree about the proper definition of the term *music*—indeed, almost every theorist gives a different one—it may be permissible to use the expression 'Aeolian Music,' at least with the same right with which the vocal effusions of the nightingale are commonly designated as the nightingale's song."[2]

Engel may have had the musical conscience of Eduard Hanslick whispering in one ear. Hanslick was Western art music's greatest champion for a complete break with nature: "For music, there is no such thing as the beautiful in nature." The deathly residue of entrails, sinews, catgut, and the sheep guts from which humans made musical instruments was where nature helped make music, rather than any living creature: "Nature does not give us the artistic materials for a complete ready-made tonal system but only the raw physical materials which *we* make subservient to music. Not the voices of animals but their entrails are important to us, and the animal to which music is most indebted is not the nightingale but the sheep."[3]

Likewise, the musical nature of living trees appealed to Hanslick only upon their demise, as a supply of wood for the string and woodwind sections. Animals and vegetables were required to cease their organic existence and become silent in order to mimic the inorganic "mute ore from the mountains . . . proper building materials of music, namely pure tones."[4] Abiotic forces were not as mute and stationary as ore; they were animated in movements that did not originate in human activity and therefore the sounds they made could not be musical:

> Against our claim that there is no music in nature, it will be objected
> that there is a wealth of diverse voices which wonderfully enliven
> nature. Must not the babbling of the brook, the slap of waves on the
> shore, the thunder of avalanches, the raging of the gale have been the
> incentive to a prototype of human music? Have all the murmuring,
> squealing, crashing noises had nothing to do with the character of our
> music? We must in fact reply in the negative. All these natural
> manifestations are nothing but noise, i.e., air vibrations of
> incommensurable frequencies.[5]

The Aeolian was "mere noise" for Hanslick and anything musical it might have to offer would not come from nature, but only from the artfulness of special instruments built to wrench beauty from it. For him instruments

were supposed to sound out worlds of their own making and remain apart from any natural environment.

Carl Engel's scholarly project demonstrated a more capacious attitude toward "a peculiar imagination which is not possessed by every lover of the noble art of music."[6] He cites several instances in which music was heard with no one playing, and with no special instruments present to tease music from nature. In 1695, in the mountains near Bergen, Norway, a farmer led three musicians to listen to an uncanny music:

> It was nearly midnight when we arrived at the farmyard. . . . Now, when my master, the organist, and the cantor had been sitting in that cold place during about a quarter of an hour without hearing anything, they grew impatient, and began to upbraid the peasant, saying, "How long do you intend to make fools of us?" But the peasant begged them to have a little more patience, and to keep quiet.
>
> Suddenly it began to sound in the hills as if tones were produced in our immediate neighborhood. First a chord was struck; then a single tone was sounded, apparently for the purpose of tuning the instruments; then commenced a prelude on the organ; and directly afterwards we heard a number of voices accompanied by cornets, trombones, violins, and other instruments without being able to see any performer. . . .
>
> At last, when we had listened a long time, the organist having become uneasy about these invisible performers and subterranean musicians, called out to them: "If you are of heaven, show yourselves; but if you are of hell, leave off that mysterious music."[7]

Engel was sure that cliff concerts near Bergen could still be heard, weather permitting, "any winter night, when the requisite condition of the atmosphere, or perhaps a change in the temperatures of the air, causes the delicate leaves of the fir-trees to vibrate, and when the crevices in the rocks occasion a draught."[8] He also cites a trumpet sound arising from a group of six or seven hills with deep gullies on the mountain of Ambòndrombé on the island of Madagascar. At one end, the gullies are blocked except for a narrow passage through which the strong winds rush. Such effects are distinct from thermal effects that make certain rock formations sound at sunrise: Alexander von Humboldt and Aimé Bonpland reported a gigantic rock on the Orinoco River that sounds like an organ, due no doubt to similar processes that make the statue of Memnon emit, "when struck by the solar rays, a vocal sound!"[9]

The American naturalist John Muir was such an avid listener to the performances of the wind through the trees that he thought he could locate his position by the distinct sound of certain species and hear musical intricacies "when the attention was calmly bent." In "Song of the

Silver Pine," he praises the species as the Stradivarius of trees in the region, giving forth

> the finest music to the wind. After listening to it in all kinds of winds, night and day, season after season, I think I could approximate to my position on the mountains by this Pine-music alone. If you would catch the tones of separate needles, climb a tree. They are well tempered, and give forth no uncertain sound, each standing out, with no interference excepting during heavy gales; then you may detect the click of one needle upon another, readily distinguishable from their free, wing-like hum. Some idea of their temper may be drawn from the fact that, notwithstanding they are so long, the vibrations that give rise to the peculiar shimmering of the light are made at the rate of about two hundred fifty per minute.
>
> . . . I drifted on through the midst of this passionate music and motion, across many a glen, from ridge to ridge; often halting in the lee of a rock for shelter, or to gaze and listen. Even when the grand anthem had welled to its highest pitch, I could distinctly hear the varying tones of individual trees—Spruce, and Fir, and Pine, and leafless Oak—and even the infinitely gentle rustle of the withered grasses at my feet. Each was expressing itself in its own way—singing its own song, and making its own peculiar gestures—manifesting a richness of variety to be found in no other forest I have yet seen. . . . The sounds of the storm corresponded gloriously with this wild exuberance of light and motion. The profound bass of the naked branches and boles blooming like waterfalls; the quick, tense vibrations of the pine-needles, now rising to a shrill, whistling hiss, now falling to a silky murmur; the rustling of laurel groves in the dells, and the keen metallic click of leaf on leaf—all this was heard in easy analysis when the attention was calmly bent.[10]

For Muir, it was not an Aeolian concert of strings but of needles, and the needles moved from vibratory to percussive, from tones to clicks and vice versa given the intensity of the wind. There was a sense that the sounds of the needles must be understood in the life supported by the trees themselves, in the "wing-like hum" of birds and insects. Moreover, there was a wind speed that would reflect and refract the light into an audiovisual performance. People watch the wind blow over the surface of a lake in complex arrays of ripples; Muir simply reported similar shimmering from an elevated perch itself shaken by the wind.

The Aeolian also erodes hard and fast distinctions between nature and technology, a categorical cavitation that can occur wherever movement is involved. The music of the wind can be produced by nature, by old purpose-built devices such as the Aeolian harp, and by modern devices not built for

the purpose. The same transductive processes occur regardless of whether they involve naturally occurring phenomena or anthropic devices, and whether they are unwitting or intentional. The most trenchant commentary on the unwitting Aeolian of non-purpose-built devices occurred in the journals of Henry David Thoreau, when the music of nature was heard in telecommunications technology.

. . .

The artist is at work in the Deep Cut. The telegraph harp sounds.

Henry David Thoreau

During the 1850s, while Eduard Hanslick fortified Western art music against the incursions of nature, Henry David Thoreau embraced a natural music at the forefront of the destructive incursion of transportation and information into nature: the Deep Cut of the railroad and telegraph.[11] Like many romantics and transcendentalists, Thoreau favored the Aeolian; unlike them, he did not think that the vibratory world was always in the service of a reverberant soul. Moreover, his notion of the Aeolian did not have orchestral strings lurking musically in the wings, ready to take a solo at center stage, but was performed most notably by an unlikely source—the wind blowing across telegraph lines—as an expression of what he called *sphere music,* a singular, terrestrial version of the music of the spheres.

Sphere music involved torque and turbulence occurring across a physical field of magnitudes, from the minute to heliospheric, without evaporating metaphysically into the heavens: "All things are subjected to a rotary motion, either gradual and partial or rapid and complete, from the planet and system to the simplest shellfish and pebbles on the beach as if all beauty resulted from an object turning on its own axis."

How can a man sit down and quietly pare his nails, while the earth goes gyrating ahead amid such a din of sphere music, whirling him along about her axis some twenty-four thousand miles between sun and sun, but mainly in a circle some two millions of miles actual progress? And then such a hurly-burly on the surface—wind always blowing—now a zephyr, now a hurricane—tides never idle, ever fluctuating—no rest for Niagara, but perpetual ran-tan on those limestone rocks—and then that summer simmering which our ears are used to, which would otherwise be christened confusion worse confounded, but is now ironically called "silence audible," and above all the incessant tinkering named "hum of industry," the hurrying to and fro and confused jabbering of men. Can man do less than get up and shake himself?[12]

In this mechanical, that is, pre-electromagnetic, formulation it was not necessary to invent a perpetual motion machine, since we all live on one that is continually performing its own music.

Society did not notice itself amid earthly magnitudes because it was too blinkered by commerce and entranced by its own immediate clamor when, not far away, "in all swamps the hum of mosquitoes drowns this hum of industry," and its insights were parochial and cowardly unless they occurred in the field of magnitudes that was sphere music: "Unless the humming of a gnat is as the music of the spheres, and the music of the spheres is as the humming of a gnat, they are naught to me."[13] This was what Charles Ives meant when he wrote that Thoreau "seems rather to let Nature put him under her microscope than to hold her under his."[14]

Thoreau privileges the Aeolian among all the sounds in nature to the extent it was capable of sensing magnitudes of sphere music at local and global scales. He had his own modest Aeolian harp made of rosewood, but the most important one was strung on a much larger scale: "The resounding wood! How much the ancients would have made of it! To have a harp on so great a scale, girding the very earth, and played on by the winds of every latitude and longitude, and that harp were, as it were, the manifest blessing of heaven on a work of man's!"[15] For Thoreau, it was as though this harp had been strung with the cartographic lines of longitude and latitude, but his grand harp was neither virtual nor at such regular intervals. It had been built at the same time as the national and imperial spread of telegraph lines; in fact, they were one and the same. He called this technological wonder the *telegraph harp.*

It was not simply that he heard the Aeolian in purpose-built and non-purpose-built technology; he heard an unintended nature in the midst of the most advanced media technology of his day. Much like other telecommunications technologies appearing over subsequent decades, Thoreau's telegraphic harp was particularly adept at annihilating the space and time of history. The sound of the telegraph lines made "Greece and all antiquity seem poor in melody," and it meant that America need not defer to the root of its Western origins.[16] He was familiar with how the literature on the Aeolian stretched back to mythic antiquity, but the ancients could not have "stretched a wire round the earth, attaching it to the trees of the forest, by which they sent messages by one named Electricity, father of Lightning and Magnetism, swifter far than Mercury, the stern commands of war and news of peace, and that the winds caused this wire to vibrate so that it emitted a harp-like and Aeolian music in all the lands through which it passed, as if to express the satisfaction of the gods in this invention to no god."[17]

His rhapsody echoed the "methodless enthusiasm" of the companies that, by 1850, had laid more than one million kilometers of line throughout America.[18] However, at the same time Thoreau was distinctly pessimistic about telegraphy and its companion technology, the railroad. Both benefitted commerce, but there was nothing intrinsically beneficial about commerce itself unless it was accompanied by humanity, and he was particularly disgusted by how these technologies improved the commerce of slavery in the southern states.[19]

He was similarly ambivalent about the Deep Cut, a swath of clear-cut land through which the railroad tracks ran and the telegraph lines followed. It was a broad path hacked through forests and foliage, channeling through hillsides and leaving raw banks of dirt, sand, and rock exposed. The Deep Cut, however, positioned Thoreau within the world when, at dusk, it was transformed into an observatory: "The first faint reflection of genuine and unmixed moonlight on the eastern sand-bank while the horizon, yet red with day, was tingeing the western side. What an interval between those two lights!"[20] He observed the elements and seasons as freezes immobilized the rocks, spring brought new life, rain flowed down the banks, and the banks flowed down upon themselves, as described in his well-known paean to the Deep Cut that appeared in the "Spring" chapter of *Walden.*

> The forms which thawing sand and clay assume in flowing down the
> sides of a deep cut on the railroad through which I passed on my way to
> the village, a phenomenon not very common on so large a scale, though
> the number of freshly exposed banks of the right material must have
> been greatly multiplied since the railroads were invented.... As it flows
> it takes the forms of sappy leaves or vines, making heaps of pulpy
> sprays a foot or more in depth, and resembling, as you look down on
> them, the laciniated, lobed, and imbricated thalluses of some lichens; or
> you are reminded of coral, of leopard's paws or birds' feet, of brains or
> lungs or bowels, and excrements of all kinds. It is a truly grotesque
> vegetation.[21]

Commerce had cut through the land, turned it inside out, exposing "a cave with all its stalactites turned wrong side outward," lined it with the dead trees of the telegraph poles and railroad ties so that a fire-fed beast could pass through, but in its wake there were signs of a recuperative if not revanchist nature, much like spring itself.[22]

Thus, he found pleasure in listening to the scattered percussion of the rocks and dirt falling down the bank and to the Aeolian stylings of the telegraph harp in this scene of destruction. "I see the sand flowing in the Cut

and hear the harp at the same time. Who shall say that the primitive forces are not still at work? Nature has not lost her pristine vigor, neither has he who sees this. To see the first dust fly is a pleasant sight. I saw it on the east side of the Deep Cut."[23] At times he sees "perfect leopards' paws" carved in the eroded sand while "the latent music of the earth had found here a vent. Music Aeolian . . . Thus, as ever, the finest uses of things are the accidental. Mr. Morse did not invent this music."[24]

He not only heard the wind's vibratory effects through the air, he felt them in the earth seismically at his feet and heard them in surrounding posts not connected to the wire: "As I cross the railroad I hear the Telegraph harp again . . . its vibrations are communicated through the tall pole to the surrounding earth for a considerable distance, so that I feel them when I stand near. And when I put my ear to a fence rail it is all alive with them though the post with which it is connected is planted 2 feet from the telegraph post—Yet the rail resounded with the harp music so that a deaf man might have heard it."[25] Within a larger recuperation of nature, the wind breathed new life into the cellular structure of the dead wood of the telegraph poles, even when no airborne sounds could be heard.

> Yesterday and today the stronger winds of autumn have begun to blow, and the telegraph harp has sounded loudly. I heard it especially in the Deep Cut this afternoon, the tone varying with the tension of different parts of the wire. The sound proceeds from near the posts, where the vibration is apparently more rapid. I put my ear to one of the posts, and it seemed to me as if every pore of the wood was filled with music, labored with the strain, as if every fiber was affected and being seasoned or timed, rearranged according to a new and more harmonious law. Every swell and change or inflection of tone pervaded and seemed to proceed from the wood, the divine tree or wood, as if its very substance was transmuted. What a recipe for preserving wood, perchance, to keep if from rotting, to fill its pores with music! How this wild tree from the forest, stripped of its bark and set up here, rejoices to transmit this music! When no music proceeds from the wire, on applying my ear I hear the hum within the entrails of the wood, the oracular tree acquiring, accumulation, the prophetic fury.[26]

Thoreau may have been the person to write most profusely about the telegraphic Aeolian, but the American artist Charles Burchfield best painted its sound. Like Thoreau, he celebrated nature sounds; as a student at the Cleveland School of Art in 1915, he wrote, "It is a perversion to think that man-made music is superior to nature's. I can listen tirelessly to an endless wind in the tops of some forest; or the tinkle of some brook; or the calls of

Figure 3. Charles Burchfield, *Telegraph Music,* 1949. Watercolor and ink on paper, $11^5/_8 \times 17^5/_8$ inches. Burchfield Penney Art Center, The Charles Rand Penney Collection of Work by Charles E. Burchfield.

crows. While a prolonged concert by an orchestra of the greatest composers may often produce, by their length, only weariness."[27]

Less than two weeks later, he wrote down in his journal, "All along the Canfield Road I was accompanied by the 'telegraph harp' which is the fitting music of such weather. I must always associate it with wide wind-swept fields in afternoon sunlight. While the humming of the pole just passed was still strong in my ears, the song of a new pole in a higher or lower and sometimes minor key, commenced. Between the poles I heard the clipping of the clashing wires which was like the call of an unceasing katydid on an August night."[28] His first effort at depicting the sounds of the telegraphic Aeolian was the watercolor *Telegraph Music* (1917 and 1949), which served later as the basis for the larger *Song of the Telegraph* (1952). The latter is one of his best-known works and, as Nancy Weekly has written, "practically every square inch of the painting writhes with sound."[29]

There are also reports of indigenous peoples from at least three conti-nents listening to the sounds of the telegraph lines. These reports were filtered through European cultural interpretations. Ernestine Hill charac-terized Aboriginal encounters with the Australian Overland Telegraph Line

laid from Darwin to Adelaide during the 1870s as produced by the Stone Age meeting Civilization: "For a long time the Singing String, its poles humming a high sinister note, was the Voice of terror in the bush."[30] The fact that fractured glass insulators sourced from telegraph poles were used to make spearheads gives this scene a different tone.[31]

After decades during which telegraph lines reaching westward in the United States were sites of deadly confrontation, Henry Farny painted *The Song of the Talking Wire* (1904). As James Bunn describes, "Farny wrote in a letter of 1884 that at an Indian agency in Montana he had seen a man named Long Day who would stand next to a telegraph pole and listen to its hum. Because Long Day wanted to become a medicine man, Farny wrote, he would listen at the pole and tell others that he 'heard spirit voices over the wire.'"[32] In the wake of such awful violence, this painting was a means for Farny to communicate to others in his race a sentimentalized Native American existence that would confirm their own superstitions.

William Henry Hudson, the British naturalist of Argentine birth, remembered, "in South America, seeing a group of natives standing and listening to the tremulous musical hum that rose and fell with the wind, and hearing them gravely say that they could hear the voices of men sending messages and talking to each other over long distances, but could not make out what they were saying."[33] The French anthropologist Claude Lévi-Strauss in *Tristes Tropiques* repeated information that Native people in Brazil confused the Aeolian sounds with bees.[34] Or perhaps they found the sounds analogous to insect sounds, as did Hudson once back in the English countryside:

> Even for us there is a slight something of mystery in the swelling and dying tones, and the sound is in itself beautiful and very natural. It closely resembles that most musical and human-like sound of insect life, which may be heard in many spots on the high downs in July and August; a sound of innumerable bees and honey-eating flies in the flowering heather, their individual small voices blended into one loud continuous hum that rises, too, and falls with the wind. A man led blindfolded over the downs to one of these flowery places, and standing there in the hot breeze, would probably think that he was listening to the harp of the tall wooden pole and suspended wires.[35]

Misinterpretation about what was actually making the sounds was not uncommon. In 1873, *Harper's* pointed out how frequently people confused the Aeolian effects of telegraph lines with a sound generated by the electric current; another myth was that woodpeckers and bears were attracted to the telegraph poles, thinking that the sound of electricity or the Aeolian was the sound of insects in the wood.[36]

The weather imparted other types of sound and vibrations to the line, including implausible and inaudible ones. Thoreau thought that there were differences in the sound of the telegraph harp at different temperatures, while others described cold days in the absence of wind when the lines "were covered in pendant ice needles, a sort of rime, which moved to and fro indicating a torsional or twisting vibration."[37] Telegraph operators heard the activity of "men working upon the wire miles distant," and other people heard thunderstorms 300 to 400 miles away.[38] Of course, telegraphy was commonly used to report on the weather, but some saw the potential for acoustical and mechanical vibrations on telegraph or telephone lines as indicators.[39] One individual in 1885 realized that his house acted as a resonating chamber for vibrations transmitted by an attached telephone line, enabling him to hear weather pending hours away:

> Probably some thousand Americans have noticed the automatic storm-signaling of wires by sound-vibration. I allowed a telephone-wire to remain for a long time attached to one corner of my (frame) house because of its practical utility as a weather-prophet. When not a leaf was stirring in the neighborhood and not a breath to be felt, the deep undulations were audible in almost every room, although mufflers had been duly applied. Before that, some hours in advance of every severe storm, the upper story was hardly inhabitable on account of the unearthly uproar, which would have made a first-rate case for the Society for Psychical Research. . . . I had it removed, finally, because there was sickness in the house, and its doleful prophecies were not appreciated.[40]

E.T.A. Hoffmann thought that sundry Aeolian harps were "playthings" unless tested by severe weather. "To tempt Nature to give forth her tones is glorious," he wrote, and to move toward the limits of this end he offered the *storm harp:* "It was made of thick cords of wire, which were stretched out at considerable distances apart, in the open country, and gave forth great, powerful chords when the wind smote them."[41]

This variability between sensing instrument and musical instrument is why ecotheorist Timothy Morton says that Aeolian harps and other devices can be considered "in ways closer to science than to art, nearer to modern sensors and seismographs (or ancient weather cocks, for that matter) than to the idea of an 'art object,' something in a frame, in an exhibition space or in an anthology, discrete, separated, isolated, and focused."[42]

What Thoreau's *sphere music* does is place these instruments on a global and geophysically turbulent scale, "a harp on so great a scale, girding the very earth, and played on by the winds of every latitude and

longitude," and doing so among the technologies of telecommunications. Thus, we have musical winds blowing across globally distributed sensing arrays and a ubiquity of communications in a natural history of media. Put a telephone in-circuit with Thoreau's telegraph lines and there would simultaneously exist a monochord and antenna. And we have yet to mention the *aquaeolian* music made by the ocean waves plucking "at strings stretched from Europe to America," proposed in 1918 by the Russian poet Vladimir Mayakovsky, with the transatlantic cable elevated in his mind.[43]

4 The Aelectrosonic and Energetic Environments

Henry David Thoreau and Thomas Watson were enthralled with the sounds of nature in the wires, Thoreau with what he heard on the outside, Watson from the inside. The difference between telegraph and telephone lines was not significant; telephones were regularly placed in-circuit with telegraph lines and submarine cables. It would have been possible to hear the effects of environmental electromagnetism and the Aeolian effects of wind blowing over the same line at the same time. The electromagnetic effects would not be Aeolian; they would be Aelectrosonic.

The Aeolian and Aelectrosonic are manifestations of naturally occurring energies, the former rooted in physical states of mechanics and the latter in electromagnetism. They have different relationships to media in their propagation, vary in perceptibility by humans, and require different naturally occurring conditions or anthropic transduction, known as technology, to be heard. Both the Aeolian and Aelectrosonic have unpredictability in common; so even though they are of qualitatively different classes of energy, they are more amenable to an evolving cosmogenesis than to a structured cosmology.

The disorderly dynamics of Thoreau's sphere music and Watson's evolutionary natural theology contrast with the ordering principles of the Pythagorean acoustical cosmos, with its associations with the ideal, divine, consonant, rational, and harmonic. The music of the spheres was a mythical sound that had terrestrial explanations and musical consequences. It was an imaginary sound based on the physical reality and mathematical abstraction of the vibrating string of the Pythagorean monochord that were mapped onto the passive heavens, reflecting back to help bolster certain types of music.

A technological timeline of musical cosmoses could be strung from the antiquity of the monochord to lines of telecommunication. Along this

trajectory, the Pythagorean cosmos would loose its last vestiges of order, and not just more *untuning of the sky* that John Hollander described occurring in the seventeenth century.[1] In the mid-nineteenth century, Thoreau understood how orbiting and rotating in the heliosphere perturbed the terrestrial winds into making sphere music, similar in manner to the mechanics of indeterminacy seen swirling in Van Gogh's starry night sky later in the century. But it was an expanding electrical and telecommunications environment that enabled Watson to wonder whether he heard the actual sounds of storms on the sun, emissaries of an unstructured electromagnetic cosmos that undermined grand harmonies with little noises.

Thomas Watson heard the electromagnetic cosmos shortly before Friedrich Nietzsche announced that God had died. On the same page as the obituary, Nietzsche gave instructions on how to undermine a Pythagorean idealization of the cosmos—"of positing generally and everywhere anything as elegant as the cyclical movements of our neighboring stars"—by simply shifting one's gaze to the miasma of the Milky Way.[2] Harmonies were obviously fragile in the last quarter of the nineteenth century; all that was necessary to break them was to look a little askance or listen to the telephone at night. The phonograph was not up to the task, according to Villiers de l'Isle-Adam. It could replicate certain events but not "an eloquent silence, or the sound of rumors. In fact, as far as voices go, it is helpless to represent the voice of conscience. Can it record the voice of the blood? . . . It's helpless before the swan song, before unspoken innuendos; can it record the song of the Milky Way?"[3] Electromagnetic media were, in contrast, resonant with the actual cosmos; it would not be long until Karl Jansky went on national radio with a live relay of the actual sound of radio emanating from the Milky Way.

Space is the place where cosmic sounds of the Aeolian and Aelectrosonic part ways. Thoreau's sphere music was composed of a universe of turbulence and torque, but it needed the right atmosphere to be produced, whereas the transduced sounds of electromagnetism make their way across the vast vacuums of the actual universe. In other words, cultural notions of the cosmos have evolved from a mythical acoustics to a material electromagnetism, from an acoustical imaginary to an electromagnetic real.

If we take energy at its base level in movement, then the next thing to note is its movement within and between classes of energy: transduction. The term is most often defined as the means by which one state of energy moves to another, but in fact the meaning changes as it moves from one disciplinary field to another. Whereas the term is applied with precision within a broad range of scientific disciplines, and applied broadly within a

limited number of discourses in the humanities, I would like to work some-where between, containing the term to the gross energetic categories of "sound" (acoustics/mechanics) and electromagnetism in keeping with the topics of this book, while making a simple distinction between *transduction-in-degree* and *transduction-in-kind*.[4] Transduction-in-degree is movement within a larger class of energy, whereas transduction-in-kind is movement between different classes of energy.

Setting aside for a moment the transduction involved in hearing itself, the Aeolian is mechanical music in that it belongs within physics to classical mechanics, as do the sounds of acoustical instruments. The movement of the wind is transduced by an object (bamboo, the strings of an Aeolian harp, a telegraph line) into sound, an intensification and rarefication of the medium of air, and thus involves steps of *transduction-in-degree*, remaining within the class of mechanics.

The Aelectrosonic involves transduction across two major states of energy, converting electromagnetic activity into the mechanics of audible sound; in the case of Watson, the transducer was a telephone (the line and device). Because there is a movement across qualitatively different forms of energy, a transformation from electromagnetic waves to acoustical waves, from electromagnetism to mechanics, from radio to sound, there is a *transduction-in-kind*.

These determinations of in-degree and in-kind, and the presence of different classes of energy involved, have influenced what is and what is not "technology" and, thus, whether technology obstructs access to "nature." While both Thoreau's and Watson's nature met in telegraph and telephone lines, Watson's Aelectrosonic nature required an anthropic transducer-in-kind to be heard. Moreover, the mechanics of Thoreau's Aeolian nature belonged to an immediate family of naturally occurring transducers-in-degree: for example, bamboo broken in a storm, a stand of saplings, or desiccated guts. The Aeolian also belongs to specially built instruments (Aeolian harp, piano abandoned in a field) that are associated with technology. In this way, Watson seems unfairly burdened by his telephone. It is a technological device that rhetorically blocks nature as surely as it allows experiential access.

Similar presumptions operate in what has stood and stands as "technology" among musical instruments. The presence of a qualitatively different energy, electricity, not only transforms musical instruments into "technology," it magically eradicates the technological status existing in nonelectronic, "acoustical" instruments. Who can confront the iterations of the piano and not know them as technology? Symphony orchestras have always been large technological assemblages and are still veritable

refurbished factories of yesteryear, presented in specialized architectural spaces that themselves are sophisticated technological achievements.

Because orchestral instruments resist electricity, they retain footing in a presumed nature. You can hear an Aeolian nature playing in the wind and string sections, if not the cosmological overtones reported by zealous enthusiasts of symphonic works. Electricity has a power to distort relationships, with acoustical instruments receding back toward nature (violin sections sawing their way back toward forests) and electronic instruments lurching into a modernist futurity, further from nature. Histories of electronic music become processions of technological control devices with negligible mention of what they control (see chapter 10); they have been born and live under a pure sign of technology without a notion of the Aelectrosonic that provides a footing in nature.

It is common to observe that technology is what makes the inaudible audible and that we are listening too much through technology to have significant immediacy with nature. This would make more sense if not for the inaudibility of the wind until a tree makes it audible to the physiological mechanism of hearing, or for the inaudibility of atmospheric electricity until brush discharge makes it audible. The environment is rife with transducers-in-degree and in-kind that are not understood to be technological. And this is the wolf child statement of the problem; it occurs before wind blows through trees in an orchard or commercial forest where the trees themselves are technological expressions, or before wind blows through trees in state-designated reserves of nature, and certainly before winds blow atypically due to global warming.

Moreover, if transductions-in-kind could themselves block human engagements with nature, then there would be none, since they exist in the physics and physiology of perception. Hearing has often been imagined to be a transduction-in-degree alone, the oscillating pressure of external sounds moving down tympan alley into the head, through flesh, bone, and fluid all the way to waves swaying cilia within the inner ear. But it does not end there; hearing involves two instances of transduction-in-kind.

The first transduction-in-kind occurs when the mechanical movement of the inner hair cells of the cochlea open ion channels that excite electrochemical signals in the nervous system and brain. The second transduction-in-kind occurs when the nervous system, in very rapid response to an incoming sound (and sometimes on its own, unprovoked), sends signals back to motile cells on the cochlea that create vibrations in the fluid of the inner ear, setting up subtle dynamics beneficial for pitch discrimination and amplification. These acoustical vibrations are sounds made by the ear:

otoacoustic emissions.[5] They may be very slight, but they are acoustical phenomena nonetheless. They are, in effect, a returned if not reverse transduction and the physiological basis of an active rather than passive model of hearing, a site of movement and reciprocity, going out to meet the incoming world, rather than remaining a phenomenal destination at centripetal subjecthood.

In the nineteenth century, the transduction-in-degree in mechanical models of hearing were associated with forms of sound propagation in stethoscopes and sound storage (the diaphragms in phonautography and early phonography), what Jonathan Sterne calls *tympanic*, after the vibratory membranes of the middle ear; indeed, the tympanic took concrete form in Alexander Graham Bell and Clarence Blake's ear phonautograph.[6] Even at the time, corporeal models of media struck people as anthropomorphic, even though one of the first membranes used was the skin of a beer sausage. Ironically, by excluding the nervous system (which itself was more quickly associated with electromagnetic transmission), such models of hearing and technology were incompletely anthropomorphic.[7]

Corporeal models also ran counter to the electrical conduct of physics, chemistry, and materials research in engineering amid the onrush of sounds and ideas of sound associated with the microphone and telephone, as we have seen. Edison developed his carbon button microphone for the "speaking" or "talking telegraph," which would go on to be a major component in the telephone handset for decades to come. The metal plate diaphragm on the surface transduced sound to mechanical motion, but it was stressed matter, the pressure-dependent resistance of the carbon that served as the transducer from mechanical motion to electricity, accompanied no less by a *molecular music*.[8] Alexander Graham Bell, in his early paper on the telephone, spoke of "molecular vibrations" and hearkened back to 1837 and C.G. Page's *galvanic music*, where "molecular derangements" are at the root of the sound.[9] Similarly, D.E. Hughes observed that, in his microphone, "the diaphragm has been altogether discarded, resting as it does upon the changes produced by molecular action."[10] The molecule directed the transductive mechanism away from anatomy toward physics, from the body toward materiality and environments of energy.

· · ·

If after millennia of hearing Aeolian sounds in the environment without technological devices they were heard in telegraph lines, what would be the Aelectrosonic equivalent prior to hearing an electromagnetic nature in the telephone? The piercing crack of lightning striking close by comes quickly

to mind, as does the basso profundo of thunder rolling around the country-side. But there are also other, less common sounds from the same ambient, atmospheric electricity. At the turn of the nineteenth century, C.F. Volney was convinced by a violent thunderstorm storm in Philadelphia that America had greater quantities of electrical fluid than Europe, because the pulsations of the fluid "seemed to my ear and my face like the wind pro-duced by the wings of some passing bird."[11] The fact that the atmospheric electricity seemed to prefer certain places to others for its natural habitat led M.J. Fournet to ask, do "there exist certain countries more electric than others?"[12]

To answer Fournet one need not travel far and wide but up, since some of the finest electrical atmospheres are found atop mountains. Pike's Peak in Colorado was "celebrated for its electrical storms. . . . The storms occur when the air is moist; the most favorable condition is during the time a light, soft snow is falling. When the hands are held up sparks emanate from the tips of the fingers. At such times with considerable wind the anemom-eter cups look like a circle of fire. Each flake of snow as it alights on a mule's or burro's back gives a spark like a fire-bug."[13]

During 1856, a French scientific expedition was on the slopes of the vol-cano Nevado de Toluca near Mexico City; with a storm approaching, they decided to descend to a lower elevation. The storm subsided; "the travelers were enveloped in a grey fog, accompanied by hoar-frost; and they noticed the hair of their Indian guides in agitation, as if about to rise up. Soon there came a dull, indefinable sound, at first weak, though in all directions, and then growing stronger and stronger, very distinct, and even alarming. It was a universal crepitation as if all the little stones on the mountain were jostled together."[14]

A Mexican physician reported a similar incident in 1845 when a cloud enveloped his party atop a mountain: "The guides and himself experienced electrical sensations at all their extremities—their fingers, noses, and ears, followed by a dull sound, though no thunder was heard. The long hair of the Indians became stiff and erect, giving their heads an appearance of enormous size. . . . The noise at length grew more intense. It appeared to extend throughout the mountain, and was like the rattling of flints, alter-nately attracted and repulsed by electricity; but was probably due to the tapping sound of innumerable sparks starting from the rocky soil."[15]

In 1767, members of a French research team on Mount Breven in the Alps "had only to raise a hand and to extend a finger to feel a kind of prick-ing at the extremity . . . soon followed by another, that as the sensation became more apparent it was accompanied with a kind of whistling." One

person with a hat trimmed with gold lace "heard a fearful buzzing round his head," while sparks flew also from a button on his hat and the metal cap at the end of his walking cane. In 1863, a group of climbers approaching the summit of the Jungfrau in the Swiss Alps were caught in a storm and forced to descend. In the middle of thick snowfall, there was a violent clap of thunder, and soon after one person's climbing sticks emitted "a kind of whistling . . . a noise resembling that which a kettle makes when the water boils briskly." The party stopped and noticed that all their climbing gear was producing a similar sound: "These objects did not discontinue their singular whistling even when one end was placed in the snow." Hair and fringes on their hats went stiff and "they heard the electrical whistling at the end of their fingers when moved in the air. Even the snow emitted a sound analogous to that which is produced by a sharp hail-storm."[16]

In 1865, at another point in the Alps—Piz Surlej near St. Moritz—a climbing party encountered strong atmospheric electricity. One person was suffering such sharp burning pains, like being bitten by wasps, that he searched through his clothes for pins. Then "our attention was drawn to a noise which reminded us of the humming of wasps. It was produced by our sticks which sang loudly and resembled the noise of a kettle when the water is on the point of boiling; this lasted, perhaps, about twenty minutes. . . . Our sticks vibrated less and less as we descended, and we stopped when the sound had become sufficiently weak, only to be heard by putting our ears close to them."[17]

In 1886, two members of the US Geological Survey were near Dixie Butte above a fork of the John Day River, in what is now the Umatilla National Forest in Oregon, when during an electrical storm that was creeping up on them one of them heard "a buzzing sound seemingly coming from beneath their drawing table" set up for their maps, but when he put his hand beneath the drawing sheet he "received an electric shock which sent him staggering back." The rocks near the summit around their encampment began to give "forth a humming, musical sound, and all the surrounding air was evidently surcharged with electricity, passing into the mounting peak through all the crags and projecting points." This was all captivating until they stood up and were filled in such a quantity of "electrical fluid" that their bodies were but a jumbled "picking of needles" and "their hair stood up like bristles, their muscles twisted."[18] They raced down the mountain as quickly as they could, no doubt without wondering whether the "humming, musical sound" deserved a detachment often afforded to musical listening.

During a storm near the Pyrenees, one person saw an "electrified lily" bathed in "diffused violet light."[19] As David Livingstone reported,

something similar occurred in the hot dry winds of the Kalahari Desert, where the "wind is in such an electric state that a bunch of ostrich feathers held a few seconds against it becomes as strongly charged as if attached to a powerful electrical machine, and clasps the advancing hand with a sharp crackling sound," and the fur on someone's coat shaking from the movement of a wagon was rendered luminous, giving out "bright sparks accompanied by distinct cracks."[20]

Visual delights were writ large in the natural electrical phenomena of the aurora borealis, but it took some effort on the part of people who heard it to persuade others that the sound actually existed. Reports on the visual display of the aurora borealis go back to sky fires, night suns, blood rains, and milk rains of antiquity, but there was little mention of their sound. However, from the latter half of the eighteenth century there came an increasing anecdotal record from both polar auroras.[21] Making his way north and west of Hudson Bay, the British explorer and invader Samuel Hearne wrote in December 1771, "I can positively affirm, that in still nights I have frequently heard them make a rustling and crackling noise, like the waving of a large flag in a fresh gale of wind," a note that may have been responsible for mentions of auroral audibility in poems by Lord Byron and William Wordsworth.[22]

Earlier reports were scientifically controversial because it was agreed that the aurora occurred at approximately 100 kilometers above the surface of the earth, reaching as high as 800 kilometers. It would be impossible to hear sound from that distance, and a close coordination between visual activity and sound could not occur because of the delay in the speed of sound. Reports from laypeople and indigenous Arctic peoples were met with suspicion; however, "The Eskimos were questioned only after we found that they were calling us 'foolish white men,' because we had said that the aurora was inaudible."[23] Enough so-called civilized men of education and standing, including surveyors and professionals in remote townships, reported hearing the sounds that the anecdotal record could no longer be easily dismissed. Still, there were expeditions where numerous and vigorous auroral displays were seen but silent, and the lack of an adequate scientific explanation remained vexing.[24]

On a cold still night in the upper latitudes, the sounds of the aurora borealis might compete with "nothing noisier than the soft-footed Malemiut dog," or there might be deceptive sounds, "the whistling of the wind, the drifting of the dry snow, the distant murmur of the sea, the crackling of snow which begins to freeze again after a temporary thaw; lower pitched sound of miles of ice; or a sound due to the rapid freezing of the

moisture of [one's] breath, and the tiny tinkle made by the minute crystals as they slowly descended under gravity close to [one's] face, sufficiently close for the ear just to catch the faint sound."[25] (This and the following descriptions of sound are from the sources in note 25 and are not individually footnoted.)

But it was the redundancy in the descriptions of the auroral sounds that would lend legitimacy to the overall record, with about "95% of them classified as hissing, swishing, rustling or crackling," not to mention claps, flapping, snaps, snapping, spittering, sizzling, crickling, creaking, buzzling, whizzing, whizzling, whiffling, whipping, rippling, roaring, rushing, sweeping, fanning, and a "soft, slithering whisper." The charm begins when one asks hissing, swishing, rustling, crackling *like what?*

- a slight hissing sound, as when the wind blows on a flame
- a hissing noise, like that of a musket-bullet passing through the air
- similar to escaping steam, or air escaping from a tire
- a hissing or swishing noise, as of someone shaking a wisp of straw
- swishing . . . like that produced by a handful of birdseed being thrown in the air to fall on a hardwood floor
- the swishing of a whip or the noise produced by a sharp squall in the rigging of a ship
- more the click made by a comb drawn through the hair, than a swish
- crackling of steam escaping from a small jet . . . possibly the sound would bear a closer resemblance to the crackling sound produced by spraying fine jets of water on a very hot surface of metal
- breaking a handful of small dry twigs
- "crackle" or the burning of a hemlock broom
- burning grass and spray
- a couple slices of good fat bacon are dropped into a red-hot pan
- as if the largest fire-works were playing off
- deer crashing through undergrowth
- never heard any noise quite like it before . . . moderately loud and resembling the rustling of a silk dress or the continuous crushing of aluminum foil of the type once used around chocolate bars

And sounds that might accompany the actual energies involved "a sharp, snapping noise, like the discharge of an electric battery; small static discharges; like one heard in an electric power house; when they are particularly quick and vivid, a crackling noise is heard, resembling that which accompanies the escape of the sparks from an electric machine; a

high-tension electric current when charging a set of horn-gap lightning arresters; and it is probable that electricity can change into sound."

There was recourse to performance when descriptive analogs seemed inadequate: "a very low sound something like that made when you sound 'S' repeatedly; a whispered 'Sh!'; a shu, shu, shu; the long drawn articulation of the word SHOE through pursed lips; faint 'crickling' or 'spittering' sound, similar to a weak electrical sparking such as obtained by stroking a fur animal; by whirling round a stick swiftly at the end of a string; the swinging of an air hose with escaping air." Certain records were careful to mention the lack of any musical features, whereas others described sounds that "resembled music produced when the strings of a harp are lightly touched; like the music produced by violin strings when the violin is on or near a piano; and a long drawn out noise, faint but perfectly distinct, and a few high musical notes very sweet and clear."

Many descriptions used poetic materials to fix the ephemerality of sound to the vision of the auroras' diaphanous drapes and the stiffness that the cold imposes on flowing:

- rustling or switching of silk
- rustle of a stiff silk robe of a person walking
- a woman walking in a stiff silk dress
- a person moving about dressed in voluminous folds of taffeta-silk
- the brushing of silk
- folding dry paper or very stiff silk
- the folds of heavy silk were shaken
- gentle waving of a silk flag
- the waving of a large flag in a fresh gale of wind
- not musical, it was a distinct tearing, ripping sound as when thin muslin is ripped or torn apart

Even if not musical, the coordinated light and sound attracted aesthetic attention. As one person noted, "I was within the Arctic circle for four years and never tired going out of the tent to see and listen to the lights," and another told of "aurora parties, at which times we would sit up for hours paying great attention to the skies." Another person described the spatial, environmental scale of the sound and light: "We were arrested by strange sounds, like the swishing and brushing together of particles of finely-broken glass. The sound came in great waves, passing slowly backwards and forward over the auroral arc. Sometimes the wave, with its musical tinkling, would almost seem to surround us; then it would recede so far as to

be almost inaudible. Then again it would come nearer, and then drop down quick near to us and then recede again up high overhead. For the most part, however, the wave travelled back and forth regularly over the auroral arcs nearest to us."

Scientists at the time were incredulous about hearing the auroras because it was commonly assumed that the height of the auroras would place any source of the sound too far away. Aurora sound was presumed to be synchronous with visual display, but if the source was so far away, the sound should be arriving after the visual event. Reports of auroral sounds rarely associated them with low-hanging auroras; nevertheless, reports of low visual display did occur. Aboard one ship the aurora was "so low down in the air that it barely cleared the tops of the masts. It flamed forth in all the colors of the rainbow and was followed by a peculiar sound, precisely such a sound as would be produced by rubbing together a well-dried skin in the hands." Elsewhere, one person reported that he and others at a government radio station were enveloped in "a light mist or fog-like substance in the aurora." He extended his hand and "a colored fog and a kaleidoscope of colors was visible between the hand and the body. . . . By stooping close to the ground it was possible to see under this light, which did not go below four feet from the ground. The low-hung aurora lasted fifteen minutes, while great streaks and shafts of light came and went in the heavens." Yet another person was "standing in the dark of my stable watching the display through the open door, I heard very distinctly, a crickling sound overhead, my attention was then directed to a vent about half an inch wide and a foot long in the board roof overhead. Here luminosity in the form of strings of sparks was entering, and penetrated to a depth of an inch or two down to about a foot, the depth changing erratically and at a speed that was readily followed by the eye."

People insisted that the sound actually occurred in the environment rather than their heads or, a little more qualified, "If this is a hallucination, it is a very strange one." They were also adamant that it was attributable to the auroras themselves rather than other sounds. Many noted how it was unlike any sound they had ever heard and, best as a person might try, "my description is weak in comparison with the reality."

Energetic environments became more noticeable as telegraph lines stretched out across the earth during the nineteenth century. Telegraph lines were a long conductor, a trait they shared with railroad lines, metal piping, steel bridges, submarine cables, and eventually, telephone lines and electrical lines. Just like lightning rods and church bells with wet ropes, telegraph lines attracted energies from within the environment. This was

nowhere better perceived than through the Apollonian eye of one American author in 1873 writing for *Harper's*. Constructing a unique cartographic vision of the United States, he reveled in an image of the railroad system, by that time a dense network of black lines that organized a swarm of economic and domestic life across the breadth of the continent. Yet, it was the telegraph system following and departing from the railroad that led him to imagine what no map had ever shown: "If we could rise above the surface of the earth, and take in the whole country at a bird's-eye view, with visual power to discern all the details, the net-work of the telegraph would be still more curious to look upon. We should see a web spun of two hundred thousand miles of wire spread over the face of the country like a cobweb on the grass, its threads connecting every important centre of population, festooning every great post-road, and marking as with a silver lining the black track of every railroad."[26]

To place the telegraph system itself into context, his mind's eye grew a new sensory capacity:

> The observer, whom we have supposed capable of seeing electricity, would find that the whole surface of the earth, the atmosphere, and probably the fathomless spaces beyond, were teeming with manifestations of the electric force. Every chemical process, every change of temperature, all friction, and every blow, in nature or in art, evolves it. The great process of vegetation and the reciprocal process of animal life, all over the globe, are accompanied by it. As incessantly as the sun's rays pass around the earth, warming every part, in alternation with the cooling influence of night, great currents or fluctuations of magnetic tension, which never cease their play, circulate about the globe, and other, apparently irregular, currents come and go, according to laws not yet understood, while the aurora borealis, flaming in the sky, indicates the measureless extent of this wonderful power, the existence of which the world has but begun to discover.[27]

This constantly moving and interchanging force shares the same space as the turbulent planet that produced Thoreau's sphere music, but it was a different class of energy: imperceptible to the ear but plausible nevertheless based on the extrapolations of telegraphers, engineers, and scientists. Whereas Thoreau asked for humility from a person paring his fingernails oblivious to the earth spinning through the heavens, the author here asks for a similar candor of magnitude between the modest voltages of communication and their larger energetic environ:

> Our observer would see that these great earth currents infinitely transcend the little artificial currents which men produce in their

insulated wires, and that they constantly interfere with the latter, attracting or driving them from their work, and making them play truant, greatly to the vexation of the operators, and sometimes to the entire confusion of business. If a thunderstorm passed across the country, he would see all the wires sparkling with unusual excitement. . . . Now and then he might see the free electricity of the storm overleap the barriers, and take possession for the moment of some unguarded circuit, frightening operators from their posts.[28]

Since William Gilbert's terrella in the late sixteenth century, the earth has been modeled as a large magnet, and after Kristian Birkeland's terrella in the late nineteenth century auroras would be simulated at the laboratory scale, but here the daily means of distance communication informed an imaginative energetic vision of the earth.[29]

In 1873 when this was written, as well as three years later when Thomas Watson heard sounds from this environment, the energetic effects of the larger context on telegraph and telephones lines were attributed to *earth currents*. This could mean electrical, magnetic, or electromagnetic activity occurring in the ground and atmosphere, under the influence of atmospheric electricity, lightning, auroras, magnetic storms, cycles of sunspots and solar flares, geomagnetism, or telluric currents. They were understood to exist at the planetary level, occur throughout the solar system and, perhaps, the entire universe.[30] The auditory reception of earth currents and other disturbances to communication was commonly attributed to induction, another catch-all term at the time; and depending on context, the sounds and other registrations were noise and interruption or detection of natural phenomena, what now are called forms of sensing.

Earth currents were first communicated in the telegraph system through the movement of needles and in the disturbed functioning and crude sounds of telegraph devices. "Spontaneous electrical currents," that is, electricity not provided by batteries to telegraphic lines, were scientifically measured by W.H. Barlow on telegraph lines when not is use for their normal business purposes. Beginning after "the evening of the 19th of March, 1847, a brilliant aurora was seen [in England] and during the whole time of its remaining visible, strong alternating deflections occurred on all the [needles of telegraphic] instruments."[31] Barlow conducted his experiment using galvanometers in-circuit with telegraph lines 40 to 50 miles in length to test the incidence, direction, and intensity of currents in the atmosphere; he noted that the "unusual disturbances" of the "large deflections" of the needle were also observed outside England on the same date. In this way, he used communications technology as a scientific instrument for sensing at a

geophysical scale, just as the telephone would be used a quarter century later and, later still, other long lines would test "natural electric currents in the earth's crust."[32] Replacing intentional messages over the telegraph lines were "the apparently aimless and meaningless movements of the magnetic needles when vibrating," spelling out "the expressive finger-signs of a dumb alphabet, in which nature is explaining to us certain of her mysteries; and already, too, we are learning something of their significance."[33]

If there were any doubts about the effects of the auroras on telegraphy, then the massive magnetic storms of August and September of 1859 would have eliminated them. The events are remembered because of the coincident observation of solar flares by Richard Carrington and Richard Hodgson and, because of their magnitude and effects on worldwide telecommunications, they are still studied today within the context of monitoring space weather.[34] The auroras were seen at latitudes where they were extremely rare, they repeatedly made telegraph communications impossible, and they destroyed equipment. Most interestingly, at times they made it possible to disconnect the batteries and operate the system using the energy accumulated in the lines, that is, messaging "wholly on the auroral current" and when there was "an aurora on the line," what now would be called energy scavenging or energy harvesting.[35] There were dangers in the presence of so much power. Screws and other metallic parts at a Western Union office in Chicago melted and the switchboard caught fire a dozen times.[36] One operator in Washington, DC, felt the effects of the aurora when a spark leapt between the telegraph key and his forehead. Others reported sparks spraying from the equipment in the offices and along the lines themselves.

As telegraph lines became more pervasive, they had the advantage of being both a large sensing array and the means to communicate the data. The major auroral displays that occurred on February 4, 1872, "spread almost simultaneously over the telegraph world," as W. H. Preece wrote.[37] The "telegraph world" in this case was described by the sphere of influence of the aurora borealis "seen as far south as Africa and the Persian Gulf and [it] created a battery of effects in telegraph mechanisms."[38] Reports were received from the lines located in the United States and in Toronto, Paris, Gibraltar, Malta, Constantinople, Alexandria, Suez, Bombay, Persia, and so on. Sparks flew and large sharp cracks were heard in the offices connected to submarine cables, with the longer lines creating the largest sparks.[39]

Preece's role with the British General Post Office meant that the "telegraph world" had other connotations of power. Another British telegraph

engineer involved in the collective reporting on earth currents was also pleased to report that "the rapid process civilization has made during the last quarter of a century has been aided in no small degree by the Electric Telegraph."[40] But, then again, sometimes the Electric Telegraph ran through an *electric country:* "In India, electric disturbances in the atmosphere occasion remarkable difficulties in working telegraphic lines. The apparatus seems delirious, and works backwards and forwards. Storms of dreadful violence tear up the posts and threaten to melt the wires; so that, as a narrator observes, we need not be surprised that Indian telegrams are often as puzzling as the cuneiform inscriptions on Babylonian bricks."[41] Thus, we have another answer to M.J. Fournet's question, do "there exist certain countries more electric than others?"[42]

The dramatic effects that auroras had on the telegraphs were usually reserved for lightning and thunderstorms. Just like Benjamin Franklin, who rigged up bells to alert him to the buildup of atmospheric electricity, telegraph offices had bells that warned of dangerous levels. One thunderstorm in New York City on February 22, 1882, set off other bells in the police headquarters telegraph office: "When the violent thunder clap came a flash of electricity darted from the wire under the transmitting box of the west circuit across the room . . . a bluish hue and globular form, and appeared to be as large as any of the electric lights in Fifth Avenue and Broadway. . . . The electric ball, diminished in size, traveled along the north side of the room and disappeared at the instrument to the wires which protect the vault of the Manhattan Savings Institution are attached. It started the bank's burglar alarm."[43]

The effects of a nearby storm could injure and kill telegraphers, fuse the metal in the equipment, and send huge sparks to objects across the telegraph office.[44] Lightning and lesser atmospheric electrical discharges were known to produce their own letters on the telegraph and "lines in operation indicated wrong signs, dots became dashes, and the spaces were either multiplied in size or number, according to the direction of the earth currents induced by thunderstorms."[45] Telegraphers could also find themselves interpolating and responding to the weak signals of another telegrapher until they realized that they had been carrying on a conversation with spasmodic currents in the atmosphere whose style they had not immediately recognized.

Thunderstorms 300 to 400 miles away were registered on the telegraph and, eventually, on telephone lines ("We thus see that it is possible by merely observing whether the disturbance increases or decreases, to determine when a storm is approaching us or passing in the opposite direction"),

while lesser fluctuations were associated with snowstorms ("*hail* did not seem to have an effect"), with other seasonal events, with the regular oscillations of day and night, and with the transient, exceptional nights produced by solar eclipses.[46] Again, this is the telegraph system as a detector of phenomena, not merely a means to communicate about those phenomena. After 1876, people began listening to these and other energies on the telephone.

5 Inductive Radio and Whistling Currents

Because they were long metallic conductors, telegraph and telephone lines and cables attracted surrounding energies from each other and from the environment. When lines ran close enough to each other, their electromagnetic fields interacted and through induction "leaked" information to one another, and some of that information was musical. From this simple fact, two commonly held presumptions in media history need to be qualified: first, that music was not heard over the air until the advent of radio (qua Reginald Fessenden), and second, that messages were securely contained within wires until Guglielmo Marconi's wireless broadcasts.

Moreover, this electromagnetic interaction resulted not merely from the proximity of lines to one another; when the circuits of a line were completed by being returned through the earth, the earth was brought into play. Two things happened: the earth itself was rife with energies from the environment and people could be heard communicating underground. Being "in-circuit" with the earth was understood to mean that the circuit extended along the line in one direction and through the ground in the other. This began in the early days of telegraphy and became known as the *earth circuit, earth return,* or *grounded circuit.*[1]

Although the principle was known among electrical researchers as early as 1803, Carl August von Steinheil became best known for having proposed the idea for telegraphy in 1838. Because the telegraph lines followed the railroad tracks, with their parallel long metallic conductors, he thought that the rails themselves could be used to carry the signal. He discovered instead that the earth itself would serve the purpose. It occurred to him that the signal "cannot be confined to the portions of the earth situated between the two ends of the wire," and that it might continue to indefinite distances, and he questioned "whether it is necessary or not to have any metallic

communication at all for carrying on telegraphic intercourse."[2] These principles would later find their way into the field telephones and signal surveillance in the trenches of World War I, where the seeds of whistler science were planted.

Putting the earth in-circuit was an attractive proposition because it meant that only single telegraph or telephone lines were required for the completion of the circuit and the sending of a message, cutting costs by half over running lines both ways. Eventually, when the ground became too populated with messages or noisy with earth currents, a second line, or multiplexing, was used to create a *metallic circuit*. This produced a closed circuit, eliminating most of the crosstalk, interference, noise, and the electromagnetic sounds of nature. When the open circuit of an earth return was closed by a metallic circuit, closed out too were the sounds of nature.

When combined with the unprecedented sensitivity of the telephone, the sounds of this new energetic environment piqued curiosity, raised questions, provided aesthetic pleasure, and served as a curse, since its capacity to listen lent itself indiscriminately to a range of sounds and "mysterious noises":

> This was, perhaps, the most weird and mystifying of all the telephone problems. The fact was that the telephone had brought within hearing distance a new and wonderful world of sound. All wires at the time were single, and ran into the earth at each end, making what was called a "grounded circuit." And this connection with the earth, which is really a big magnet, caused all manner of strange and uncouth noises on the telephone wires.
>
> Noises! Such a jangle of meaningless noises had never been heard by human ears. There were spluttering and bubbling, jerking and rasping, whistling and screaming. There were the rustling of leaves, the croaking of frogs, the hissing of steam, and the flapping of birds' wings. There were clicks from telegraph wires, scraps of talk from other telephones, and curious squeals that were unlike any known sound. The lines running east and west were noisier than the lines running north and south. The night was noisier than the day, and at the ghostly hour of midnight, for what strange reason no one knows, the Babel was at its height. [Thomas] Watson, who had a fanciful mind, suggested that perhaps these sounds were signals from the inhabitants of Mars or some other sociable planet. But the matter-of-fact young telephonists agreed to lay the blame on "induction"—a hazy word which usually meant the natural meddlesomeness of electricity.[3]

Certain sounds among this mélange were not so mysterious. The most familiar sound in the early telephone was the alphabetic pulse of Morse code

overheard from nearby telegraph lines. John J. Carty remembered, "A wire strung from Boston to Lawrence, about 26 miles, on a telegraph line. Anybody listening on that telephone wire could hear all the telegraph messages. It was as though we had an old-fashioned drum corps and each drummer began drumming a separate time."[4] Later, "very well defined musical sounds" let the telephone listener know that an electric tram was passing by.[5]

Alexander Graham Bell's "articulating telephone" was preceded by a number of musical and harmonic telegraphs and telephones, including one by Bell himself, all having ancestry in Charles Page's discovery in 1837 of "galvanic music," tones produced in an iron bar from rapid magnetization and demagnetization.[6] Elisha Gray investigated the possibility of transmitting music over telegraph lines as early as 1867. Prior to Bell's telephone, Gray used his "musical telephone" to transmit "a number of familiar tunes" across the street in an after-hours demonstration to his friends in Milwaukee during late 1874 or early 1875, and he found that other people besides his intended audience also heard the transmission: "I was surprised to learn next morning, by inquiries coming from various points in the State, from offices through which ran the three [telegraph] lines supplied by the battery, that the tunes played were all reproduced audibly and distinctly by the relays in the various offices along the line. Some of the operators, being ignorant of the invention of the [Gray] telephone at that time, were very much amazed at this new exhibition of the musical powers of their instruments."[7]

Gray demonstrated his telephone by transmitting music from Philadelphia to Steinway Hall in New York City (April 2 and 4, 1877) and to the Brooklyn Academy of Music (April 3); the transmissions were overheard on a different wire by a party in Red Bank, New Jersey. When the editor of the *Journal of the Telegraph* was asked how this could be possible, he explained, "If you were not on the wire used for transmitting the music, the vibrations must have been caused by induction, or leakage from the wire used."[8]

Another example occurred shortly thereafter when music from several concerts of the Edison Singing Telephone—"experimentally, a success; financially, a failure"[9]—were heard unexpectedly in upstate New York and Providence, Rhode Island. On the evening of August 28, 1877, Clarence Rathbone of Saratoga Springs was talking to a friend on a private telegraph line equipped on either end with Bell telephones, when they were surprised to hear the sound of music. After reporting the incident in the morning paper, Rathbone was informed that the songs he heard were the same as those transmitted in a concert between the Western Union Building in New

York City and Saratoga Springs. It was determined that his private line ran parallel to a transmitting line and that the music was heard through induction. Rathbone enlisted help from friends at the Western Union office in Albany to test this further:

> Upon putting the instrument to our ear, a bubbling sound like the boiling of water was heard, which upon close attention proved to be the clicking of Morse instruments. Part of the writing could be read, but the most of it was a confused jumble. Later in the evening the instruments were put in circuit on a wire which runs alongside the telephone wire from Albany to New York. The music was then heard very distinctly and much louder—so that by placing the instrument in the center of the room . . . persons seated around the room could hear the music with perfect distinctness."[10]

Concerts between New York and Albany, Troy and Saratoga Springs were overhead for several more days. The same concerts were overheard by William Channing in Providence, part of a group associated with Brown University that assisted Bell with developments to the telephone. In a letter to the *Providence Journal,* Channing wondered, "how did this music get upon the wires?" The ironic, retrospective feature of the following passage is that a curious observation, perhaps delectation, of noise was interrupted by music:

> Two gentlemen, scientifically inclined, on the evening of Tuesday, August 28th, were listening with telephones to the sounds of atmospheric electricity, collected by a telegraph wire extending three or four miles over the housetops. Suddenly, above the "hail-stone chorus" of electrical discharge, was heard an air, sung by a tenor voice, apparently a long way off. Then followed a difficult exercise by a soprano voice, then an air on a cornet or similar instrument. At intervals during the evening, several familiar pieces were sung and played. At the close, soon after 10 o'clock, a few short sentences were repeated in an oracular manner, the words being almost, though not quite, distinguishable.
>
> On Thursday August 30th, a similar concert was listened to, and it recurred again on Sunday, September 2nd, Wednesday the 5th, and Tuesday the 11th. On all these occasions the same voice and instruments were heard. Once or twice the instrument was thought to be a flute, and once or twice was possibly accompanied by the soprano voice. On all the evenings but one, short oracular sentences were spoken, not quite distinguishable, and even more unaccountable than the music. On the Sunday, these came in the middle of the performance instead of at the end. On Sunday, two or more religious airs were sung Greenville and Old Hundred being probably of the number. No duet was ever

heard. Among the familiar airs sung were the Marseillaise Hymn, "How so Fair," "Who's at my Window," "Then you'll Remember Me," "Roll on, Silver Moon" and "Alma Mater." . . . A natural question is, where did this music come from? A much more important question, scientifically considered is, how did this music get upon the wires?[11]

The concert was so informal that Channing ruled out that it had been transmitted on purpose and thought instead that certain circumstances had rendered the telephone an "eavesdropper" on someone's parlor entertainment. A more thorough investigation showed that the telegraph lines transmitting the concerts to upstate New York ran parallel for a short distance with lines that ran from New York to Boston and Providence, and that the music was also a consequence of induction, only this time occurring in succession along two or three sets of parallel wires at different locations. Channing's explanation was accompanied by a general discourse on further research made possible by the sensitivity of Bell's telephone.[12]

During 1877, C. E. McCluer, manager of the Lynchburg, Virginia, Western Union office, heard "weird music" on his own private line, where he was experimenting with the telephone and had regularly listened to what were mysterious sounds of atmospheric origin.[13] Returning one Sunday from church, no less, he heard a different sound, "what at first impressed me as being an angel voice from the spirit land, rendering what to my excited senses seemed to be a most heavenly and ravishing melody." Soon a man began singing as well, but the two singers were not performing as a duet; they sang different religious hymns and in different keys. McCluer discovered eventually that Western Union employees at two different offices in Virginia had been experimenting with transmitting music using "make-and-break" instruments and that operators on the other end would listen with their ears closely pinned to their telegraph relays. They conducted these experiments on Sunday because the offices were closed for regular business. McCluer was familiar with induction—he had for years heard weak telegraphic signals from other lines in his own telegraph sounder—but he did not think that induction could explain how the signals from one of the singers could have traveled from one line such a great distance.

· · ·

C. E. McCluer took pride in his "superlatively sensitive Bell telephones."[14] A communications device, its sensitivity exceeded the scientific instruments at the time and became legendary.[15] The current that it needed to operate was "so small that the electric current of a single incandescent lamp

is greater 500,000,000 times. Cool a spoonful of hot water just one degree, and the energy set free by the cooling will operate a telephone for ten thousand years. Catch the falling tear-drop of a child, and there will be sufficient water-power to carry a spoken message from one city to another."[16] As a telegraph engineer, McCluer was familiar with the effects of earth currents in telegraph lines, but he could never have known that they were associated with "strange and at times almost uncanny noises":

> From the night the telephones were installed my attention had been attracted to the mysterious whisperings and strange frying noises which were heard almost constantly through the telephones, particularly during the quiet hours of the night. It became my custom when I went home at night, no matter how late it was, to spend a few minutes listening to the strange and at times almost uncanny noises that the telephone gave forth, and speculating as to their origin. My telegraph instruments had never offered any indication of earth currents, except during the prevalence of an auroral display, and while I had learned that the atmosphere was continually traversed by electric currents in greater or lesser profusion, it had never occurred to me that the bosom of old mother earth was permeated and torn by similar electrical manifestations. Hence the weird noises and faint peculiar cracklings which my telephones for the first time revealed to me were fascinating to me, and I spent much of my leisure time in a study of the interesting phenomena .[17]

Like Thomas Watson, McCluer and many others during the last quarter of the nineteenth century listened to the sounds of an electrical nature. They engaged them intentionally even as they encountered them as noise, as did W.H. Preece: "There are certain natural currents flowing through the crust of the earth. They are called 'earth' currents, and at times acquire such considerable energy, that, with a telephone pressed to each ear, I have been told, although I have not experienced it, that the noise made is as though 'your brains were boiling.'"[18]

One of the first descriptions of an electrical sound to gain widespread currency was William Channing's description in 1877 of lightning in the telephone as sounding "like the quenching of a drop of melted metal in water, or the sound of a distant rocket." The sound of molten metal falling into water or oil circulated for years to come, much like the fly footsteps of D.E. Hughes's microphone, albeit without the rococo elaborations.[19] Channing was actually listening for such sounds when he happened to hear the music of inductive radio.

There was a great variety of sounds in the telephone; one of the more unique ones was a "deafening roar which drowned the voice . . . which

resembled that of a distant waterfall," heard on the telephone lines in Singapore during the explosions of Krakatoa.[20] Most, however, were raucous and filled with crackling and static. During an early long-distance call on a telegraph line between New York and Chicago, "You could hold up the receiver at some distance from your ear and hear the sputtering and frying of that Morse induction very distinctly. It sounded like hail rattling on a roof, but still you could talk past it."[21] Alexander Graham Bell himself described the major categories of interference from defects in the device or from other communications devices in the vicinity, or from "earth currents."[22]

The sounds were so pervasive, prosaic, and occupational that they were often broken down into types. The *Practical Information for Telephonists* from 1893 listed five classes of noises heard on the lines:

First: Frying, hissing and bubbling noises.

Second: Screaming and whistling noises.

Third: Jerking and rasping noises.

Fourth: Morse or other telegraphic communications in course of transmission on other wires.

Fifth: Telephonic conversation or vocal sounds in process of transmission on other wires.[23]

The jerking and rasping noises of the third class of noises were attributed to defects in the lines and telephone devices themselves and had a quick remedy in better inspection and repair. The sources of the fourth and fifth classes were obvious—a *leakage* or *induction* of other communications—even if reducing their influence proved to be difficult:

> The noises and disturbances of the first and second classes are, I conceive, almost totally due to earth currents, atmospheric electricity and thermo and hydro-electric reactions. There is, likewise, always free electricity in the air and in the clouds, which acts on the earth and on the wires, the latter being generally conductors to earth. These noises are much more intense by night than by day, on long lines reaching their maximum about 12 midnight, the disturbances of the second class, screaming and whistling noises, becoming especially intolerable in the night.[24]

The screaming and whistling was likely to have included the electromagnetic waves of whistlers and other forms of natural radio, although they were still lumped together with sounds attributed to *earth currents* and *induction*.

Ten years later, noises in the telephone were again listed, but this time in an important scientific paper by J. E. Taylor. After eliminating consideration

of defects of the device and matters of "leakage" from nearby lines, he came up with another five categories of noises heard in the telephone:

(i) Uniform flowing or rushing of water: this is usually a daytime disturbance, and is occasionally of considerable vigour.

(ii) Intermittent crackling: an accompaniment of other disturbances.

(iii) Bubbling and boiling of water: the usual form of nightfall disturbance, but also frequently occurring in the daytime.

(iv) Rocket disturbances. These are peculiar and characteristic, having some resemblance to the sound produced by a rocket rising in the air. They commence with a shrill whistle and die away in a note of diminishing pitch. They vary in intensity, but always have a similar duration of from two to four seconds; are freely heard at night, and only occasionally during the day.

(v) Disturbances due to high frequency effects, inaudible on the telephone, but evidenced on the coherer, magnetic detector, or other form of Hertzian receiver.[25]

Clearly, *rocket disturbances* is an apt description of whistlers. Taylor likened the sound to meteors streaking across the heavens at high velocity, which suggested to him that the electrical effects received in the telephone might be related to ionization in the "upper rarefied atmosphere" caused by the ultraviolet light of solar radiation. This intuition was concurrent with and independent from Arthur Kennelly and Oliver Heaviside's more famous theorization of the existence of the ionosphere, what would be known as the Heaviside layer responsible for reflecting radio waves over the horizon.[26] Kennelly and Heaviside's formulation was prompted by Marconi's transatlantic transmission of the letter *S* in 1901, whereas Taylor's theory was prompted by sounds heard in the telephone since 1876.

Just before the nineteenth century came to close, there was a brief scientific report in *Nature* in 1894, written by W. H. Preece. In his role at the British General Post Office, he equipped workers at outposts with telephone receivers that they used to gather evidence on occurrences of "sunspots, earth currents, and the Aurora Borealis on their telegraph lines."[27] He summarized observations of an aurora borealis display occurring March 30–31, 1894, from three locations:

- At a station at Llanfair PG on the Island Anglesey, Wales: " . . .'twangs' were heard as if a stretched wire had been struck, and a kind of whistling sound."

- At Lowestoft, the eastern most point in England: "Noise on 408 (Liverpool-Hamburg) wire seemed like that heard when a fly-wheel

is rapidly revolving," and "sounds in telephone appear like heavy carts rumbling in the distance."

- At Haverfordwest in southwest Wales: Peculiar and weird sounds distinctly perceived, some highly pitched musical notes, others resembling murmur of waves on a distant beach. . . . The musical sounds would very much resemble those emitted by a number of sirens driven at first slowly, then increased until a 'screech' is produced, then again dying away.[28]

The third observation was an early description of natural radio in terms of musical sound, something that would become common during the 1920s and afterward. These observations were made around the time that Marconi was cobbling together his first wireless telegraphy device and, in fact, two years later Preece would become Marconi's champion in Great Britain. Thus, in scientific reports, in operator manuals, in the noises and music of the telephone, radio was heard before it was invented, even for people close to Marconi.

We have seen that whistlers were observed for six years from 1888 to 1894 on a very long telephone line at the Sonnblick Observatory high in the Austrian Alps and that W. H. Preece arranged telephonic observation on telegraph lines during visible aurora activity in 1894. The scientific literature proper, however, flowed from signal corps observations on both sides of the trenches during World War I, first with a paper by the German physicist and electrical engineer Heinrich Barkhausen and then by the British radio scientist Thomas L. Eckersley.[29] This proximity of natural radio to battlefields was characteristic of scientific research through the twentieth century and would become greatly increased during World War II and the Cold War. The entire earth was seen increasingly as nothing but a big battleground, with all its physical properties and processes having strategic military value, from submarine communications in the oceans, to gamma ray monitoring in outer space, to radar reflecting off the moon. Where once there were night skies and the cosmos peering through weather, there was now command and control.

In "To the Planetarium," Walter Benjamin understood that it was not just forces being called forth on the battlefields of World War I, but the performance of a new union with the cosmos enacted through a grand military ritual. The commune with the cosmos by those whom Benjamin calls "the ancients" had long ago been conducted through collective *ecstatic trance (Rausch)*, but this would lapse into the solitary and distanced optical stance of astronomy. However, ecstatic trance would return with terrible vengeance on the collective stage of World War I battlefields as "an attempt

at new and unprecedented commingling with the cosmic powers." As Benjamin wrote, "Human multitudes, gases, electrical forces were hurled into the open country, high-frequency currents coursed through the landscape, new constellations rose in the sky, aerial space and ocean depths thundered with propellers, and everywhere sacrificial shafts were dug in Mother Earth. The immense wooing of the cosmos was enacted for the first time on a planetary scale—that is, in the spirit of technology."[30]

Thus, gazes upon the planes of photography and cinema (Benjamin's commentary is well known) continue past the local domain of dioramas and panoramas "to the Planetarium," a space within which the magnitude of the earth performs in the cosmos. Within such a planetarium, Thomas Watson's listening sessions and his natural theology represent an earlier modern detachment that Benjamin belittled as the "poetic rapture of starry nights," a solitary commune with the heavens as the earth heaved in spasms of self-destruction.[31]

The electrical forces, that Benjamin describes, hurled into the open country, high-frequency currents coursing through the landscape, literally, through the ground, were the responsibility of signal corps personnel and the environment in which they worked. Communications at the entrenched front lines were often a tangle of meandering telegraph and telephone wires strung ingeniously and desperately along rigged poles, trees, and detached branches acting as crutches. The British forces called the helter-skelter results of such makeshift means *comic airlines*. Because the lines were exposed to bombardment, cutting, and surveillance through splicing, there were numerous backup systems for relaying messages back and forth from the front lines, including dogs, pigeons, motorcycles and foot soldiers, and devices that communicated through the ground underfoot.

One way to assure that no lines were cut was to eliminate the lines. The German signal corps used an earth dipole field telephone called the *Erdsprechgerät*, literally "earth speech device," for communication and surveillance of enemy communications. Heinrich Barkhausen used a similar earth-mode device made from two grounds placed hundreds of meters apart, each connected to a common amplifier and telephone. It turned the ground into part of a circuit detecting inductive currents and into an antenna receiving natural radio: "During the war, amplifiers were used extensively on both sides of the front in order to listen in on enemy communications. Partly because of faulty insulation and also due to inductive action, stray earth currents spread out from the vicinity of the telephone line. Although these currents are extremely weak, they could be made audible by exceedingly high amplification."[32]

While monitoring enemy communications, Barkhausen and his fellow signal corps members heard natural radio: "At certain times a very remarkable whistling note is heard in the telephone. At the front it was said that one hears 'the grenades fly.' So far as it can be expressed in letters, the tone sounded about like 'peou.' . . . These whistling tones were so strong and frequent on many days that at times listening in was impossible. . . . These same whistling tones also occurred in the sea, with copper electrodes dipping into seawater."[33] Because of the Doppler character of the sounds of grenades flying, the hissy whistling of burning fuses passing quickly in the air above the front would have been genuinely terrifying. Barkhausen rested knowing that the whistling sounds he heard were somehow geophysical. He did not speak of these sounds as musical, but he did mention a "remarkable periodic process" that he had trouble explaining.[34] In 1919, immediately following the war, he published what is considered to be the first scientific paper on whistlers.

Meanwhile, during the war, Thomas L. Eckersley worked in service of the British Special Wireless Section stationed in Egypt and Salonika. He was assigned to the direction-finding (D/F) unit, which entailed the use of specialized loop antennas to locate the source of enemy transmissions. Whereas cryptographers decoded wireless messages to learn about enemy troop plans, D/F units used their antennas to locate where transmissions originated. Even if no useful military content occurred in a message, or the message could not be decoded, the "signature" and location of the signal itself served as valuable information crucial to military operations.[35] At the time, Eckersley postulated that reflections from the Heaviside layer were responsible for certain D/F errors, an understanding that improved intelligence in the area and presaged ionospheric research in the 1920s.[36]

In the second scientific paper written on whistlers, Eckersley began, "It has been known to workers in 'Radio' for some years that if a telephone or any other audio-recorder system is placed directly in series with a large aerial, disturbances of a musical nature can be heard."[37] Elsewhere he thought that such atmospheric disturbances were "semi-musical in nature" and owed what music they had to the dispersive action of an "upper conducting layer" of the atmosphere, an "assembly of electrons in a rarefied atmosphere."[38]

"Music" was used for both descriptive and analytical purposes in early natural radio research. There was a larger class of descriptors for audio frequency sounds that included parasitics, statics, X's, strays, and vagrants, until an agreement developed by the British Radio Research Board in 1921 sought to replace them with the general term *atmospherics*, although in

1925 Eckersley was still referring to *musical strays*.[39] Distinguished from the more common atmospherics of clicking, crashing, rattling, fizzing, and grinding, musical atmospherics could include *tweeks* and *chinks;* "long duration audio atmospherics" could include whistlers, swishes, and *Pfeiftone*.[40]

Everett T. Burton and Edward M. Boardman at Bell Telephone Laboratories studied "audio-frequency atmospherics" on submarine cables and loop antennas attached to a telephone and classified them along a range between *musical* and *nonmusical*.[41] Using recordings and oscilloscope readings made from both submarine cables and a long antenna, they discussed atmospherics that included *nonmusical* sounds such as "deep rumble intermittently broken by noises variously described as spashes and surges," *quasi-musical* sounds of "hissing or frying," *slightly musical* sounds at higher frequency due to their *slightly tonal* character, and "two varieties of *distinct musical* atmospherics . . . given the names 'swish' and 'tweek.'"[42]

What is fascinating about this scientific classification of natural nonmusical, quasi-musical, and musical phenomena during the 1920s and 1930s is that it paralleled the avant-garde aesthetics of composers such as Edgard Varèse and Henry Cowell, who worked with category-busting gradients of musical-to-nonmusical sound (noise). Also, in terms of musical aesthetics, glissandi and sliding tones were championed by composers from Ferruccio Busoni through the avant-garde, including both Varèse and Cowell, as intrinsically more "natural" than the arbitrary fragmentation of tones into the notes of temperament. Indeed, an idealized whistler consisting of the noise from the initial full-spectrum impulse of lightning, followed by momentary silence and the sweep of a glissando, embodies the holy trinity of avant-garde musical aesthetics: noise, silence, glissando.

The next flush of whistler research occurred after World War II, most significantly with L. R. O. Storey, who explained the duration of the whistler by proposing that the propagation must take place along the flux lines of the earth's geomagnetic field, carrying the initial impulse far from the surface of the earth to the opposite hemisphere. This line of research was integral to establishing the existence of the magnetosphere during the 1950s, and it made clear that whistlers operated on a grand geophysical scale, where storms in one hemisphere could be heard on the other side of the equator in the other hemisphere, although, as early as 1912, W. H. Eccles already suspected that radio disturbances in England originated in thunderstorms in western Africa.[43]

Figure 4. Idealized whistler event structure: noise, silence, glissando. From Robert A. Helliwell, *Whistlers and Related Ionospheric Phenomena* (Mineola, NY: Dover Publications, 1965), 5.

But just as whistlers took on this new geophysical scale, the musical gradients and "colorful onomatopoetic vocabulary" used by scientists gave way to visual figures deriving from the technological means that enabled whistlers to be stored on tape recorders and reproduced, analyzed, and published on spectrographs.[44] By the time Helliwell's standard text was published in 1965, the gradated domain of nonmusical, quasi-musical, and musical had given way to the visual dominance of nose and knee whistlers; one-hop, two-hop, fractional hop, hybrid, echo train, multi-component, and multiple source whistlers; and hook, dispersive, non-dispersive, multiphase, drifting, quasi-periodic emissions and triggered emission atmospherics.[45]

More important, as early as 1953 scientists began looking and listening for one-hop and two-hop whistlers on a geophysical scale excited not by lightning strikes but by nuclear explosions.[46] This culminated most spectacularly in July 1962 with Starfish Prime, a 1,400 kiloton device detonated 400 kilometers above Johnston Island near Hawaii. This so-called rainbow bomb exploded in outer space so, although there was no sound, a one-hop whistler was monitored in Wellington, New Zealand, after a journey of 6,800 kilometers. The artificial aurora the bomb created was visible to onlookers in Hawaii, who had been alerted that there would be a nuclear spectacle for their viewing pleasure. Just as there had been aurora parties in the nineteenth century, people in Hawaii threw artificial aurora parties, performing a ritual "commingling with the cosmic powers . . . in the spirit of technology," on a planetary scale.[47]

Also in 1953, while the science became more muted and visual, some dramatic sounds of whistlers found their way onto an LP record marketed for audiophiles, amateur radio operators, and popular science aficionados. *Out of This World* had one side devoted to earthquakes and the other side to

whistlers and sferics (short for *atmospherics*), both with narration to explain the basic science involved and to place the phenomena in larger contexts. In 1966, Alvin Lucier used this LP in his composition *Whistlers*, which followed his composition using brainwaves, another source of, as he understood it, natural electromagnetic sound. Combined, these sounds described a natural electromagnetic space from brainwaves to outer space and, with other musical and artistic works in the 1960s, presaged an increasing use of physical earth sounds and earth signals as raw material.

6 Alvin Lucier

Brainwaves

It isn't a sound idea, it's a control or energy idea.

Alvin Lucier

Alvin Lucier may have been the first person to use whistlers in a work of
art or music with his composition called, appropriately enough, *Whistlers*
(1966). Around the same time, if not before, the Swedish composer Karl-
Birger Blomdahl included recordings of natural radio along with the
sounds of satellite telemetry in his experimental television work
Altisonans, as will be discussed in chapter 15, but Lucier's work is at the
core of this study because he understood whistlers to belong to a larger
class of natural electromagnetic sounds, amid a trade of sound and
signal.

Lucier was predisposed toward such sounds because of his breakthrough
composition the year earlier, *Music for Solo Performer*, in which he incor-
porated the energies of brainwaves as control mechanism and sound.
Brainwaves too were natural electromagnetic sounds that, with whistlers,
formed for Lucier an electromagnetic spatiality from the scale of the indi-
vidual to earth magnitude. Before discussing *Whistlers* and the related
natural radio works that followed, it is necessary to introduce Lucier, his
brainwave composition, and Edmond Dewan—the physicist who intro-
duced Lucier to brainwaves—and to discuss their interactions.

Although Lucier is now associated with canonical works in the history
of twentieth-century music, and has exerted a positive influence across the
arts, sound arts, media arts, and arts/sciences that shows no sign of fading,
in 1965 he was a composer who was not composing. Lucier taught service
courses in the Music Department at Brandeis University in the Boston area,
and he was not treated very well by his composer colleagues. He had
rejected their European emulations but had not found a place for himself as
a composer in the ranks of American experimentalism.

Experimental musicians in the United States were required, like many jazz musicians, to go to Europe for financial support and recognition. Nationalist and colonial dynamics were well at work. Western art music composers and institutions in the United States as a whole looked to the European homeland for cues on "modern music" while ignoring, downplaying, or simply attacking homegrown developments in experimentalism, which itself had developed through alternative European canons, through various world and African American musics, and through many nonmusical influences.

On an extended visit to Europe in the early 1960s, Lucier was struck by the interest and tangible material support for American experimentalism and was encouraged by the confidence that experimentalists demonstrated while there. Once he saw a heated conversation between Karlheinz Stockhausen, the composer and a champion of American experimentalism, and the philosopher and composer Theodor Adorno at a seminar conducted in Darmstadt. The pianist and composer David Tudor conducted the seminar, featuring performances of pieces by George Brecht, the Fluxus artist, and Walter Marchetti, from the Spanish experimental group Zaj. These were works and ideas outside the struggle between Igor Stravinsky and Arnold Schönberg that drove Adorno's vision of twentieth-century Western art music. As Lucier reported, "Adorno and Stockhausen were having a big argument about the aesthetics of this music and Tudor, who is such a shy person, just looked at them—it was a big European argument—and said quietly to Adorno: 'I'm afraid you just don't understand this music.'"[1]

In 1961 Lucier was in residence at Studio di Fonologica in Milan, the electronic music studio founded by Bruno Maderna and Luciano Berio. He composed an audiotape piece entitled *Elegy for Albert Anastasia*—a work *barely there* because many of the sounds employed were literally subaudible—preparing him for the subaudibility of brainwaves. Still, audiotape music in itself was somewhat anathema, emulating the European achievements of *musique concrète* of Pierre Schaeffer and Pierre Henry. In contrast was the *liveness* of American live electronic music, with its basis in improvisation and indeterminacy.

Lucier's encounter with American experimentalism in Europe loosened the shackles of European-derived academic "modern music." Returning to Brandeis and still not treated well, he nevertheless decided that experimental musicians had a significant institutional advantage over his conservative colleagues: "Most of my teachers were bitter; they were writing music that wasn't getting played. It was a terrible way to be an artist, to be totally disengaged from your society. When John Cage and David Tudor came into

town they would play anywhere. All they needed was a couple of tables to put their electronic equipment on. They didn't have fancy equipment; they had very cheap equipment anyone could buy. Tudor would wire it together. They performed their own music. They didn't wait for the symphony orchestra to ask."[2]

Lucier was active as a choral conductor of new music and a participant within the culture of experimentalism, but he still did not know what to do next as a composer. "I couldn't continue writing neoclassical music, which I had been writing earlier. We all loved Stravinsky. He was easy to imitate (badly). I felt terrible because I was supposed to be a composer and I didn't have any ideas."[3] Then he got an idea that developed into his *Music for Solo Performer.*

The score reads:

> The alpha rhythm of the brain has a range of from eight to twelve hertz, and, if amplified enormously and channeled through an appropriate transducer, can be made audible. It can be blocked by visual attention with the eyes open or mental activity with the eyes closed. No part of the motor system is involved in any way. Control of the alpha consists simply of alteration of thought content—for example, a shifting back and forth from a state of visual imagery to one of relaxed resting.
>
> Place an EEG scalp electrode on each hemisphere of the occipital, frontal, or other appropriate region of the performer's head. Attach a reference electrode to an ear, finger, or other location suitable for cutting down electrical noise. Route the signal through an appropriate amplifier and mixer to any number of amplifiers and loudspeakers directly coupled to percussion instruments, including large gongs, cymbals, timpani, metal ashcans, cardboard boxes, bass and snare drums (small loudspeakers face down on them), and to switches, sensitive to alpha, which activate one or more tape recorders upon which are stored pre-recorded, sped-up alpha.
>
> Set free and block alpha in bursts and phrases of any length, the sounds of which, as they emanate from the loudspeakers, cause the percussion instruments to vibrate sympathetically. An assistant may channel the signal to any or all of the loudspeakers in any combination at any volume, and, from time to time, engage the switches to the tape recorders. Performances may be of any length. Experiment with electrodes on other parts of the head in an attempt to pick up other waves of different frequencies and to create stereo effects. Use alpha to activate radios, television sets, lights, alarms, and other audio-visual devices.
>
> Design automated systems, with or without coded relays, with which the performer may perform the piece without the aid of an assistant.[4]

Lucier got the idea to make music with brainwaves from Edmond Dewan, a physicist and officer with the Air Force Cambridge Research

Laboratories and Lucier's colleague from the Physics Department at Brandeis University. Theirs was a chance encounter that, at another level of historical retrospect, was not so accidental at all. It is impossible to discuss *Music for Solo Performer* without including Dewan and, in fact, it is impossible to talk about Lucier's transformation into a mature composer—he has repeatedly acknowledged this himself—or his influential engagement with science without discussing Dewan's influence. What is not so well known is that Dewan's casual collegial suggestions led to two other compositions, *Whistlers* and Lucier's most famous work, *I am sitting in a room*. This chance encounter also illustrates why it becomes impossible to talk about American experimentalism in any comprehensive way distinct from the knowledge and technologies flowing from the militarized science of the Cold War, more specifically, cybernetics.

Dewan was a friend and associate of the mathematician and cybernetics pioneer Norbert Wiener. Wiener's influence on himself and many other scientists was substantive and liberating and, for this reason, Dewan thought that the situation was parallel to John Cage's influence on Alvin Lucier and other musicians. *Music for Solo Performer* can thus be understood as a manifestation of cybernetics within music, a meeting of Wiener and Cage, one step removed.

The score for *Music for Solo Performer* includes a diagram describing a circuit comprised of what Andrew Pickering calls, in his book on cybernetics and the brain, a *nonmodern ontology* of technology, psychology, physiology, and acoustical space.[5] A *circuit* is a "going around." Most of the circuits familiar to us today are tightly folded and compressed with distinct inputs and outputs, and they either work or they do not. Being closed, they are comparable to the *metallic circuits* in telegraphy, telephony, and satellite communications, as opposed to the open circuits of earth returns and ionospheric reflectivity. The circuit of *Music for Solo Performer* is an open one that nevertheless feeds upon itself.

The electrochemical activity in the brain of the performer leads to the electronics (electrodes, amplifiers, filters, switches, lines, loudspeaker drivers), then to the direct and resonant mechanics of the sound-making objects in proximity with the drivers, some of which are loudspeakers, to the acoustical spaces of the objects and spaces intervening in the distances, and then back to the performer, to the inner ear, where the transduction of sound from mechanically vibrating cilia opens ion channels to electrochemical signals that lead again to electrochemical activity in the brain.

Music for Solo Performer, in our nineteenth-century jargon, places things that are usually not regarded as technological *in-series* or *in-circuit*

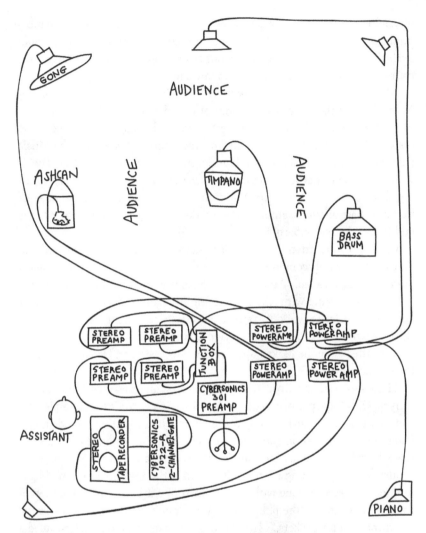

Figure 5. Alvin Lucier, graphic score for *Music for Solo Performer*. Image courtesy of Alvin Lucier; restoration by Pia van Gelder. From Alvin Lucier, "Music for Solo Performer," in *Review 1972*, edited by Malcolm Troup (London: Guildhall School of Music and Drama, 1972), n.p.

with an identifiably technological system wherein energy becomes the great equalizer, circulating through a transductive flow in and out of electrical/electromagnetic, acoustical and electrochemical energies, in and out of signals and sounds, perceptible and imperceptible states, an arrhythmia of speeds, traversing the distances of electronic circuits, performance space,

physiological and neurological pathways.[6] Where acoustical performances might appeal to resonant bodies and cellular structures, *Music for Solo Performer* circulated energetic domains from acoustical to electromagnetic, coursing through a greater range of materials and materiality of forces.

Music for Solo Performer premiered on May 5, 1965, at *A Concert of New Music* at the Rose Art Museum of Brandeis University. Lucier organized the event, which meant he could invite John Cage, the composer he respected most. However, given his unsympathetic colleagues in the Music Department, he approached Sam Hunter, an accomplished curator and critic who had come from the Museum of Modern Art in New York as the founding director of the Rose Art Museum. Hunter had made a number of important acquisitions, among them works by Cage's friends Jasper Johns and Robert Rauschenberg.

Cage agreed to attend on condition that Christian Wolff be invited and that Lucier himself compose a piece for the concert. "I said I didn't have a piece," Lucier recalled. "And there was a silence on the phone. Then I said, 'Well, I am working with a brainwave amplifier, but it doesn't work. I can't get the amplifier to work.'"[7] With Cage's encouragement, Lucier followed through with his composition. Lucier was later amused that, during the concert, the person he looked up to became his assistant. He later dedicated the composition to Cage.

The concert at the Rose Art Museum was underway as the audience arrived, with Cage performing *0'00"*, subtitled *4'33" No. 2* (1962), a piece he had first performed in Tokyo. The score read, "In a situation provided with maximum amplification (no feedback), perform a disciplined action," and Cage described it once as "nothing but the continuation of one's daily work, whatever it is, providing it's not selfish, but is the fulfillment of an obligation to other people, done with contact microphones, without any notion of concert or theater or the public, but simply one's daily work, now coming out through loudspeakers."[8] For his Rose Art performance, Cage fulfilled a daily task of answering letters, a generosity to correspondents and collaborators for which he was well known. That the audience arrived while the performance was already underway emphasized its quotidian character.

Cage sat at a table, typed at the typewriter, and drank from a glass of water; contact microphones amplified the sounds and a throat microphone amplified the vocal and peristaltic sounds. Throat microphones were easily obtained through war surplus outlets, underscoring the quotidian character of the military. One person likened the sound of drinking water to the "pounding of giant surf."[9] This was a long-standing interest for Cage; as early as 1937 he had called for experimental music centers equipped, in the

spirit of D.E. Hughes and the microphonic imagination, with "means for amplifying small sounds."[10] The best-known small sounds for Cage were two, normally inaudible sounds of his body, a low one and a high one, that he heard during his visit to an anechoic chamber, which provided a scientistic foundation for his aesthetic of silence, that is, that no such thing as silence exists.

The anechoic chamber at Harvard was a device, like his throat microphone, engineered as part of the military effort during World War II; indeed, throat microphones were probably tested in the anechoic chamber he visited.[11] An attending scientist or engineer told him that the sounds he heard were the low sound of his blood circulating and the high sound of his nervous system. Although the explanation for the latter sound is highly unlikely (unless the nervous system is equated with tinnitus), the next piece on the program at *A Concert of New Music,* Lucier's *Music for Solo Performer, for enormously amplified brain waves and percussion,* would indeed involve sounds from a part of the nervous system: the brain.[12]

As Lucier sat in a chair, electrodes were ceremoniously attached to his scalp. He then closed his eyes and did nothing. Soon, rumbling sounds came from speakers deployed throughout the room, shaking and resonating the instruments and objects in contact with the speakers or in near proximity to them. He opened his eyes and the sounds stopped. Closing his eyes as if to listen closely soon rewarded him and other people with something to listen to. As performance, seemingly the less he did the more sounds he made.

The scientific gear that Lucier used for the performance was given to him by Edmond Dewan. Lucier remembers running into him in 1964 at a time that Dewan was studying the energy spectra of brainwaves and, in fact, had gained national media attention for his invention of a control device using brainwaves: "Dewan had a large brain wave amplifier . . . he tried to get other composers interested in his apparatus, but they thought it was a joke. Brain waves! But I didn't think it was a joke, because I didn't have any ideas, which is a wonderful state to be in, because you can just accept anything. So I said, sure, I'll take your amplifier. I always talk about this piece; I can't get away from it. I always start with this piece."[13] Dewan had purchased two of the medical differential amplifiers (Tektronix Type 122) that he used in his brainwave research at a fraction of their normal price at an electronics clearance sale. He set out to offer his assistance and equipment to composers at Brandeis who might want to make music using brainwaves. This was an intrepid but, as we shall see, not a singular gesture by a scientist to seek out an artist based on an intuition; and, like all intuitions, such actions are both simple and complicated to trace.

Dewan approached composers at Brandeis but they were not interested. These were Lucier's "modern music" colleagues who would, after all, drive him to seek support within the visual arts. One of them was close to *Perspectives in New Music,* an academic journal that would demonstrate little interest in experimental music for many years. General neglect was typified by the fact that the Brandeis Electronic Music Studio existed in the basement of the library largely despite the Music Department. It had "no full-time personnel: it was staffed by music department instructors and students who had other commitments."[14] Neglect moved into infantile antagonism during the premier of *Music for Solo Performer:* "Two of my Brandeis faculty colleagues were there, too. During the performance one of them pretended to be asleep while the other gave him a hotfoot."[15] One of them was the chair of the department.

Dewan remembered meeting Lucier briefly when they were both students at Yale; that is why he recognized Lucier in the halls of Brandeis. Just as Lucier had no idea what he wanted to do at the time, Dewan only had a vague idea of how brainwaves might be used for music. He knew that alpha waves occurred at such low frequency that they needed to be transposed somehow into the human audible range. He and others had done this by recording them and playing them back at a faster speed. This would make a sound, and sound was the stuff of music. That was about as far as he got.

Once Lucier accepted this idea he did so completely, developing it from simply producing a sound to an increasingly complex process. He was initially "inspired by the imagery and technology of electroencephalography."[16] The imagery of electroencephalography (EEG) included more than graphic scribbles; it invoked scenes of sick people in hospitals hooked up to wires and advanced scientific machines. These were scenes removed from public view and audition but were just as real as any landscape:

> In one way art has always been dealing with a state that you find yourself in. Here we are! Born in this time, and these things are here. The EEG was here without me doing anything about it. See, I don't think of technology as technology. I think of it as landscape. We're born and brought up in a landscape and there's not much I can do about the fact that there are EEG amplifiers. I mean you could hardly pass a law ending it, right? There's nothing I can do to invent it or to make it go away. So I see it as a landscape. If you worked in a medical center EEG would be just like a tree; it's what you see every day.[17]

For Lucier there was a therapeutic hope in "the immobile if not paralyzed human being who, by merely changing the states of visual attention, can

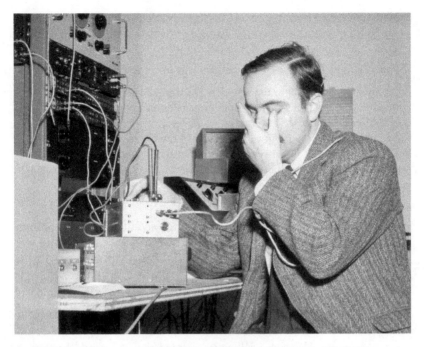

Figure 6. Alvin Lucier practicing brainwave control in the Brandeis Electronic Music Studio, 1965. Image courtesy of Alvin Lucier.

activate a large configuration of communication equipment with what appears to be power from a spiritual realm."[18] This, as we shall see, was in direct reference to how Dewan thought his brainwave control device might be used in cases of total paralysis. The appeal to spirit may have been atypical for Lucier, but importing therapeutics into composition was not, with stuttering (his own and others) and speech impediments animating certain of his compositions, including *I am sitting in a room.*

It occurred to Lucier that he was also looking at a unique congruence of art and science as his experimental music entry point. His friend Gordon Mumma had used seismological data in his piano compositions from the early 1960s and another friend, James Tenney, researched psychoacoustics at Bell Labs from 1961 to 1964 while composing computer music. But the field was still open, and using brainwaves and sophisticated scientific instrumentation seemed to be of a different order than other forms of electronic music: more science less engineering. It also set Lucier apart from Cage, which was an issue for certain composers and artists at the time; Cage's influence was liberating, but it could also be preemptive. Cage, as

Pauline Oliveros remembers, had "respect for scientific investigation but I never heard him discuss scientific interests."[19]

However, there were practical problems. As Lucier told Cage on the telephone, getting his brainwaves to behave was proving difficult:

> At night I would go into the Brandeis Electronic Music Studio, in the basement of the Library, and I'd put electrodes on my scalp, turn the amplifier on and try to generate alpha waves. It was very difficult because there was noise in the room and in the electrical circuitry. Often I couldn't distinguish between electrical noise in the amplifier or my alpha waves. . . . To sit there with electrodes on my scalp, shut my eyes, and make alpha come out was not easy in those days. The popular biofeedback fad had not occurred yet. I'm talking about 1965.[20]

Still, Lucier knew that he was onto something and at one point his proprietary streak took on a comic character. A few days before the Rose Art concert, he was on the stage in the Brandeis musical hall rehearsing with electrodes attached, practicing with the equipment, with the assistance of Tony Gnazzo, a graduate student in music. No one else was in the theater and Lucier thought his privacy was assured. When someone unexpectedly entered, Lucier instructed Gnazzo to throw a towel over his head so no one could see the electrodes. Whoever entered the hall would have seen Lucier sitting on a solitary chair, towel over his head, wires dangling from underneath.[21]

7 Edmond Dewan and Cybernetic Hi-Fi

On the program for *A Concert of New Music,* the physicist Edmond Dewan was listed as "Technical Assistant." After the performance, as the applause died down, Lucier took to the floor and introduced him as the co-composer. Dewan was uneasy about being classed as a composer, half-jokingly because the US Air Force might wonder how he was spending his time, but more because of his respect for composers. He had developed this respect as an avid amateur and accomplished organist, with special interest in twentieth-century French organ music of Jehan Alain, Olivier Messiaen, Jean Langlais, Marcel Dupré, and Pierre Cochereau.[1] Lucier was impressed with Dewan's skills and with how the organ with its three keyboards took up so much room in his house. Dewan's children remembered how he would play at their bedtime. He was not particularly interested in electronic music per se but played on one of the most widespread of electronic instruments.

Besides being an adjunct professor at Brandeis, Dewan was a research scientist working for the Air Force Cambridge Research Laboratories (AFCRL) at Hanscom Air Force Field at Bedford, not far from Brandeis. At the same time, he was conducting his brainwave research at the Stanley Cobb Laboratories for Psychiatric Research at Massachusetts General Hospital. It may seem odd that someone with such strong career military ties could have made his way freely among the radicalized student body of a liberal American university during the mid-1960s. However, Richard Lerman, a student at Brandeis who assisted Lucier with his compositions, did not remember Dewan being stigmatized in any way. Lerman was more surprised that a military man would be as creative and intellectually open as Dewan, with no trace of "the tragic insolence of the military mind," as Dewan's friend Norbert Wiener put it.[2]

Dewan studied physics at Yale under the supervision of Henry Margenau, physicist and philosopher of science. In 1957 with Margenau's assistance, Dewan published a paper in *Philosophy of Science* titled "'Other Minds': An Application of Recent Epistemological Ideas to the Definition of Consciousness," where he refers to the encephalographic research by W. Grey Walter, showing "interesting correlations between certain forms of electrical activity in the cerebral cortex and certain states of awareness."[3] Dewan speculated, "Someday a comprehensive correspondence between physical observables in the cortex (e.g., electrical, chemical, and others not even yet suspected) and subjective conscious experience will be found."[4] Fending off Henri Bergson, who posed that "a parallelism between psychological and physiological activity denies free will," Dewan wrote, "It might be that the act of measurement of a thought process will affect that process and bring about a complementarity similar to those found in Quantum Mechanics."[5]

Dewan's theoretical interests were broad and his mathematical skills widely applicable over the course of his career. His dissertation was on weaknesses he found in a widely accepted equation used for classifying stars according to their spectra, and he would later research ball lightning, gravity waves, and optics in the turbulence of the atmosphere, among other topics, including militarily sensitive issues put under strict classification.[6] Listed as working at the Electromagnetic Radiation Lab of the AFCRL, Dewan published a brief paper in 1959 describing reasons for anomalous radio signals from *Sputnik*. Just like its shiny surface that was seen crossing the night sky by millions of people, *Sputnik* was purposefully designed to broadcast at frequencies that radio amateurs around the world could tune in to. Sometimes its "beep-beep" transmissions interacted with the ionosphere in strange ways, producing so-called anomalous effects resembling passages of electronic music.

His work took a dramatic turn after he met Norbert Wiener at a conference at MIT during the early 1960s. They became friends and colleagues, visiting and speaking on the telephone frequently until Wiener's death in 1964, and it was Wiener who suggested that Dewan study brainwaves.[7] To honor his friend, in 1967 when Dewan developed a brainwave control device that used a computer to translate alpha waves into letters, the first word written by the brain was C-Y-B-E-R-N-E-T-I-C-S.[8] Dewan was not interested in brainwaves for their own sake; he was motivated instead by Wiener's mathematical treatments of nonlinear oscillations wherever they might shed light on a problem, by his own larger mission to gain philosophical insight into consciousness, and by the even larger aesthetic of

pursuing the beauty of science, which he found best described by Henri Poincaré:

> The scientist does not study nature because it is useful to do so. He studies it because he takes pleasure in it, and he takes pleasure in it because it is beautiful. If nature were not beautiful it would not be worth knowing, and life would not be worth living. I am not speaking, of course, of the beauty which strikes the senses, of the beauty of qualities and appearances. I am far from despising this, but it has nothing to do with science. What I mean is that more intimate beauty which comes from the harmonious order of its parts, and which a pure intelligence can grasp.[9]

Dewan's brainwave research was part of a large U.S. Air Force research project on the spatial disorientation experienced by helicopter pilots and crewmembers produced by the stroboscopic light shining through helicopter rotor blades. One person reported "a flitting black barred shadow effect from the rotor blades. In the space of a few seconds, I seemed to be enveloped in a violently pulsating reddish mist that thickened and blotted out all visual discernment (even of the cabin fixtures) and produced a panic sensation that massive, brilliant fire balls were being hurled at me."[10] Flicker and its psychophysiological effects were well known by this time, but Dewan was quick to say that he studied power spectra of brainwaves, not flicker.[11]

In the course of his research Dewan devised a brainwave control mechanism. This was not as easy and safe as it might seem today: other researchers at Massachusetts General Hospital accidentally electrocuted a cat. With electrodes placed on the scalp, a specialized medical amplifier and an electronic switching mechanism, he identified changes in his brainwaves and turned a simple bedroom lamp on and off. Just as Boy Scouts used flashlights to communicate in the night, it was obvious that the lamp was capable of Morse code. Thus, Dewan could communicate without speaking, writing, or moving. It was simply a matter of switching from on to off by generating and blocking alpha waves. He also paced his pauses so that they could be read on a scrolling electroencephalogram as the dots and dashes of letters and, slowly, the letters of words. Dewan imagined that his laboratory setup could eventually enable communication for people who suffered from complete paralysis, the coma vigil, or locked-in syndrome such as Jean-Dominique Bauby chronicled in *The Diving Bell and the Butterfly*. Dewan eventually realized that elaborate technology was unnecessary, since the tiniest external movement to signal code was much easier than lumbering in and out of alpha wave states. Bauby, for example, wrote his book by blinking.

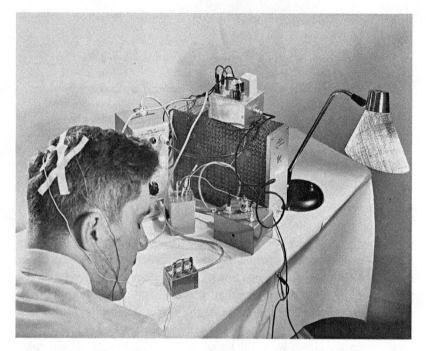

Figure 7. Edmond Dewan at his brainwave control device, 1964. Image courtesy of Brian Dewan.

Dewan was not expecting media attention for his invention, so it caught him entirely by surprise when local reporting spread to a national level. The focus on the potential for prosthetic communication shifted to an impending future where the *brain could talk*. As the *Boston Globe* reported:

> For a time, he opened and shut his eyes to produce the voltages. After a while, however, he kept his eyes closed and concentrated on seeing through his eyelids—a technique which still enabled him to control his alpha rhythms.... Sitting in a chair, absolutely motionless with his eyes closed he was able to turn the light off and on at the bidding of a colleague by "willing" his brain waves off and on. In a second experiment the lamp was replaced by a device that makes an audible "beep" when switched on. With this arrangement, Dr. Dewan attempted to send a Morse code message.... It took approximately 25 seconds per letter, but he was able to spell out, with relatively little difficulty, "I can talk."[12]

According to the same reporter, this was "one of the most extraordinary experiments of all time." On another occasion, Dewan cleverly told the reporter for *Science News Letter* that he could "speak his mind."[13]

Media attention catapulted to another level when a report on Dewan's research appeared above the fold on the front page of the *Washington Post*, with the headline "Man's Brain Waves Can 'Talk,' Overcoming Speech Barriers." The article described the device, process, and therapeutic potential and was sure to mention, "This does not mean that persons can read each other's minds."[14] Unfortunately, the caveat did not prevent several deranged people from telephoning Dewan with threats to stop him from reading their minds.

The pinnacle of media attention came when a journalist and production crew from Walter Cronkite's *CBS Evening News* visited Dewan's lab and filmed a demonstration. The program aired before a national television audience of millions at a time when there were only three networks broadcasting in the United States. With the press that he received, Dewan was invited to demonstrate his device at several institutions and conferences in the United States. While turning the light on and off at a conference in Tampa, Florida, the lights of the entire city went out, leaving audience members to momentarily ponder Dewan's will to power.

Dewan's invention was not the first time that brainwave control was introduced to American mass culture. That honor belongs to the 1956 science-fiction film *Forbidden Planet*, a pre-*Sputnik* space-age rendering of Shakespeare's *Tempest* seen through the highball lens of cocktail-party Freudianism. In one scene, Dr. Edward Morbius (Prospero), living on a remote planet (island), demonstrates a technological device used by the Krell, an extinct race of vastly superior intelligence. He dubs it the "plastic educator" because he suspects it was used "to condition and test their young." Much like the county-fair game where a puck is catapulted up a vertical gauge by a sledgehammer, Krell youth exercised the brute force of their intelligence to float a marker up a gauge. "Now, over here you see the electromagnetic waves of my brain sending that indicator up half-way," says Dr. Morbius. He then demonstrates his intermediate skills of manifesting a small virtual image of his adult, virginal daughter (Miranda), as long as he can keep her in his consciousness from microsecond to microsecond. This sets the incestuous stage for a psyche structured along Freudian lines, unconsciously unleashing virtualized "monsters from the Id," fed by the autonomous power of massive banks of computers also left by the Krell.

Ironically, like *Music for Solo Performer*, this too was the product of an oblique meeting of Norbert Wiener and John Cage at the site of a brainwave control mechanism making sound. Louis and Bebe Barron created the electronic sound effects and music for all aspects of *Forbidden Planet*,

including the brainwave interaction with the "plastic educator." The film was remarkable in many ways; among them, it was the first sustained exposure of electronic music composition to a mass audience. The Barrons were closely associated with John Cage through the *Music for Magnetic Tape Project*; they were commissioned to provide the recorded sounds used in Cage's *Williams Mix* and Earle Brown's *Octet* (the leftovers from *Williams Mix*), and they composed *For an Electronic Nervous System* as their own contribution to the project.[15] Moreover, Louis Barron was greatly influenced by Norbert Wiener's *Cybernetics*, using the theoretical drift between technology and biological life-forms to ascribe animal-like behaviors to the electronic circuits he constructed. Thus, the soundtrack of *Forbidden Planet* was situated at the crossroads of Cage and Wiener, not unlike *Music for Solo Performer*, but with very different results.

Edmond Dewan was unaware of *Forbidden Planet*; however, he recuperated his science-fiction street cred through his fictionalized guest appearance in Martin Caidin's novel *The God Machine* (1968):

> Scientists at the Cambridge Research Laboratories had worked for years in brainwave communications experiments. Dr. Edmond M. Dewan trained skilled volunteers to alter the pattern of the alpha-wave rhythm of the brain, the low-frequency wave related to visual perception. Being able to turn on or off, at will, the alpha rhythm meant an interruption of an electrical source from the brain. By amplifying brainwave signals it was possible for these "alpha adepts" to conduct a crude binary digit system of communications.[16]

Dewan's *alpha adepts* have evolved slowly but surely. In recent years, game developers have accessed his patent as a control device.[17]

As Dewan's first adept, the first thing that Lucier had to do in composing *Music for Solo Performer* was to resist making a tape piece. Because alpha waves transduced directly to acoustics are subaudible, that is, they exist below the level of human audition on the sound spectrum, this did not leave many options for live performance: "Everybody told me to make a tape piece . . . take the brain waves, record them and do a beautiful tape piece. But the crucial decision I made was to do that piece live, to sit in front of an audience and produce alpha—made all the difference in the world. That was a milestone."[18] Lucier could have increased the speed of recorded brainwaves to boost them into audible range and, in fact, he did just that. *Music for Solo Performer* includes triggered recordings of "sped-up alpha," but they were supplemental to the live performance: "Basic to my work is making audible that which was inaudible. . . . But it's got to be done in an artistic way, whatever that is, and that's a careful way—a careful and beautiful and unexpected way."[19]

For the live performance, he realized that the mechanics of acoustics could function in a different way. Although sound at ten hertz cannot be heard, it can be felt and under the right conditions, as Lucier discovered, it could be seen:

> When I was producing alpha in the studio I looked at the loudspeaker that the brain waves were coming through. We didn't have the grille cloth on; you could see the cone of the speaker. It was a KLH 6 loudspeaker. In Cambridge, Massachusetts, at that time, they were developing the first home hi-fi loudspeakers. The acoustic-suspension speaker was being manufactured by AR and KLH for home use. And when the bursts of alpha came through the speaker, I could see the speaker cone moving, almost as much as an inch. So I thought, "The speaker is a performer." It's not just where the sound comes out, where the music comes out. It's a performer. It's doing something. It's doing work. So, because the alpha waves were so powerful and rhythmic I thought, if I put something up against the loudspeaker, right up against it, anything—a gong, a drum, timpani, cymbals, a cardboard box—the alpha waves could sympathetically vibrate a percussion ensemble.[20]

Dewan was particularly impressed with how Lucier used the subsonic bursts from the speakers to drive the sound making in a live setting, and the composer Gordon Mumma, in his formative essay on *Music for Solo Performer* written in 1967, agreed. Mumma set the stage in saying that "the great diversity of equipment-configuration which is possible with recent electronic-music procedures seems to have made systems-analysis essential on a fundamental level of contemporary musical creation."[21] The "most significant electronic-music aspect" for *Music for Solo Performer*, Mumma wrote, "is that the loudspeakers are not the final part of the system. Generally, the loudspeaker is the ultimate sound-producer in an electronic-music system. It is the final object from which the sound emanates, ready for the ears of the audience. Instead, Lucier has extended this system-concept and uses the loudspeakers as transducers or triggers for the natural, resonant sounds of percussion instruments."[22]

When Mumma mentioned "system-concept," he was using the language of cybernetics that he picked up on the job and applying it to activities in electronic music. He worked as a writer of nonclassified reports at Willow Run Laboratories, a research center attached to the University of Michigan, that was part of the same military research network as the Air Force Cambridge Research Labs. *Systems-concept* was a department with the overarching task to coordinate other systems in military command and control, intelligence, sensing and monitoring, logistics, administration,

computing, and so on. As applied to music, Mumma simplified the defini-
tion of "system-concept thinking" to "one in which the composer created a
system from which a composition was conceived."[23]

Mumma, who performed the piece as well as having constructed the
portable equipment that Lucier used in later performances, was well placed
to provide an insider's perspective:

> Much of the audience does not immediately comprehend that electrodes
> are being implanted on the soloist's head. Some, perhaps, have never
> seen nor heard of such a thing, even for non-musical reasons. In any
> case, the situation is both ambiguous and dynamic. This period of time,
> before the first tapped brainwaves are directed to their resonant
> instruments, is really quite mysterious. After the sounds have begun,
> one comes to recognize the coincidence of the soloist opening his eyes
> with the stopping of the alpha-articulated sounds. Closing of the eyes
> will not necessarily start the alpha again. The process of non-visualizing
> must occur. This is a specially developed skill which the soloist learns
> with practice; and, no matter how experienced the soloist has become,
> various conditions of performance intrude upon that skill. A
> performance of *Music for Solo Performer* by a skilled soloist is a matter
> of exercising great control over conditions which are hardly ever
> completely predictable. The soloist who can achieve sustained sequences
> of rapid alpha bursts, which are distributed from the resonating
> instruments throughout the audience, creates a *tour-de-force*
> performance.[24]

Reasons that *Music for Solo Performer* was recognized as a particularly
powerful contribution to experimental music can be found in its concep-
tual and theatrical elements. Generating alpha waves not only required the
eyes being closed, it required an absence of visual thinking, which puts a
cognitive and musical twist on Marcel Duchamp's antiretinal art and,
moreover, renders *concept* in the lingua franca of brainwaves. The perfor-
mance of such concentrated interiority presents an oscillation of various
insides and outsides among audience members. It seems very intimate,
perhaps invasive for the spectator to watch someone doing nothing for an
extended period of time, whereas Lucier understood it from the perform-
er's perspective, with the "person sitting there without having to make a
single muscular motion, yet showing something, unobserved, I mean that
you cannot observe from outside. It's a very intimate situation."[25] Having
the performer sit and do nothing also mirrored the broad liminal states
already present among audiences at certain musical performances: audi-
ence members are well rehearsed in slipping into hypnagogic states, usu-
ally interrupted by spasms of self-consciousness or prodding by the people

next to them. More distantly, *Music for Solo Performer* ironically resembles the tape-music composers who also do not perform in front of their audiences.

However, the most apparent conceptual theatricality of Lucier's composition is the one it shares with John Cage's *4′33″*. "Most music is busy," said Lucier. "The players have to move, the actions of a pianist for example are important, but in this piece electronics allows you to go directly from the brain to the instruments, bypassing the body entirely."[26] In certain forms of music, the more complicated or graceful the motor skills the better chance a performance will be perceived as virtuosic. At the premier of Cage's *4′33″*, David Tudor, by everyone's estimation an extraordinary virtuoso of the piano, sat at the keyboard and did not play. He withheld performance so that musical attention would be shifted to the nonintended sounds of the surrounding environment. Similarly, in *Music for Solo Performer*, the performer performs by not performing. Even within the interior dynamics of the performance, "The harder you try [to generate alpha waves], the less likely you are to succeed; so the task of performing by not intending to, gave the work an irony it would not have had on tape."[27]

Thus, when Lucier said that the underlying idea of *Music for Solo Performer* entailed "a control or energy idea" rather than one dominated by sound, it is important to understand that the "control" he had in mind, literally, entailed a certain lack of it.[28] "Discovery is what I like," he said, "not control."[29] Cage had codified a distancing from control in his notion of indeterminacy; in his piece, Lucier brought it to bear specifically on electronic music and cybernetic systems, which themselves opened up to the energetics between sound and a "generalized signal," in James Tenney's phrasing.

As previously stated, the history of electronic music had been understood as a procession of devices designed to control energy from one end to the other, with various impulses (through a synthesizer or computer) that remained electronically hardwired within a system until they left the loudspeakers as sound. There was little regard for the nature of the energy controlled. With *Music for Solo Performer*, Lucier interrupted this linear notion with a feedback loop, and then he broke open the feedback circuit by inserting himself and acoustical space, equalizing all elements within a circuit.

Most obviously, the system of the composition (and composition of the system) broke open the technological closure of the linear circuit of electronic music and *let in some air*. It used acoustical space to modulate a sound much as an electronic circuit would modulate a signal. This is consistent with Lucier's later works as well: "Most of the time my sounds do some kind of work."[30]

In his composition *I am sitting in a room* (1970), air in a space acted as a component that could exist in-circuit with a hardware configuration, whereas in *Music for Solo Performer* the energy transit was subtler.[31] Putting air in the circuit set up a transductive trade between acoustics and electromagnetism and opened intervening spaces, propagations, distances, and other artifacts and attributes commonly collapsed in technological channels. This would become a tactic increasingly apparent in the Lucier compositions that followed.

Along with air, Lucier introduced himself into the circuit, but only in a displaced way, not as a performer. "The speaker is a performer," Lucier says, but both the performer and the loudspeakers were silent in *Music for Solo Performer*. It was only when the loudspeakers became performers in a percussion ensemble that sounds were made and, coming full circle, only upon hearing the sounds made by (not from) the speakers did the "solo" performer know whether she or he was performing, that is, generating alpha waves in the first place. As Gordon Mumma remembered, "It was the (slightly delayed) responses of the resonating percussion sounds that I recognized—when I had that state of attention."[32]

This continual cycling through a series of displacements distributes any conventional set of technomusical locations (performer at the beginning, loudspeaker at the end) throughout whatever space in which the performance takes place. All specific locations usually susceptible to representation are likewise everywhere and nowhere in particular, cycling around in physically and physiologically transduced trades of acoustical and electromagnetic energy.

Alongside the system of the composition, at the time there were three overlapping technological systems that *Music for Solo Performer* embodied, each of them belonging to a specialized space and comprised of separate components: science laboratory, electronic music studio, and the room in the home for listening to music on the hi-fi stereo system. The science laboratory was transplanted from Edmond Dewan's setup, in the electrodes, specialized amplifiers, and so on. The electronic music studio was in the basement of the library at Brandeis, among other places in the musical culture to which Lucier belonged. Hi-fi was already a union of art and science and the electronic music studio was a research practice within the arts.

Unlike electronic music or scientific gear, hi-fi had direct and scalable access to audiophile and consumer markets. The Boston area was the hub for home hi-fi component systems—turntable, radio receiver, pre-amplifier, amplifier, and loudspeakers—as they made their way from high-end enthusiasts to broader consumer markets in the 1960s. In the program for *A*

Concert of New Music, Lucier mentioned a retail hub of consumer electronics—Audio Lab Inc., Cambridge—as readily as he did the technical assistance of Edmond Dewan. In instructions for *Music for Solo Performer,* Lucier talked about the role of speaker cones, grille cloths, and AR and KLH speakers as another composer might discuss techniques or attributes of a musical instrument.[33]

To truly appreciate Lucier's responsiveness to the technological milieu of the Boston consumer hi-fi industry, we need to flash forward a few years to what would become his best-known composition, *I am sitting in a room* (1970), and its association with Amar Bose, founder of the well-known Bose Corporation.[34] Bose was one of Norbert Wiener's PhD students at MIT; his dissertation was an application of Wiener's theories of nonlinearity to a study of room acoustics and loudspeaker design. Edmond Dewan knew Bose through his association with Wiener and it was Dewan who informed Lucier about a demonstration of room acoustics that Bose conducted, which gave Lucier the idea for *I am sitting in a room.*

Bose approached loudspeaker design as way to not only reproduce a musical performance but also emulate the space in which a musical performance takes place. He felt that others had put too much emphasis on an idealized responsiveness of loudspeakers within abstract spaces, rather than the actual day-to-day spaces in which people listened to recordings. Anechoic chambers were very abstract spaces in which loudspeakers were tested in the Boston area. Their waffled walls absorbed all sounds without reflecting (echoing) any back, emulating a "free field" where sounds dissipate unimpeded by anything in an environment but a constant medium. A free field is in effect an *infinite outside,* in other words, not a room at all. It is also a theoretical environment without life; before the designers of the first anechoic chamber named it for echoes and their absence, the customary expression for a soundproof space was a "dead room."

For Bose, the theoretical opposite of an anechoic chamber would be "a room with perfectly reflecting walls and no sound absorption by the air," in which any sound would disappear in a field of its own reverberations.[35] Somewhere between these two theoretical opposites would be where people lived.

> Conventional loudspeaker design has tended to optimize parameters that are appropriate for the case in which the direct radiated field from the loudspeaker is predominant at the position of the listener. The emphasis upon flat frequency response on axis in free field and upon improving the dispersion at high frequencies are examples of this design. This approach might be appropriate if the speakers are to be

listened to out of doors or in an anechoic chamber. However, it leaves much to be desired when the listening environment is the living room and the object is to simulate as many as possible of the properties of the sound in a concert hall.[36]

Edmond Dewan invited Amar Bose to present his latest research at the Air Force Cambridge Research Labs, and part of his presentation included a demonstration of room acoustics. Dewan remembered Bose reading a poem into a microphone and recording it—then playing the recording back into the room, recording that, playing that back, and so on (merrygoraumd, to paraphrase James Joyce's German-inflected pun). Bose repeated the process a few times. During each iteration, the poem gathered up the resonances of the room and the words became less distinct; eventually, as Dewan remembered, "it sounded like bells."[37] Bose himself recounts, "The demonstration was done in the early 1960s for the purpose of illustrating what the normal modes of a room do to sound. If you go through these normal modes just three times, the result sounds like bells, whether the source is music, speech, or pink noise. These demonstrations were given to illustrate the problems of reproducing sound after it had gone through a concert hall, for example, and then through a living room."[38] Lucier did not attend Bose's demonstration; instead, Dewan told him about it a few years later in the hallways at Brandeis.

> Dewan remarked that there was a professor at M.I.T. who was designing a new type of loudspeaker. His name was Bose. And the way he tested his speakers was to recycle sounds through them to see if there were any unwanted peaks, to make sure the speakers were flat. It was kind of an acoustical test. I just happened to meet Dewan in the hallway and he casually mentioned this fact. It wasn't a big deal. So one night I got a couple of Nagra tape recorders—they were the best you could find at that time—an ordinary Beyer microphone and a single KLH loudspeaker. I went into the living room in my rented apartment. . . . I sat in a chair in front of the microphone and asked myself "What can I put into this room?"[39]

Lucier used the same recycling technique in *I am sitting in a room*.[40] Of course, whereas Bose's larger quest was to design speakers that emulated performance spaces within domestic settings, that is, reproducing one space within another, Lucier's intent was to excite and experience whatever space the performance took place in.

Because *I am sitting in a room* requires a room, Lucier could not perform it outside or in an anechoic chamber that emulates a free field. In a room with no resonance, performing the composition would take innumer-

able iterations and an interminable amount of time and would probably become saturated by the rising noise floor of the equipment itself. Nevertheless, herein lies a difference between John Cage and Alvin Lucier: Cage found legitimacy for his aesthetic of everyday listening to environmental sounds in a scientific space that eliminated them, whereas Lucier found in science the means for listening to any and all spaces. Through the anechoic chamber Cage was liberated into a free field, whereas Lucier heard the variability of actual spaces.

The revelation of Lucier's compositional practice during this early period was based on an interchangeability of room and space, where both could either house systems, become components in systems, or dynamically fold one within another. In this way, there was a transformation in his attitude toward music making from "what can I put into this room" to "what can I put this room into?"

Lucier stated that the experience of performing *Music for Solo Performer* "led me in two directions at once. One was an interest in space as a musical component and the other was . . . an interest in exploring natural sounds. The spatial aspect was inspired by the experience of sitting in one spot in a room and hearing the sounds emanate from so many geographical locations around you."[41] He extrapolated from the unique distribution of speakers within a given space to geographical spatiality and, with his next composition, *Whistlers* (1966), extended it further. Lucier transposed musical transposition to another key, moving spatiality to the magnitude of the earth.

8 Alvin Lucier

Whistlers

William Duckworth: Why did you move from brain waves to an
 interest in natural sounds?
Alvin Lucier: Well, brain waves are natural sounds. . . . The interest in
 natural sounds came about simply because I had uncovered a natural
 sound source.
Duckworth: What did that lead to?
Lucier: Well, one of the things I became interested in was ionospheric
 sounds. They are caused by electromagnetic storms in the
 ionosphere. Like alpha they are natural phenomena that human
 beings have not been aware of. They are really beautiful and, under
 certain conditions—usually at night—you can receive them with
 radio antennas.

Whereas *Music for Solo Performer* is one of Alvin Lucier's best-known
compositions, *Whistlers* is obscure.[1] It was, in fact, withdrawn from his
catalog. Nevertheless, he readily identified with the work; for several years,
it helped establish his initial reputation within the larger community of
experimental music. Along with the brainwaves of *Music for Solo
Performer,* the natural radio of *Whistlers* roughed out a new space of pos-
sibility within signals, from brainwaves to outer space.

 Moreover, although *Whistlers* was withdrawn, the idea behind it was
not. The first incarnation of *Whistlers* was a live filtering of recorded pas-
sages of whistlers and atmospherics taken from an LP released by Cook
Recordings. The second was a recording of that performance. The third was
a failed attempt at directly incorporating live reception of atmospherics and
whistlers. The fourth was the composition *Sferics* (1981), based on Lucier's
own recordings amid the mountains of Colorado, and then, lastly, a related
composition, *Navigations for Strings* (1991).

 Edmond Dewan thought that if Lucier was interested in the musical pos-
sibilities in the naturally occurring electromagnetism of brainwaves, then
he would be interested in speaking with his colleagues at the Air Force

Cambridge Research Labs who conducted research on ionospheric radio.[2] Such a suggestion would have been warranted; the sounds of natural radio were already judged to be closer to music. Even though transduced brainwaves were subaudible, whistlers and atmospherics were in the audio frequency range, that is, already in the range of normal human hearing. Moreover, the sliding tones of certain types of atmospherics, and especially the glissandi of whistlers, have conventional musical properties prior to being imported into contexts of music.

Lucier does not remember Dewan mentioning whistlers or recommending that he visit the scientists at the Air Force Cambridge Research Labs. Instead, he attributes his initial interest in whistlers and atmospherics to listening to the LP *Out of This World* (1953), from the library at Brandeis. The LP was part of the Cook Laboratories, the label of the inimitable Emory Cook, the most innovative American recordist and phonographer of the 1950s. The first side of the LP contained Cal Tech seismologist Hugo Benioff presenting the sounds of earthquakes; we will discuss Benioff and this side of the LP in chapter 11. The second side featured Dartmouth physicist Millett Morgan presenting the "sounds of the ionosphere." After reviewing the side with earthquakes, a *New York Times* columnist commented on "cosmic music for sale":

> Probably more startling and awesome is the other side of the same record in which Mr. Cook has embalmed weird sounds from outer space—the music of the cosmos.
>
> These sounds were drawn from the skies by Dr. Millett G. Morgan at Dartmouth's Thayer School of Engineering. They are weirdly patterned swishes, whistles, tweeks and peeps caused by electrical impulses that emanate from celestial spheres.
>
> They bounce off the ionosphere, the fluctuating formation of cosmic dust and air that embraces earth at an elevation of roughly fifty miles. They skip shrilly from hemisphere to hemisphere, and the recording tracks them in their amazing gamboling.[3]

Morgan also issued another Cook Laboratories LP in 1955, *Ionosphere*, devoted entirely to whistlers and atmospherics. Morgan headed one of two prominent research teams in the United States, "Whistlers-East," while Robert A. Helliwell at Stanford University directed "Whistlers-West." Both followed the lead of L. R. O. Storey at Cambridge University, who first made sense of the involvement of the magnetosphere in the production of whistlers.[4] The public face of Storey's research was his 1956 *Scientific American* article "Whistlers," with the banner explaining that there was music involved: "They are musical sounds that may be heard in a radio

receiver tuned to very low frequencies. Originating in the atmosphere, they provide a new method for exploring its outlying regions."[5]

As a *New Yorker* magazine article described the LP, "*Out of This World* reproduces the swishings and tweekings of electrical disturbances in the ionosphere, sixty miles above the surface of the earth, which a Dartmouth professor of electrical engineering picked up on an antenna atop a hundred-foot tower."[6] Much of Morgan's side of the LP consists of an interview between Morgan and Cook, friends who first met when they worked at the student radio station at Cornell. It was Cook who suggested to Morgan that he release his ionospheric recordings.[7]

The interview is interspersed with narrated examples of different types of atmospherics, and the last ten minutes consists of an uninterrupted string of recordings. In trying to make the phenomenon of whistlers comprehensible to himself and the listeners of the LP, Cook compared the dispersion of the full-spectrum electromagnetic burst of lightning into the magnetosphere, jumping over the equator from one hemisphere to the other, to form a glissando, to a deck of cards. He also compared the scales of geophysics and geopolitics:

MORGAN: The excitation of the ionosphere by a bolt of lightning is pretty much like hitting the ionosphere with a hammer, exciting it across the full frequency spectrum. You can hear lightning crashes on the very high frequencies and the usual communication frequencies in the broadcast band; and low frequencies where aircraft warning beacons operate; and even at audio frequencies such as these, which produce the swishes or whistlers.

COOK: I've only been exposed to this situation now for a short time, and it's hard to dig in and find some way to relate it to something we know about. Let me try this out as a metaphor on you. Let's compare the lightning stroke to a deck of cards, perhaps. There are more than fifty-two cards in it, but there's—there's a deck of cards before us, which is in its original shape and piled all one on top of the other, it becomes a lightning bolt. But Fourier told us some years ago that any such phenomenon is composed of a large number of individual frequencies or pitches, tones rolled up into one ball of wax and occurring simultaneously, which would add up into this one particular lightning bolt. Could we say that, in the process of transmitting this deck of cards from the Northern to the Southern Hemisphere and back, that the cards get strung out all the way from the Deuce of Clubs to the Ace of Spades; the Deuce of Clubs, being the lowest frequency, comes back with the last in order.

MORGAN: Yes, that's a perfectly satisfactory representation of the phenomenon, I think. If each card travels with a little different velocity than its neighbor, then the deck would be smeared out in the process of the trip.

COOK: Now, the reason for all this taking place, and it's hard for us to imagine a sudden impact like a lightning bolt stringing out over such a long period of time as I understand it, as they're traveling way out beyond a diameter of the earth down to the Southern Hemisphere and back. This idea of hemisphere bouncing is a great concept on the grand scale, but it seems to me it dwarfs the concept of even geopolitics.[8]

Millett Morgan's research focused on the points at which the fleeting and diaphanous magneto-ionic flux lines would form to connect the Northern and Southern Hemispheres and on how whistlers operate at different latitudes. These "conjugate points" form sister-city arrangements with different parts of the globe through geomagnetism rather than geopolitics. In other words, different parts of the world are in wireless communication with one another in an expressiveness of storms.

Morgan's crew worked with the flux lines between the Aleutian Islands and the south island of New Zealand and between Bermuda and the Falkland Islands. Morgan also found activity in Africa promising, since it was geomagnetically *married* with Europe in a conjugate relationship. On his LP *Ionosphere,* simultaneous recordings of natural radio were made in New Hampshire and Washington, DC, a stereo separation of over six hundred kilometers that would make speaker placement difficult. At one point, static produced by rain in Hanover can be heard.[9]

Alvin Lucier was impressed with the immense energies (lightning strikes) that teased out over such great distances (tens of thousands of kilometers into the magnetosphere, approximately six earth radii into space, from one hemisphere of the earth to another) in order to produce purely pitched glissandi. Emory Cook commented on this hemisphere bouncing, how the scale of geophysics surpassed that of the geopolitics that normally kept its radio waves closer to earth, whereas Lucier was entranced in the concrete concentration of geophysical magnitudes of energy and distance perceived in the small sounds, an auditory poetics of earth magnitude.[10] This is a particularly clear example of *transperception,* in this case meaning hearing in a sound the influences of intervening space traversed by a signal or sound.

With *Music for Solo Performer,* Lucier resisted making a tape piece but, unlike brainwaves, atmospherics and whistlers were not a readily available

live source. Whistlers, in particular, are notoriously unreliable, depending on thunderstorms, geomagnetic activity, ionospheric conditions, phases of solar activity, electromagnetic interferences, and so on. Using the recorded sounds from the LP, Lucier noted, "I experimented with this material, processing it in various ways—filtering, narrow band amplifying and phase-shifting—but I was unhappy with the idea of altering natural sounds and uneasy about using someone else's material for my own purposes. I wanted to have the experience of listening to these sounds in real time and collect them for myself."[11] However, Lucier performed *Whistlers* several times in this manner, including a large-scale version at Winterfest in Boston (February 21, 1967), with a group that included members of the Sonic Arts Group and Brandeis graduate students Richard Lerman and Daniel Lentz, both of whom would go on to notable careers in sound art and music composition. Lerman, who built two "resonating band-pass filters" through which the reel-to-reel recordings were played, remembered black-and-white video cameras on tripods focusing on the action for live projection, with "Alvin asking us to get close-ups of the electronics and the ears of the performers."[12]

A recording of *Whistlers* was featured, somewhat ironically, at the First Festival of Live-Electronic Music, a festival held jointly at Mills College in Oakland and University of California at Davis, December 4–6, 1967. Its saving grace was that it was live-feed recording from a previous performance. It was presented during the first evening of the event held at Mills, although Lucier himself was not in attendance. Tony Gnazzo, who had been Lucier's graduate student at Brandeis, worked at Mills, and was one of the organizers of the festival, said that *Whistlers* was already well known when it was scheduled, that is, its reputation had preceded it. It was known, he said, in conjunction with *Music for Solo Performer*, to have formed a breadth extending from brainwaves to outer space.[13]

A thorough report on the festival by Will Johnson appeared in the third issue of *Source: Music of the Avant Garde*, the key publication, based in Davis, of writings and scores concerning experimental music and the arts. Johnson noted that "Lucier's attitude as a composer is unique among the composers represented at the festival. His role is essentially that of the explorer, and his reason for designating this particular phenomenon is that ordinarily one would be unable to hear it. The concert situation serves as our opportunity to experience this sound world, and the composer is our intermediary." Citing Lucier, he described the sounds of *Whistlers* as being created "by the spinning electromagnetic fields above the earth" and reasoned that the audiotape qualified for a concert of live electronics because

live reception of whistlers was seasonal: "Actually, the performance heard at the festival was a tape recording of a 'live' performance; atmospheric conditions make a 'live' performance feasible only in the summer months."[14] It is curious that liveness defaulted to seasonal time rather than human presence, but more curious was the editorial note on *natural radio* cut midparagraph into Johnson's report: "Ed. Note: Perhaps this is not so 'natural' in some cases. The VLF portion of the r-f [radio frequency] spectrum runs from 4 to 6 kc [kilocycles, kilohertz]. If you monitor this portion of the radio spectrum, you are apt to hear the strange sounds Mother Nature makes in the r-f spectrum. These are called 'Whistlers'—long descending screams caused by lightning. You can also hear sounds called 'The Dawn Chorus,' 'chirps,' 'clicks,' atomic blasts and the ionized trails from rising missiles."[15]

This editorial note was a little window onto the interplay between Cold War science and the technological milieu of experimental music. Whistlers by their nature are infrequent, but luckily more frequent than atomic blasts and missile launches; still, the radio amateurs that frequently tuned to the skies were used to a variety of signals and means of propagation across a range from natural to unnatural. Those involved in the sport of receiving signals from distant parts of the globe (D/Xing) were known to take advantage of signals reflected off the heated, ionized tails of meteors, as well as being enlisted in reporting back on radio scattering from missile trails as a fallback means of emergency communications, just as earlier they had been enlisted to monitor the beeps of *Sputnik*.[16]

Studying VLF emissions produced by nuclear explosions was part of a larger scientific task of producing and monitoring seemingly every possible electromagnetic and acoustical (seismic, infrasound) signal and chemical and isotopic signature from around the world.[17] This was where, in Emory Cook's terms, geophysics and geopolitics became congruent, demonstrating how science, amateurism, and the arts overlapped with military exigencies. One of the earliest studies of whistlers produced by nuclear explosions involved the test shot Nancy, the detonation of a 24-kiloton nuclear device at 300 feet at the Nevada Test Site as part of Operation Upshot-Knothole (March 24, 1953). Nancy produced a two-hop whistler recorded at Stanford University; that is, the signal from the blast went on a round-trip from Nevada to the Southern Hemisphere and returned north to Robert Helliwell's station at Whistlers-West. Such information on "Explosion-Excited Whistlers" alluded to in the *Source* editor's note was available at the time in Helliwell's (now classic) text, *Whistlers and Related Ionospheric Phenomena*, published in 1965.[18] The type of natural radio signals heard in

Lucier's *Whistlers*, in other words, had been joined with unnatural signals traversing the earth since the Trinity test and the bombings of Hiroshima and Nagasaki.

One night a few months after the *First Festival of Live Electronic Music*, Lucier was at University of California at San Diego for a short residency, invited by Pauline Oliveros, who considered him "the poet of electronic music."[19] He attempted a truly live version of *Whistlers*, which did not go very well: "We got the theory down. The practice was just not there," Oliveros said.[20] They were not sure how to make the right type of antenna but had some help from a physics student who dutifully wrapped meters of copper wire around a triangular base. They also "extended a couple hundred feet of hook-up wire to an antenna down and across a canyon. . . . Nothing much happened. All we got was hum and a good bit of static."[21]

On the night of the performance on a glider field overlooking the Pacific Ocean, Oliveros fondly remembers the Italian composer Niccolò Castiglioni looking "down at this box and this stuff that was going on and [in a thick accent] he repeated, 'How is it organized?'"[22] In anticipation, she said, "I felt the same charged atmosphere as a performer as I had when I first experienced the *Music for Solo Performer* as a listener," and the liveness of the event was no doubt made more lively by the possibility of rattlesnakes.[23] But the sounds were disappointing; there was a lot of "sputtering" and, as Oliveros put it, "It was really staticy."[24] And Lucier remembers, "We didn't get any sferics but did hear signals from aircraft flying over to Vietnam."[25]

After abandoning the live performance versions of *Whistlers* in the mid-1970s, Lucier composed *Sferics* in 1981. The term *sferics* is short for atmospherics, which meant that the composition was not dependent on receiving the more elusive whistlers, and this time Lucier got both the theory and practice right thanks to assistance from the composer Ned Sublette and a hobbyist book he suggested. *Listen to Radio Energy, Light, and Sound* (1978), written by Calvin Graf, an electronics engineer for the US Air Force, still has cult status for many artists because of both the technical how-to it imparts and its contagious curiosity (for example: "I was amazed when I was able to use the induction pickup to *hear* the magnetic field sound that an ordinary paper clip makes when you bend it back and forth").[26] It included a section on how to build a large-loop VLF antenna, accompanied by an informed discussion of natural radio.

Instead of attempting to receive natural radio near the electromagnetic interferences of an urban area like San Diego, Lucier took a pair of antennas on a hopeful search for an "electromagnetic wilderness" in the mountains of Colorado over the course of several nights. As he wrote in his diary for

August 4, 1981, "Drove jeep, filled with recording apparatus, two antennas, to meadow. Too much hum: forgot that underground power lines cross here. Moved to upper dirt road, lookout over river. . . . Good sferics, but picked up some hum in one antenna . . . 4:30 AM . . . absolutely lovely results. Sferics, dawn, one raucous bird, perhaps a magpie."[27]

Different nights, different places with varied success; the nights them-selves suggested another composition: "telescope aimed at a twinkling star or other shimmering object. Solar cell receiving amplified twinklings. Reactive sounds."[28] Finally, on August 27, Lucier made the recordings that would become *Sferics:* "Off to Church Park around 10 PM. . . . Heard a faint beautiful whistler around 11:30, so started recording immediately. Recorded five 45-minute tapes, until about 6 AM. I was so cold I wrapped two blankets around me, drank coffee, and listened."[29] Knowing how atmospherics and whistlers were generated already lent spatial dimensions to the little sounds that Lucier heard under the expanse of the sky. Lucier also "discovered that the sounds that pop out of the ionosphere are not the same [in any two spots] ten feet apart on the earth, so you get beautiful stereo images with two antennas."[30]

He also discovered that there was no such thing as a pristine electromag-netic wilderness. One night he picked up "Scandinavian-sounding speaking plus a mysterious sinusoidal melody."[31] There is a soft spot in the heart of the Anglo-American ear for Swedish because its sounds like English played backward, and the soft spot in Lucier's first thought was to play the record-ing back to his young daughter. There was another sound that was more troublesome: "Throughout the night I was getting beautiful tweeks and bonks and an occasional whistler, but the Omega signals were omnipresent. They were really irritating."[32] Elsewhere he commented, "As I listened to these lovely sounds, I noticed the presence of extremely high-pitched tones, up around 10 to 12 thousand cycles per second, which recurred with unnat-ural regularity. I later learned that these were signals from the Omega Navigation System, used for position fixing and guidance of aircraft and ships throughout the world."[33]

The Omega system came from a long line of military navigation sys-tems used during the twentieth century for naval and aeronautical location and guidance. Developed by the US Navy Electronics Laboratory and Naval Research Laboratory in the late 1960s, when Lucier was listening, it trans-mitted at three frequencies (10.2, 11.33, and 13.6 kHz) with enough power to be received up to six thousand nautical miles away: "The intent is to embrace the earth in a permanent network of identifiable grid lines, part or all of which can be measured in any of several ways at the pleasure of the

navigator."[34] The Omega system was eventually superseded by the GPS and Galileo satellite navigation systems.

To add insult to the injury of interrupting electromagnetic nature, the sounds insinuated themselves as an earworm—geopolitics interfering with geophysics inside Lucier's head: "Over the years these tones have haunted me. I have often found myself humming or whistling some version of them as I went about my daily tasks. Over time, I gradually compressed them into a single 4-note melodic cell, consisting of two descending whole tones (B, A, B-flat, A-flat), outlining a minor third. I often thought of using them in a musical work."[35]

He took the opportunity when he was commissioned by the Hessischer Rundfunk in Frankfurt to compose a piece for the renowned Arditti Quartet, which he titled *Navigations for Strings* (1991).[36] Although global navigation transmissions do not normally inspire string quartet compositions, Lucier was skillful in transposing the spatial concerns from earth magnitude to the scales of a performance space.

In *Navigations for Strings* Lucier used beating patterns based on the four notes he had derived from the Omega transmissions. Beating is created when two pitches are close enough to interfere with one another; and depending on the proximity of pitches, interference will create different rhythmic rates and compel acoustical and psychoacoustic effects as the sound occupies and moves (navigates) through the performance space.[37] When he first started using this technique in 1973, it was a means of generating "simple to complex and still to moving sound geographies with sine waves." The pitches become so close and increasingly complex that the musicians must tune into them according to the speed of the pulse of the beating, rather than by ear. Over the course of *Navigations for Strings,* the "sound melts into the environment," and the sound mass "disintegrates . . . into the heating system or air conditioning."[38] Filmmakers and sound engineers have a name for that almost imperceptible room sound produced by heating, air conditioning, ventilation, fluorescent lights, and other continuous sounds and resonances. They call it *atmos,* short for atmosphere. As Calvin Graf explained in his book, with Omega transmitters located around the world one benefit for the amateur was the possibility of hearing "several of the transmissions beating against each other."[39]

9 From Brainwaves to Outer Space

John Cage and Karl Jansky

Alvin Lucier sounded the bounds of a natural electromagnetic spatiality, from brainwaves to natural radio reaching out many earth radii from the earth's surface. Because *Music for Solo Performer* and *Whistlers* informed Lucier's early reputation as a composer, this energetic framework was not lost on other people. When *Whistlers* was featured at the *First Festival of Live Electronic Music* in 1967, the organizer, Tony Gnazzo at Mills College, remembered that Lucier's reputation for "brainwaves and outer space" preceded him to the West Coast, and Charles Shere confirmed this when he summed up Lucier's music as "incorporating such organic and cosmic sonic activity as brain waves and ionosphere electrical disturbances."[1]

In the previous year, John Cage acknowledged and acted upon Lucier's ideas in his *Variations VII* (1966), composed for the famous *9 Evenings: Theatre and Engineering* series at the Armory in New York. In a letter to David Tudor in which he workshopped his ideas for *Variations VII*, Cage wrote that, among the many sound sources, there could be sources "from outer space if possible (like Lucier) (we can give credit to Lucier for brain and outer space)."[2]

Cage's general aesthetic had been bolstered by auditory interoception, by the two sounds inside his body he heard during his visit to an anechoic chamber at Harvard. One of the two sounds, he was told, was produced by his nervous system in operation. This was a private audition inside a sequestered scientific space, whereas the brainwaves in *Variations VII* were monitored in a performance for public consumption. Similarly, he had used star charts as an inscriptive device in *Atlas Eclipticalis* (1962) and planned to do so in *Atlas Borealis* (unrealized, 1966), but in *Variations VII* he sought out actual sounds of radio astronomy.[3] It is not clear whether he knew that the sounds could have been the noisy residue of the Big Bang.

If *4'33"* was Cage's "silent piece," then *Variations VII* was his "transmission piece." The overriding feature of *Variations VII* was that sounds were "live" and invoked from immediate to increasingly distant sources. The immediate internal sounds of both bodies (brainwaves) and electrically animated objects (appliances, a blender or fan with contact microphone attached, or oscillators, all fed from distant electrical generation) were joined by distant sounds from wired (telephone) and wireless communications technologies, and through the detection of cosmic rays from deep space by Geiger counters. All without leaving the building.

Transmission can be a two-way street. Following Cage's predilection for audition over utterance, for the centripetal forces of listening over the centrifugal broadcasts of expression, it is more accurate to call *Variations VII* his "reception piece." His idea that all that is necessary for music to exist depends on how one's attention is directed, that is, how one tunes in, is also evident in *Variations VII*. In his notes to the composition, the transduction involved in tuning in becomes a form of fishing, where centripetal musical listening hauls in all sound: "catching sounds from air as though with nets, not throwing out however the unlistenable ones . . . making audible what is otherwise silence therefore no interposition of intention. Just facilitating reception."[4]

Cage characterized *Variations VII* as involving transmission/transformation, with all sounds received or generated live from telephone lines, radios, contact microphones on small appliances, broken light beams of photoelectrical devices, oscillators, and so on, and with no recordings used.[5] The signal and sound sources were to be transformed but not manipulated: feedback and tuning in to "single static frequencies" were okay but nothing "quasi-melodic." The radios were to be tuned in to both long-wave and short-wave frequencies (including the underutilized FM band at the time) associated with long-distance reception, reducing the likelihood of melodies and quasi melodies surfacing from the commercial band.[6]

Around the time that Cage made plans for *Variations VII*, he participated in an on-air conversation with the composer Morton Feldman on the community radio station in New York, WBAI (July 9, 1966). They began talking about radio on radio. Feldman talked about going to the beach only to have his experience intruded upon by rock music blaring from transistor radios. Acknowledging the ailment, Cage recommended a remedy. He had adjusted "to that problem of the radio in the environment, very much as the primitive people adjusted to the animals which frightened them and which probably, as you say, were intrusions. They drew pictures of them on their caves. And so I simply made a piece using radios. Now, whenever I

hear radios—even a single one, not just twelve at a time, as you must have heard on the beach, at least—I think, 'Well, they're just playing my piece.'"[7]

The idea of musicalizing the environment did not make Feldman feel any better:

> FELDMAN: ... I can't conceive of some brat turning on a transistor radio in my face and [my] say[ing], "Ah! The environment!"
>
> CAGE: But all that radio is, Morty, is making available to your ears what was already in the air and available to your ears but you couldn't hear it. In other words, all it is, is making audible something which you're already in. You are bathed in radio waves—TV, broadcasts, probably telepathic messages, from other minds deep in thought (both laugh). ... And this radio simply makes audible something that you thought was inaudible.[8]

Cage's tolerance was argumentative. The *beach*, already a highly mediated stand-in environment for nature, meant being bathed not only in sunlight but also in the industrialized electromagnetic waves of the United States radio spectrum that were transduced by transistor radios, a frequency range Cage avoided in *Variations VII* by specifying longer and shorter waves.

In the various categories of sound for *Variations VII*, brainwave sounds were included among internal body sounds, along with the heartbeat, nervous system, breathing, and voice. Since all other internal bodily sounds would be of an acoustical origin, the default association of brainwave detection with the nervous system alludes to the high sound Cage heard in the anechoic chamber. And, of course, Cage was the person who urged Lucier to follow through with *Music for Solo Performer* and assisted him in the first performance at the Rose Art Museum. Lucier's composition was renowned within the ranks of experimental music and, as we have seen, Cage would not be the only one to take recourse to brainwaves.

Outer space was a different story. The idea and reality of live sounds from outer space were two different things. It is unclear how Cage heard of Lucier's idea for *Whistlers*, since he was mostly out of the country during the period.[9] It may have been second-hand, since Cage equated the sounds with "outer space" whereas Lucier understood the sounds to be terrestrial rather than extraterrestrial, even if the signal could reach into the near outer space of the magnetosphere. The salient point, however, was that in 1966 Lucier was still using recordings of whistlers and atmospherics and Cage wanted to avoid the use of recordings in his composition.

Cage asked Bell Labs engineer Billy Klüver for help in securing live sounds from outer space. After all, Bell Labs was assisting with *9 Evenings*;

radio astronomy had been discovered there; and the lab's most important discovery, empirical evidence for the Big Bang, had been made just a couple years earlier in 1964. However, as Klüver recounted, "[Cage] wanted to pick up the sounds from outer space. I asked a colleague, Rudy Kompfner, what they heard over the antennas at Bell Labs at Holmdel. He said, 'It sounds like "sssssss."' Cage said, 'That's marvelous. I want it.' But I was not able to convince Rudy that it was any better to use the Holmdel antenna to have white noise from space than just placing a noise generator at the Armory."[10] Although Bell had provided *9 Evenings* with a number of telephone lines for live feeds from around the city, a line to carry a radio astronomical feed from Holmdel, New Jersey, about fifty miles southwest of the city, was unfortunately not forthcoming.

Six years earlier, Kompfner had been in charge of constructing the Holmdel Horn Antenna; part of its function was to pick up the weak signal reflected off the passive communications satellite *Echo*, a huge hundred-foot-diameter reflective balloon that was launched into orbit on August 12, 1960. John Pierce, the director of research at Bell Labs described it as "a horn reflector antenna, which would receive things from the sky but wouldn't receive noise from the earth.... It was made that way because we got very little power from *Echo*—only a billionth of a billionth of a watt, and we had to use that to send a voice signal or a fac-simile signal."[11]

Four years later the same antenna would be used by Arno Penzias and Robert Wilson in their discovery of the cosmic microwave background radiation. At first, Penzias and Wilson thought that the persistent noise they heard was pigeon shit, but when that variable was removed from the antenna the noise left over from the Big Bang was confirmed. Therefore, when Kompfner refused to cooperate with Klüver and Cage on *Variations VII* to provide a live feed from Holmdel to the Armory in New York City, he did not understand that a "sssssss" is not just any "sssssss." Cage knew that noise from a noise generator was not sound from outer space, nor any other form of transmission. Sound of pigeon shit or the birth of the universe: both no doubt would have been fine.

Kompfner was probably not aware that thirty-three years earlier Bell Labs had piped the first sounds from outer space to New York for a live broadcast on national radio. They were heard "courtesy of the Long Lines department of the American Telephone and Telegraph Company" from a Bell Labs antenna located at Holmdel, no less. Moreover, the host of the show, rather than being dismissive about the noise, encouraged his thousands of listeners to listen to *the static within the static.*

Monday night May 15, 1933, at 8:30 P.M. the *Radio Magic* show broadcast its episode "Hearing the Radio of the Stars." It aired on WJZ and the NBC Blue Network from New York City following *Today's News with Lowell Thomas, Amos 'n' Andy,* a couple of songs, and one-half hour of the Marx Brothers, Groucho and Chico. The host, Orestes H. Caldwell, was knowledgeable and clearly explained the astronomy, radio, and electronics involved. As editor of the industry magazine *Electronics,* he was one of the people responsible for moving the word *electronics* into vernacular usage.

The guest of the show was Bell Labs engineer Karl Jansky, who ten days earlier had been featured on the front page of the *New York Times:* "New Radio Waves Traced to Centre of the Milky Way; Mysterious Static, Reported by K.G. Jansky, Held to Differ from Cosmic Ray." The story left the requisite dismissal of alien communication to the end of the article.[12] Jansky's detection of extraterrestrial radio marked the beginning of radio astronomy as a science. Schooled in direction-finding antennas that had underscored studies of the ionosphere in the 1920s, Jansky focused his research on locating a persistent high-frequency noise. Making sure to eliminate the noise of his "singing amplifier," he patiently recorded data over many months, reducing other variables to three types of noise: the crashing static of local thunderstorms, "very steady weak static" from distant thunderstorms, and "a very steady hiss type static the origin of which is not yet known."[13]

Caldwell, the WJZ host, began by putting Jansky's accomplishment in the context of long-distance reception. Previous programs in the series had "taken part in some long-distance broadcast pick-ups—from across the continent, from Europe and from Australia. But tonight we plan to have a broadcast pick-up from further off than any of those, a pick-up that will break all records for long-distance!" And just moments before introducing Jansky, Caldwell opened the national radio lines to the sound of the center of the galaxy:

> In a moment, I want you to hear for yourself this radio hiss from the depths of the universe. We are going to let you listen in on Mr. Jansky's sensitive radio receiver there at Holmdel, N.J., and you will hear the noise of static. Part of this static you will hear is due to atmospheric causes right here on earth, like any static. But another part of what you will hear is that extra static which comes from the depths of space itself and is continuously changing in position around the horizon, as is detected and evidenced by thousands of records kept at the receiving station.
>
> Now, through the courtesy of the Long Lines department of the American Telephone and Telegraph Company, I will let you listen on

the sensitive receiving set at Holmdel, 50 miles southwest of New York City. Mixed in with the static you will now hear, will be the hiss of radio from the start.

HISS (10 seconds)

Please understand that a large part of this sound you just heard is due to earthly static, but mixed with it, is the slight but regularly changing static hiss which Mr. Jansky discovered as coming from a definite point in the sky of stars. Let's hear this radio hum from the depths of the universe once again.

HISS (10 seconds)[14]

Caldwell's appeal to a national audience to listen to *the static within the static*, no doubt unprecedented, was in keeping with the occasion. The disjunctive magnitudes behind long distances had been normalized by astronomy; suns many times more powerful than our own had been reduced to stars twinkling in the night sky. But somewhere in the static was a static sound "which astronomers tell us is at least 30,000 light years from the present position of earth and solar system," which meant that the magnitude of the source was not measured against the sun, but against a terrestrial power of a national radio broadcaster: "The power necessary to transit to earth even such a radio hiss as the stellar part of that hiss we have just heard, would have to be pretty prodigious. It would take a radio station many millions of millions of millions of times as powerful as any we have on earth today."

And, just before saying good-bye to his guest, Caldwell reached once more to the Holmdel line: "Perhaps the radio audience would like to tune in on Sagittarius again. He we are. *HISS* (10 seconds)." As an advocate for the radio industry, Caldwell then encouraged everyone to attend to regular antenna maintenance, especially after rough winter conditions, saying that "if you suffer from electrical interference a shielded lead-in may be of help in reducing man-made static, although it will be of little aid in eliminating natural static."

Unwilling to simulate the sounds of a radio telescope with a noise generator, Cage opted for the detection of cosmic rays from outer space using a Geiger counter. Although in his notes under the category of "cosmic, gamma" he calls for two Geiger counters, looking at film footage of the performance at *9 Evenings* it appears that only one was used and that it may have been a Technical Associates F-6 model, a rather large device that was used for uranium prospecting.[15]

The "cosmic" of cosmic rays already had an avant-garde music pedigree. While writing about Edgar Varèse's composition *Ionisation*, the novelist

Henry Miller appealed to the writings of modernist composer and occult magus Dane Rudhyar: "Every tone . . . is a molecule of music, and as such can be dissociated into component sonal atoms and electrons, which ultimately may be shown to be but waves of the all-pervading *sonal energy* irradiating throughout the universe, like the recently discovered cosmic rays which Dr. Millikan calls interestingly enough, 'the *birth-cries* of the simple elements: helium, oxygen, silicon, iron.'"[16]

Of course, in 1966 the raspy clicking of a Geiger counter was as much a click track of the Cold War as the beeping pulse of *Sputnik*. It was more associated with terrestrial radiation and a nuclear threat that fell from the sky rather than extraterrestrial transmissions. As a sensor of high-energy electromagnetic activity, it was positioned between nature and geopolitics— if one listened to the clicks within the clicks—even as the transmissions in *Variations VII* were tuned below and above the overtones of commerce.

10 For More New Signals

Modern telecommunications began with message devices that resonated with and received signals from the larger energetic environment. It was with these devices and within these environments that the aesthetic trade in the Aelectrosonic began, when earth currents and natural radio were heard on the telephone, a device used for commune as well as communication. Resonance and reception rendered wired devices wireless and sensitive in other ways to the environment.

Electromagnetism in the arts began to make its presence audible in the 1920s and 1930s with two classes of modern devices, the wireless (radio) and electronic music instruments, but attunements toward natural environments beyond the social traffic in communication or the local instrumentalism of the device were rare. Not until the 1960s, after the air had been primed with decades of radio broadcasting, with threatening atmospheres of gamma, broadcast television, global telemetry of satellites, and with the mobility of transistor radios, did electromagnetism begin to be conceived *as nature*, as artistic raw material in an environment of signals.

Also in the 1960s, the aesthetic drive in avant-garde, electronic, and experimental music for sonic plenitude—*for more new sounds*, in John Cage's words—had become widespread and accelerated, aided by a proliferation of musical, media, computational, and scientific devices. When individuals looked past the surface of these devices to the currents running through them, or put them in-circuit with their own bodies or with larger environmental sources, the result was a drive *for more new signals*. The trade of acoustics and electromagnetism had existed as a source for sounds and more new sounds, to be sure, but now it belonged to a budding parallel plenitude of electromagnetism in a larger energetic cosmos.

Sound and signal combined meant that electronic music became a means by which nature was perceived. This is counterintuitive: electronic music was and still is channeled through a nearly exclusive sign of technology that by its intrinsic nature is supposed to be extrinsic to nature. Nevertheless, at the time, it occurred within what the composer Gordon Mumma called "the *astro-bio-geo-physical application* in live-electronic music," due in part to the variability and shared audiophonics of scientific instruments, musical technology, and consumer electronics.[1]

Of course, not all electronic music was equally disposed. Elsewhere Mumma distinguished between those electronic musicians who "impose the formalities of non-electronic and European concert traditions" and those who "develop their art from their experiences with electronics and the diversity of the culture in which they live. One result is that music can become an organic part of its environment."[2] It was the latter form of electronic music that was poised to tune in to electromagnetic nature at local, global, and astronomical scales.

Therefore, from the noises of nineteenth-century telecommunications devices responsive to their energetic environments, through avant-garde openness to more new sounds from lived environs rather than musical traditions, the closed circuits of electronic music were opened to a cosmos of more new signals.

. . .

The sky is only an antenna with a wide range.

André Breton

The classical electronic music of the 1920s and 1930s was steeped in radiophonic technologies, but radio was largely understood in terms of an accelerated diffusion of forms of older cultural practices, with the logic of distance leading to tropes of earth magnitude.[3] At the time, the geospatial imagination in literature and the arts prompted by wirelessness was geopolitical rather than geophysical; it followed the social force fields of imperial communications networks, proletarian desires, and peripatetic nationalisms. Edgard Varèse proposed a series of works that would invoke "voices in the sky, as though magic, invisible hands were turning on and off the knobs of fantastic radios, filling all space, criss-crossing, overlapping, penetrating each other, splitting up, superimposing, repulsing each other, colliding, crashing. Phrases, slogans, utterances, chants, proclamations. China, Russia, Spain, the Fascist states and the opposing Democracies all breaking their paralyzing crusts."[4]

Grand scales were common within the Russian, Ukrainian, and Soviet avant-garde, given the continental breadth and doctrine of proletarian internationalism. Vladimir Mayakovsky tried to persuade the Eiffel Tower to direct its long-distance transmissions away from bourgeois priorities, while the literary theorist Viktor Shklovskii described how the revolutionary form of Tatlin's Tower, also known as the Monument to the Third International, connected earth with sky: "A cylinder below takes a year to make a turn; a pyramid above turns once a month, and a sphere makes a full turn every day. The waves from the radio station situated on the very top of the spiral perpetuate the monument in the air."[5]

In his poem "The Fifth International" (1922), the Soviet poet Mayakovsky telescoped a microphonic imagination onto the stage of global sounds, where he heard both the miniscule and macroscopic, providing us with yet more sounds of a fly's footsteps in the tradition of D.E. Hughes. He could do this because: "I . . . I . . . I . . . I'm the radio, I'm the tower . . . ," with electromagnetic access everywhere at once.[6]

> . . . it's not just that my ears can pick out a
> fly's flight—
> I can hear
> the pulsebeat on every little fly paw . . .
> But what's a fly—a fly is nothing.
> I can hear,
> because I've got a kind of telescopic ear,
> how the millstones of the world
> produce a deep major note.[7]

For the poet Velimir Khlebnikov, writing in 1919, there were sidereal connections with history and politics. The foreshortened length of starlight was a pinpoint cipher, a *signal* containing life, history, and wisdom: "Let us suppose that a wave of light is inhabited by intelligent beings who possess their own government, their own laws, even their own prophets."[8] He then laid the trajectory of the starlight laterally upon the earth in a signal that cut the political puppetry of telegraph and telephone lines: "And is not the purpose of division to dismantle the wires of states and governments that intervene between the eternal stars and the ears of mankind? Let the power of the stars be wireless."[9]

In a more rarified atmosphere yet nevertheless canonical is a pun-fest passage from James Joyce's *Finnegans Wake* (1939) that refers to a Bellini-Tosi direction-finding antenna. This D/F antenna, named after two engineers and developed by the Marconi Wireless Telegraph Company, was widely used as a means of location and navigation, much like GPS is

used today. Joyce makes a characteristically cryptic and elaborate pun on Bellini-Tosi to compare the navigational purposes of the antenna with the migrations of Italians to England. With the addition of one letter *t* he conflates the engineers who invented the D/F antenna with two Italian composers of bel canto and saccharine songs, Vincenzo Bellini and Francesco Paolo Tosi. The latter, like Marconi himself, achieved fame and fortune after navigating from Italy to England, where he was at the service of the king: "supershielded um-brella antennas for distance getting and connected by the magnetic links of a Bellini-Tosi coupling system with a vitaltone speaker, capable of capturing skybuddies, harbour craft emittences, key clickings, vaticum cleaners, due to woman formed mobile or man made static and bawling the whowle hamshack and wobble down in an eliminium sounds pound so as to serve him up a mele-goturny marygoraumd, eclectrically filtered for allirish earths and ohmes."[10] Many eclectic noises, interferences, resistances, and scattering references are induced by this passage. They finally navigate in peripatetic electromagnetism from signals aboard a ship (harbour craft emittences [HCE]) to other eclectic and electric transmissions, to reception by the Earwicker radio grounded (earths) in Irish hearts, hearths and homes (ohmes).

In 1933, the Italian Futurists F. T. Marinetti and Pino Masnata wrote the manifesto *La Radia,* in which they proposed that a new form of radio art could involve "the utilization of interference between stations and of the birth and evanescence of the sounds."[11] Like Joyce, this was an unusual passage to the extent that it was fairly well informed by radio science and engineering. In an extended gloss of the manifesto, Masnata demonstrated a lay knowledge of physics and expanded on the artistic possibilities for radio interference and fading:

> Every radio listener knows of two phenomena typical of radio reception:
>
> > a) interference caused by another station which whistles throughout the music or competes with it;
> > b) fading, which in Italian we call *evanescence,* that is, the mysterious appearance and disappearance of sounds due, so it appears, to a layer of ionized air that envelops the earth and reflects or refracts the electromagnetic waves (the Kennelly-Heaviside layer).
>
> While these phenomena are normally bothersome, because they are accidental, we believe they could be used artistically.[12]

This may be the earliest statement to entertain the possibility of an art interacting with the ionosphere, in contrast to content-oriented radio art in the tradition of Hörspiel.

It does, however, align with sentiment that at the time was common among a number of artists and composers who in their youth listened to radio interference and the sounds of the device by tuning between stations. As the Polish poet and artist Stefan Themerson reminisced, "When I was 14 (in 1924) I built myself a wireless-set. . . . What fascinated me more than the fact of hearing a girl's singing voice coming to my earphones from such strange places as Hilversum, was the *noise*, to me the Noise of the Celestial Spheres, and the divine interference-whistling when tuning. It became an instrument for producing new, hitherto unheard sounds, which at the time no person would have thought had anything to do with 'music.'"[13]

The American experimental composer and electronic music pioneer Pauline Oliveros had a similar story: "Sometime during the mid-1930s I used to listen to my grandfather's crystal radio over earphones. I loved the crackling static. . . . I used to spend a lot of time tuning my father's radio, especially to the whistles and white noise between the stations." In a trenchant statement that goes far beyond artistically celebrating a productive failure mode, she concludes, "I loved all the negative operant phenomena of systems."[14]

· · ·

The idea of a plenitude of sounds was an influential fixture in the history of modernist, avant-garde, experimental music and the arts of sound during the twentieth century.[15] Sonic plenitude was constructed in relation to constrained and expanded notions of what qualified as musical sound; it was either all the sounds in the world, including the musical sounds, or all the other sounds in the world. A plenitude could be rhetorically summoned in implicit or explicit ways, be invoked through techniques of listening and direction of attention, be alluded to formally in practice (the glissando was understood as scanning the plenitude of pitches actually existing in the world), or be reproduced through allusion, imitation or, most notably, technological means.

Over the course of the century, a third category of sonic plenitude grew alongside existing sounds and musical sounds: the generation of hitherto nonexistent sounds. This process belonged most notably to the technological area of sound synthesis. The generation of new sounds promised to bolster sonic plenitude, seemingly preventing it from being exhausted; however, sound synthesis was used mainly to imitate existing musical sounds, could only aspire to generating the world of other sounds, and proved not to be as fecund as originally imagined.

Unanticipated in these early formulations of modernist profusion, musical expansionism, and quotidian wealth were rich fields and waves on the other

side of the transductive bridge to signals. These signals could not be reduced to information, as prefigured in the functional role of musical notation, nor merely serve as information running through technological devices; they belonged to an energetic state that already existed in spheres of signal plenitude, in naturally occurring and anthropic ways. Robert Millikan's cosmic rays and extraterrestrial signals located by Karl Jansky were still exotic items in the 1930s, and the technological march of progress was shielding itself from the terrestrial interferences of natural radio.

The first heyday of electronic music was closely associated with radio technology devices as local means for generating sound rather than as devices for transmission. Metaphysical and physical environments were most often supplanted by an ether informed by occult practices or an older period of physics. Nevertheless, it was a radio engineer, a prominent one at that, who was able to state outright that electrical music was nature, even if he alluded mainly to electrostatics. In a 1937 issue of *Modern Music*, Alfred Norton Goldsmith, one of the founders of the Institute of Radio Engineers, claimed that electrically produced music partakes in *nature* as surely as the mechanical/acoustical instruments accepted within a symphony orchestra, a dance hall, or lounge room:

> There are some ancient prejudices to shatter before electric musical instruments and the music produced on them can be generally accepted by the musical world. Tradition dies hard, and there is something intangible and impersonal to our generation about electricity as compared with the supposed intimacy of mechanical instruments. From time immemorial we have accepted the "naturalness" of music blown on a pipe or evoked from a bowed or plucked string. But electrical forces are just as natural as mechanical forces. The sparks from cat's fur or the shuffled foot in dry weather are at one end of a vast gamut which ends in the flash of lightning. And who shall say that the lightning blaze followed by the deep reverberation of thunder is not a natural music of the storm? We can and should first divorce ourselves from the thought and prejudice that electrically-produced music is less natural or further from normal human needs and expression than music produced by mechanical means.[16]

Goldsmith categorized electric musical instruments, "emino" in his abbreviation, and enthused over their theoretical ability to produce any tone, overtone, attack, formant, or timbre "capable of production by vibrations of the air," including those in an indefinite extension of pitch both downward and upward. Inhibiting this "rich realm for musical exploration" were the "human factors" of scientists and musicians being able to productively interact with one another.[17]

John Cage codified an earlier avant-garde drive for sonic plenitude by incorporating percussion, musical noise, the sounds of technological devices, environmental sounds, and whatever could be heard as music. His sonic plenitude was a mechanical/acoustical one focused on devices as discrete sources of sound (even if they were radiophonic, as in *Imaginary Landscape No. 4*) rather than as transductive junctures for different states of energy. Not until his composition *Variations VII* (as discussed in the previous chapter) would he invoke an environment of signal plenitude that, along with other composers and artists working in the 1960s, acknowledges an electromagnetic nature. He associated an expanding presence of music with earlier notions of small sounds, further revealed through microphonic means, that met their limit in (mechanical) vibrations at an atomic level.

Like the budding composers and poets from the 1930s just mentioned, by 1940 Cage included "static between the stations" as one of the sounds he wanted "to capture and control" for use in *the future of music.*[18] Cage was unhappy about the way that electronic music instruments at that time were used to imitate existing instruments and, thus, to reproduce the past; instead, any and all means should be used to expand sonic possibilities for an "all-sound music of the future."[19]

In "For More New Sounds" (1942), Cage sought engineering evidence of sonic plenitude by citing research on sound synthesis associated with Bell Telephone Laboratories. The telephone, as we have seen, has a special place in the play between sound and signal. Thomas Watson listened to sounds of natural radio in the telephone not dissimilar to certain electronic music sounds, and in 1899 an electrical engineer proposed that *electrical music* could be produced "by the simultaneous action upon a loud-speaking telephone of several currents of proper pitch and waveform synthesized in the line-wire," which will "inevitably influence, to a marked degree, musical ideas and philosophy."[20] If this was a reference to Thaddeus Cahill's designs for the telharmonium from the 1890s, which would eventually transmit music over telephone lines, much as Elisha Gray, Edison, and others had done (see chapter 5), then the engineer was correct.

Cage sought inspiration and legitimacy in Vern Knudsen's paper "An Ear to the Future" (1939), which discussed the musical possibilities of extending artificial voice-production technology (Homer Dudley's vocoder) to produce musical and extramusical sounds: "a type of 'Voder' which not only can imitate or suggest the sounds of nature . . . but also can produce myriads of sounds heretofore unheard or even unimagined."[21] Invoking the Voder spoke of a desire for the voice to speak its environments during a period in Cage's career before his aesthetic strategy switched from one

founded on utterance to one founded on audition, a development parallel to his disposition toward control (expression) and relinquishing control (chance, indeterminacy).

With respect to overcoming the "human factors" between scientists and musicians that Goldsmith mentioned, Cage filtered inconvenient details in Knudsen's position to conform to his own avant-garde aesthetic. Cage did not cite the programmatic "sounds of nature, as the rolling and breaking of waves at the seaside, the roaring and splashing of waterfalls, or the murmuring of trees in the forest," in Knudsen's paper; nor did he mention that Knudsen thought these capabilities for synthesis were but a means to supply a "background of adventitious noise or 'unpitched sound'" that would accompany music. No doubt most vexing for Cage, not a fan of big German orchestral music or any means of musical manipulation, was Knudsen's statement that "modern acoustics can and should furnish the musical artist with new tone colors and new sound effects which a Wagner or even contemporary composers could utilize to enhance the beauty, interest, and emotional effects of music."[22]

While the possibility for a fundamentally new level of technical control and synthesis had been developing for some time, it reached a new level with the advent of digital signal processing. Sounding similar to the electrical engineer from 1899 musing over the possibilities of the telephone but going beyond the bounds of music, Max Mathews, the pioneering computer music engineer at Bell Labs, wrote, "All sounds have a pressure function and any sound can be produced by generating its pressure function. . . . It will be capable of producing any sound, including speech, music, and noise. A digital computer, plus a program, plus a digital-to-analog converter, plus a loudspeaker come close to meeting this capability."[23]

Mathews was well aware of the practical difficulties of synthesizing certain types of sound. He was also personally encouraging of new developments in music, even as the research requirements were indistinguishable from the need for a more convincing emulation of conventional musical instruments. His concern for both experimental and emulative approaches ran into contradictory idealizations of sonic plenitude and strict control. Experimental music was driven by the loosening of many aspects of control as a means toward plenitude, as was the case for improvisation and Cagean indeterminacy (i.e., once Cage had gone beyond his earlier desires for "capture and control").

The composer James Tenney was well placed among these conditions. He worked closely with Max Mathews and other engineers while in residence at Bell Labs from 1961 through 1964 and was the first person to compose a

sophisticated body of work using digitally synthesized sound (the way most music is presently heard). He began his residency influenced by the ideas of Edgard Varèse and finished with the ideas of John Cage. But those were not the only signals in Tenney's personal mix. He was also enthralled with the writings of the radical psychoanalyst Wilhelm Reich, known for marshaling the orgasm in the fight against fascism and describing a cosmos suffused with energy. Reich had become increasingly popular among bohemian communities in the United States, but it was another engineer at Bell Labs, Sheridan Speeth (see chapter 11), who introduced Tenney to the writings of Reich.

The year after he left Bell Labs, Tenney's attention shifted to transformative notions of a *generalized signal* and *total transducer* that, most immediately, joined technological devices with bioenergetic signals of the body. Tenney felt that modernist auditory expansionism implied its own exhaustion: that composers from Anton Webern and Edgard Varèse to John Cage had in effect achieved sonic plenitude in music. Cage, in particular, theoretically codified the impossibility for more new sounds once he proposed that any sound could be musical sound through acts of attention alone. There was "nowhere" left to go for classes of more new sounds even as, on a practical level, this opened listening to a myriad of new situations that themselves seemed inexhaustible.

The evolution of digital sound synthesis, however, transformed the ground rules by which these composers worked: "Electronic music has evolved not to create new sounds (there are none, finally), but to go beyond sound, by way of the generalized *signal*."[24] By *signal* Tenney meant several things. It was not just an atom of information; it was what moved incessantly through a determined movement from voltage differences, the base, processual constitution of all signals, and any sound through digital synthesis. There could be no more "new sounds" because movements within an acoustical event or among events formed in this technological control disrupted atomistic notions of "a sound."

Signal also had no intrinsic allegiance to sound as it moved among codes, media platforms, and sensory states. A signal otherwise meant for the production of musical sound could also be used, for instance, to control a device with a visual output. Finally, this led to experiential possibilities moving among untold energies through what Tenney called a "total transducer" that "begins to involve all of human experience, all dimensions of it."[25] Tenney wrote these words soon after composing *Metabolic Music* (1965), an interoceptive piece based on the monitoring of brainwaves and other signals of one's body and influenced by the ideas of Wilhelm Reich. The

generalized signal, therefore, ran the gamut from the close control of digital signal processing to the removal of constraints from the body in its relation to the environment.[26]

Tenney composed *Metabolic Music* a matter of weeks after (and oblivious to the existence of) Alvin Lucier's *Music for Solo Performer*—"the brainwave piece" discussed in chapter 6. Gordon Mumma, colleague of Tenney and Lucier, wrote some of the most insightful commentary on the activities of American experimental music at the time. In a survey of live electronic music, he included *bio* signals among what he called the *astro-bio-geo-physical application* in the live electronic music of sounds and signals arising from new scientific research and instrumentation: "With the development of ultra-sensitive electronic equipment during the past half century, much previously unknown astrophysical, biophysical, and geophysical activity has been detected. Geophysical activity had been experienced in the physical manifestations of tides, earthquakes, and tsunamis. But the accurate measurement of this activity, as well as the formerly undetected microseisms, gravity waves, long-period resonance, and seismic propagation characteristics of the earth, were possible only with the development of low-noise, high-gain amplification and electronic transducers."[27]

As we shall see in the following chapter, Mumma pioneered this area in the early 1960s when he incorporated seismic data from earthquakes and underground nuclear testing into his music. He believed that the world was open to a new type of music, that "there is all the wiggy area, like wave periods of the ocean, to go into."[28] For Pauline Oliveros it was "waves, any waves."[29] *Newsweek* magazine was on top of the story in mid-1967: "At Brandeis University composer Alvin Lucier has applied electrodes to the skull in order to draw music from amplified alpha rhythms in the brain. He has also tuned into those electromagnetic disturbances which scientists call 'whistlers,' 'tweeks' and 'bonks' that bounce off the ionosphere and hurry at great speeds between the poles. Sweden's Karl-Birger Blomdahl has made music from the 'birdsong' emanating from satellites and from magnetic storms caused by the sun's activities." And, after mentioning Mumma's seismological interests, the *Newsweek* article conceded that "nature is yielding some strange music these days."[30] There was a conflation of mechanical with electromagnetic waves under the rubric of science, but through science there was a reestablishment with nature. Instead of engineering tighter control, the way in which all of these waves upon waves were already in movement was best met with the experimental aesthetic that Mumma saw operating in the work of Oliveros, Lucier, and his own, where "one did not have control. One had influence."[31]

With *wiggy* waves functioning acoustically and electromagnetically at earth magnitude, sound and signal were now appearing terrestrially at a local and grand musical scale. Over the long duration of the Pythagorean music of the spheres, and after innumerable composers incarnating the cosmos in their music over the last few centuries, experimental music in the 1960s began shedding the mythical and metaphorical for the analogs and actuality amid the *astro-bio-geo-physical*. What was earlier a song of technology per se, sung in electronic music, returned to its resonances with nature that first started in nineteenth-century telecommunications.

As we have seen, Alvin Lucier went geophysical in 1966 with his composition *Whistlers* and, as we shall see, Karl-Birger Blomdahl went geophysical and heliospherical around the same time with his composition and televisual work *Altisonans*. There is a possibility that Lucier was comfortable making music of earth magnitude because his friend Gordon Mumma had been doing just that for over five years already. To understand Mumma's music, we need to peel our attention from the sky, lean down, and put an ear to ground to listen to the standing reserve of the underground, because it was not just nature yielding strange music at earth magnitude.

11 Sound of the Underground

Earthquakes, Nuclear Weaponry, and Music

In Aristotelian earth science, earthquakes were part of the weather. In his *Meteorologica* Aristotle points to the Aeolian island of Lipari, just north of Vulcano, to discuss how winds, waves, earthquakes, and volcanism relate to one another. Strong gusting seas force wind and waves against the bulwark of the shore and they have nowhere to go but underground; waves buckle the land and trapped wind is vented by volcanoes.[1] This makes total sense: during the great earthquake that hit San Francisco and Northern California on April 18, 1906, one person in Cotati, just south of Santa Rosa, looked out onto "the open level floor of the valley" and saw that "the surface of the earth waved like water. . . . Trees swayed heavily, and there was a sound as if a strong wind were coming before the earthquake began."[2] We are not meant to walk on water.

I will never forget being in an earthquake near Seattle in which the ground itself became acoustic, with swelling waves traveling down through the road, making houses I knew well bob up and down like ships on the sea.[3] "A moment destroys the illusion of a whole life," writes Alexander von Humboldt in *Cosmos*. "Our deceptive faith in the repose of nature vanishes, and we feel transported as it were into a realm of unknown destructive forces. Every sound—the faintest motion in the air—arrests our attention, and we no longer trust the ground on which we stand."[4]

During the eighteenth century, the grand scales of the earth and heavens were channeled through notions of the sublime. What would otherwise be experienced as the grandeur of the mountains or the beauty of the night sky were ratcheted into the sublime through peril, presentiment, and incomprehensibility. The Alps were sublime because their beauty was perceived by travelers perched on a treacherous trail. Sound on its own could also invoke the sublime, according to Edmund Burke, because "excessive

loudness alone is sufficient to overpower the soul, to suspend its action, and fill it with terror."[5] It is odd, therefore, that Immanuel Kant, in formulating his notion of the sublime, never made use of his own earlier writings on the Lisbon earthquake of 1755.

The audible sounds of earthquakes come from the movement of the ground and what rests on it, and from the voices of people and other animals, such as "the crocodiles of the Orinoco" that Alexander von Humboldt saw "leave the trembling bed of the river and run with loud cries in the adjacent forests."[6] In Yosemite Valley in 1872, the naturalist John Muir awoke at two in the morning "and though I had never before enjoyed a storm of this sort, the strange, wild thrilling motion and rumbling could not be mistaken, and I ran out of my cabin, near the Sentinel Rock, both glad and frightened, shouting, 'A noble earthquake!' feeling sure I was going to learn something. The shocks were so violent and varied, and succeeded one another so closely, one had to balance in walking as if on the deck of a ship among the waves."[7] Most dramatically, in the immediate aftermath of the quake,

> It was a calm moonlight night, and no sound was heard for the first minute or two save a low muffled underground rumbling and a slight rustling of the agitated trees, as if, in wrestling with the mountains, Nature were holding her breath. Then, suddenly, out of the strange silence and strange motion there came a tremendous roar. The Eagle Rock, a short distance up the valley, had given way, and I saw it falling in thousands of the great boulders I had been studying so long, pouring to the valley floor in a free curve luminous from friction, making a terribly sublime and beautiful spectacle—an arc of fire fifteen hundred feet span, as true in form and as steady as a rainbow, in the midst of the stupendous roaring rock-storm. The sound was inconceivably deep and broad and earnest, as if the whole earth, like a living creature, had at last found a voice and was calling to her sister planets. It seemed to me that if all the thunder I ever heard were condensed into one roar it would not equal this rock roar at the birth of a mountain talus. Think, then, of the roar that arose to heaven when all the thousands of ancient canon taluses throughout the length and breadth of the range were simultaneously given birth.[8]

The earth's call to her sisters would have dissipated in thin air, but under the right conditions sounds could heard many kilometers away by terrestrial inhabitants. In New Zealand, the Murchison earthquake of June 17, 1929, created "sounds in the area of greatest destruction [that were] deafening and of extreme loudness, creating as great panic as the earthquake itself. Most observers described them as tremendous subterranean explosions. At

Nelson, about 85 kilometers from Murchison, the sounds resembled the whistling and rush of wind."[9] When sounds reflect off atmospheric layers it is also possible for people at great distances to hear them, while closer to the epicenter people hear nothing.

Charles Davison, the doyen of earthquake sounds, spent much of his career cataloging and classifying how people heard earthquakes. In his 1905 book *A Study of Recent Earthquakes*, he paid particular attention to how the sounds of the Hereford earthquake in England on December 17, 1896, were heard and how they were heard at different distances. Without the benefit of contemporary sound recording technologies, the older technological forms of linguistic analogy and imitation were employed. Mapping anecdotes produced *isoacoustic* lines that were superimposed over *isoseismic* information gathered by less garrulous seismological instrumentation:

> The sound which accompanied the shock was of the same character as that heard during all great earthquakes. It is often described in such terms as a deep booming noise, a dull heavy rumble, a grating roaring noise, or a deep groan or moan; more rarely as a rustling or a loud hissing rushing sound. As a rule, it began faintly, increased gradually in strength, and then as gradually died away; and this no doubt is the reason why it sometimes appeared as if an underground train or wagon were approaching quickly, rushing beneath the observer, and then receding in the opposite direction. Occasionally, the sound was very loud, being compared to the noise of many traction-engines heavily laden passing close at hand, or to a heavy crash or peal of thunder. But its chief characteristic was its extraordinary depth, as if it were almost too low to be heard. According to one observer, it was a low rumbling sound, much lower than the lowest thunder; and another compared it to the pedal notes of a great organ, only of a deeper pitch than can be taken in by the human ear, a noise more *felt* than heard. It will be seen presently how the sound, from its very depth, was inaudible to many persons.
>
> A few observers described the sound in terms like those quoted above, but by far the larger number compared it to some more or less well-known type, and in many cases the resemblance was so close that the observer at first attributed it to the object of comparison. The descriptions, which present great varieties in detail, may be classified as follows: (1) One or several traction-engines passing, either alone or heavily laden, sometimes driven furiously past; a steam-roller passing over frozen ground or at a quicker pace than usual; heavy wagons driven over stone paving, on a hard or frosty road, in a covered way or narrow street, or over hollow ground or a bridge; express or heavy goods trains rushing through a tunnel or deep cutting, crossing a wooden bridge or iron viaduct, or a heavy train running on snow; the

grating of a vessel over rocks, or the rolling of a lawn by an extremely heavy roller; (2) a loud clap or heavy peal of thunder, sometimes dull, muffled or subdued, but most often distant thunder; (3) a moaning, roaring, or rough, strong wind; the rising of the wind, a heavy wind pressing against the house; the howling of wind in a chimney, a chimney or oil-factory on fire; (4) the tipping of a load of coal, stones, or bricks, a wall or roof falling, or the crash of a chimney through the roof; (5) the fall of a heavy weight or tree, the banging of a door, only more muffled, and the blow of a wave on the sea-shore; (6) the explosion of a boiler or cartridge of dynamite, a distant colliery explosion, distant heavy rock-blasting and the boom of a distant cannon; (7) sounds of a miscellaneous character, such as the trampling of many men or animals, an immense covey of partridges on the wing, the roar of a waterfall, the passage of a party of skaters, and the rending and settling together of huge masses of rock.[10]

By the late-1930s Davison had accumulated a massive archive of twenty thousand mostly British anecdotal accounts and had categorized their sounds:

1. Wagons, carriages, motor vehicles, steam rollers, traction engines, or trains, passing, as a rule very rapidly, on hard ground or a rough road, over a bridge or through a tunnel; the dragging of heavy boxes or furniture over the floor.

2. Thunder, a loud clap or heavy peal, but very often distant thunder.

3. Wind, a moaning, roaring, or rough strong wind; the rising of the wind, a heavy wind pressing against the house, the howling of wind in a gorge or chimney, a chimney on fire.

4. Loads of stones falling, such as the crash of a shattered chimney, the tipping of a load of coals or bricks.

5. Fall of heavy bodies, the banging of a door, the blow of a sea wave on the shore.

6. Explosions, distant blasting, the boom of a distant cannon.

7. Miscellaneous sounds, such as the trampling of many animals, an immense covey of partridges on the wing, the roar of a waterfall or the distant moaning of the sea, a low pedal note on the organ or the roll of a muffled and distant drum, the fall of heavy rain on the leaves of trees, and the rending or settling of huge masses of rock.[11]

He then correlated these types of sound to the distances at which they were heard and observed: "There is no very marked change in the percentage of references to passing vehicles, thunder, or the fall of heavy bodies. There is, however, a distinct rise outwards in the references to wind, and a decline in those to loads of stones falling and to explosions. The general result is that,

as the distance from the origin increases, the sound tends to become smoother and more monotonous."[12]

Even when they are inaudible, earthquakes and other seismic events are acoustical. What cannot be heard can be felt, as acoustical waves move through the earth and move the ground, and subaudible sounds travel unheard from one end of the earth through to another. Seismology began in a modern form in 1857 with a systematic approach to instrumentation and proposals for distributed earth observatories, while the teleseismological capability to detect events thousands of kilometers away developed from 1889, when Ernst von Rebeur-Paschwitz detected an earthquake in Tokyo on his seismometers in Potsdam and Wilhelmshaven (over 8,000 km away).[13] Seismologists had already calculated the velocity of seismic waves through different kinds of rock using controlled shocks set off by explosives, thus making it possible for Rebeur-Paschwitz to calculate the time delay involved as a vibrating Japan washed up in the middle of Europe.

These receptions at earth magnitude were not Guglielmo Marconi's s-s-s stretched 3,500 kilometers across the Atlantic Ocean in 1901, but the perturbations of seismometers in 1889. Indeed, the lines of Rebeur-Paschwitz's seismic readings were an observation reaching toward the "whole earth" long before the reverse astronomy of "earthrise" and "blue marble" photography in the 1960s.

It is impossible know whether Rebeur-Paschwitz experienced these marks aesthetically, but it is not impossible to do so. They involve the same foreshortening poetics of force, distance, and residual medium that Alvin Lucier found in whistlers. But instead of a lightning strike, there was an initial seismic shock; instead of electromagnetic signals traveling several earth radii into the magnetosphere and back to another hemisphere, the seismic waves traveled halfway across the earth; and instead of being propagated through a diaphanous density of magneto-ionic flux lines, the waves traveled through rock. Both whistlers and seismic waves originated with monumental energy and resulted in small, discrete signals: pendular scratchings or glissandi. (This will be explored further in chapter 12, on long sounds and transperception.)

The sublime certainly returns when people hear seismological signals in sound. As Harold Allen recalls,

> When I was a Senior Scientist on the staff of the Space Sciences Division of the Jet Propulsion Lab of the California Institute of Technology at Pasadena, California, Dr. Charles Richter, creator of the method for classifying earthquake intensities called the Richter Scale, treated me with a play back of a tape recording of earthquakes that he

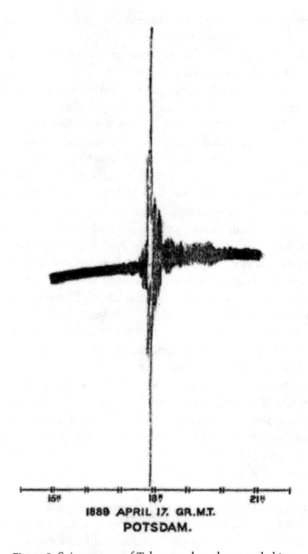

Figure 8. Seismogram of Tokyo earthquake recorded in Potsdam by Ernst von Rebeur-Paschwitz, 1889. From Ernst von Rebeur-Paschwitz, "The Earthquake of Tokio, April 18, 1889," *Nature* 40, no. 1030 (July 25, 1889): 294–95.

had made. First he played it at normal speed. The normal speed play back was muffled, dull, and not interesting. Then he played it at 20× [twenty times faster]. It was fantastic! I will never forget it![14]

Such effusiveness is not limited to scientists and engineers; the eminent media theorist Friedrich Kittler too was moved by the uncanny property of seismic sounds in the laboratory:

> Take an earthquake like the one in Kobe with thousands of casualties, seismographically record its inaudible slow vibrations, replay the signals of the entire horrific day in 10 seconds—and a sound will emerge. In the case of earthquakes that, like those in the Pacific, result from the clash of two tectonic plates, the sound will resemble a high-pitched slap, in the case of those that, like those in the Atlantic, are the result of the drifting apart of two continental plates, it will, conversely, sound like a soft sigh. Thus, the spectrum, that is, a frequency composition, gives the violent events timbre or quality: America becomes Asia. A short time ago I was privileged to hear the timbre of such quakes and I will not forget it for the rest of my life.[15]

Aesthetics are prepossessed in the device, to be sure, with intoxicating spatial effects that Kittler had once revered in the stereo techniques in 1960s and 1970s album rock. However, instead of the spiral torque of a Pink Floyd LP reanimating space across a pair of home hi-fi loudspeakers, here was time compression that played back the spatial sounds of the Great Hanshin earthquake of January 17, 1995, across a transit prepossessed by the seismic real of atomic weaponry a half century earlier.[16]

Audiophiles had listened to sounds from the underground since the early 1950s, and before that America and Asia had decompressed sound and seismology in atomic warfare outside the laboratory. Modern seismologists had used controlled explosions since the beginning of their craft to calculate travel times in their own vicinity, but long-distance detection remained reliant on natural geophysical events. All that changed with the invention of a new seismological instrument: the atomic bomb. As later reported, "Early in the morning of July 14, 1945, a brilliant flash of light over a New Mexico desert ushered in the Atomic Age. When the occasion was publicly announced several weeks later, seismologists realized that at last a powerful tool was at hand for exploring the deep interior of the earth; an energy source of the magnitude of earthquakes having precisely known coordinates in time and place."[17] The quickness with which seismologists welcomed atomic weaponry as instrumentation into their experiments was outstripped only by those who used entire cities as scientific test sites in the first place.

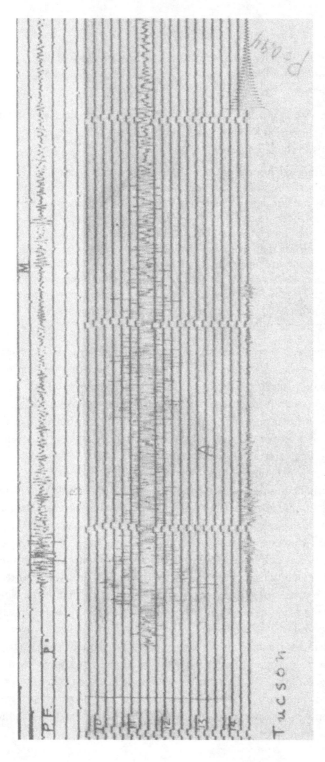

Figure 9. Seismograms of the Trinity atomic bomb test recorded at Pierce Ferry (740 km away) and Tucson (437 km away), Arizona. From Dean S. Carder and Leslie F. Bailey, "Seismic Wave Travel Times from Nuclear Explosions," *Bulletin of the Seismological Society of America* 48 (October 1958): 378.

The first atomic bomb was exploded at the Trinity test site near Alamogordo, New Mexico, on July 16, 1945. Seismographic and atmospheric instruments detected the test from ten distant locations (from 437 to 1,136 km away), measuring the ground waves and airwaves produced by the explosion.[18] The seismic measurements were compared with earlier measurements of quakes traveling through different layers of Southern California, whereas the measurements of the atmospheric sound waves were calculated using historical data from, no less, Krakatoa.

William Laurence, science writer for the *New York Times*, recorded the sound on the ground at Trinity journalistically, delaying its release until after the atomic bombing of Japan. He was given a very high-level security clearance and was on the payroll of the US Department of War as a propagandist. His reporting was positioned under the sign of *gamma* at the beginning of the atomic age, or rather, at Genesis on day one at ground zero. The occasion itself was apparently not self-sufficient enough to report objectively, since it called forth enough of a breathless mix of biblical fanaticism and high-modernist literature to secure him a Pulitzer Prize.

The nighttime Trinity test emitted "a light not of this world, the light of many suns in one. . . . One felt as though one were present at the moment of creation when God said: 'Let there be light.'"[19]

> The roar echoed and reverberated from the distant hills and the Sierra Oscurro range near by, sounding as though it came from some supramundane source as well as from the bowels of the earth. The hills said yes and the mountains chimed in yes. It was as if the earth had spoken and the suddenly iridescent clouds and sky had joined in one affirmative answer. Atomic energy—yes. It was like the grand finale of a mighty symphony of the elements, fascinating and terrifying, uplifting and crushing, ominous, devastating, full of great promise and great forebodings.[20]

The reference to echoing among the hills derives from Psalm 98, where "all the earth" is asked to "make a joyful noise unto the Lord . . . make a loud noise, and rejoice, and sing praise. . . . Let the sea roar, and the fullness thereof: the world, and they that dwell therein. Let the floods clap *their* hands: let the hills be joyful together." Laurence elevated the hills to an erotic plane by echoing the words of Molly Bloom's soliloquy: "first I put my arms around him yes and drew him down to me so he could feel my breasts all perfume yes and his heart was going like mad and yes I said yes I will Yes."[21] Just over a decade earlier James Joyce's novel was considered pornographic; now it had joined the Lord in the first atomic orgasm.

Laurence longed to repeat his *petite mort* with mass civilian death at Hiroshima but arrived too late at the Micronesian island of Tinian, departure point for the atomic bombing missions over Japan. He was onboard one of the bombers on the mission to Nagasaki: *The Great Artiste*. The bomber should have a place in discussions of art and science. It was named for the putative sexual prowess of its commander and would be emblazoned with the nose art of a Latin lover in the wake of the Zoot Suit Riots in Los Angeles, another moment from the war in the Pacific. The bomber's mission was to drop radio-transmitting instrument canisters on parachutes over Hiroshima and Nagasaki to measure the blasts. Unbeknownst to the citizens below, who had numerous reasons at hand for why they had been spared the conventional bombing that had leveled many Japanese cities, these were two cities that had been designated by the United States as "virgin targets."[22] As much as the instrument canisters, the cities were a means of scientific measurement.

Hibakusha (bomb-affected people) mentioned a *noiseless flash*: "Only those at some distance from the explosion could clearly distinguish the sequence of the great flash of light accompanied by the lacerating heat of the fireball, then the sound and force of the blast, and finally the impressive multicolored cloud rising above the city."[23] Fumiko Nonaka looked up just as "there was a piercing flash that bit into my face. I felt my body shrivel with a hiss like that of dried cuttlefish when you grill it."[24] For the people on the ground, the bombs' spectacle of sight and sound would become embodied in the term *pika don*, Japanese for the flash of light followed by the onomatopoeia of the sound of the explosion. Third-degree retinal burns prevented many of those who saw the light from seeing again and, toward the upper range of the electromagnetic spectrum, gamma radiation was neither seen nor heard but nevertheless manifested in *atomic bomb illness*, *atomic cancer*, and the *atomic plague*.

Three months later, the people of Los Angeles could see and hear it for themselves. On October 27, 1945, they gathered in the Memorial Coliseum for the *Tribute to Victory*, a reenactment of the atomic bombings, with a spectacle reminiscent of Albert Speer's Cathedral of Light at the Nuremberg rallies and with similar technical specifications: fifty searchlights of 800 million candlepower each, letting there be light. The Hollywood actor Edward G. Robinson narrating the spectacle over a public address system. As the *Los Angeles Times* reported, "At a signal, a low-flying B-29 skimmed over the bowl, the multicolored searchlight beams tinting its gleaming silver with pastels. As the big bomber roared over the peristyle, a terrific detonation shook the ground, a burst of flame flashed on the field, and great billows of smoke mushroomed upward in an almost too-real depiction of devastation.

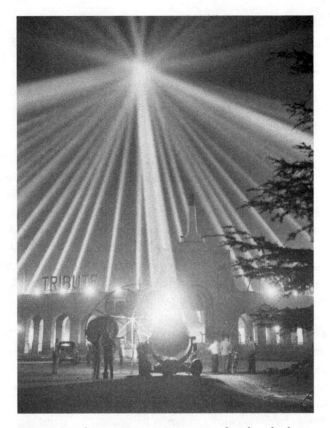

Figure 10. *Tribute to Victory*, 1945. "Nearly a hundred huge lights totaling billions of candlepower cover the Los Angeles Memorial Coliseum with a multicolored crown for the Tribute to Victory Celebration of October 27th. Each light is of 800 million candlepower and each is equipped with a 16-foot color wheel, the largest ever built, the formation throwing designs of multicolored lights to crown the spectacular presentation." © Bettmann/ CORBIS.

As the smoke snaked skyward, red and blue lights played over the white column with magic effectiveness."[25] The audience unwittingly emulated other features of the bombing. Depending on estimates, the hundred thousand people who gathered for the event at the coliseum were about the same number who had died at Nagasaki by the end of August.

Although the Trinity test was the first high-energy explosion to have "seismic significance" in an instrumentalist logic of geophysics, it was

detonated, like the bombs over Hiroshima and Nagasaki, aboveground and thus did not erotically "couple" with the earth to register a significant "range of seismic perceptibility."[26] Along with William Laurence's biblical orgasm, this evoked once again the *ecstatic trance* and *immense wooing of the cosmos* under the spirit sign of technology that Walter Benjamin saw enacted on the killing fields of World War I. However, the first true atomic coupling, one that would truly communicate through planetary vibration, would have to wait until Bikini Atoll.

There was a series of tests at Bikini. Only the observers of the Trinity test and the inhabitants of Hiroshima and Nagasaki had ever seen and heard an atomic explosion; the Bikini tests were reenactments that would upstage the *Tribute to Victory* at the Los Angeles coliseum. The whole world was invited to the spectacle and for those who could not attend it was the most photographically and cinematically recorded event in history. It caught the eye of French designers, who developed a female swimsuit at the atomic scale that meant that the depopulation of the Marshall Islands would be coupled with sexually charged fashion in the West.

For scientific and military purposes, innumerable sensors and receivers were poised like cameras to capture and distinguish all the signals. The first test was an airburst like the first three atomic explosions—Trinity, Hiroshima, and Nagasaki—so its "seismic significance" was limited. The Bikini Baker test, however, was conducted about thirty meters underwater in the lagoon surrounded by the atoll and thus had greater earth coupling, with *perceptibility* registered at seismological stations in the atomic homeland in the southwest quadrant of the United States, a signal return toward Trinity.[27]

The seismologist Charles Richter noted that "we felt that the elapsed times from the [Bikini Baker] shot, which of course was very accurately timed, to the arrival of the seismic waves at these stations were perhaps the single most important observations made in instrumental seismology up to that date, because they were the first to give us an absolutely positive control over the speeds of the propagation of seismic waves to large distances."[28] Later, two scientists in Australia found evidence in Operation Castle, the series of hydrogen bomb tests at Bikini Atoll, to support the existence of the inner core of the earth.[29] These were but opening salvos in the intimate relationship that militarism would develop with the earth sciences and seismology.[30]

· · ·

"New York is a trembling city. It quivers most when subway, bus, elevated railroad and motor traffic picks up in morning and evening rush hours.

Heavy milk trains make its rocky underpinning jig before dawn. Earthquakes clear across the world can titillate it."[31] So wrote Meyer Berger in his *New York Times* column on Wednesday, August 19, 1953, with the heading "2 Quakes, Blast and 'Atom Bomb': Busy Night." It was a character sketch of Reverend J. Joseph Lynch, a seismologist from a strong tradition of Jesuit seismologists, equipped with his battery of seismometers sunk into the bedrock running under Fordham University. One of the seismometers was a supersensitive Benioff model that could "multiply tremors 100,000 times" and detect events thousands of miles away.

On Sunday, August 16, 1953, just before midnight, the New York metropolitan area was rocked by a tremor at about the same time as a large gas explosion at the New York Naval Shipyard in Brooklyn claimed the lives of two workers. Newspaper reporters woke Father Lynch out of his sleep to find out what the seismometers said. It turned out that a small earthquake centered in Bergen County was felt throughout the city at 11:22 P.M. and the shipyard explosion had occurred at 11:33 P.M., with the explosion leaving no distinct seismic mark, but it happened to have occurred "in the same split second as a faraway quake" some two thousand miles away. Lynch was not able to get back to bed until the early morning hours because people "celebrating the Feast of St. Rocco were touching off a new type of carnival explosive that the trade jestingly calls Atom Bomb, because it's louder than old charges. Nervous people kept calling to ask Father Lynch if we weren't having a string of local earthquakes."[32] Earthquakes and atom bombs were on people's minds on August 19, 1953, the day of Berger's column, and not just because of the local tremor. One week before, a series of earthquakes had devastated two of the Ionian Islands off Greece and international relief efforts were well under way. The day after the column, August 20, the *New York Times* reported that the Soviet Union had exploded its first hydrogen bomb.

Meyer Berger was not finished with atomic age earthquakes. His column on April 4, 1955, "Earthquakes and Cosmic Music for Sale on Disks" begins,

> Elemental forces that once affrighted men or excited them to awe are entrapped today in vinyl from Atom Age entertainment. On Friday, for example, the daily journals carried front-page accounts of an earthquake in the Philippines. On the same day, by coincidence, Emory D. Cook, sound wizard, released earthquake recordings for home use. . . .
>
> Now anyone can step into a record shop and say, "Sell me a earthquake," and have one wrapped for him on the spot. In the parlor the purchaser can sit back and smugly hear Mother Earth in anger.

He gets the full earthquake effect. Cracking and sundering forma-
tions deep in the globe give off vibrations that make the ears slat like
window shades. The rooms seem to shake. Some of the quakes burst like
thunder. At one point the listener is told to watch the record to see his
needle actually imitate earth's writings in labor.[33]

The earthquakes on sale were recorded by Hugo Benioff at Cal Tech using
a seismometer of his own design. Along with Charles Richter, Benioff was
one of the most recognizable names in seismology because his seismome-
ters were used so widely. He tape-recorded the earthquakes and played
them back at different speeds on side A of the LP *Out of this World*, another
recording by Cook Laboratories. We have already discussed Emory Cook,
"the first king of audiophile spectacle";[34] the "cosmic music" that Berger
mentions on the B-side consisted of the sounds of whistlers and ionospheric
radio recorded by Millett Morgan that Alvin Lucier used for his composi-
tion *Whistlers* in 1966.

Out of This World rendered the acoustics of earthquakes and other seismic
events sensible to audiophiles, citizen scientists, amateurs, and others through
their home-entertainment equipment. There was a persuasive proxy technol-
ogy at play, set up through the similarity between the seismometer at Cal
Tech and the hi-fi system, "as though we were to place the needle of a pho-
nograph cartridge in contact with the bedrock of the earth in Pasadena."[35]
Audiophiles were put at ease by being assured that certain subtle noises they
heard were the product of a technological sophistication capable of sensing
microseisms caused by "meteorological conditions, originating in the depths
of the oceans, shaking ocean bottoms in some sort of immense resonant phe-
nomenon."[36] There was nothing wrong with their equipment; instead, the
noise floor they heard was evidence that the entire "earth never *quite* ceases
its moving."[37] This idea was brought home finally in the possibility that the
low frequencies on the recording might damage speakers or cause the tone
arm to bounce around. As the album notes half-jokingly read,

EARTHQUAKES FOR HOME USE
It is understood as a condition of sale that Cook Laboratories, Inc., will
in no way be responsible for damage this phonograph record may cause
to equipment directly or indirectly. For users with wide-range woofers
this disclaimer shall be construed to include neighbors as well, dishware
and pottery.[38]

And, to put the earthquakes themselves in a way that everyone would
understand, "The Bikini underwater atom bomb produced a magnitude of
5.0 at Pasadena, comparable to the 6.75 of the nearer-at-hand Hawaiian
shock."[39]

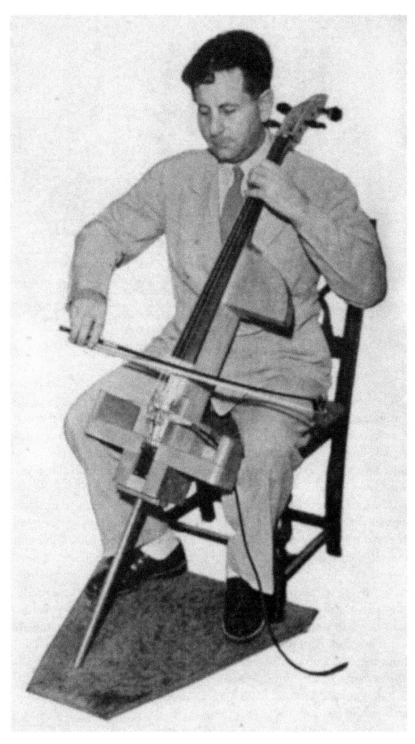

Figure 11a. Hugo Benioff with his electric cello, 1945. Image courtesy of the Benioff family.

Figure 11b. Hugo Benioff's loudspeakers for frequency groups of the electric cello: 40–300, 300–3,000, 3,000– 14,000 cycles. Image courtesy of the Benioff family.

Out of This World was not Hugo Benioff's first venture in combining his seismometric instruments with sound; he also used his instrumental know-how to create some of the earliest examples of electrical violins and cellos. "Quake Inspired Violin Invention; Tone Said to Astound Musicians; New Instruments, Developed by Dr. Hugo Benioff on Seismograph Principles; Are Played in California Concert," read a 1938 *New York Times* article.[40]

The instruments had no resonant bodies but instead worked on the same piezoelectric principles as Benioff's seismometers, with a distorting crystal or crystals for "controlled transduction of the energy of string vibrations into electrical energy vibrations" that were then highly amplified.[41] Instead of a unitary bridge of, say, a violin that transfers the vibrations of the strings to the resonant body of the instrument where they are acoustically amplified, the bridge mechanism on Benioff's instruments were segmented, with each string having its own element that transferred vibrations directly to a transducer. The only resemblance they had to regular instruments was from the standpoints of appearance and that of the performer, "who is accustomed to the physical form and 'feel' of the standard instrument."[42] Benioff's electric cello was made of maple and weighed twenty-five pounds, and each of its three frequency ranges (40–300, 300–3,000, and 3,000– 14,000) was equipped with its own loudspeaker.

This was not a simple technological transfer; there were earth-scale acoustics involved. Studying massive earthquakes over 8.0 on the Richter scale, Benioff noted a similarity between the buildup and release of a "worldwide stress system" and the behavior of a bow moving across a string.

> Thus the constant speed of the bow corresponds with a constant rate of strain generation within the crust. At the conclusion of an active period the faults all become locked corresponding with the phase in the bowed-string cycle when the string becomes attached to the bow. During the quiescent period, the strain accumulates at a constant rate in the same way that the string is displaced by the bow at a constant rate. Finally, when the stress becomes greater than the locking friction, the faults begin to slip and this corresponds with the condition in the string cycle when the bow loses hold of the string.[43]

Unlike the string of a Pythagorean monochord myth of a rational correspondence between a particular type of music and the cosmos, Benioff's analogy was better grounded. One difference between earthquakes and the mechanism for his stringed instruments, however, was that the latter were "of such nature that no uncontrollable vibrations are introduced to the system."[44]

Benioff built a cello based on the principles of his seismographic fiddle but his musical instruments, although geophysical, never became properly geopolitical. In contrast, while at Bell Labs (1959–64), Sheridan Dauster Speeth worked on a method for distinguishing the sound of naturally occurring seismic events from those of underground nuclear blasts using sound. In this task he would appeal to the ears of cellists.

Speeth was an intense and intriguing polymath, autodidact, inventor, and peace and antipoverty activist who, during the 1960s, interacted with some of New York's most interesting artists. He studied under B.F. Skinner at Harvard and received his PhD from Columbia University while working concurrently at Bell Labs in Murray Hill, New Jersey. He developed expertise in psychoacoustics, mathematics, and computation and in 1959 began to educate himself in geophysics and seismology: "My finest professional achievement [while working at Bell Labs] was the discovery of a set of techniques for distinguishing underground nuclear explosions from natural earthquakes using seismic signals (low frequency sound). I also worked on the detection of signals in noise by the ear, synthetic sounds and music, the statistical structure of music, and related subjects."[45]

Seismology did not play a significant role during World War II; it gained greater attention in the lead-up funding for the International Geophysical Year but was still a much lower priority compared to other earth and

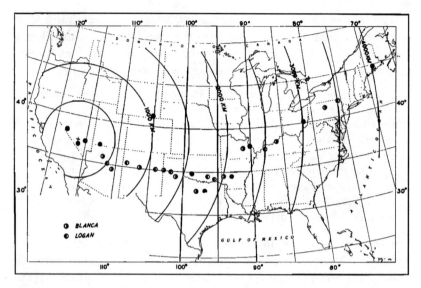

Figure 12. Seismograph stations arrayed across the United States during Operation HARDTACK underground nuclear tests, October 1958. From Carl Romney, "Amplitudes of Seismic Body Waves from Underground Nuclear Explosions," *Journal of Geophysical Research* 64, no. 10 (October 1959): 1489–98.

atmospheric sciences.[46] All that changed when President Eisenhower, through negotiations for a test-ban treaty with the Soviet Union, initiated a research and development program in seismology for underground testing detection (later known as Project Vela Uniform). Preliminary investigations had already been undertaken of the first fully contained underground test—the Rainier shot at the Nevada Test Site on September 19, 1957—but they were limited by a lack of coordination and the inconsistent quality of the readings. Seismic measurements of the explosions conducted under Operation HARDTACK at the Nevada Test Site during 1958 were approached more methodically by the US Air Force and resulted in the first substantial data sets for underground testing.[47]

It was under the aegis of Eisenhower's decree and the sets of data available from Operation HARDTACK that Speeth turned his attention toward seismology in 1959. Speeth's progressive political and humanitarian interests both motivated and inhibited his seismological work.[48] He was confident that his research would contribute to slowing down the nuclear juggernaut, but his political affiliations and peace activism drew suspicion and kept him from a level of security clearance that would have supported his research.[49] Speeth's

paper "Seismometer Sounds" was finally published, but only after a series of delays and revisions, including the elimination of an entire section "Suggestion for a Detection System," which would have been an opportunity to connect his research more directly with arms control.[50]

What Speeth did was to render seismometric data audible in order that signals from nuclear explosions and naturally occurring events could be differentiated by trained listeners. Seismic data from a nineteen-kiloton explosion (Blanca, on October 30, 1958) was recorded at distances of 600, 900, 1,000, 1,200, 3,000, and 4,000 kilometers, and also a five-kiloton explosion (Logan, on October 16, 1958) recorded at 500, 700, and 4,000 kilometers.[51] Along with earthquake data from Bell Labs' seismometry lab at Chester, New Jersey, the data from HARDTACK was then "digitalized," dumped off onto analog tape, and played to test subjects who had been trained to listen for the differences.

Using psychological skills learned from his studies with Skinner, Speeth trained students from a local high school and staff members at Bell Labs to discriminate between bombs and quakes—BQ or QB—with a reported positive identification at 90 percent. Eventually, he preferred individuals with a different type of behavioral training, that is, with cellos. Speeth was a gifted violinist who had trained for many years at the Cleveland Institute of Music before attending Oberlin College, but violinists did not regularly dwell in the lower frequencies of seismic sounds. At first he thought that bass players would be best on the low end, but he found that their pitch discrimination was not as keen as cellists'.[52] Although the cellists would soon lose out to algorithms and computers, Speeth was, as his brother said, "pleased and somewhat amused to give employment to a bunch of cello players for a short period of time."[53]

Speeth brought his musical skills into play with seismological sounds in another regard. During the late 1950s and early 1960s, the acoustics and behavior section at Bell Labs was at the forefront of digital sound technology and early developments in computer music. Speeth worked closely with Max Mathews, who is perhaps best known for developing digitally synthesized sound for music with his MUSIC programs. In fact, Speeth's twelve-tone composition *Themes and Variations* was included on a record produced at Bell Labs, *Music from Mathematics:* a significant recording in the early annals of computer music.[54] The short hornpipe-sounding composition, as with all the compositions by others on the recording, was made on an IBM 7090 computer with a "digital to sound transducer," the same equipment Speeth used for his seismological research; it was capped off with a very short coda, under two seconds, of a noisy blast described on the

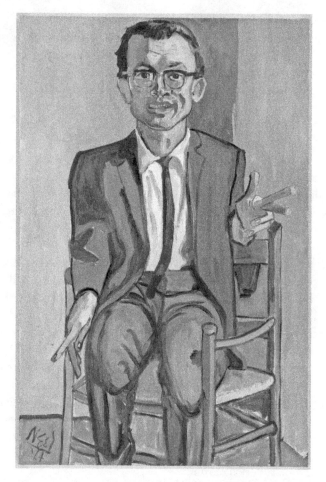

Figure 13. Alice Neel, *Sherry Speeth,* 1964. Oil on canvas,
42 × 28 inches. © The Estate of Alice Neel, courtesy of
David Zwirner, New York/London.

liner notes as "a computer-processed recording of a seismogram, sped up by
a factor of 300."[55]

During the 1960s, Speeth interacted with a number of significant artists
in the New York area. While he worked at Bell Labs, his office was just
down the hall from James Tenney, who was a composer-in-residence of
sorts under the auspices of conducting psychoacoustic research from 1961
to 1964. Tenney's partner was the artist Carolee Schneemann, who would
become very well known for her passionately political and erotic work in

painting, dance, film, and performance. It was Speeth who introduced Tenney and Schneemann to the writings of Wilhelm Reich, which proved to be very important for both of them.[56] He also lent the term *chronotransduction,* in lieu of *opera,* to *Escalator Over the Hill: A Chronotransduction* (1971), perhaps the best-known work of composer Carla Bley and poet and lyricist Paul Haines, a friend of Speeth; but art audiences may know Speeth as the subject of one of Alice Neel's most recognizable paintings (*Sherry Speeth,* 1964).[57]

After leaving Bell Labs, Speeth worked on classified military projects in avionics at Cornell Aeronautical Laboratories in Buffalo, New York, from 1965 to 1967 and also worked on "unconventional armaments," including a sound weapon aimed at sphincter relaxation, what would later become known as the "brown note" among post-punk literati, and a device that blurred enemy vision. The composer Gordon Mumma remembers similar military research at Willow Run Laboratories near Ann Arbor: "low-frequency air-vibration assaults on human organs, e.g., the bladder and anal sphincter, which had the effect of involuntarily releasing existing human contents. That was very much on the far side of the basic seismological research," in contrast to the seismological priority of petroleum exploration in the bowels of the earth.[58] For Speeth, design of nonlethal armaments was a continuing compromise between his scientific skills, funding opportunities, progressive politics, and peace activism, a compromise he soon abandoned to design toys, educational devices, and equipment for disabilities.[59]

· · ·

Gordon Mumma has been mentioned in this book several times already. In what follows, I concentrate on the setting that gave rise to his series of compositions called *Mographs,* based on seismographic data of naturally occurring seismic events and underground nuclear testing. These compositions were significant in many respects; for the purposes of our discussion, they represent an early musical relationship to geophysical data, a rendering of the "long sounds" of seismic activity, and they presaged the way in which earth-scale phenomena and the material culture of Cold War science were manifested in works by other artists and musicians, specifically, in *Whistlers* by his friend and collaborator Alvin Lucier. Moreover, the scientific context within which the *Mographs* arose happened to be animated by the research of Sheridan Speeth.

Mumma is central to any conception of American experimentalism and one of the most cogent commentators on its activities, during the 1960s and since. He was associated with the ONCE Group in Ann Arbor and with

Sonic Arts Union (with Robert Ashley, David Behrman, and Alvin Lucier), and he composed, performed, and toured for years with John Cage and David Tudor while in residence during the intense period from 1966 to 1974 with the Merce Cunningham Dance Company. Among his fellow musicians he has been a rich resource of technological creativity and, in contrast to the institutionally supported centers of electronic and computer music, Mumma was one of the groundbreakers of the now-pervasive DIY aesthetic in live electronic music. He also holds an important position in the recent history of science and the arts. His musical and technological expertise and his scientific as well as theatrical and literary interests are all the more remarkable considering that he is largely an autodidact or, rather, make sense because of this.

Mumma began tinkering with electronics while he was a boy during World War II. In the years after the war, scarcity transformed to largesse as military surplus stores grew flush with electronic gear, and during the 1950s he could be found scouring the shelves. He was not alone: live electronic music and DIY across the arts in the United States benefitted from military excess.

He also practiced his craft on radios and his father's phonograph: he would dismantle them while taking notes, put them back together, and they would work fine. While at summer music camp at Interlochen in Michigan, the otherwise conservative repertoire took on additional interest when the camp technician took the performances he had cut onto a phonograph disc and played them back through an oscilloscope. Everything was enthralling when converted to frenzied lines on a tiny radar or television screen. At the same camp, another character pulled Mumma aside and introduced him to arcane tuning systems. In one summer he gained an unofficial education in both old and new possibilities for music.

He did not last long in the Music Department at the University of Michigan, fleeing instead into the ranks of literature and theater more open to the challenges of the contemporary. "I didn't take note, or have any understanding, or respect for the boundaries between music, literature, theater," a sentiment he maintained throughout his career.[60] In the disciplinary logic of American academe, music did not need theater but theater needed music. To protect student composers from being accused of an unproductive distraction by their own department, the Theater Department credited them on the programs with "sound" rather than music. "*Gordon Mumma, sound:* that was a very great treasure, because *sound*—that got me off the hook," he says.

The Theater Department had two new tape recorders for playing music at rehearsals and during productions. Mumma used them for composition,

not just recording and playback; cutting and splicing and changing tape speed generated results in the field of musical experimentation. On song, he took one apart, took notes, and put it back together. He used these skills in 1961 for customizing a two-track tape recorder, adding an additional set of heads; it was portable so he took it across the Atlantic for the ONCE Group performance at the 1964 Venice Biennale.

"Sound" allowed Mumma mobility between literature, theater, and music, and his DIY abilities opened new possibilities in compositional practice and live electronic music. He could modify anything and construct "instruments that had no cultural precedence." He recalls, "I had no—this is important—no cultural precedence imposing upon me to make sounds or music or whatever." In the late-1950s, there were not very many musical works to emulate, even if he had wished to do so. "I had no repertory except my own," he says. This no doubt freed him to compose music from among the sounds of his daily life that, in the early 1960s, happened to be the laboratory sounds of earthquakes and underground nuclear explosions he encountered at his day job.

Mumma left the University of Michigan but remained in Ann Arbor, attaching himself to its cultural life and patching together his economic existence by holding down a battery of part-time jobs. He was happy to land a full-time job at the Willow Run Laboratories in nearby Ypsilanti. During the war, the site was occupied by Ford's huge B-24 bomber manufacturing plant; after the war, part of the area was sold to the University of Michigan, which established the Willow Run Laboratories as a bastion of Cold War research. Mumma was hired at Willow Run to assist researchers in air-traffic control and systems analysis and to write reports. He was, in his own words, a "writing janitor" employed to clean up the language of others.

Since he had only a low-level security clearance, his work had little to do with sensitive military-related research and he had no working connection with the Seismics Group at the Acoustics and Seismology Lab (ASL). He was familiar with the topic of seismology, having been interested in a full range of acoustics since his teens. For whatever reason, one day he was invited "to listen to speeded-up tape recordings of seismic activities, i.e., speeded up to be in human-audible range," at the ASL. This was not a critical breech of security; although there were different levels of classification (which some of my correspondents from the period were still careful about nearly a half century later). Much ASL research went into the public domain fairly quickly, including some findings pertaining to underground nuclear testing. Secrecy had to contend with both the dynamics of generating knowledge and the theater of domestic and international politics.

It is not known who exactly invited Mumma to listen to the tapes, although it could very well have been Gordon Frantti from the Seismics Group at the ASL. Frantti had been in the lab for several years. He studied the energy spectra of seismic events and, with Leo Levereault, authored a 1964 report and published a 1965 paper that focused on the ability to discriminate through listening between earthquakes and nuclear explosions. The 1964 report took as its point of departure Sheridan Speeth's 1961 research paper at Bell Labs mentioned earlier in this chapter, but instead of testing musicians' ears, it used as its twenty-three test subjects "staff members of the Acoustics and Seismics Laboratory, including engineers, technicians, secretaries, and student assistants."[61]

Mumma's first *Mograph* was in 1962, so he would not have been among the test subjects. If the tests had been carried out earlier, then Mumma would have remembered the mind-numbing formality of making the "approximately 1500 auditory decisions" required of each test subject. More likely, he was part of a preliminary stage of the research or was simply invited to listen because the researcher knew of his musical background and scientific interests. Yet it was clear that these tests had no special agenda involving musicians. When I told David Willis, the director of the ASL at the time, about Speeth's preference for cellists at Bell Labs, he replied, "The ears of acousticians are perfectly fine."[62]

There was common ground between Mumma and the researchers because seismology was a land of tape recorders. Mumma remembers being taken into a room at the ASL and seeing a range of instrumentation, a number of regular tape recorders that traded with each other at high and low speeds, one tape recorder that had obviously been customized, and very nice AR loudspeakers everywhere. Compared to the gear that he and his fellow musicians were scraping together, such largesse struck him as war booty, not just the goods bought with the flush of Cold War funding, but also the fact that tape recorders themselves were the engineering spoils of German defeat.

The main attraction of seismology to tape recorders was that "the signal is stored in electrical form so that the equivalent of the original event can be recreated at any future time," as one of David Willis's papers stated.[63] Through the tape recorder, earthquakes and explosions became portable and repeatable. This allowed traffic between the field and the lab but also mobility on the battlefield. The ASL was a part of the multifaceted Project Michigan that involved sensing used for detection and command and control.[64] Detection of presence and magnitude pertained to the enforcement of nuclear testing treaties, whereas command and control was applicable to

battlefield decisions. While Mumma could travel lightly with his custom-ized four-track recorder to the Venice Biennale, seismologists were aiming for their machines to travel into the fields to detect the seismic and low-frequency signatures of enemy tanks, submarines, and sea vessels. Monitoring is integral to targeting.

There was additional common ground between the concerns of seismol-ogy, music, and electronic music. As Mumma stated, "Time-shifting and space-shifting, fundamental to the context of seismology, have always been an issue for some performing musicians, e.g., organists who perform in many different 'time-delay' and 'space variant' spaces. For me the entire context included the ongoing and natural 'warping' of our acoustical and psycho-acoustical perceptions, the positioning of sounds in time and con-trastingly diverse spaces."[65] Speeding up, slowing down, delaying, and reversing sound had been employed since the 1920s, both in the construc-tion of sound film tracks (for music and sound effects) and in the use of phonographs for music composition.[66] This tendency became codified in *musique concrète* beginning in the late 1940s, first in the use of phono-graph discs and then with tape recorders, and during the 1950s tape loops began to be used in live performance. The Seismics Group used giant tape loops up to 150 feet long, as did John Cage in live performance in *Rozart Mix* (1965). Seismologists by necessity were interested in the lower bounds of the audible and so were composers such as Alvin Lucier and Pauline Oliveros. Someone in the ASL told Mumma that increasing the speed of the tape recording made the seismic events sound more musical, whereas Mumma himself thought that they were already musical at the slow pace of twenty hertz, that is, as they become audible. Finally, Frantti and Levereault played earthquakes and explosions in reverse to their listening subjects. The initial sonic *attacks* of the events were disorienting, so they thought that it might help people discriminate between types of events by tactically sneaking up on the attacks from the rear.

Attack is apropos when attempting to detect a nuclear explosion. Attacks were, likewise, in the vernacular of electronic musicians and piano players. An attack is punctuation that occurs at the beginning of a sound envelope, the structure of a typical sound event. It is a major or minor onslaught of a sound out of silence or one that differentiates itself from a noise floor, after which it sustains and decays. It announces a world of cause and effect that is enacted or defeated. Piano keys and pedals are struck and depressed in the millisecond timing of a trained musician's anticipatory reflexes, whereas the trigger on a nuclear device could give way to centuries of radioactive decay.

A distant seismic event is particularly good for experimental music because there are at least two classes of attack. The same event creates primary and secondary waves (P-waves and S-waves). Although they are now known for their vibrational characteristics (pressure waves and shear waves), the designation referred to the difference in arrival times due to how waves propagate through different media. Their relationship was key to identifying the source (location, type of event) and therefore critical in the entire mission of the ASL.

The staggered timing of the event added dimensions to the triangulated monitoring from different locations, evoking a terrestrial space that, for Mumma, corresponded to the acoustics of performance spaces.

> P-waves and S-waves, which come from the same source, travel different routes, and are received by distant seismograph stations at different times. In listening to their sounds, I could follow most of the polyphony, and brought my classical music "counterpoint" analysis skills to the process. Also, the "attack" characteristics of underground explosions, tending to be immediate, were very different from the aggregate slipping attacks of rumbling earthquakes and tectonic plate stress-releases. The "slipping" attacks were clearly of lower "fundamental" frequency than the short-duration explosion attacks. I identified the earthquakes as having a legato-articulation rather than the explosion's staccato cluster—my musical analysis.[67]

Mumma's exposure to the laboratory sounds of seismic events led him to create a series of compositions called *Mographs*. They were named by their size and year composed, their size being an allusion to magnitude associated with seismic events and *size mograph* a pun on the source of data (seismograms, diagrams, and maps from the ASL). Whereas Benioff and Speeth concentrated on cellos and violins, the *Mographs* were composed for piano, multiple pianos or, in the case of *Medium Size Mograph 1963*, piano (four hands) and specially designed electronics.

The *Mographs* have been seen as an early example of sonification, that is, an auditory means of data display, but they transcend any indexical relationship that might be associated with sonification with their great variety of compositional approaches and instrumental techniques.[68] In the *Mographs*, time is split between attacks, slowed down by the medium of the earth, sped up by techniques of the tape recorder, or arbitrarily set through a visual correlation of data and musical notation. The distances and spaces once associated with speed and duration are contracted and stretched. Yet, underneath all this malleability is an earth-scale event. As Michelle Fillion summed it up, "Although the pitches, registers, and vertical combinations

are the composer's choice, the rhythmic attacks and some of the dynamics are predetermined by the seismic wave patterns. . . . The resulting sound-scape unfolds with the unpredictable conviction of nature."[69]

The scores themselves are a meeting point of new forms of musical notation with the graphical practices of laboratory science. Some are pre-cisely notated, whereas *Medium Size Mograph 1962* is a "choreographic map of performance activities" describing positioning of the hands but not specific notes, relating geophysical motion to movements at the keyboard. Some *Mographs* are exceedingly short, such as *Very Small Size Mograph 1962*, which in effect is an isolated attack with a long resonant decay, as the instructions read: "With all dampers raised. Precise, loud attack. Hold until inaudible."

In *Medium Size Mograph 1963* Mumma attacked the attacks and enlisted his technological skills to do so. Following from his earlier compo-sitions, this *Mograph* was for piano. The piano related to his technological interests because he understood the piano itself as a piece of technology, even though he was frustrated with its inability to remain current.[70] Everything came together in *Medium Size Mograph 1963*, in which the piano met live electronics. It was Mumma's first *cybersonic* composition and one of the key works in the early history of live electronic music.

Just like Frantti and Levereault, Mumma realized that "the initial milli-seconds of the sound 'attack' were important in identifying the character of the sound source," and this was one of his initial motivations for the work.[71] In the 1950s he had experimented with cutting moments out of the attacks from recordings of certain instruments, and he noticed that even trained musicians would have difficulty identifying the source. Instead of using a razor blade to cut slivers of audiotape, Mumma created circuitry (a diagram of which is included in the score) that "changed the articulation of the piano sounds by a gated envelope-follower, readjusting the natural acoustical envelope of the piano's attack and decay, so as to have the attack character-istics occur slightly after the piano sound had already begun."[72] By elec-tronically splitting the attack, he sought to modify the sound "so that ini-tially the piano kept some of its 'identity,' and as the *MSM 63* progressed that 'identity' would metamorphose into a more 'distant identity.'"[73]

In his essay on the ONCE Group, Richard Schmidt James commented on Mumma's ability to relate seismographic data to compositional practice: "The arrival pattern of the wave front of an underground explosion is actu-ally quite complex, due to the variable refraction of different geological strata. As a result Mumma could, for instance, derive all of the specified duration relationships of *Medium Size Mograph 1963* from a single seismic

Figure 14. Gordon Mumma, *Medium Size Mograph 1963*, p. 1 of 3. © Gordon Mumma, 1963–2001 BMI.

event—certainly a novel variant on the serialists' preoccupation with deriving an entire piece from a single motivic cell."[74] By "explosion" perhaps James was referring to *Large Size Mograph 1962*, for which the catalog entry reads: "A totally serialized composition for piano solo. The rhythmic figures and sequence durations are derived from seismographic recordings of wavefront arrivals from the Mt. Rainier underground nuclear explosion."[75] By "Mt. Rainier," Mumma actually meant Rainier Mesa at the Nevada Test Site, where the first full coupling of a nuclear bomb with the earth occurred.[76] It was, consequently, also where the problem of distinguishing a "shot" from other seismic sounds became evident.

Members of the ASL made regular trips to the Nevada Test Site. David Willis returned to Willow Run one time and found that Mumma had been moved into his office. Although there were many low-level staff members, Willis remembered Mumma decades later because Mumma, besides being an unusual name, was also his wife's maiden name. Later, Willis was also involved in underground tests on Amchitka Island, including the detonation of the Cannikin test, the largest underground nuclear explosion by the United States; he was later employed by the oil industry. This was not uncommon. Seismologists, once a subaltern class among scientists, received increased funding, job security, and influence through their association with the energy sources of big underground economies: nuclear testing and the petroleum industry. What was once a geophysical craft had become geopolitical.

Seismological monitoring was also used by the United States to determine the feasibility of conducting illegal tests, ostensibly by others but also by itself. If a blast in a certain substrate or within a certain type of cavern could be absorbed, then tests larger than specified in a disarmaments treaty could be carried out. The most public of these were two nuclear tests in a salt substrate below inhabitants near Hattiesburg, Mississippi. The point for signal discrimination, therefore, was not merely to denote detonation but also to control ambiguity and create confusion.

Mumma remembered two researchers at the ASL discussing plans to contact seismologists involved in oil exploration to learn how to best achieve such masking. He also heard about the tactic of distraction, in which the noise of conventional explosions was to be used to mask a nuclear test, thus the task of better identifying signals was used to better confuse them. He said that nature, the earth, was only part of the propagation being studied; the rest was political. As a musician he could hear the differences in attack clearly but knew that that was not the point, that there was a purpose for all the underground clutter: "Nothing clean, let alone the confusion of activity underground. It was all political activity."[77]

12 Long Sounds and Transperception

Seismic waves are long sounds that are underfoot and below the human audible range. As such, they belong to a larger class of long sounds that, like other forms of sound, have been heard and composed in music and the arts. A long sound is usually thought to be one that lasts a long time; yet there are sounds that are long in distance as well as duration. Moreover, some long sounds can be heard as having acquired their character through the course of their propagation, acoustically and electromagnetically. In this way, a sound is as much of the intervening space as it is from the source. I use the term *transperception* to denote the perception of those characteristics—the influence of objects and artifacts, modulation and media (e.g., rock, air, Internet), and the time required by distance—along with the source. Very simply, transperception is an apperception, a consciousness or intrinsic awareness of an energy that includes what has been traversed. In terms of the naturalization of telecommunications, it is also a perception of what has not been annihilated.

Long sounds were transperceived before telecommunications, but telecommunications increased the distances at the same time as they accelerated transmission and destroyed perceptible distances in a flash of light. The annihilation of space and time earlier exercised in sea travel and accelerated in nineteenth-century telecommunications is still rehearsed and tested as communications are routinely entrenched at an earth scale; but unless something can be done about the size of the earth and the speed of light, there will never be total annihilation.

The solipsistic goal to enclose the entire earth in a metallic loop was expressed in 1887 when a writer in the *New York Times*, trumpeting a decade of success for the telephone, predicted, "The final triumph will be when a gentleman can send a whisper round the planet into his own

ear."[1] This was an improvement on the seventeenth century, when sound traveled around the earth more slowly but still more quickly than the sun. Marin Mersenne used the blood coursing through his veins to calculate that it would take just over twenty-one hours for sound to travel around the world. Basing himself in a "natural well-tempered pulse" to beat out the time between seeing the flash of a firearm and hearing its report, he calculated the speed of sound.[2] What he perceived was a difference between seeing the source of the sound and hearing the sound itself, which he also observed with canons, trumpets, bells, hammers, and the like.

He knew, however, that there were no common sounds loud enough to travel around the earth. There was only one sound capable of such loudness—the angels trumpeting Judgment Day, which he calculated would take about ten hours to reach everyone on earth.[3] The Lord is omniscient and, like light, instantaneous, but the trumpet sound on high would travel in a transcendent medium of angel air, emanating from what would amount to medium earth orbit between the earth and a satellite-based location system like GPS. However, if the trumpet sounds were transmitted on a light beam, then the space probe *Voyager I* would have been in a position to photograph the angels several years ago.

The sound of the planets themselves would not be noisy enough to interrupt angel trumpets, according to the debunking of the Pythagoreans that Aristotle penned in *De Caelo* (On the heavens). If there were a Pythagorean music of the spheres, then, because the spheres are extremely large and traveling at great speed, Aristotle pointed out, they would make the loudest sound imaginable. Thunder could split rocks, he said; this sound, if it existed, would be much louder than thunder.

Thunder is the most common terrestrial long sound, its charm aided by the source made visible in lightning and observable with the delay between thunder and light. However, loud, distant sounds without a perceivable source have been called different things in different languages: brontides, mistpouffer, mugito, Barisal guns, guns of Seneca, Moodus noises, and uminari; "the fishermen on the Banks of New Foundland knew them as 'Seefahrts' (sea farts?)."[4] The *gouffre* in Haiti is ascribed to earthquakes and distant weather, among other sources, and includes sounds "described variously as resembling the noise of a 'heavy wagon passing over pavement, of thunder rolling in the distance, of dynamite exploding or of cannon being fired off, of water falling on dry leaves, of the wind blowing through high forest trees in a tempest. Yet all of these sounds may be heard without any appearance of storm.'"[5]

A vicar at Croix-des-Bouquets gave a detailed account of the *gouffre* from November 7 to November 13, 1911, and how it sounded both day and night, including one instance "that can not be imagined . . . it was as if a mountain of glass were shattered, and the noise seemed echoed in all directions."[6] A Portuguese Jesuit in southern Brazil in the seventeenth century was more certain as to the source of what the inhabitants of the area called "an explosion of stones." After several days' tracking, he narrowed it down to a stone, "a sort of nut, about the shape and size of a bull's heart, full of jewelry of different colors, somewhat like transparent crystal, others of a fine red, and some between red and white, imperfect, as it seemed, and not completely formed by nature. All these were placed in order, like the grains of a pomegranate, within a case of shell harder than even iron; which, either with the force of the explosion, or from striking against the rocks, when it fell, broke into pieces, and thus discovered its wealth."[7] Even when the source of a sound is located, it can remain mysterious.

Historically, eruptions of jewels pent up in a bull's heart were never high on the list of likely sources for distant sounds. When not thought to be severe weather (thunderstorms, hurricanes), the most common suspect was military activity, only because of the infrequency of volcanic and seismic activity in most parts of the world when compared to the enduring nature of military activity. The loudest sounds in modern times traveled almost 5,000 kilometers only to be heard as heavy guns. The sounds were those from the cataclysmic explosions of Krakatoa on August 27, 1883, and "were heard in Ceylon, in Burmah [sic], at Manilla, at Doreh in the Geelvink Bay (New Guinea), and at Perth on the west coast of Australia. . . . If a circle is drawn from Krakatoa with a radius of 30 degrees, 1,800 geographical miles, or 3,333 kilometers, the circle will go exactly over the furthest points where the sound was heard."[8] The Krakatoa explosions were heard predominantly as fire from heavy guns signaling a distant battle or rehearsal, pending attack, distress call, or even a cannon salute from a departing ship.

The most distant sound was registered on the island of Rodrigues, a British possession in the Indian Ocean, 2,968 miles (4,777 km) away from the eruption. When reports were "heard coming from the eastward, like the distant roars of heavy guns," soldiers were sent to their posts.[9] At Diego Garcia in the central Indian Ocean, and in several other locations, the sounds were thought to have been guns fired by a ship in distress; at Karimun, 355 miles (571 km) from Krakatoa, "several native boats were dispatched to render assistance" and 522 miles (840 km) away in Singapore two steamers were sent out to check for the distressed vessel.[10] In St. Lucia Bay, 1,116 miles (1,796 km) away, "The noise of the eruption was plainly

heard all over Borneo. The natives inland, who murdered poor Witti, when they heard the noise, thought we were coming to attack them from the east and west coasts and bolted away from their village."[11]

A report published in *Nature* less than a year after the explosion noted that the sound covered about one-sixth of the circumference of the earth and one-fifteenth of its surface, while a report from the British Royal Society put the coverage at one-thirteenth.[12] The sounds were not uniform. They were heard in certain directions better than others, and at times people closer to the eruption heard little or nothing while people farther away in the same direction clearly heard a loud sound. The Dutch geologist Rogier Verbeek attributed the trajectory of the sound to the wind and speculated that clouds of ash "would act on the sound waves like a thick soft cushion," muffling sound at shorter distances while the sound traveled over the cloud to places farther away. This was before refinements in the scientific field of atmospheric acoustics.[13]

Pressure waves from Krakatoa traveled around the earth seven times. A similar thing happened in 1908 when a meteor fell near Tunguska in Siberia; and, after 1945, sensing infrasound generated by explosions became an important element in monitoring nuclear bomb testing. Nuclear weapons were responsible for very long anthropogenic sounds in the ocean. The loudest was the basin-scale transmission of a thirty-kiloton bomb known as WIGWAM. It was detonated at a depth of 650 meters (about 2,100 ft) deep in the Pacific Ocean about 800 kilometers (almost 500 mi) off the US–Mexico border and produced "acoustic echoes from many islands, seamounts, and other topographic features throughout the entire Pacific Ocean," from Amchitka in the Aleutian Islands in the north to Okinawa in the west and to Fiji in the south.[14] The purpose of the test was to gauge the susceptibility of submarines to nuclear warfare: the test submarines in WIGWAM were called, with genocidal and femicidal élan, *squaws*.

The ocean is hospitable to long sounds, because denser media conduct sound better. In the ocean there is a cold *deep sound channel* (also known as the SOFAR—sound fixing and ranging—channel) that is capable of conducting sound great distances. Research into how submarines could be detected acoustically given the changing temperatures at different layers in the ocean led, inversely, to testing temperature changes in the SOFAR by studying long-distance acoustical transmissions in what is called ocean acoustic tomography. The temperature of the ocean is an important measurement in the study of global warming; therefore, long sounds are situated in the channel from Cold War to Warm War.

Very long oceanic sounds were transmitted off an island located in the southern Indian Ocean directly south of Rodrigues (where Krakatoa was heard) during a major ocean acoustic tomography test conducted in 1991. As pun luck would have it, the test was located off Heard Island. For hour-long intervals over five days, extremely loud sounds of 220 decibels were released into the waters deep off Heard and were detected by hydrophones halfway around the world (a range of approximately 17,500 km, about 10,875 mi): Newfoundland to the northwest, to Monterey on the coast of California, and Whidbey Island in Puget Sound in Washington State to the northeast.[15] Further tests were halted after concerns were raised that such continuous loud sounds could damage large marine mammals and disrupt their communication, orientation, and migration.[16]

Thirty years earlier, explosive charges let off in the sound channel near Perth, Australia, were detected in Bermuda.[17] Roger Payne was off the coast of Bermuda a few years later with hydrophones poised 700 meters (about 2,300 ft) deep that were usually used by the Palisades SOFAR station to listen for Soviet submarines.[18] He heard a few explosions, but his first purpose was to listen for humpback whales. In 1970 he compiled recordings into *Songs of the Humpback Whale.*[19] The LP's phenomenal success distributed whale sounds great distances over the land.

Not all of Payne's research was directed to issues of communication, i.e., in the sense of messages. His research with Douglas Webb noted how fin whale sounds also proceed by "*not* postulating meaningful communication."[20] Instead, Payne and Webb focused their research on "simple signaling of place" through the "exceptionally loud, low frequency sounds" of the fin whale *(Balaenoptera physalus).* This was equivalent to the split in signal corps activities during World War I between deciphering coded messages from the enemy and using direction-finding antennas to locate the sources of the signals, that is, messaging and location/homing. What communication existed was reduced to *there is a fin whale here.*[21]

Payne and Webb theorized that there could be enormous distances, thousands of kilometers, between different herds and that the whales descended down to the SOFAR to sound off to one another (SOFAR used to be compared with going into a telephone booth to make a long-distance call, when telephone booths were still common). These distances were confirmed by SOSUS (sound surveillance system), the distributed array of hydrophones that the United States used for submarine tracking. The whale sounds could be understood in at least two ways: there is a fin whale (maybe more) here or somewhere in an existential sense, or there is fin whale or more here at a distance you can surmise in the sound you hear.

Composers responded immediately to the call of the whales in the same way that Olivier Messiaen responded to birds: Alan Hovhaness with *And God Created Great Whales* (1970) and George Crumb with *Vox Balaenae, Voice of the Whale* (1971). Alvin Lucier, too, created a composition, but did so not by postulating musical communication about whales themselves but by appreciating their ability to communicate with one another over great distances through a unique, albeit very cold, sound propagation channel. Instead of *there is a whale somewhere in here,* his composition *Quasimodo the Great Lover* (1970) postulated that, in effect, there are distances in here to hear. The full title of the composition continues: *"for any person who wishes to send sounds over long distances through the air, water, ice, metal, stone, or any other sound-carrying medium, using the sounds to capture and carry to listeners far away the acoustic characteristics of the environments through which they travel."*[22]

Lucier first heard recordings of whale sounds at a lecture that Roger Payne delivered at the University of California at Santa Barbara in 1969:

> What struck me more than the sounds . . . was the ability of whales within a species to communicate with one another over tremendously long distances, across ocean basins in some instances. They do this by echoing their sounds within a specific temperature layer in the sea so that the sound doesn't get absorbed into the bottom of the ocean or dissipated out through the surface. I was very impressed by that. So instead of imitating the sounds of the whales, or using Payne's recordings, I imitated the feature that struck me strongest, their amazing long-distance sound-sending ability.[23]

Quasimodo the Great Lover consists of several pages of instructions that leave the details for realization open to the performers. It is based on a series of microphone-amplifier-loudspeaker relays that are situated or linked through a number of different spaces. The instructions in part read, "In large, single places such as prairies, glaciers or ocean basins, use single systems of great power or several weaker systems in series. Connect small, separated spaces such as rock formations within faults, detached railroad cars on sidings, the rooms, foyers, and corridors of houses, schools, or municipal buildings with relays of systems, adding shorter distances to make longer ones."[24]

An initial sound is sent into the system and, instead of an electronic circuit alone modulating the sound, the intervening space also does so. In this way, *Quasimodo* resembles *I am sitting in a room* because they both are systems of transductive trade between sound and signal and use the acoustical influences of the space to modulate the sound. Whereas the

electronic parts of the circuit in *I am sitting in a room* are used with a break in time for recording and playback, those in *Quasimodo* are used for transmission in a continuous movement from sound to signal to sound, and so forth.[25]

In his instructions, Lucier gives a practical example of how a three-story building of an American high school could be set up so that "all sounds that move through this system, from loudspeaker to microphone and so on, are processed by the physical characteristics of the classroom, corridors, stairwell, lobby, and gymnasium. Longer distances and further processing may be brought about [by] deploying additional relay systems in libraries, laboratories, cafeterias, offices, and boys' and girls' locker rooms."[26] In effect, he is patching a building as one might have patched a synthesizer at the time.

Here again Lucier takes what would normally be a closed circuit of transmission and breaks it open to let in some air, in this case, the air filling the corridors and rooms of a high school building. Elsewhere he is quick to say,

> Not only through the air, but through anything, through ice, wood, or metal, or ground, so that the distance traveled will pick up—will modulate the original sound. . . . I would imagine doing it on the tops of mountains, for example, in Colorado, sending it from peak to peak over a range of mountains. Or putting a transducer into a glacier, and picking the sound up on the other side; or putting an underwater microphone, underwater loudspeaker, underwater microphone picking it up on the other side of a lake.[27]
>
> What would happen if you sent sounds through a glacier and they were picked up on the other side by a microphone and then sent through the Pacific Ocean? Sound travels very differently under water. It travels faster and it also echoes in certain ways from the temperature layers. And then it is picked up again on the other side of the Pacific Ocean or did I say Atlantic Ocean? And then it goes through the Alps [laughter] and then it comes down and goes across the New York Giants football field. Spaces where the sound would pick up the acoustics of whatever spaces or places that the sounds travel through. That to me is a fantastic idea.[28]

When one interviewer checked Lucier on the fanciful nature of such ideas, Lucier insisted that "it's not so far from the truth" and referred to the US Navy's ELF (extremely low frequency) antenna in Clam Lake in northern Wisconsin, which brings miles of bedrock in-circuit with an overhead line to communicate with nuclear submarines around the world. The rock may have been used as an antenna but the transmissions were electromagnetic instead of acoustical and, Lucier added, "the Navy has another agenda . . . mine is artistic."[29]

In the notes for *Quasimodo the Great Lover,* Lucier made a concession to whale sounds when he instructed the use of their "music" as a model in order to "compose a repertory of simple sound events such as single pitches of short or long duration, simultaneities of various densities, upward and downward sweeps," and so on.[30] One suggestion was for "motives seemingly modal in character," that is, *quasi-modal,* if that rings a bell. The preferred vocal form was whistling, because "whistles are simpler wave forms than vocal sounds, and it seems to me that we needed something simple at the beginning of the microphone-speaker systems if we were to capture the acoustic characteristics of all those corridors and stairwells. If we had started with complex sounds, there would have been too much confusion at the end."[31] Whistles had, of course, made a prior appearance amid long-distance propagations in *Whistlers,* and pure-tone glissandi would crisscross Lucier's subsequent sine wave works.

A notable performance of *Quasimodo* by Laura Cameron and Matt Rogalsky used sampled sounds of the American robin that, when slowed down, emulated the glissandi of the whales and formed their own intricate patterns.[32] They also used audio streaming on the Internet for a global-scale performance originating at the University of Edinburgh, then moving through the University of Glasgow; Norwich and Hatfield in England; Brussels; Bratislava; Kingston, Ontario; Middletown, Connecticut; Vancouver, British Columbia; Perth, Western Australia; and finally to The Hague. As Rogalsky explains, "Each location got what was coming from the previous location, but the 'end product' was also being streamed and was also available in each location should anyone want to listen."[33] One of the people listening was Lucier. He was sitting in the World Music Hall at Wesleyan University and heard the sound of a robin modulated by spaces in Edinburgh, Glasgow, Norwich, Hatfield, Brussels, Bratislava, and Kingston. The sound resonated with a Javanese gamelan in the World Music Hall before continuing to Vancouver.

The way *Quasimodo* goes in- and out-of-circuit with both acoustical and electromagnetic energies, of acoustical space and electrical circuits, of sound and signal, reiterates Lucier's earlier desire to break open the closed circuit he saw in use with synthesizers, computers, and DIY electronic component systems and let in some air. And it also repeats transductive trajectories in the "mixed circuits" in the history of telecommunications, in earth returns, ionospheric reflections, and elsewhere (see chapter 20). It would be possible, following Lucier's lead, to create and understand mixes and mashes that are transperceived environmentally.

Perceiving the effects of what inhabits and imbues these spaces and distances—whether trading in transductions-in-kind or transductions-in-degree, or in sounds and/or signals in all manner of media—is a matter of *transperception*. A sound is not merely a sound from its source; it includes intervening media (air, atmospheric currents from wind and temperature, ionized air, rock, walls, electronic circuitry, etc.), objects, and artifacts, including the final absorptions, reflections, and modulations made by the immediate environment of shoulders and clothing, head, hair, hearing aids, the transductive physiology of hearing, and so on. Indeed, in this sense it can be said that a sound is always sounds.

In his journal, Henry David Thoreau describes the intervening spaces and perceptual processes that make up transperception for both visual and auditory phenomena. Visually, he points out that the whole notion of *landscape* is, at a minimum, what is seen at a distance plus the intervening space. Travel to the place you find enchanting and what was the landscape will lose the picturesque quality, since only with a "depth of atmosphere to glass it" does landscape exist. It is a spatial dimension that raises havoc with indexicality: "Heaven intervenes between me and the object—by what license do I call it Concord River."[34] Listening at a distance has its own acoustical equivalent of intervening lens, glass, or heaven that can be heard in "that portion of the sound which the elements take up and modulate."[35]

> I hear Lincoln bell tolling for church. At first I thought of the telegraph harp. Heard at a distance, the sound of a bell acquires a certain vibratory hum, as it were from the air through which it passes, like a harp. All music is a harp music at length, as if the atmosphere were full of strings vibrating to this music. It is not the mere sound of the bell, but the humming in the air, that enchants me, just [as the] azure tint which much air or distance imparts delights the eye. It is not so much the object, as the object clothed with an azure veil.[36]

It is not merely the air in the intervening distance that modulates the sound; the sound has also "conversed with every leaf and needle of the woods. It is by no means the sound of the bell as heard near at hand, and which at this distance I can plainly distinguish, but its vibrating echoes, that portion of the sound which the elements take up and modulate—a sound which is very much modified, sifted, and refined before it reaches my ear."[37]

In Thoreau's journal, the Lincoln bell is heard alone echoing through the woods, whereas in *Walden* the Acton, Bedford, and Concord bells join in and echo from "vale to vale," each echo being a quasi source in itself, with a foundation in wood rather than the metal of the bell. The sound gathers up wood as surely as it is strained through leaves and needles of the woods.

Elsewhere Thoreau compares the echoing bell with his own voice and writes, "The echo is to some extent an independent sound, and therein is the magic and charm of it. It is not merely a repetition of my voice, but it is in some measure the voice of the wood."[38] Thoreau hearing the elements of the wood gathered up in his voice, or what used to be his voice, is very different in principle from the gentleman who "can send a whisper round the planet into his own ear."[39]

Instances of transperception in literature and life are not uncommon but their character is commonly disregarded. Perhaps it has been overridden in how broadly the concept of mediation is applied. Mediation is constituted by a similar mix of materiality and imagination, but it is normally imagined from a position outside experience, frequently from the side, as in sender-receiver diagrams, or commandingly from above, as in cartographic notions of networks. Sender-receiver diagrams aspire to generalize informational messages into a static free field of energy called a situation, when in fact there are innumerable situations in which no one sends and no one receives.

Even within a primacy of messaging, mediation and transperception both presume the existence of channels of intervening space and time that are not evacuated. But in mediation, channels, noise, and mediation itself are identified at their peril; channels are known to be collapsed, noises silenced, and mediation ultimately self-sacrificed, taking on the speed of light to become transparent. On the other hand, a Thoreau-like transperception leaves all the leaves, needles, wood, and mist where they are. If mediation were not so self-effacing, then transperception could be understood as a foreshortened mediation, foreshortened from any direction within experience, whereas in mediation senders and receivers are imagined from the outside and from the side.

Some may see a star twinkling in the sky, others a star and roiling atmospheric lensing, others still Dopplered starlight warped in space-time scintillating in atmospheric and anatomical lensing moving into a transductive cascade in the retina where the brain joins the eye. Transperception evolves through a conscious fore-hearing or fore-sight by a person knowing or imagining what is involved, yet it becomes embodied like everything else and need not be rehearsed each and every time. The field is always complicated because elements—the propagated energy, paths of propagation, media and matter, objects and bodies, ambiences and environments—continually exchange with one another.

There are, of course, historical factors. Prior to the 1920s, people hearing a whistler probably did not hear lightning as a probable source. Prior to the

1950s, people hearing a whistler may have heard lightning from great distances. After the early 1950s, it was possible to hear the sliding tones of sferics coming from great distances and whistlers coming from lightning at even greater distances after having been modulated by flux lines in the magnetosphere. This is what Alvin Lucier had heard in whistlers. Internalizing the energy source, source location and distance, and process of propagation and trajectory resulted in a transperception of a poetic disjuncture of immanent distances and large powers in little sounds. There was a poetics in knowing that the huge energetic power of a lightning strike had generated a broad range of frequencies and that these frequencies were teased out, some traveling more slowly than others, over thousands of kilometers, interacting with the ionosphere and magnetosphere, all to be foreshortened in little lilts of short sliding tones and delicately sweeping glissandi. It would, of course, be unnecessary to reinvigorate such knowledge every time Lucier transperceived the geophysical scale of the earth. Although the scale might not be the only thing in the sound, it would be in the sound.

Space is also reformed by an inability to completely annihilate it through telecommunications technology and that space, that inability, can be perceived. Now that the final telephonic triumph of people hearing themselves whisper around the world has been achieved, the world is known through its delay, its break in instant solipsistic gratification. Electromagnetism travels at the speed of light, in the *blick* of an eye, and has made the earth smaller, but the earth will forever be big enough to make instantaneous communication a desire. It would take 134 milliseconds for one lap around the equator at the speed of light in a vacuum, but a vacuum along the equator would be impossible to manufacture and hazardous to walk across. Optical fiber results in a delay in glass, and things get slower still, given all the switches, protocols, processing, buffering, interfaces, and other factors that go into what engineers call *the problem of latency*—that is, delay—in contemporary networked communications. A brief absence or deformation can prevent the collapse of a channel; in this way, latency saves the earth from total annihilation.

In the early 1960s, Nam June Paik provided us with a musical test that is still applicable on a planet ubiquitous with wireless:

Play in San Francisco
the left-hand part of the Fugue No. 1 (C. Major)
of the "Wohltemperiertes 1" (J. S. Bach)
Play in Shanghai
the right hand-part of the Fugue No. 1 (C. Major)

of the "Wohltemperiertes" (J. S. Bach)
Commencing exactly at 12 noon 3rd of March
(Greenwich mean time) at Metronome tempo [quarter note] = 80
—it can be broadcasted at the
same time from both sides
of so called "pacific" ocean.[40]

Whereas minstrels once wandered across land on foot and across more foreign lands in lyrical imagination, contemporary musicians who want to perform live with one another from disparate global locations run into problems of latency. Musicians already work with acoustical latencies in the air; there might be 5 to 10 milliseconds in a small group whereas "a double bass player listening to the triangle player on the other side of an orchestra will encounter latency of around 80 to 100 milliseconds."[41] Professional string quartet players can begin to experience problems in performance at about 25 milliseconds, so it is fortunate that they already sit fairly close to one another. Only in certain types of music can a musician show up late for a performance that is already under way, which is what happens when latency jams the global from one moment to the next.

Nam June Paik's split-hands performance of *The Well-Tempered Clavier* would not be well-tempoed. It would be difficult enough for two people to coordinate hands with the precision that Bach requires if the keyboards were right next to each other, let alone in Shanghai and San Francisco. Because (at the time of this writing) the optimum network latency one-way across the Pacific Ocean is at about 110 milliseconds, the left hand would not know what the right hand was doing, and people listening anywhere in the world who knew Bach would know.[42] This does not amount to failure. Allowing the expanse of the ocean to leak into keyboards creates new contrapuntal intricacies and renders Bach contemporary. Beethoven's *Moonlight Sonata* is different when bounced off the moon.

13 **Pauline Oliveros**

Sonosphere

Pauline Oliveros, one of the central figures in experimental and electronic music, has over a long career developed the notion of what she calls the *sonosphere.*[1] Unlike R. Murray Schafer's notion of soundscape, Oliveros's sonosphere embraces a full sweep and barrage of energies, including the magnetic, electrical, electromagnetic, geomagnetic, and quantum, as well as the acoustical. It resonates among personal and interpersonal, musical, earth, and cosmological scales informed by physics and metaphysics. Furthermore, unlike soundscape, there is no stigma of technology arising from a moral chasm between nature and technology: "Some of the most beautiful sounds in the world are produced by the cries of creatures such as the loon, coyotes, spring peepers, tree frogs, cicadas and many more. From the Technosphere we have the beauty of vanishing carefully crafted signal sounds such as train whistles, foghorns, bells and others that once were an integral part of communities."[2]

Oliveros's idea of the sonosphere runs deep. It rises up from the turbulent movements and geomagnetism of the core of the earth, the fluid convections in the core and convection in the atmosphere from the momentum of the earth's spinning orbit in the sun's thermal influence, and moves out through analogies and transductive intermediaries of acoustical and electromagnetic fields and waves. When she first coined the term, she says, "I was thinking of the core of the earth, an octagonal iron core that spins, and that the sonosphere emanates from the core and the waves—the wave forms enter [the spinning] and radiate from the core all the way up. . . . It interrelates to everything else: the atmosphere, the stratosphere, the magnetosphere, and so forth. . . . From the sonosphere you should be able to map an overview of waves that are waving. The waves are out there and they're waving."[3]

But the sonosphere is not merely waves; it is also constituted by particles of energy: "There is a communication with matter that is a communication with energy. There is a field that is set up between yourself and the phonons and waves. . . . The phonon is to sound as photon is to light. We have sound particles; we have light particles. Maybe it is possible to perceive phonons. I don't know."[4] Elsewhere, as part of what she calls *quantum listening*, Oliveros posits a "deep relationship between Chi Kung and Quantum Field Theory," and she describes how "in practicing Chi Kung I have experienced listening with the palms of my hands to sense electromagnetic fields."[5] Her corporeal practice is bolstered by a spiritual technofuturism, and she imagines a time when a chip "implanted in a human or a machine" could facilitate a *quantum improvisation:* "Moment of local sound—moments of moving sound with the ability to detect locations from light years away—defining new interdimensional spatiality. What would a spatial melody sound like—a pitch beginning in Saturn moving to Aldeberon to Sirius to Earth? . . . Space is the place—I hear you Sun Ra!"[6]

Oliveros accepts contributions from both the biosphere and the technosphere into her performances.[7] After one concert, people independently asked how she was able to coordinate the timing of the fire engine sirens outside the performance space so well; at other times, thunder and lightning proved providential in what she affectionately calls "Pauline's orchestration."[8] During a performance of Alvin Lucier's *Music for Solo Performer* in the early 1970s, waiting for the sound of brainwaves became a lightning rod for a thunderstorm. As Lucier recounts, "She [Oliveros] got a Zen meditator and a bunch of technicians. . . . Pauline had everything set and the performer sat there and nothing happened. Several minutes went by and the technicians started checking the wires. And nothing happened. Then all of a sudden there was a lightning storm, a huge storm. Pow! And rain came pouring down on the Quonset hut. All this percussion and lightning and thunder. It was a real-time installation."[9] Oliveros also mused that the interrelation of brainwaves, electronic circuits, and sound in *Music for Solo Performer* meant "that we no longer needed electronic music studios; we already had them in our brains."[10]

Moreover, she was willing to map brainwaves onto the earth scale by correlating them to global television networks, where a veritable entrainment of brainwave oscillations occur through broadcasts of major news events. When the funeral for Princess Diana was broadcast on television, the fact that it was the largest media event in history meant that "many more brainwaves were coordinated by a shared experience simultaneously

than ever before."[11] Here wonderment, geophany, and empathy were exercised through the global media celebrity of disenfranchised royalty.

As Gordon Mumma once wrote, "Pauline Oliveros is involved in both rational and non-rational aspects of music. She is diversely skilled in instrumental and electronic music techniques. She also uses procedures of extrasensory perception and telepathy."[12] She comes from a spiritual and occult tradition among American modernist composers that was influenced by Theosophy and included Henry Cowell, Ruth Crawford, and Dane Rudhyar, as does her contemporary in experimentalism David Tudor, whom she considered "one of the most spiritual persons I knew."[13] Tudor, who was not usually forthcoming about his dedication to Anthroposophy, discussed it with Oliveros, but she was "mainly interested in his approach to making music and his approach to making community."[14] Theosophy was a place where women could assume a spiritual leadership anathema to the entrenched patriarchal authority of Western monotheistic religions, and for many people Oliveros has assumed a similar presence in music.

Within the tradition of Theosophy there was a notable engagement with the physical sciences. Beginning in the last quarter of the nineteenth century, Theosophy invoked contemporary physics, alongside a panoply of Western esotericism, Hinduism, and occult practices, in proposing a vibratory cosmos. Its main criticism of science was that it was limited by its attachment to material realities and rationality, whereas clairvoyance, supersensory experience, and so on could access "other realms" and give a more complete picture of reality. However, the anthropocentric tenets of traditional religions were evident in other realms of Theosophy inhabited by quasi-theistic phantoms who consulted on the conduct of human activity.

Like many occult practices, Theosophy adhered to simplistic and arcane numerical systems that were far more rationalistic than respectable mathematicians at the time would condone. Indeed, Theosophy can be understood as a reaction to the mathematical modeling of physical realities that was jeopardizing the observational practices of science inherited from the Enlightenment. In response, Theosophy based itself on an experiential physics, extended perceptual capabilities, and simple mathematics. Most modernist artists and musicians were attracted to these features of Theosophy, rather than to its set of astral authorities.

Theosophy also delved into atmospheric and geophysical acoustics. Madame Blavatsky wrote that "the Northern Buddhists, and all Chinamen, in fact, find in the deep roar of some of the great and sacred rivers the keynote of Nature" and that it is "a well-known fact in Physical Science, as well as in Occultism, that the aggregate sound of Nature—such as heard in the

roar of great rivers, the noise produced by the waving tops of trees in large forests, or that of a city heard at a distance—is a definite single tone of quite an appreciable pitch. This is shown by physicists and musicians."[15] On the physics side, Blavatsky referred to Yale University professor Benjamin Silliman, who wrote the following passage in a textbook: "*Key-note of nature.* The aggregate sound of nature, as heard in the roar of a distant city, or the waving foliage of a large forest, is said to be a single definite note, of appreciable pitch. This tone is held to be the middle F of the pianoforte—which therefore be considered the key-note of nature."[16]

C. W. Leadbeater, a leader among the second generation of Theosophists, extended this ambient acoustics to earth scale and recuperated it into the perennial myth of the music of the spheres:

> There is a yet higher point of view which all the sounds of nature blend themselves into one mighty tone—that which the Chinese authors have called the KUNG; and this also has its form—an inexpressible compound or synthesis of all forms, vast and changeable as the sea, and yet through it all upholding an average level, just as the sea does, all-penetrating yet all-embracing, the note which represents the earth, in the music of the spheres—the form which is our petal when the solar system is regarded from that plane where it is all spread out like a lotus.[17]

In effect, he imagined the earth as a big spherical gong that resonated with all accumulated acoustical activities, spiritually reverberating within a larger tonal universe. The actual science of earth "hum" is more recent and nowhere as triumphant. The earth is continuously ringing, independently of seismic events, between two and seven millihertz due to energy exchanges between the lithosphere, hydrosphere, and atmosphere. The hum is exceedingly weak—its cumulative global force if harnessed would power a few lightbulbs—and it sounds off fifteen octaves below middle C.[18]

Pauline Oliveros's notion of sonosphere is influenced both by contemporary physical sciences and the tradition of occult engagement with the physical sciences typified by Theosophy. In 1998 Oliveros composed *Primordial/Lift* based on the admixture of brainwave entrainment, Schumann resonances, and geomagnetic reversal presented in a New Age book by Gregg Braden, *Awakening to Zero Point: The Collective Initiation.* All of these phenomena are real, but Braden's concoction took pseudophysics to a brand new level. Schumann resonances, named after the German physicist Winfried Schumann, are the low-frequency electromagnetic resonances of the entire earth; they are, in effect, the sound of a big spherical gong made

up of electromagnetism rather than acoustics. Their fundamental frequency of 7.8 hertz is the product of electromagnetic standing waves determined by the size of the earth-ionosphere waveguide and speed of light. Geomagnetic reversals are when the magnetic poles wander and then exchange places due to chaotic fluctuations in the earth's molten core. It has occurred in the past and, according to their geophysical rhythm as studied in paleomagnetism, another reversal is overdue.

According to Braden's 1994 book, the New Age was fast approaching because the Schumann resonance had moved from 7.8 hertz, and Braden predicted it would reach 13 hertz by the year 2010. A geomagnetic reversal would then occur and the earth would start spinning in the opposite direction, although he never said what the braking distance would be before everything was thrown in reverse. The result, Braden let us know, would be apparent to everyone because the sun would rise in the west and set in the east, as opposed to people waking up on the wrong side of the bed. The increasing frequency of the Schumann resonance would entrain people's brainwaves from their dozy alpha state (where Lucier's *Music for Solo Performer* takes place) to a more vigorous pitch of 13 hertz, that is, in the beta range, "the waking state approaching hyper-wakefulness and high alertness. *As we collectively move toward the vibration of 13 Hz, Earth, and all life upon Earth, is just beginning to wake up.*"[19] It goes on and on and becomes increasingly bizarre. Braden did not merely exploit gullibility and hope; he ended up by spinning this New Age awakening into yet another Christian Resurrection, albeit with the new dawn of Christ resurrected on the opposite horizon.

Artists operate under a different license than occult magi, religious authorities, and New Age charlatans. Audiences are not required to convert to Catholicism to listen to Olivier Messiaen, and viewers of paintings by Wassily Kandinsky or works by Joseph Beuys need not be familiar with Rudolf Steiner's Anthroposophical texts. And it is not as though learned physicists are immune to musical mysticism. Physics professor Brian Greene in *The Elegant Universe* states outright, "With the discovery of superstring theory, musical metaphors take on a startling reality, for the theory suggests that the microscopic landscape is suffused with tiny strings whose vibrational patterns orchestrate the evolution of the cosmos. The winds of change, according to superstring theory, gust through an Aeolian universe."[20]

When these winds blow across the ear ports of a conductor, oddly, no one hears brass or woodwinds. The acoustical cosmos of the symphonic repertoire is located instead among the true inheritors of the Aeolian, that is, in

the string section, and only then among first chair violins. The conductor Joseph Eger in his book *Einstein's Violin* is particularly incorrigible:

> Music is based on the same vibrating waves as the tiny strings (a trillionth of a trillionth the size of an atom!) described in string theories.... Can it then be claimed that the only difference between superstring theory and the common understanding of music is a matter of scale? Consider for a moment the first violinists in an orchestra.... If one takes a string and elongates it to cosmic scale, that string would be subject (like everything else) to curved space-time. The vibrating string, whether from a violin, or of quantum size, will eventually curve back on itself, like the superstring loops previously described. One can speculate that this vibrating string and its fellows could create a kind of "heavenly music" imagined by Kepler and other scientists before and after. The special wave and frequency patterns that we call music and that elicit universal responses from all life (not just from human beings but also from animals and plants) extends throughout the cosmos.[21]

With musical metaphors taking on Greene's "startling reality" and Western art music grandiosely resonating with the entire cosmos like never before, the tiny wriggling spawn of the Pythagorean monochord are absolutely everywhere, even though the microphonic means to amplify these tiny violins oscillating in n-dimensions remain in the design phase. At least among occult versions not everyone is a second brass citizen scattered rows behind the first chair.

Andrew Deutsch, a former student of Oliveros who was key in commissioning *Primordial/Lift* and performed at its premier, noted that "Pauline told us [the performers] all about Braden's book and his ideas, but she did so in a way to trigger our imaginations, rather than as a 'scientific fact.'"[22] The only precondition put on the commission was that it involve Tony Conrad on violin. The score includes schema for instrumentation, interaction and, ultimately, improvisation that were already part of Oliveros's musical practice and energetic cosmos. The *Primordial* section also includes a textual schematic for interoception: to listen to, embody, and/or emulate cell dividing, muscle contraction/expansion, blood circulation, and nerve firing. As Deutsch put it, this attunement was consistent with Oliveros's performance approach of "listening to everything all the time and reminding yourself to listen." The sustained sounds of the *Lift* section are underpinned by Conrad's close attunement to how a note changes over long durations, or as Deutsch says, "his amazing ear."[23]

The influence of the Braden book itself is most evident in the overall structure of *Primordial/Lift* and in its emulation of the Schumann resonance with the ambience created by the low-frequency oscillator. The oscillator

sweeps from 7.8 hertz toward 13 hertz over the course of 45 minutes of the *Primordial* section and then sustains 13 hertz for 30 minutes of the *Lift* section. Although the frequencies were subaudible, they were amplified and, as Deutsch recounts, "the oscillation filled the room, pressed on your head and eardrums, but was not heard as anything other than an ambient element, and it was used to amplitude-modulate the performers and sounds," such that everything played "*is* in the pulse of the oscillator."[24] Oliveros's simulated Schumann resonance was felt on the body and in the body and was heard as its effects were heard. Indeed, Oliveros said that her true motivation for the composition was not so much Braden's meaning behind the sweep from 7.8 hertz to 13 hertz, but to "feel how that feels."[25]

That a low background tone would influence phenomena, or that there would be a relationship of a fundamental to epiphenomenal overtones, hearkened back to when Oliveros was a girl on long car trips with her parents: "I would lie in the back seat listening intently to the modulation resultants produced by [their] voices interacting with engine vibration."[26] It also relates to her use of combination tones, an acoustical effect she learned when she was sixteen from her accordion teacher that formed the basis of her early electronic music: "I wished for a way to eliminate the fundamental tones so I could listen only to the combination tones. When I was thirty-two, I began to set signal generators beyond the range of hearing and to make electronic music from amplified combination tones. I felt like a witch capturing sounds from a nether realm."[27] Using tones below and above the audible range to produce tones within the audible range paralleled the transduction-in-kind between acoustics and (unheard) electromagnetism and was, thus, productive of her energetic cosmos. These epiphenomenal relationships of the effects of the unseen and unheard are conducive to spiritual thinking, just as they are fundamental to science and operative daily in technological devices: all that Oliveros has embraced in her sonosphere.

As we have seen, Oliveros wondered whether the global broadcasts of Princess Diana's funeral, being the largest television event in history up to that time, simultaneously entrained brainwaves among the worldwide viewers into a sonospherical synching. In July 1969, nearly three decades before Princess Diana's funeral, Oliveros was watching what was at that time the largest media event in history: the launch of *Apollo 11* and the lunar landing. As we shall see, it would involve a different set of Dianas.

"I saw the astronauts landing on the moon," says Oliveros. "I thought, the moon reflects light, why couldn't it reflect sound? Why couldn't I send sound to the moon and get the echo to come back?"[28] The two viewings

were related insofar as Diana was also the name of the Roman goddess of the moon. In 1987 Oliveros created *Echoes from the Moon,* an installation and performance device setting for reflecting and receiving radio signals off the surface of the moon, with the composer Scot Gresham-Lancaster as technical liaison.

Gresham-Lancaster was technical director at the Center for Contemporary Music at Mills College when Oliveros retained him to investigate how it might be possible to have "a live microphone in a gallery in New York that patrons could speak into and hear their voices return."[29] He found articles on "moon bounce" in his neighbor's amateur radio magazines. Radio amateurs began bouncing signals off the moon in 1960, much as they had bounced signals off the ionosphere during the 1920s. One of the articles led him to make contact with one of the authors, David Olean in Lebanon, Maine, who generously offered his expertise, high-powered amplifiers, and twenty-four yagi antennas he had installed on a hillside. A high-quality return phone line between New York City and Lebanon proved too expensive, so Oliveros traveled to Lebanon to make recordings to use for the New York exhibition: "I sent my first 'hello' to the moon from Dave's studio in 1987. I stepped on a foot switch to change the antenna from sending to receiving mode and in 2–1/2 seconds heard the return 'hello' from the moon. The sound shifted slightly downward in pitch—a Doppler effect caused by the motion of the moon moving relative to the earth. . . . Then I played with the moon using a tin whistle, accordion and conch shell."[30]

For an outdoor performance in 1996 at California State University in Hayward, Gresham-Lancaster once again assisted Oliveros, but this time phone lines were successfully set up with a ham operator in Syracuse, New York, Mark Gummer. There was a lunar eclipse that night, and when each sound made returned in an echo the audience cheered. Later in the evening Gresham-Lancaster set up a phone line with radio operator Don Roberts on Bainbridge Island, Washington, and Mike Cousins at the Stanford Research Institute. Remarkably, Cousins used the huge, 150-foot-diameter antenna on a hill behind Stanford known as the Dish, a Cold War landmark that had been dormant for the previous twenty years.

Four hundred people lined up that night to "touch the moon" with their voices.[31] It was the type of experience that Oliveros had intended for the exhibition in New York a decade earlier. Hearing one's own voice can be strange, but there is an unlikely intimacy when it returns after having traveled over 750,000 kilometers. And there can be sensuality in the very act of touching the moon. This was evident in one of the earliest proposals for telephoning the moon, reported in the *Los Angeles Times* in 1895, based in

the possibility of "communication on the well-known laws of ether vibration. The ocean of ether waves quivers to every touch. It binds the planets together with an iron hand, flexible yet firm, solid yet infinitely elastic. It is the ideal medium for the transmission of signals. When an iron mass is in the vicinity of these electrical vibrations, a buzz or hum is given out. . . . If the moon contains iron, and there is reason to believe that it does, the striking upon it of these marvelous vibrations would give rise to a murmur of sound."[32]

The idea of individuals touching the moon with their voices, or making it murmur as one might send waves across an ocean, is in sharp contrast to the masculine aggression involved in the first moon bounce and in the most famous echo from the moon. The first successful moon bounce occurred in 1946 as part of Project Diana when a radar signal from Camp Evans in New Jersey was returned after 2.5 seconds. The lead engineer, Lt. Col. John DeWitt Jr., had worked at Bell Labs starting in 1929, where he was inspired by the reception of radio astronomy signals from the Milky Way by fellow Bell Labs engineer Karl Jansky. In 1940, DeWitt attempted unsuccessfully to bounce radio signals off the moon as a means to study the upper atmosphere. On the other side of World War II, equipped with high-powered radar developed during the war, the project under DeWitt's direction was successful on January 10, 1946. He decided to name it Project Diana because, "The Greek [sic] mythology books said that she had never been cracked," alluding to Diana's virginity.[33]

The most famous echo from the moon occurred during the *Apollo 11* lunar landing itself in a radiotelephone conversation between President Richard Nixon in the Oval Office of the White House and astronauts Neil Armstrong and Edwin Aldrin on the lunar surface. A global television audience could hear Nixon's voice echoing back as he spoke. In a carefully crafted script, he let everyone know that "this certainly has to be the most historic telephone call ever made," or, more precisely, "this certainly has to be the most historic telephone call ever made . . . istoric elephone call . . . I just can't tell you . . ."[34] You can hear him stutter a pause as he hears the sound of his own voice, a latency interjected into his imperial message. He announced to the world that "for one priceless moment in the whole history of man, all the people on this Earth are truly one," in what happens to also be the "proudest day" in the lives of all Americans, as the Sea of Tranquility washed over the Gulf of Tonkin. On the deck of the aircraft carrier after splashdown, in a "mission accomplished" moment, the president let loose with an axiom that echoed throughout the Nixonian cosmos: "This is the greatest week in the history of the world since Creation."[35]

Figure 15. Katie Paterson, *Earth-Moon-Earth (Moonlight Sonata Reflected from the Surface of the Moon)*, 2007. Disklavier grand piano; installation view, Cornerhouse, Manchester, 2011. Photograph © We are Tape, courtesy of the artist.

Five years before Nixon used the moon to reflect American superpower back to earth, in a draft letter to John Cage the artist Nam June Paik imagined a different future in which telecommunications had reverted back to long-distance travel:

TELE-PET
Radio dominated 50 years and gone.
TV will dominate 50 years and will gone
What comes next?
How white, black, yellow people spend their
leisure time in the earth, between their vacation
in the moon???
Play moonlight sonate on the moon?
.
In 1970, play moonlight sonate on the moon.[36]

Indeed, Alvin Lucier's *Music on a Long Thin Wire* (1977) came from a dream; a very long wire went to the moon and back: "I thought of the American West where we have those barbed wire fences that go on for miles."[37]

More recently, the artist Katie Paterson created *Earth-Moon-Earth (Moonlight Sonata Reflected from the Surface of the Moon)* (2007). With

Figure 16. Katie Paterson, *Earth-Moon-Earth (Moonlight Sonata Reflected from the Surface of the Moon)*, 2007. Ink on paper. Photograph © Katie Paterson, courtesy of the artist.

the assistance of radio operators Peter Blair in Southampton, England, and Peter Sundberg in Luleå, Sweden, Paterson bounced Morse code signals of the score of the first movement of Beethoven's *Moonlight Sonata* off the moon and then retranscribed the echoed information back into notation, which was then played back in exhibition on a player piano.[38]

Because the signal was scattered by irregularities on the moon's surface and was otherwise corrupted in the sending and receiving devices, in the two-way transit through the ionosphere and magnetosphere, and in the process of retranscription, the performance has notes missing, unscheduled rests, and fuller collapses in timing. You can see these differences clearly in the echo of the code: the lunar surface battered by meteorites in the pockmarked score.

Even minor differences are noticeable to the ear; the vernacular status that the composition has for many people means that variations can be felt in an embodied way. At professional levels, imperfections in performance are amplified as flaws in the constitution (body, psyche, talent, training, etc.) of the performer, with larger mistakes unforgivable; this ritualistic, disciplinary stress is one of the reasons that classical music is so ripe for satire. Here, however, there is no performer taking the heat, and the somber tone of *Moonlight Sonata* actually lends itself to fading, faltering, weakness, and failure. Indeed, Paterson employs a novel subtractive sonification based on ever-present loss. Regular radar scans of the surface would employ much higher power and include repetitions to override error, producing a refined data set that a conventional sonification strategy would then transform into music or another art of sound. Paterson's approach is different. Just as one hears the Pacific Ocean leak into the off-timings of Nam June Paik's version of Bach, in *Earth-Moon-Earth* you hear the moon in what Beethoven does not sound like.

Pauline Oliveros and Scot Gresham-Lancaster were not done with the earth-moon-earth circuit or other planetary and stellar return circuits. Oliveros wanted to develop a continuous feed with the moon, "so that it would be possible to play with the moon as a delay line," much as she had done with audiotape-delay techniques in the 1960s.[39] Gresham-Lancaster was also contemplating the $8^1/_2$ minute echo that would accompany, if possible, *Echoes from the Sun,* and both artists were "talking about planetary bounces as well. Maybe a network of bounces."[40] Here, Oliveros's sonosphere goes heliospheric as it heads toward the rest of the universe and interdimensional spatiality.

14 Thomas Ashcraft

Electroreceptor

The intensity with which Thomas Ashcraft pursues both science and art causes a collision that has produced a beautiful array of self-representations. New Mexico friend and neighbor Bruce Nauman chose Ashcraft for a show at the CUE Art Foundation in the Chelsea district of New York. For that occasion his biography read,

> Ashcraft Thomas: aka "Tom from Heliotown," aka "Tom"; extrapolator, gum and tradecake designer, experimenter, specimen trader, precipitator;
> Practitioner of the scientific method;
> Practitioner of slant vision, of micro-monumentalism, of ultra-logic and chance;
> Sculptor, artisan, money stylist: *Red Money Issuance;*
> Cultivator;
> Electro-Receptor;
> Research Director: Jupiter Pulse and Power: Energy Utility
> Born: Rub City, 1951
> Intercept: heliotown.com[1]

More than anything else, Ashcraft observes. He studiously records masses of evidence, with careful attention given to the weak signals and very little things that dominate the environments in which he lives.

Microorganisms, bacteria, and viruses are little things but they add up to a biomass much larger than that of humans; in recognition of this, Ashcraft has designed coins. As composer and independent scientist David Dunn has written, "The iconic form of the bacteriophage becomes a template for universal coding of monetary units—instead of human royalty—questioning what the dominant life form on earth really is, vertebrate or virus."[2] Likewise, what appears to be weak is not. Weak radio signals from outer space originate from powerful forces that traverse enormous distances.

Figure 17. Thomas Ashcraft, *Bacteriophage Coin*, 1983, silver. Image courtesy of the artist.

Those Ashcraft hears bursting from Jupiter originate in the planet's huge magnetosphere that, if it could be seen with the naked eye from earth, would appear many times bigger than the moon. At one time, Ashcraft was interested in panspermia, the notion that the "seeds of life" came from outer space. A bacteriophage, after all, looks suspiciously like a lunar landing capsule, and they are, like any virus, a "dry biologic" that might be more conducive to travel in the cold vacuum of space usually hospitable only to electromagnetic transmissions.[3]

Ashcraft's micro-monumentalism is very different from the heroic microcosm-macrocosm from cells to outer space in Diego Rivera's murals *Man at the Crossroads* or *Man, Controller of the Universe,* for the simple reason that "man" in Ashcraft's cosmos presumes no position of control, only cohabitation. Feral naturalist work in his micro-monumentalism involves microscopically observing and documenting in thousands of short movies the wet biologic of microorganisms found in the rain barrels cohabiting on his property near Santa Fe. Wassily Kandinsky's later work in Paris was based on observing similar microorganisms, and cataloging can be found in the archival drive of many contemporary artists. Ashcraft's

microcosmic dedication is also reminiscent of the novelist Vladimir Nabokov, who investigated butterfly genitalia for hours each day.[4]

Amateurism is a form of love, etymologically and in practice, but Ashcraft would rather avoid the term since in vernacular usage it confuses the professional metrics of both science and art. From stargazing to cosmology, astronomy has long been fertile ground for all variants of amateurism and for independent and institutional science. David H. Levy is a good example. A writer with degrees in English literature, he discovered dozens of comets and asteroids, and his name is on one of the most famous of all comets: Comet Shoemaker-Levy 9. Discovered in 1993, Shoemaker-Levy was by mid-1994 heading for a spectacular collision with Jupiter. Radio as well as optical astronomy was trained on this event worldwide; in New Mexico, that included the Very Large Array radio observatory and the more modest means of Thomas Ashcraft: "I observed the predicted collision times with essentially the same equipment I use now for Jupiter observations; a short wave radio, dipole antenna, tape machine and paper strip chart recorder."[5]

Ashcraft's true inspiration, however, was Grote Reber, another "amateur" who was responsible for establishing the field of radio astronomy as a science. Following Karl Jansky's lead, Reber, a radio engineer, built the first big dish radio telescope in his backyard in Wheaton, Illinois, and began a long life of radio mapping the sky. Like Ashcraft, Reber was driven to observe the world on several fronts, including botany, carbon dating Hawaiian lava flows and Aboriginal sites in Tasmania, meteorology, and more.[6] Ashcraft particularly admired Reber's willingness to move from the United States to Tasmania in order to be a better *electroreceptor:* "He followed his inner vision and also his electromagnetic sensitivity all the way to Tasmania, where the ionosphere is supposedly thinner. He wanted to access the longer radio wavelengths that pass through the thinner sky there!"[7]

It is in his role as artistic and scientific electroreceptor that Ashcraft conducts his radio astronomy and terrestrial radio work. When a meteor, fireball, or "shooting star" enters the earth's upper atmosphere, it leaves a trail of ionized particles in its wake. An FM radio station signal that would otherwise continue, traveling up through the upper atmosphere out into space unimpeded, can reflect off the trail of the meteor as though it was a shard of mirror. D/Xing, the long-distance sport of radio amateurs, has long looked toward meteor showers as a means for reaching farther over the horizon. Ashcraft, on the other hand, observes; the result is a Cagean indeterminacy writ on a geophysical scale: "Radio meteor observers take advantage of this

physical property of radio frequency and radio propagation properties of the meteor. We don't know what the radio is that will be bouncing in at some moment; it might make some interesting poetic utterance."[8] Ashcraft collects these *moments* and calls them specimens, placing them in the same discursive environment as the microorganisms in his rain barrels. Both are sustained by precipitation from different layers of the sky. The ionized tail of one meteor contained a woman's voice: "I'm pregnant."

Ashcraft's delectation of debris is comparable to the art of Kurt Schwitters. Instead of picking up scraps of urban experience from city streets, Ashcraft isolates specimens from the cosmopolis of radio space. At his home in New Mexico in May 1996, Ashcraft collected specimens from FM transmissions in California scattered off the wake of the space shuttle *Endeavor*—in effect, a long, slow meteor—as it headed for a landing in Florida. Two static-filled minutes were replete with quick fade-ins and -outs of the *bah-dap* of a clarinet, perhaps, and other music. Had these signals not been reflected off the ionized shard of the space shuttle, they would have kept traveling through the upper reaches of the ionosphere, radiating from the earth like fuzz off mold.[9]

The space shuttle reflections contained much unintelligible speech; what seemed to be an earnest commentary rounded off into a low-frequency pulsing was chopped up by a deep thoracic clipping and lacerated by the segmentation of syntax and spiking modulation. Affect, gender, and demeanor of the speech remained oddly intact and, remarkably, two hot spots of intelligibility survived: "that have made this nation great" and "the invisible God."[10]

That *that have made this nation great* and *the invisible God* survived amid turbulent happenstance was due to statistical probabilities set by the patriotic and Christian redundancies of American broadcast. These signals were further mixed in New Mexico, where science, military, the security state, and corporate America thrive in mutual parasitism. Ashcraft monitors the day and night sky in the "Rio Grande research corridor," home to the Very Large Array radio astronomy installation and to two laboratories born from the gamma radiation bursts of the Manhattan Project: Los Alamos National Laboratory and the Sandia National Laboratories.[11]

Although Ashcraft receives no salary from Sandia, the lab has provided him with an experimental all-sky video camera to monitor meteors and fireballs. It can "see over the entire state of New Mexico and up into Colorado and down into northern Mexico, 300–400 miles distant in all directions."[12] The camera has quick reflexes toward bright flashes and its role is to record high-velocity impacts of anything that falls from the sky.

Indeed, communications and intelligence satellites resemble meteors when they disintegrate and burn up upon reentry.

During Shoemaker-Levy, Ashcraft developed the love and skills for receiving radio from Jupiter, specifically, Jupiter *bursting*. The earth radio also bursts to other planets in the solar system. As Gerrit Verschuur summarizes it, "The earth would appear as the strongest radio source in the sky at 60 Hz. Those radio signals originate in the auroral regions. . . . It is an odd coincidence that worldwide sources of commercial alternating current are distributed at 50 or 60 Hz, a frequency which happens to be at the natural frequency of the earth's burst radiation."[13] Only when conditions are right do the spikes of the auroral crowns transmit. The same is true with Jupiter.

Jupiter bursting is natural radio broadcast at a heliospheric scale. Radio bursts from Jupiter when one of its moons, Io, passes over one of the special regions of the planet. Io is volcanically active, exceedingly so, and spews out ionized materials that get caught up in Jupiter's magnetosphere, resulting in the transmission of a powerful cone of sporadic radio emissions out into space. When Earth enters and exits the edges of this dancing cone, that is, when Jupiter, Io, and Earth are all aligned, the bursting of radio Jupiter can be detected on Earth. The two types of bursts from Jupiter are called L-bursts and S-bursts. The longer L-bursts pulse like ocean waves rolling and crashing onto a beach, whereas the shorter S-bursts have been described as gravel falling on a tin roof, or a plastic bag blowing and snapping against itself in a stiff wind. Remarkably, if S-bursts are slowed up 128 times, they sound like a flurry of strong whistlers stacked upon one another, which itself sounds like interpenetrating flocks of impossible birds.

On May 29, 2007, Ashcraft held a performance event at the Center for Contemporary Arts in Santa Fe. It shared the site with another observation artwork, James Turrell's *Skyspace (Blue Blood)* (1988). Ashcraft's performance was scheduled between 2:00 A.M. and 4:00 A.M. to catch a "Well-aligned Io-B Pass." At 3:37 A.M. a small audience heard a weak signal but a signal nevertheless. Ashcraft described it as "wild Jovian electromagnetic surf" rendered "triumphal and very evident" when amplified over large loudspeakers.[14]

The patience required of the audience would have been similar to sitting in a movie theater waiting for a momentary flash of the projector's light beam, to catch a glimpse of an image on the screen. Only, in this case, the projector was torquing 400 million miles away, the image was radiophonic noise, and the screen was the surface of the earth where the audience sat like a speck of dust. There would be no other way but through patience to hear the sound of one's position amid the solar system, on the edge of the

transmitted cone of radio, basking directly in line with the bursting interaction of Jupiter and Io.

A little over a year later, on two nights in June, the Center for Contemporary Arts was once again the *venue-edge,* as Ashcraft calls it, for the cone of Jupiter bursting: *Harnessing Wild Electricities from Outer Space for Energy, Information, Sensation and Pleasure.* Around forty people showed up the first night of the performance and fifty on the second, listening under the night sky to various frequencies of *shhhhhhhhhhhhh-hhhh* fluctuating spatially in the stereo field of two loudspeakers as Ashcraft tuned the receiver. Shortly after the event began on the first night, Io aligned with the C-Region of Jupiter, and strong Jupiter bursting was heard. The next night, when Io orbited over the B-Region, the sounds were sparser. To add variety, Ashcraft set up his "radio meteor array that filled the air with interesting *pings.*"[15]

The event announcement informed audience members that the radio bursts were "central nervous system friendly."[16] For Ashcraft the electroreceptor, the beaming of bursts sweeps across Earth and hits the top of his head at the same time it is heard conducted through the antennas and radio gear into the energetic system of his body: "I'm receiving these direct emissions from Jupiter coming right into my central nervous system in about forty minutes travel time at the speed of light from Jupiter. It's a high. It's a buzz. It's exhilarating. It's mysterious. Who knows what it is? But here I am in direct contact with Jupiter."[17] Ashcraft soaks up electromagnetic transmissions into his body with the poetic reverence of a sun worshipper. Indeed, he considers all perception a form of "bioporting" energy. Sharks, rays, eels, dolphins, and egg-laying mammals are capable of electroreception, that is, the perception of electricity. Ashcraft, at the venue-edge, says, "I'm the electroreceptor. I'm receiving and putting out this sound on multiple frequencies that may be tapped into for potential central-nervous-system effect. I'm exploring this new form. It's real, but I know I'm on some sort of edge, as it should be."[18]

15 Black Sun, Black Rain

The American poet Harry Crosby was a heliophanist: he worshipped the sun. In "I Climb Alone" he wanders through the night until, "At last there is a filament of gold. There is the color of the dawn. There is the rising sun burning with gold. She comes toward me as I stand naked on the highest mountain top. The flock of stars have vanished but the Sunstar rises. I feel my eyes filling with fire. I feel the taste of fire in my mouth. I can *hear* fire."[1] A well-heeled bohemian, Crosby is best known for his Black Sun Press, prescient publisher of a number of significant modernist authors. At the center of his universe were suns, black suns, and mythic figures of Icarus, complex sources of living and portents of death that he acted upon. As a modern-day Icarus he planned to fly an airplane into the sun and ended instead in suicide with his lover. Unlike Thoreau's collectivism and geophany, Crosby's heliophany collided with solipsism.

During the 1960s, there was no need to fly into the sun; there had been for two decades, with the advent of nuclear weaponry, the means to bring the power of the sun down to earth. In 1957, the Soviet satellite *Sputnik* moved across the night sky due to a rocket delivery system that meant that there was effectively no place on earth where a sun could not descend. The United States responded soon thereafter with the *Explorer* series of satellites, but only after the Soviet Union sent the dog Laika into orbit with no prospect of returning. The space race ensued, with the intent of sending humans farther away from the earth toward the sun. Rocketry, therefore, provided countervailing directions: an Icarus flying toward the sun or a reverse Icarus of nuclear suns descending from a stigmatized sky. Since the 1960s, the intrinsic solipsism of capitalism has brought the actual sun, rather than its proxies, closer to earth with global warming.

In 1966, the composer Karl-Birger Blomdahl created *Altisonans*, a work of experimental television broadcast to a national television audience in Sweden.[2] In a sophisticated vernacular of experimental film, it begins with the sound of birds greeting a dawn of a black sun that becomes a black pupil of an eye through which *Altisonans* is viewed. The program ends being engulfed in the sun's searing bright light to the sound of solar radio. Between, the birds meld with naturally occurring electromagnetism (whistlers, atmospherics, earth's magnetic fields) and the sounds of telemetry from the *Sputnik* and *Explorer* satellites. In certain cultures birds are intermediaries between terrestrial and heavenly existence, so it is consistent that satellites orbit between the earth and the heavens and were commonly referred to as birds.

Blomdahl, a well-known composer and public figure, was one of Sweden's most prominent modernists. He championed radical tendencies within the arts through the Monday Group and Fylkingen; and, after becoming director of the Swedish Radio Music Department in 1964, he helped establish the Electronic Music Studio. He is perhaps best known for his dystopic space-age *Aniara* (1959), an eclectic late-modernist opera that included *concrète* and electronic music pieces among the bulk of its instrumental and vocal composition. Had his life not been cut short, he might have been known also for the experimentalism at the core of *Altisonans*.

Just as Alvin Lucier's inspiration for using naturally occurring electromagnetism came from personal interaction with a physicist (Edmond Dewan), the idea for *Altisonans* came from Blomdahl's meeting in 1964 with Ludwik Liszka, a physicist and astronomer. Liszka worked at the Kiruna Geophysical Observatory (now the Swedish Institute of Space Physics) above the Arctic Circle, where, among the sounds of natural radio and along with many other interests, he analyzed ionospheric and auroral influences on the reception of data signals transmitted by satellite in the late 1950s and early 1960s.

"Those days the satellites had a very simple, tone-coded telemetry and the satellite transmissions could be acoustically quite intriguing," Liszka remembers. "At certain conditions the tone sequence was repeated periodically. I noticed early a similarity between those sequences and the song of a redwing [a common thrush] we could hear in the spring."[3]

Blomdahl happened to meet Liszka on the island of Capri; he was in residence at the San Michele Foundation working on his opera *Herr von Hancken*, and Liszka was working at the Swedish Solar Observatory. Liszka later shared his observation of this sonic similarity between birds and satellite telemetry: "I demonstrated some of those sounds for Karl-Birger and

he became fascinated. So already in 1964 he understood about the acousti-cal side of the geophysics and space research."[4] Bird sounds, natural radio, and space sounds would form the basis of *Altisonans*.

In the summer of 1966, Blomdahl stayed with Liszka and his family, while he researched materials at the Kiruna Geophysical Observatory.[5] Sture Palmér, well-known recordist for Swedish public radio, supplied the bird sounds; all the other sounds used in *Altisonans* came from the insti-tute: whistlers, ionospheric radio, pulsations from the earth's magnetic fields, broadcast radio sounds scattered off the aurora borealis, solar radio received by a riometer (which measures the ionosphere's absorption of electromagnetic waves), and telemetry from the *Sputnik 4* and *Explorer 7* satellites.

The sound composition begins with bird songs and, over the course of approximately twenty minutes, they meld with space sounds sped up and slowed down, and then the whole piece ends in the solar noise that accom-panies a forward movement into an engulfment by the sun. For the visual imagery, Blomdahl used graphical data from high-speed magnetograms (photographic recordings of magnetic field fluctuations of the solar sur-face), films of the sun and solar flares, oscilloscopic and other forms of data, and video feedback.[6] The sound and images are richly conceived, composed, and interrelated.

Since the work has not been widely distributed, I will attempt a cursory description. *Altisonans* starts on a black screen with the sounds of birds, and slowly a dawn seems to rise, but it is in fact the frame being pulled back on a black sun or, rather, a coronagraph, a black circle historically imposed on a telescopic image to study the corona of the sun. The black circle of a coronagraph masks the light, whereas the black circle of a pupil lets the light pass. As the frame pulls back farther, the black sun becomes the pupil of a solar-terrestrial eye, inside which is a split, warbling flame that sug-gests an asymmetrical bird in flight. These wing-flames glide and dissolve in arcing flares and will eventually be related to solar flares and shown to be generated by the warping televisual plasma of video feedback. Solar flares and data are matted, mapped, and reversed against one another amid skeins of bird-signal sounds, with graphics lensed to appear spherical, plan-etary. Data traversing the screen resembles forms of musical notation that were new in the 1960s. As the film began in black and led to dawn, it ends in white with the shot moving closer and closer into the sun, accompanied by searingly high-pitched solar noise.

Blomdahl stated that he did not want to make a film, but "a sound and vision composition completely bound to the world of radiation," a world

dominated by the sun: "One must be reminded that all of this comes from the sun, that it is our almighty power source. Its eruptions release storms that affect the whole of our part of the cosmos, our existence, and causes disturbances of different kinds."[7] The sun is an almighty power that, unlike religious almighty powers, does not worry about its subjects. Blomdahl's use of solar noise as the grand finale of *Altisonans* was, according to Liszka, meant to point to a grander finale in which "the sun will still be there after humans have destroyed themselves."[8]

In this way *Altisonans* is a tale of an ecological Icarus, alluded to earlier in the apocalyptic narrative of Blomdahl's opera *Aniara*, where the last vestiges of earth's human population are exiled from their poisoned planet on a spaceship to float and perish in space. Blomdahl's own passing prevented his next opera from presenting a similar theme. That opera was to be based on the novel *The Saga of the Supercomputer*, by Olof Johannesson, pseudonym for the Swedish physicist Hannes Alfvén, which recounts the earth's history from the perspective of the evolution of computers.[9] By the end of the book the narrator is revealed as a supercomputer trying to decide whether to rid the earth of humans, now that they have served their evolutionary function.

Liszka gave Alfvén's book to Blomdahl while he was in the hospital recovering from a heart attack and they held many discussions about it. Once he recovered, Blomdahl contacted Alfvén to assure his collaboration and set plans in place to use a computer-synthesized voice for the narrator, electronic music and sound effects, and heliospherical and geophysical input from Kiruna, including cosmic signals used in an indeterminate control mechanism, sounds and signals in keeping with Alfvén's research in plasma physics and cosmology for which he would soon receive the Nobel Prize.[10] The new opera showed that Blomdahl was fully at home in an electrical and magnetic environment in flux, as the epigraph to *Altisonans* (from a poem by Erik Lindegren) declared: "Because our only nest is our wings."

．　．　．

About one and a half minutes into *Black Rain* (2009), a comet tail fans out feather-like in the solar wind and blows across the screen; it may be the McNaught Comet discovered in 2006. Then, amid a miasma of flares, ghosted reflections off lenses, spins, striations, quick stutter-step cuts, and flashing scans, a distant Comet Encke, a naturally occurring Icarus, approaches the sun and, in the brutal vicissitudes of space weather, a coronal mass ejection blows off its tail. There is a plotting and positioning going

Figure 18. Semiconductor (Ruth Jarman and Joe Gerhardt), *Black Rain,* 2009. Data courtesy of the Heliospheric Imager on the NASA *STEREO* mission. Image courtesy of the artists.

on, but in the middle of space there is no perspective. The only orientation is in the fire of the sun.

Black Rain is a "moving-image work" (screen, installation, performance) by Semiconductor, the name under which Ruth Jarman and Joe Gerhardt collaborate as artists. The work develops its sound and images from data transmitted by heliospheric imagers aboard *STEREO,* the pair of satellites whose job it is to fly closer to the sun to monitor the space weather it produces before it hits the earth. *Brilliant Noise* (2006), an earlier work, uses data from both ground-based and satellite solar observatories. Both works were created in part in association with the Space Sciences Laboratory (SSL) at the University of California at Berkeley, as was the artists' well-known fictional documentary *Magnetic Movie* (2007), on the electromagnetic and magnetic fields that scientists tend to every day.

Semiconductor were in the early days of their residence at SSL when, much like Alexander Graham Bell at the Paris Meudon Observatory over a century earlier (see chapter 16), they recall, "We came across a still image of what turned out to be the sun. We were fascinated by this image and wondered why we hadn't seen anything like it before." They are not the only ones that find solar images compelling: "When we show people *Brilliant Noise* they ask 'Did you make that?' and we say that's the sun. 'That's the sun?!' People haven't seen it."[11]

It is uncanny that our backyard star would be uncanny. It traffics the energies that sustain life on earth; even the unearthed fossil fuels that have tilted the energy balance against human habitation are little more than stored transmissions. But for most people, for the time being the sun escapes our daily attention, and looking into it has always meant the end of looking. Scientific images of the sun sit at the end of mathematical, engineering, and computational manipulation. Imagined as a one-to-one analogue, the image is little more than an interpretive default, with modes of sensing and representation intervening at each point. Presumptions are designed into devices and information conditioned by social exigencies. Signals cascade through energy states, intervening space, data conversion and modeling, audiovisual display and venue, physiology and cultural constructs. Not even the sun can survive unscathed but, still, some does shine through. Thus, the image is an incremental analogue.

Contemporary astronomical images, such as those produced by the Hubble Telescope, represent phenomena otherwise invisible to the human senses and are thus aesthetic exercises. Hubble images reduce what is seen among technologically sensed phenomena and then color-code an impossible jewel-encrusted universe, as though the cosmic egg were from Fabergé. Semiconductor associate the air-brushed all-seeing god-eye view of the universe with glossy publications; and, indeed, distant galaxies on display in books of Hubble images are, at this very moment, exerting immense gravitational force upon coffee tables around the globe.

Beautiful Hubble images hold violent dynamics at safe distance and split the Kantian sublime in favor of the mathematical: no comet tails are being ripped off. The static, glitches, anomalies, and artifacts in *Brilliant Noise* and *Black Rain* also reinstate the presence of human observation through exposing technology's contingency and frailty, especially when confronting such a grand scale of natural forces. The static also represents an atmospheric distribution of information in a space where there is no atmosphere. However, noise should never be equated with an interruption of beauty; anyone seeing *Brilliant Noise* and *Black Rain* knows that Semiconductor are dedicated to beauty. But they find it instead in an expressiveness of data, in the possibilities of images that evolve and erupt in dynamic phenomenal and informational events, and in energies that course through circuits and animate codes.

For example, the solar winds consist of charged particles that hit the charge-coupled device (CCD) in the digital camera aboard the *Transition Region and Coronal Explorer (TRACE)* satellite, creating static fields and bursts of visual noise, what Semiconductor call a *rain of snow* seen in

Brilliant Noise. Conventions of scientific rendering minimize and eliminate noise as an embarrassment of the technology, rather than an engagement with existing physical forces, and, if sound is used at all, it will most likely flow from a saccharine tradition of space music. The sound in *Brilliant Noise* is instead "derived from solar natural radio . . . controlled via digitally sampling the intensity of the brightness of the image. The sound is intrinsically born from the image, creating a symphony by the Sun."[12] While straight solar radio would be heard as a near-uniform hiss, and daunting as it may be in *Altisonans,* Semiconductor emulate forces on the solar surface, flares, coronal mass ejections, and cosmic rays by generating sounds through the informational dynamics of physical events.

Instead of a rain of snow, *Black Rain* refers to solar radiation emanating in all directions through the blackness of space. Alluding to the novel *Black Rain* (1969) by Ibuse Masuji and the 1989 film by Imamura Shohei based on the book, Semiconductor relate the radiation of space weather with the fallout both radiating and precipitating from the atomic bomb dropped on Hiroshima: the explosion mixed with atmospheric conditions to create its own weather from hell, including a black radioactive rain that fell upon people and the land. The precipitation of the black rain led some people to think that they had just been attacked by a new type of gigantic oil bomb.

Semiconductor's works are multifaceted, with a deep-running politics; their allusion to Hiroshima is but one field of possibility presented by the work and should not stand exclusively as emblematic. Their allusion to the novel and film *Black Rain* is one way that Semiconductor brings heliospheric violence down to earth, but they also sensed the connection between the sun and nuclear weaponry when they first saw the solar images at SSL: "The sun is a massive powerful thing. Perhaps that's why NASA didn't release the photographs," they told me. And then half-jokingly, "People might see it and flee 1950s-style from their homes."[13]

In Cold War anxieties in the United States, the nuclear light of the sun was not merely uncanny; it carried the beautiful threat of the sublime. During the 1950s Americans were in their homes watching television, staring straight into the electromagnetic radiations of the cathode-ray tube, which was commonly pictured as a domesticated ray gun. They listened to the length of the electromagnetic spectrum of their radios with a little triangle on the dial marking where the spectrum extended all the way up into gamma. The triangle stood for CONELRAD, the emergency radio station that superseded all other stations in case of attack. It was an acronym for *control of electromagnetic radiation,* where radio and radiation meet, that itself collapsed into CD for *civil defense.*[14]

Figure 19. Sun to earth: memory of Ojiri Tsutomu, aged five in 1945, twelve kilometers from ground zero, Hiroshima. From right to left, in the last five seconds before detonation, the "nucleus" grows in magnitude as it descends and extracts the sun's power. From *Hiroshima-Nagasaki: A Pictorial Record of the Atomic Destruction* (Tokyo: Hiroshima-Nagasaki Publishing Committee, 1978), 66.

On the radio sixteen hours after Hiroshima, President Harry Truman compared the unleashing of the atomic bomb upon civilians as bringing the sun to earth: "It is a harnessing of the basic power of the universe. The force from which the sun draws its power has been loosed against those who brought war to the Far East." It was a battle in which the sun of science set upon the land of the rising sun. Truman demanded immediate surrender and promised a biblical "rain of ruin from the air, the like of which has never been seen on this earth."[15] Truman's rhetoric had special significance for Hans Bethe, head of the theoretical division of the Manhattan Project, who had earlier theorized nucleosynthesis at the center of the sun, and for Ojiri Tsutomu, who was five years old when the bomb descended on Hiroshima. Tsutomu remembered the sun feeding the nucleus of the bomb through a lightning strike until the magnitude of the bomb rendered the sun miniscule.[16]

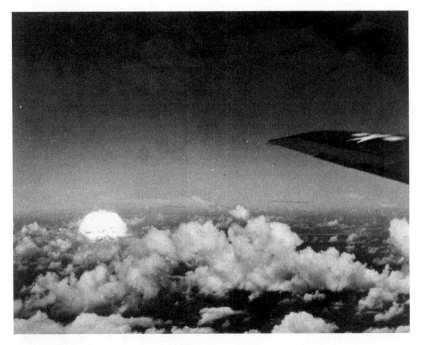

Figure 20. Sun to earth: atomic fireball as seen from the air during Bikini Able test, July 1, 1946. Photograph by Joint Army-Navy Task Force One, courtesy of the Daily Herald Archive/Science & Society Picture Library.

From the vantage point of the sun, the earth is an insignificant reflective dot against a black sky; only a tiny fraction of the sun's radiating energies—4.5×10^{-10}, that is, between the nano and pico scale—reach the earth. Yet, global warming from unearthing old sunlight and releasing greenhouse gasses in the atmosphere has brought the sun ever closer: the sun as reverse Icarus. This is not occurring in a big apocalyptic bang but in the slow burn of energy stored underground, the black rain of an oil bomb in the solar-terrestrial environment.

· · ·

What Paul DeMarinis wrote of his friend and collaborator Jim Pomeroy is applicable to himself. He describes Pomeroy as "a certain breed of American artist who grew up in the military-industrial culture of the Sputnik era: artists who had been inculcated with the codes of science and technology, but who had reterritorialized them to identify technology with culture, and electronics with communication . . . artist-tinkerers who bypassed or defied

the intended uses of technology, who disrupted the hierarchy of the messaging apparatus."[17] For DeMarinis, disrupting the messaging apparatus means investigating the hardware, politics, and histories embodied in media technologies and systems and turning them inside out in order to invent new ones. Erkki Huhtamo has coined a wonderfully apt word to accommodate DeMarinis's special set of skills, conflating tinkering and thinking to describe him as a *thinkerer*.[18]

Anyone growing up in the early glare of the television had been born under the sign of *gamma*. This generational experience was amplified for DeMarinis because of the job his father took in 1957, moving the family from Cleveland westward to

> Ely, Nevada about 100 miles downwind from the atomic test site. My father, a geneticist, had taken a job with the United States Public Health Service monitoring the pathways of radioactive fallout through the sparse ecology of the desert. Sometimes we would wake in the early hours of the morning to see a bomb go off. We'd listen to the countdown on dad's radio, watch as the sky lit up in premature desert sunrise, only to disappear into night and stars again. In the days following a test I remember seeing spectacular sunsets, red walls of fire in the evening.[19]

DeMarinis accompanied his father on trips to gather filters and dosimeters used to measure people's and places' exposure to the atomic testing that was scattering radioactive materials to the wind like sagebrush, tumbling over the vitrified sands of lonesome western landscapes. DeMarinis realized that, just like the measurement missions of *The Great Artiste*, "the Atomic Energy Commission was probably more interested in analyzing the isotope-ratios to ascertain the efficiency of the bomb, than in protecting the citizenry from their excesses."[20] Indeed, by using human populations in scientific measurement exercises, the United States became a serial producer of demographic groups: Hibakusha, Atomic Veterans, Downwinders, and the like.

During October 1957, after the DeMarinis family returned to Cleveland, *Sputnik* was traversing the sky in a mission that combined scientific experiments with the geopolitics of the Cold War. Its radio-transmitted beeping could be heard stretching over the horizon in an elongated Doppler effect modulated by the ionosphere, creating an unwitting electronic music at global scale.[21] This was at a time when television images were the only thing standing between frighteningly entertained audiences and space-age ray guns shooting at them from the back of the sets. When they went outside under the stigmatized skies of the sunny summertime, their meals

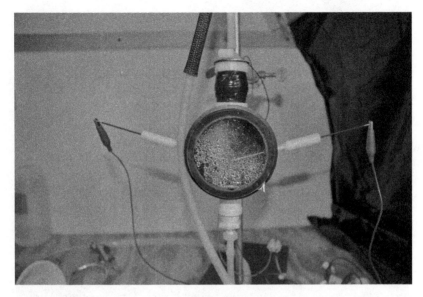

Figure 21. Paul DeMarinis, detail, *Rome to Tripoli,* 2006. Courtesy of the artist.

were served on colorful Fiestaware, the red-orange glaze being especially vibrant because it contained uranium oxide.

Fiestaware appears in one of DeMarinis's best-known bodies of work: *The Edison Effect* (1989–96). *Loving/Dying—The Unrequited Quark* is a beautifully crafted piece that looks like a hybrid of an audiophile turntable, precision lathe, and scientific experiment. A Geiger counter controls a stepping motor that advances a laser beam along an old 78 rpm LP of Richard Wagner's *Liebestod* from *Tristan and Isolde.* The grooves repeat themselves until an isolated radioactive spray of clicks from the Geiger counter moves the music onto the next groove, progressing from one sustained Wagnerian event to the next, and the more constant the radiation the less interrupted the music. A piece of Fiestaware is used as one of the sources of radiation. DeMarinis's *Loving/Dying* relocates the music of romantic-era entanglements onto the half-lives of uranium decay. The deferred union of two lovers means that a full-life can happen only in an afterlife, but their half-lives lead to lead and toxic decay, not love, just like the story says.

The capacity for DeMarinis's artworks to receive and store historical signals becomes literal in *Rome to Tripoli* (2006), based on a spark-gap radio transmitter from the first decade of the twentieth century that used the modulation of a stream of acid both for its technological function and the

politics it messaged: "A stream of sulfuric acid, mechanically vibrated by the voice, reproduces the interruptions of the vocal frequencies as a series of droplets. This stream is passed between two electrodes biased at a DC voltage. Each drop directs a short burst of electricity to a high-voltage transformer configured as a spark-gap radio transmitter. The signals are broadband and can be picked up by any AM receiver in the vicinity. The piece poses questions about the nature of one-way communications, radio-phonic, cultural or military, in particular those between Europe and North Africa."[22] The original contraption, devised by the Italian physicist Quirino Majorana, was used to transmit long-distance messages from Rome to Tripoli as a prelude to the Italian invasion of Libya. It is apropos that acid is used to stream these messages (similarly, DeMarinis constructed flame loudspeakers to play back recordings of the incendiary political speech of Stalin, Hitler, Roosevelt, and Mussolini in his *Firebirds* [2004]).

DeMarinis hears Majorana's invention as an intervention projecting Italian conquest one thousand kilometers across the Mediterranean. He hears it in a playlist of Roman roaming that includes, among others, Verdi's earlier anthem to North African invasion and a recording of F.T. Marinetti's own recitation of *Battle of Adrianopoli*, embodying the expansionist military energies of the avant-garde (a military term) in Italy, in the Futurist codification of military noise in *The Art of Noises* and early transmission of the "wireless imagination." Precedent for *Rome to Tripoli* can be found in a passage in *Finnegans Wake* by James Joyce cited previously (see chapter 10), where the Marconian trek from Italy to England ends up in transmissions of British rule across the Irish Sea, from *England to Ireland;* and in the Francophone transit from *France to Algeria* of Radio-Alger that Frantz Fanon described in *A Dying Colonialism*.[23] This should make clear that celebration of the wonders or intrinsic goodness of long-distance communications technologies is designed to facilitate forms of expansionism: colonial, imperial, military, commercial, and so on. The power of a signal depends on who is sending and who is receiving.

16 Star-Studded Cinema

It is possible to see cinema everywhere. Seeing cinema is associated with projection devices that took hold in the early twentieth century or have been dug up archaeologically from older engineering feats, but entertainments of modulated light seen in darkened spaces have always existed. Small fires have always projected dancing shadows fading into the liminal perimeter of night, and lightning strikes have always etched stutter-step frames across larger landscapes: "Flash rapidly follows flash, while at times the light bursts simultaneously from different parts of the heavens, every cloud and mountain-top appearing then 'white-listed through the gloom.'"[1] Lightning strikes globally around two hundred times a second, a nonlinear film at a high-resolution frame rate on an even grander scale.

When we see stars scintillate it is not because of their original, churning surfaces, but because of the modulating lens effects of the earth's atmosphere. Telescopes and film cameras use lenses made from cooled molten glass rather than using the fluid, moving densities of air. Rising above the earth's atmosphere, stars calm down. Atmospheric lensing, therefore, adds an artificial accuracy to what we see, restoring the dynamics of stellar surfaces lost over the light years. Storage and reanimation, projection, lensing, modulation of light, and artifice in a darkened space: these are all elements of cinema. All that is missing is sound.

Cinema and its devices have been understood through inscription. Thomas Edison wanted to develop a device to do for the eye what his stenographic device, the phonograph, had done for the ear. Anglophone film studies arose from literature departments treating films as texts, and in continental media theory Friedrich Kittler's best-known book—*Gramophone, Film, Typewriter*—flanked cinema with two other inscriptive technologies. When stored frozen frames are run through a film projector,

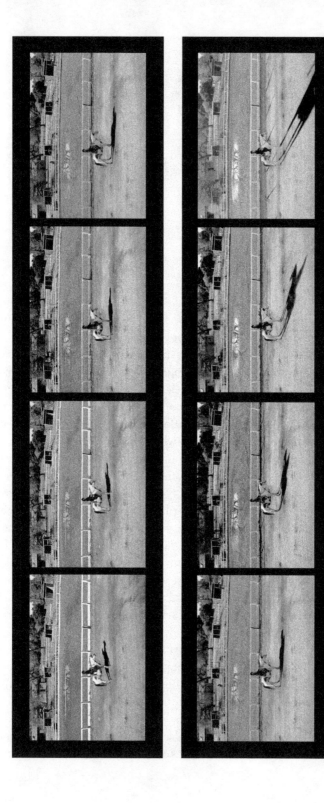

Figure 22. Rebecca Cummins, *Shadow Locomotion: 128 Years After Muybridge, The Red Barn, Palo Alto . . . 11am–5pm, February 28, 2004.* 11 × 78 inches, single row; reformatted for publication. Courtesy of the artist.

Figure 23. Alexander Graham Bell, photophone. From Alexander Graham Bell, "Production of Sound by Radiant Energy," *Journal of the Franklin Institute* 111, no. 6 (June 1881): 406.

they run faster than retinal responsiveness and consequently mimic the energy of the light illuminating them. In an inscriptive and archival sense, it is like the sun shining through a library window. Had Alexander Graham Bell succeeded in listening to the sun live with his *photophone*, we might have a transmissional notion of cinema arising from the late nineteenth century more appropriate to the televisual practices of the present. Even in failing at an archaeological cinema-as-transmission or tele-vision, however, Bell arrived at sound cinema *avant la lettre*.

The photophone that Bell developed with his assistant Charles Sumner Tainter was a pre-Marconi wireless device that carried sound on a beam of light, as though the electromagnetism at the core of telegraph and telephone wires had shed its material constraints. Sunlight was reflected off a mirror modulated by a voice, carried over a distance, where it then landed on a light-sensitive selenium disc (the element selenium, as luck would have it, derives its name from the moon). Light hitting the disc varied electrical resistance that, in turn, was heard in the earpiece as the sound of the voice. "It certainly is a very extraordinary sensation to hear a beam of sunlight laugh, cough and sing, and talk to you with articulate words," Bell said.[2] While in Paris, he tested the electrical resistance of substances other than selenium, including "a whole cigar," which "emitted a beautiful sound; and even tobacco-smoke puffed into the test tube yielded a sound."[3]

Along with its normal telecommunications uses, Bell thought that the photophone would enable him to listen to the sun. At first Bell thought that he could listen to the sun in real time. In 1880, the year he invented the photophone, Bell visited the Paris Meudon Observatory, where its director, the famous astronomer Pierre Jules Janssen, showed him telescopic photographs of "movements of a prodigious rapidity" occurring on the surface of the sun.[4]

Janssen had studied the sun in detail since 1862, when he started study-ing black lines that appeared in the electromagnetic spectrum of sunlight. These Fraunhofer lines, as they became known, are spectroscopic markers of where different elements absorb light, in effect, an interruption of the pure gradient of light by the shadows of atoms. Janssen studied "telluric lines" created by the absorption elements within the earth's atmosphere that were "always visible," and he is well known for having identified a yel-low line in the optical spectrum as the formerly unknown element of helium.[5] Janssen's legacy to cinema was his *photographic revolver*, a device to make a quick succession of photographs, about once a second, in order to document the rare tiny eclipse of the sun as Venus transited across its face. Traveling to Japan to get a good view, he documented Venus masking the sun's corona and, thus, confirmed that the corona was part of the sun and not a visual product of the earth's atmosphere. This astronomical instru-ment made its own transit into the regular study of solar eclipses, the labo-ratory, and chronophotography of Étienne-Jules Marey, and from there the frame rate accelerated into cinematography.[6]

Since it was the quick alternation of light that made the photophone work in the first place, Bell thought that the disturbances on the sun should be audible if the photophone was linked to the telescope responsible for the photographs. As we have seen, ideas of sounds of the sun were in the air at the time and were associated with telecommunications. In 1876, Thomas Watson pondered whether the sounds he heard late a night were the prod-uct of "explosions on the sun" conducted by the telephone line, an idea based on the correlation of disturbances on the sun with auroral displays and their effect on telegraph lines.[7]

In his paper "Application of the Photophone to the Study of the Noises Taking Place on the Surface of the Sun," Bell described how the resources of the observatory were generously lent to him but the sonic potential of the real-time sun were disappointing. Janssen reasoned that the events on the sun moved too slowly to be registered by the photophone, and he sug-gested a technique similar to Eadweard Muybridge's sequential photo-graphs of motion from two years earlier, along with a technique of time compression: "A series of solar photographs of one and the same spot, might be passed with a suitable rapidity before an object glass, which would give conjugated images upon the selenium apparatus. This would be a means of condensing into a time as brief as could be desired the variations which in solar images are much too slow to give rise to a sound." This was an anticipation of both sound cinema and auditory astronomy and, in at least one sense, its provocation was made clear to Bell: "It has appeared to

M. Janssen that the idea of reproducing on earth the sounds caused by great phenomena on the surface of the sun was so important that the author's priority should be at once secured."[8]

Within the history of electromagnetism and the arts, light behaved similarly to natural radio to the extent that it was perceived as a natural material force in the 1960s after having a largely discursive and instrumental status earlier in the twentieth century. Marcel Duchamp, for one, had a keen sense of electromagnetism. The art historian Linda Henderson has detailed this in the chapter "The Large Glass as a Painting of Electromagnetic Frequency," in her standard work, *Duchamp in Context: Science and Technology in the Large Glass and Related Works.*[9]

The instructions Duchamp gave to himself to "make a painting *of frequency*" contributed to his major work *The Large Glass (The Bride Stripped Bare by Her Bachelors, Even),* and other instructions pertained to the terminology of *delay,* what in network jargon would now be related to latency: "Use 'delay' instead of picture or painting; picture on glass becomes delay in glass—but delay in glass does not mean picture on glass."[10] As Henderson points out, "Such a delay is precisely what occurs when a wave of visible light (or any other electromagnetic wave) intersects a pane of glass; it is refracted, or slowed, and thus bent by the encounter. Such effects of refraction, featured in sources on the optics of visible light, had been central to the early investigations of X-rays and to Hertz's experiments with electrical radiations."[11] The delay was a veritable *slice of light* allowing ambient light and reflections to evidence properties of the propagation of light through the transparency, much like a film frame in a cinema projector.

If we follow the movement of light, we see delays everywhere as energy states change, including in the retina itself. Just as hearing results from several transductions in the ear, visual perception is phototransduction in the retina, where photons excite electrochemical signals transmissible in the nervous system and rendered sensible to the brain. The biophysics of this switching process includes the protein *transducin* in a complex *transductive cascade,* which would be analogous to the transduction-in-kind of cilia opening ion channels in the mechanism of the inner ear. However, vision differs from hearing because it lacks reverse or recursive transduction. Whereas sounds heard are accompanied by otoacoustic emissions, there is no immediate equivalent in vision. Despite body glimmer—how the body emits photons (gives off light) at different times of the day—and unlike hearing, the body does not emit light in order to see or in the act of seeing.[12]

This did not prevent the light emanating from Raymond Roussel and all that he touched when he was nineteen years old. The French author, an

Figure 24. Man Ray, *Marcel Duchamp, Tonsure*, 1921.
© May Ray Trust/ADAGP, licensed by Viscopy, 2012.

important influence on Marcel Duchamp and the surrealists, told his psychiatrist about his illuminated manuscripts, how everything he wrote "was surrounded in rays of light, I would close the curtains for fear the shining rays that were emanating from my pen would escape through the smallest chink; I wanted to throw back the screen and suddenly light up the world. . . . But I did indeed have to take precautions, rays of light were streaming from me and penetrating the walls, the sun was within me and I could do nothing to prevent the incredible glare."[13] He placed himself among all "those who feel burning on their forehead . . . the resplendent star which they carry there."[14]

Duchamp did not have a star burning on his forehead but he did shave a star on the back of his head with a stripe running toward his forehead. A Man Ray photograph of this haircut is titled *Marcel Duchamp, Tonsure* (1921), a tonsure referring to the bowl-like shaved scalp given to young

monks. Duchamp's shave resembles a shooting star or a comet with its tail in the front. The latter is most likely the case, given Duchamp's penchant for puns. The Greek root for *comet* is found in hair, a comet being a long-haired star. In the nomenclature of comets, a coma (hair) is the atmosphere of dust, ice, and gas that forms around a comet. Besides, dust, ice, gas, and hair are all prominent in Duchamp's table of elements. The coma is combed back into a tail by the fierce pressure of solar radiation, the strength of solar winds, and by the force of its orbit. At times, the wind can be so strong as to force the tail back toward the sun.

Just as comets orbit the sun in regular periods, Duchamp's shooting star had appeared once before in his work. In cryptic notes relating to a trip from Paris to the Jura Mountains he took in 1912 with Guillaume Apollinaire and Francis Picabia, a comet appears in the automobile headlights projecting light into the nighttime. In the notes, Duchamp calls the assemblage of the headlight and its projected beam a *head-light child*. Like the Christian shiny dome set in a frame of hair that is a tonsure, "This headlight will be the child-God, rather like the primitives' Jesus," given birth on earth by the rest of the automobile.[15] The headlight beam resembles the golden god rays graphically shining down upon the Madonna and her child in religious paintings. After all, in Christian folklore Jesus was first telecommunicated when God's voice impregnated the Virgin Mary on a beam of light.[16] But this is a light projected the other way, away from God's crepuscular gaze: "The headlight child will be the instrument conquering this Jura–Paris road. This headlight child could, graphically, be a comet, which would have its tail in front, this tail being an appendage of the headlight child appendage which absorbs by crushing (gold dust, graphically) this Jura–Paris road."[17]

Actual comets return to the sun in regular periods, and just two years prior to Duchamp's road trip, Halley's Comet had made one of its most notable appearances. It was relatively close to earth and visible for everyone to see and, something that would grab anyone's attention, the French astronomer and popular science writer Camille Flammarion predicted that its tail would suffocate all life on earth and that the human race would "perish in a paroxysm of joy and delirium, probably delight in its fate."[18] So instead of or, rather, in addition to the projected beam shining religiously through the darkness, Duchamp may well have had images of an actual comet still trailing in his mind when he shaved it atop his head.

. . .

Most of *art history* is a gaze narrowed upon the miniscule patch of the electromagnetic spectrum known as visible light. We can narrow that down

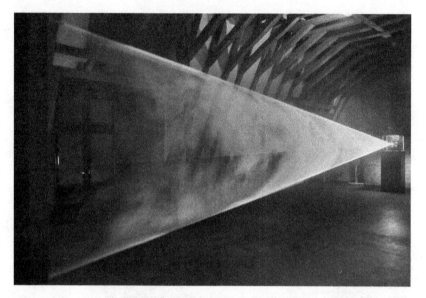

Figure 25. Anthony McCall, *Line Describing a Cone*, 1973, during the twenty-fourth minute. Installation view at the Musée de Rochechouart, 2007. Photograph by Freddy Le Saux, courtesy of the artist and Sean Kelly Gallery, New York.

further to say that art history has been written in the glow of light on and off surfaces. As the artist James Turrell puts it,

> We're doing much better with sound and with music than with light. One of the great difficulties is that because we had a culture that came out of painting, ideas about light are generally ideas about subtractive light. And so they really have to do with mixing earth to make a color, off of which light is reflected. . . . We can think of what light irradiates a paint or color, and what light comes off it. We should really be talking about additive light. And we need to talk in terms of the spectrum. We need to teach the spectrum, which is like teaching the scales.[19]

Movement is alluded to in paint through its application and modes of representation, but actual movement begins with the light as transmission from its source.

Seeing light sideways has been integral to imagining light as transmission. God rays are mythologically broadcast from a single point, and movie audiences reverentially stare forward as the theater is cut through with the side effects of light. In his 1975 essay "Upon Leaving the Movie Theatre," Roland Barthes was enthralled by the play of reflected light and shadow on

the screen: "Yes, of course, but also, visible yet unnoticed, the dancing cone which drills through the darkness of the theatre like a laser beam."[20] There is in his observation a gradient from stasis to activity to transmission. The light described a cone, but the cone was dancing. It was like a laser beam, but one that drilled through the darkness from the projector toward the screen.

The artist and filmmaker Anthony McCall codified this experience in his classic *Line Describing a Cone* (1973): "*Line Describing a Cone* is what I term a solid light film. It deals with the projector beam itself, rather than treating the light beam as a mere carrier of coded information, which is decoded when it strikes a flat surface. The viewer watches the film by standing with his or her back toward what would normally be the screen, and looking along the beam toward the projector itself. The film begins as a coherent pencil of light, like a laser beam, and develops through thirty minutes into a complete, hollow cone."[21] Where it would have been awkward for Barthes to wander through the movie theater or stand in front of the screen to stare back into the blinding white light of the cinematic numinous, "For this film every viewing position presents a different aspect. The viewer therefore has a participatory role in apprehending the event: he or she can, indeed needs, to move around relative to the slowly emerging light form."[22] Audiences in cinematic and visual arts venues become performers, watching and interacting with the film/installation, moving around under and alongside the edges of the cone, interrupting the light with long shadows, and interacting with one another. The *line* itself is a volume with an edge, much like the signals on a cone bursting.

In contrast to Barthes's "dancing cone," McCall's use of the term *solid light film* gives the impression that a light ray has a material stasis and object status rather than being the energy it is. Genre and institutional categories of film, cinema, sculpture, minimalism, and visual arts settings encircle McCall's work, splitting ultimately between the wayward fictional concerns of cinema and omnipresent appeals to presence. However, the negative operant phenomena of *Line Describing a Cone* act to retrieve light from transformation to objecthood. Evident to all who view the work are unintended glitches due to the materiality of film stock and projection process, where stars and their absences shoot down the ray in an illusion of the speeds of light and shadow.

James Clerk Maxwell first theorized electromagnetic waves in terms of light, but the plenitude of lights and the reliance on visual perception have led to a presumption that light is perceptible whereas other forms of electromagnetism, say, radio, are not. To a large extent this is true, of course, but light is also accompanied by an imperceptibility of its own movement:

the speed of light cannot be seen. Looking at light this way is one place where discourses relying on the notion of the visible versus the invisible break down. Light has no commensurate speed of sight. The visible is exaggerated. However, as we shall see, there is slowness in seeing little light at the edge of shadow.

Emitted light from the sun and stars seems to be still, although daylight is already eight and a half minutes old and the youngest starlight beyond the sun is eight and a half years old. What looks like movement are emulations: seeing sources of emitted light move—meteors, comets, lightning, polar auroras, flames and flares, radiating cinders, and so on—or seeing sources of reflected, refracted, diffracted, or masked light move. The other option is to see light from the side, to see the trajectory from the source to what is illuminated and imagine a process of transmission, as opposed to a state of light occupying a channel. Rotating perspective into a sideways position predisposes one to transperception of propagation from source to destination, but seeing the movement of light is a chimera.[23]

As the arced plane in *Line Describing a Cone* slowly develops from a solitary beam into a circle of light and hollow cone in space, material defects appear. Scratches in the black masking of the film send what look like little packets of light shooting past like meteors. When dirt and other artifacts disrupt the passage of light through the film and lens, black packets shoot through the "surface" of the cone (this *defect* is so compelling that Greg Pope and Gert-Jan Prins have concentrated it, using four film projectors and highly amplified sound in their remarkable photon-smashing performance, *Light Trap* [2008]). These positive and negative bits look like stray bits of information. They dart along the length of the cone, describing a trajectory that makes transmission indelible and demonstrates that light also travels at the speed of shadows.

Over his career, the artist James Turrell has brought formidable expertise in optics and perceptual psychology to bear on his work with light. He also has a number of origin stories through which he explains the development of his work, including one in which he sees light sideways. As Craig Adcock explains, "On several occasions, [Turrell] has reported that one inspiration for his interest was sitting in dark rooms watching slide projections of art works—something that typifies the teaching of both art history and studio art in most American classrooms. He says that he found himself staring at the light shining through the air illuminating particles of dust and finding the beam more interesting than the image on the screen. Even in terms of artists he admired, such as Rothko, he says that 'the light itself seemed somehow preferable to the pic-

tures.'"[24] Soon Turrell was emptying the projector of its slides and pointing the light beam into the corner of a room, where it appeared to be a floating box of light.

In his book on Turrell, Adcock also notes that the artist "endeavored to isolate light, to detach it from the general ambient array, so that the basic characteristics of sheer electromagnetic flux can be seen directly, unsullied by anything else."[25] In a 1971 essay in *Artforum*, the artist Robert Morris similarly associated Turrell with a primacy of electromagnetism. Morris fictionalized Turrell as Jason Traub, one of three "extra-visual artists" who had specifically become "interested in the possibility of the perception of electromagnetic energy as art material."[26]

"There never is no light," Turrell has stated, paralleling John Cage's proclamations in sound and listening about the impossibility of silence.[27] "Even when you remove light," says Turrell, "you'll notice there is still light. And the other thing is that when you take away outside sound you'll notice there is sound from your body. We actually are noisy bodies. So, I'm interested in the capacity to just perceive one[self] perceiving. . . . A lot of my work is exploring this quality of seeing yourself see."[28]

Retinal activity, however, is not limited to the eyes but is distributed across the body, which functions as an organ of ingestion:

> There are stray rods and cones in the body that are not in the retina. They are just in the skin which is an odd thing. They are located on the back of the hand, cheeks, and also the forehead and third eye—in fact most are on the top of the head. I'm interested in the physicality of light, in our being irradiated by it, almost like a treatment. . . . As human beings, we do drink light in the form of vitamin D through the skin, so we are literally light eaters. We orientate to light and have problems if we don't have it—psychological as well as physical.[29]

Light is perceived in activity in the retina in the absence of external stimuli (ideoretinal light) and while asleep, Turrell says, in lucid dreams.

Turrell distributes these energies over liminal states where darkness melds into light and colors meld into one another, rendering spectral states where light appears to occupy its own dimension rather than illuminating surfaces. Other works continue in the tradition of ancient solar and astronomical observatories and architectural oculi. In these pieces he is looking for actual rather than symbolic contact with the cosmos: "Say for instance in a work that has an open space at the top of a sky space, I'm interested in having the sky come down right at the top of the space that you are in, literally, so that you feel like you are at the bottom of an ocean of air."[30]

His observatories culminate in the cone of the monumental *Roden Crater*, an extinct volcano in Arizona, ironically now projected in art history classes around the world. The *Roden Crater* sets the geophysical stage for a type of music not dissimilar to Thoreau's *sphere music*. "In that stage set of geologic time," Turrell says, "I want to make spaces that engage celestial events in light thereby making the 'music of the spheres' in light. These pieces are performed by the rotation of the earth and the motion of planets so that they will keep themselves performing long after I'm gone."[31]

And, while there never is no light, there can be too much light. City lights can wash out the night sky and "cut off access to the universe"; so, like Watson, whose natural radio was driven out of the city by the electrical grid and trams, Turrell needs an electromagnetic wilderness in the visible light spectrum so that perception can extend further into darkness.[32] This process is called dark adaptation and it has been studied since the earliest days of psychophysics. As time unfolds light reinstates itself: "You may be looking at the light of Venus alone and you can see your shadow just from the light of Venus alone, if you are dark-adapted for about an hour-and-a-half. We see that well!"[33] The speed of light may be imperceptible but not the slowly evolving presence of little light.

But even in the Arizona outback, where anthropic lights are dark enough to let the night sky shine, there can be too much traffic in the radio range. Turrell planned to enclose one of the spaces in the Roden Crater with a Faraday cage, which would reduce the reception of radio. The space is located in a fumarole, one of the vents on the slope of the old volcano, where Turrell would place an oculus, an opening to the sky. It would remain unshielded by the Faraday cage; thus, terrestrial radio would be reduced in order to let extraterrestrial radio shine brightly with the stars through the oculus.

Below the oculus would be a pool of water that possessed, according to Adcock, a range of "perceptual purposes" involving the electromagnetic spectrum. The pool would have a quartz ring receiving light of "the combined colors of just a few stars" and transmitting it horizontally across the surface of the pool. Below the fluid surface of light would be the sound of astronomical phenomena, as "radio-bright objects pass directly overhead, their signals . . . transmitted into the water."[34] Visitors to the space would lower themselves under the surface of the pool to hear "the sound of astronomical sources many light years distant." Above the surface, given proper conditions, visitors would be able to hear the sound of another water, the rumbling of "Grand Falls located on the Little Colorado River about four

miles east of the crater."[35] The different time frames of cosmological time measured in light years would mix with the time it took the river and falls to be etched through the rock, and with the seasonal and cyclical times of the water flow, into a grander narrative with delicate, perceptual mechanisms amid a metabolic frame. We do not know whether Turrell has carried out his plans in his volcanic observatory, but this would be one way that star-studded cinema moves from a silent era into sound.

17 Robert Barry

Conceptualism and Energy

During the 1960s, discourses on materiality, immateriality, and dematerialization made for odd intersections in the visual arts and art theory. The difference between matter and energy was policed in the visual arts by perception and property. The register for what stood as artistic material was based on visual objects (painting and sculpture) that solidified their position by vying for rare commodity status, isolated objects in metropolitan art markets and their related institutions. Claims by Clement Greenberg for what constituted a properly reduced commodity were uttered in the same breath as cocktail party theoretical physics. It was in these markets that the discourses of art theory were plied and where challenges began to occur.

Distinctions between matter and energy were never that pressing for music and other performative art forms and activities. The object-mission of musical instruments has always been to willingly dissolve between the surface of a page and performance space or to join the voice and vibrate in a complexly audible cosmos. Musical instruments are switching mechanisms, objects to be used at the disposal of energies. They are transductive objects for both in-kind and in-degree movements. The practitioners of electronic music found the vibrations of acoustical energy conducive to electromagnetic oscillations as new sounds traded with new signals. Over two decades in the 1950s and 1960s, the "visual arts" increasingly admitted music, actions, events, words, and concepts as traces, if not final destinations where more stable and visual objects once stood. The acoustical energy of sound, once it had begun to be loosened from musical sound, offered itself as material to the arts.

John Cage in particular made it evident to the visual arts that sound was all around. He famously used an anechoic chamber, a sophisticated scientific instrument, where he heard the internal sounds of his body, which legitimated an aesthetic claim that vibratory and thus musical reality was

inescapable. If the body was too animated and gelatinous to stand as an unambiguous object, he imagined that it would be possible in a future physics to place an ashtray in a small anechoic chamber and listen to the vibrations of its "lively molecular process in operation."[1] This ashtray "is in a state of vibration. We're sure of that, and the physicist can prove it to us," Cage stated, and given the right type of instrumentation all that was solid melted into mechanical vibrations: "Object would become process; we would discover, thanks to a procedure borrowed from science, the meaning of nature through the music of objects."[2] Cage had earlier sought the music of objects by striking them, but here he imagined replacing the noisy process of percussion with the trained silence of an isolating, theoretically empty space (anechoic chambers emulate "free fields" where sounds encounter no obstructions) that would make music by sapping all objecthood from objects.

That there is no such thing as silence, Cage's axiomatic acoustics, was legitimated in anechoics, was echoed along the electromagnetic spectrum in the visual arts by James Turrell, who said that there is no such thing as darkness, that is, no such thing as an absence of light. As we have already seen, "There never is no light." In one of his accounts, Turrell was more interested in the projected light of the slide projector during an art history lecture than the images of paintings on the screen. In effect, light per se became the carrier wave frequency that visual art history transmitted upon, when it was not being modulated by images.

The fact that Turrell focused on the light kept him working in that small patch of visible light in the electromagnetic spectrum familiar to the visual arts. The putative concerns in painting for "light," he said, were obstructed by displacement by an object mediated by its surface. In lieu of secondary or tertiary light, he offered light as artistic material. Such concerns had been raised earlier in the twentieth century in the Rayonist painting of Mikhail Larionov but were contained to matters of representation of physical processes (as well as: "Radioactive rays. Ultraviolet rays.") rather than their direct manifestation.[3] Unlike Cage, who resisted the internal sounds of inner speech or auditory imagination (i.e., in cognitive activity where nothing vibrated mechanically), Turrell followed light physiologically through its perceptual operations and circadian chemistries (drinking the light as vitamin D) and through a physical series of transductions, from one energy state to another, all the way to the illuminated emulations of dreaming.

. . .

Where Cage said that there is no such thing as silence, and Turrell said that there never is no light, in the late 1960s the artist Robert Barry declared,

"There is not anything that is not energy."[4] He made this statement at the heart of conceptual art while explaining his artworks based on electromagnetic, ultrasonic, and entropic phenomena. Although he would not sustain this particular body of work for long, it produced some of his most iconic and canonic pieces that, moreover, provocatively posed the question of energy.

Barry not only challenged, more explicitly than anyone before him, the prevailing art discourses of materiality and immateriality with a materiality of energy that physicists, electrical engineers, and an increasing proportion of the general populace would experience as a quotidian matter; he also introduced electromagnetism per se—waves, fields, and radiation—as artistic raw material and demonstrated that art could take up different stations all along the electromagnetic spectrum.

His energy-related works were concentrated in what would prove to be one of the most significant exhibitions of conceptual art, *January 5–31, 1969*, curated by Seth Siegelaub.[5] At the exhibition itself, only two small labels on the wall signified any presence of Barry's works; otherwise, the room appeared entirely empty. The labels let people know that radio waves of specific frequencies (FM and AM carrier waves pieces) were being transmitted through the space, although there were no means to perceive them, no evidence of transmitting equipment, and no way to be assured that they were actually being transmitted.

The show was as significant for its catalog as its actual exhibition. The catalog listed pieces that were both on-site and off-site; all were specifically energy related (but for two barely perceptible, long stretched lines, one indoors and one outdoors), and all but one (the ultrasonic work) were electromagnetic (radio waves and radiation):

- (Proposal for) 99.5 mc Carrier Wave (WBAI-FM), 1968, 99.5 megacycles; 5.4 kilowatts, New York.
- 88 mc Carrier Wave (FM), 1968, 88 megacycles; 5 milliwatts, 9 volt DC battery.
- 1600 kc Carrier Wave (AM), 1968, 1600 kilocycles; 60 milliwatts; 110 volts AC/DC.
- New York to Luxembourg CB Carrier Wave, January 5–31, 1969, (N.Y. station WR2WER to Luxembourg station LX1DT), 10 meters; 28 megacycles; 180 watts.
- 40 KHZ ultrasonic soundwave installation, January 4, 1969, 8.25 ultrasonic soundwave.
- 0.5 Microcurie Radiation Installation, January 5, 1969, Barium-133, Central Park, N.Y., 10 year duration (approximate).[6]

The proposal remained just that. The transmission between New York and Luxembourg occurred off-site (the Bronx) intermittently over the course of the exhibition; the ultrasonic work was installed in the exhibition space the day before the opening and then removed; and the radioactive work was buried on the first day of the exhibition in Central Park and ostensibly exists to the present day, an unseen public art work.

The two works simultaneously on-site were *88 mc Carrier Wave (FM)* and *1600 kc Carrier Wave (AM)*; the two transmitters were hidden in a closet. FM or AM radio stations would have been equally invisible, but Barry went one step further and removed any information (modulation) from the signals. They were merely the base frequencies through which signals would be carried. In fact, if a powerful enough carrier wave is transmitted, it will override and silence a radio station on that frequency. At the exhibition, it would have been possible to carry around a transistor radio to listen to the carrier waves or, rather, to the absence of the stations usually occupying the spot on the dial. As Barry explained, "If you were down the block from the gallery and you turn your radio to a certain station, you would hear people talking or music, but as you got closer to the gallery, the radio would go silent. The radio would be silent at that spot on the dial, because the carrier wave was so strong that it would overwhelm everything else."[7] So the work was about not merely the presence of radio waves in general, or transmitting for the purposes of noncommunication, but the potential absenting of the radio stations that might occupy those frequencies by transmitting their own carrier waves. Therefore, the space was emptied of certain radio broadcasts and filled with electromagnetic transmissions. What appeared to be an empty space was, in a way, even emptier.

The room was filled with electromagnetic transmissions and gestures of absence. If one went on Barry's prior works, there would seem to be a logical extension of an increasing series of reductions in his paintings. They shared some similarity to Lawrence Weiner's removal piece—*A 36" × 36" removal to the lathing or support wall of plaster or wallboard from a wall* (1968)— also in the Siegelaub exhibition, and to John Cage's silence in *4'33"* or other forms of silence, but they were more uncanny.[8] Instead of removal or silence, the carrier wave pieces involved masking using a more powerful energy; nothing was withdrawn, something more powerful (at least proximally) was put into place. There is no good equivalent for such a procedure in sensory or object registers. It would be as though a building disappeared if a stronger foundation was added to it. It would be as though a symphony orchestra was playing feverishly but was inaudible because of active noise cancellation of only fundamental pitches. The carrier wave pieces, like

Barry's other energy works, enact another gesture where absence flips into plenitude, as in the impossibility of silence and darkness in Cage and Turrell.

Proprietary limits would have been tested had *(Proposal for) 99.5 mc Carrier Wave (WBAI-FM)* been installed. Although the community radio station WBAI had strong links with the New York arts community, they probably were not strong enough. Radio stations fear nothing more than dead air. In fact, when Barry was on WBAI later to play sound works that had single words surrounded by up to thirty seconds of silence on either side, he was asked by nervous producers to cut the silences down to ten seconds. He understood these pieces to have an energetic character in themselves, with the isolated words suspended in air, radiating in an environment emptied of the modulating influences of syntax.

Barry's energy works were at the right place and the right time for conceptual art and notions of the dematerialization of the art object. He may have been jockeying for position to make a powerful statement; however, like many artists and others who engage contemporary conditions who do exactly the same, he had an important source in family background. His interest in electromagnetism has a disarmingly simple explanation in his father's work in electrical engineering and enthusiasm for DIY electronics. Indeed, his father built the transmitters hidden in the closet at the *January 5–31, 1969* exhibition.

John A. Barry worked for many years for the Western Electric Company; one of his major projects was supervising the telephone system installation during the construction of the CBS Building in Manhattan. He was also an electronics enthusiast who, after dinner, covered the table with projects. He built his own television and, at one point during the 1940s, built his older son a lower-power transmitter that enabled him to broadcast radio programs over a local radius of their Bronx neighborhood, while the much younger Robert listened in. Robert remembers going to Radio Row in lower Manhattan (on Cortlandt Street, demolished in the mid-1960s to construct the World Trade Center) to rummage through the shops for vacuum tubes, electronic gear, and military surplus equipment.

The idea for the carrier wave pieces came to Robert Barry in 1968 while he was listening to a Moscow Radio broadcast with his student, a ham-radio operator who lived in the South Bronx.

> I noticed that my friend would listen in to Moscow Radio and when Moscow Radio came on, the transmitters were so powerful that when they first turned them on—when the transmitters were warming up, for about an hour or so—they would just blot out everything else on

that frequency, so all the other stations just went completely silent. So for about an hour, there was this complete silence on that frequency. And I thought that was a kind of interesting idea—that it was no space, no nothing, it was just absolutely silent.[9]

Barry gave his friend a set of instructions to transmit *New York to Luxembourg CB Carrier Wave* from his apartment intermittently over the three-week course of the exhibition. They enlisted a ham from Luxembourg who was initially confused about transmitting with no immediate purpose of communication, but he was cooperative nevertheless. The purpose of noncommunication was in stark contrast with the global propagandistic broadcasts of Moscow Radio.

Unlike other artists during the 1960s whose discourses on energy and electromagnetism were formed by imaginations of theoretical physics and militarized scientific knowledge generated in the context of the Cold War, Barry's interest was grounded in a distinct form of lived electromagnetism that came with the medium of radio, tied to the accomplishments of his father and the conditions of his childhood.

In the larger culture, an energy-based *ephemeralization* had been theorized for several decades by the likes of Henry Adams and Buckminster Fuller. Indeed, Fuller was fond of describing an electromagnetic plenitude in near equivalence with human fate in the cosmos.

> More than 99.9 percent of all the physical and metaphysical events which are evolutionarily scheduled to affect the further regeneration of life aboard our spaceship earth transpire within the vast non-sensorial reaches of the electromagnetic spectrum. The main difference between all our yesterdays and today is that man is now intellectually apprehending and usefully employing a large number of those 99.9 percent invisible energetic events. Humanity has therefore created for itself a new set of responsibilities requiring a ninety-nine fold step-up in its vision and comprehension. This calls for an intuitive revision of humanity's aesthetic criteria.[10]

This statement was part of a foreword by Fuller for the catalog of a small 1970 exhibition that included Barry, *Projections: Anti-materialism,* held at the La Jolla Museum of Art. It is important to keep clear, however, that Barry did not think of his energy-related works as antimaterial or immaterial. His works were immaterial only if conventional art objects were a measure of materiality, and such designation was for Barry entirely arbitrary.

In this respect Barry would have been at odds with Susan Sontag who, in her essay "One Culture and the New Sensibility" (1965), invoked Buckminster Fuller and his electromagnetic universe to point out that

"art, which I have characterized as an instrument for modifying and educating sensibility and consciousness, now operates in an environment that cannot be grasped by the senses." But then she pulls back and states, "But, of course, art remains permanently tied to the senses. Just as one cannot float colors in space (a painter needs some sort of surface, like a canvas, however neutral and textureless), one cannot have a work of art that does not impinge upon the human sensorium."[11] Barry contested solipsistic presumptions that materiality required human perception by poetically asserting the material reality of imperceptible energetic forces: "I was trying . . . to create something which really really existed, and which had its own characteristics and its own nature, but which we couldn't really perceive."[12]

Barry's work was concurrent with overarching concerns for materiality and immateriality in the visual arts during the period, best exemplified by Lucy Lippard and John Chandler's influential essay "The Dematerialization of Art."[13] Fed further by Lippard's very influential book, *Six Years: The Dematerialization of the Art Object from 1966 to 1972*, the term *dematerialization* became a lightning rod, at that time and since (as single terms in the arts often do), for discussions of materiality and immateriality within a milieu dedicated to objecthood.[14] There is an undercurrent of science and physics in Lippard and Chandler's essay that becomes explicit in their citation of the theoretical physicists Richard Feynman and Murray Gell-Mann on the intrinsic beauty of physical nature, no matter how imperceptible. Lippard and Chandler claimed that "dematerialized art" remains aesthetic in the sense used by mathematicians and scientists, even as it might abdicate conventionally visual art forms, be understood without the immediate benefit of any of the senses, and exist only in complex and abstract theoretical models.

These claims elicited a response from the British artist Terry Atkinson, one of the members of Art & Language:

> Matter is a specialized form of energy; radiant energy is the only form in which energy can exist in the absence of matter. Thus when dematerialization takes place it means, in terms of physical phenomena, the conversion (I use this word guardedly) of a state of matter into that of radiant energy; this follows as energy can never be created or destroyed. But further, if one were to speak of an art-form that used radiant energy, then one would be committed to the contradiction of speaking of a formless form, and one can imagine the verbal acrobatics that might take place when the romantic metaphor was put to work on questions concerning formless-forms (non-material) and material forms.[15]

Atkinson goes on to argue that aesthetic philosophy was irrelevant once the line between energy and matter had been crossed and that it could not be resuscitated by loose claims about beauty from theoretical physicists.

Barry refused to cede materiality and aesthetics just because he used energy for artistic purposes. There were at least two reasons. The first, as mentioned, was that Barry formed determinations about energy amid the lived experiences of electrical engineering and telecommunications, rather than via arguments-at-a-distance with theoretical physicists, appealing to their science while overriding their aesthetics. Secondly, he recognized that the dominance of painting was likewise electromagnetic, and all he sought was "to deal with all those other parts of the electromagnetic spectrum outside the visual arts, that very narrow band in there which we perceive as light."[16] If aesthetics pertained to the electromagnetic practices of visual arts, then why should there be any interruption from merely moving to other parts of the spectrum?

Aesthetically, Barry noted many "beautiful characteristics" and sculptural qualities with what he was doing. He liked that the electromagnetic waves can "exist forever. They're ever changing. They expand out into the universe, always. They're ever expanding."[17] The ionospheric reflections that enabled over-the-horizon, transatlantic radio communications had sculptural implications at earth magnitude: "Because of the position of the sun and favorable atmospheric conditions during January—the month of the show—this piece [*New York to Luxembourg*] could be made. At another time, under different conditions, other locations would have to be used."[18] Similar reflections of waves were achievable with ultrasound: "Ultrasonic sound waves have different qualities from ordinary sound waves. They can be directed like a beam and they bounce back from a wall. Actually, you can make invisible patterns and designs with them. They can be diagrammed and measured."[19]

40 KHZ ultrasonic soundwave installation, the ultrasound work in the *January 5–31, 1969* exhibition, was installed and removed on January 4, the day before the exhibition. Ultrasound is on the sound spectrum, just not within the human audible range, so its absence during the time the exhibition was in keeping with its imperceptibility and the imperceptibility of the radio waves. Barry could not hide the device in the closet because the door of the closet would not be transparent to the sound, and having a speaker in an otherwise empty room could have been construed as relating somehow to the carrier wave pieces, or to its more prosaic use as a device for repelling rodents, since ultrasound is in their audible range. Not long after the exhibition, he installed *Ultrasonic Wave Piece* (1968) in a room at the Jewish

Museum for the *Software* (1970) show curated by Jack Burnham, with this descriptor: "Ultrasonic waves (40KHz) reflected off interior surfaces, filling selected area with invisible changing pattern and forms. (Space chosen at time of installation.)"[20] *88 mc Carrier Wave (FM)* and *1600 kc Carrier Wave (AM)* carried their own sculptural implications, cohabiting the same space in the *January 5–31, 1969* exhibition while traveling through the transparency of the walls, interacting with the metallic conductivity of the building and the city, and continuing far beyond.

Finally, there was an unexpected aesthetics of radioactivity. For *0.5 Microcurie Radiation Installation*, Barry buried a small amount of barium-133 in Central Park on the first day of the exhibition; it has been decaying with a half-life of over ten years ever since. The noncommunicative transmissions of radioactivity would continue to exist long after all the carrier waves were shut down. However, they were similar in that their beginnings could be determined: "A radioactive isotope is an artificial material. It has what they call 'Zero time'—beautiful expression! That is the time when it is created. On the label of the small plastic vial in which it is contained, its 'Zero time' is printed. From that moment on, it starts losing its energy. Now the 'half-life' in this particular case was ten years, which means that every ten years its energy is decreased by half; but it goes on to infinity, it never goes to nothing."[21] A natural radioactive source would not have a zero time; only a manufactured source could have traceable origin, could decay, and then (theoretically) last forever in a radioactive version of Zeno's dichotomy paradox. There has to be an origin, if only the first day of the exhibition, to provide a poetics of *zero, half, infinity*; and the life of the exhibition continually halves. Interestingly, Lippard and Chandler ended their essay by trailing off on a similar note: "We still do not know how much less 'nothing' can be."[22]

Even as he distanced himself from the technological devices and other objects associated with radio waves, radiation, and ultrasound, Barry maintained a material reality of energy: "Later I got involved with energy without an object-source of energy. I did that using mental energy."[23] He was referring specifically to one of his telepathic pieces (they were not telepathic experiments). Not only would he discuss them in terms of transmission, much like his works involving radio waves, he discussed them, similar to Turrell and light, in terms of physiological energy, that is, "the electronic energy which takes place in the body itself. The body is constantly producing electronic energy, changing chemical energy into electronic energy."[24] Moreover, in a materiality of conceptual art, from an energetic root concepts themselves are formed.

18 Collaborating Objects Radiating Environments

A photograph of the room at the *January 5–31, 1969* exhibition documents the installation of Robert Barry's *88 mc Carrier Wave (FM)* and *1600 kc Carrier Wave (AM)*. It is a unique example of the larger practice of photographic documentation in conceptual art and other art at the time, not only because there is nothing to see, unlike, say, photographic documentation of an earthwork or performance, but also because what could not be seen (carrier waves) were themselves in the process of eliminating other signals.

The photograph documented much more: the ambient lighting, the fluorescent lights reflected in the windows, the reflections creating a phantom room outside, the familiar hum that the ballasts in the fluorescent fixtures must have caused, the electrical system powering the lights, the electromagnetic fields that the lights and the lines around the baseboards and over the door must have emitted, the conductivity of the radiator, and all the other energies being attracted and resisted by the objects and ambiences of the gallery. The photograph itself was at the end of an energetic process of light and chemistry, and the photographer too, just by being in the room, was influencing what was being photographed. As Barry pointed out, "The nature of carrier waves in a room—especially the FM—is affected by people. The body itself, as you know, is an electrical device. Like a radio or an electric shaver it affects carrier waves."[1]

Electric shavers and automobile ignition systems were notorious for interfering with radio transmissions. What other objects contributed to the ambient electromagnetic ambience of the office space on 44 E. Fifty-Second Street that served as the gallery? Just as the carrier waves transmitting from the closet continued through walls to other rooms in the building and other buildings in the city, what were the reciprocal energies? New York

Figure 26. Robert Barry, *88 mc Carrier Wave (FM)* and *1600 kc Carrier Wave (AM)*, 1968. Photograph from the *January 5–31, 1969* exhibition, courtesy of the artist.

City was not merely noisy in an audible sense; like other cities it was a big, interpenetrating electromagnetic mélange and a messy broadcaster in its own right.

Conducting objects have secretly conspired against electromagnetic waves ever since Heinrich Hertz first scientifically validated their existence. As Hugh Aitken explains, errors in Hertz's findings can be attributed to objects in the room in which he performed his experiments.

> The rows of iron pillars which ran down each side of the room were each, during the experiments on velocity, less than one half wavelength away from the base line along which measurements were taken. The iron stove that provided welcome warmth in a Karlsruhe winter was only 150 centimeters away. What effect did the proximity of these large masses of metal have on his measurements? In retrospect one can see that the effect was considerable, and that it varied with frequency. Only in this way can one account for the large discrepancies Hertz found between velocity of propagation along a wire and through space.[2]

Objects became intractable once they began to have electricity coursing through them, as any *radio service man* and *Modern Radio Servicing* manual in the 1930s could tell you. Objects were built by humans to

provide safety and convenience; but they were not always docile or cooperative. They interfered with reception in homes, businesses, and vehicular radio sets, dispatching their signals in a stealth manner. In this sense, they were collaborative objects, collaborating both for and against.

Luckily, there were instructions: the section "Identifying Interfering Devices by the Character of the Noise Produced" detailed using "portable, sensitive *noise 'hunting'* receivers with directional *loop antennas* [that] have been developed especially for tracking down the exact source of such disturbances."[3]

(1) CRACKLING, SCRAPING, SHORT BUZZES, SPUTTERING
 May be caused by: door bells and buzzers, door openers, loose bulbs in electric light sockets, loose or corroded connections in electric light sockets, floor lamps, electrical appliances and cords, broken heating elements, wet power insulators, leaky power transformer insulators, power line grounded on tree branches, elevator control contacts, high tension lines, leaky cables.

(2) CLICKS
 May be caused by: telephone dialing systems, switches of any kind, as in sign flashers, elevator controls, heaters with thermostats, heating pads, electric irons with thermostats, telegraph relays, etc.

(3) STEADY HUM
 May be caused by: poor ground on set, antenna or ground wires running close to and parallel to power line (this should not be con-fused with "tunable" or "modulation hum" which is present only when the carrier of a station is tuned in . . . nor does it include those cases of steady hum where the hum is due to some trouble existing in the receiver itself).

(4) BUZZING OR RUSHING
 May be caused by: automobile ignition, moving picture machine, arc lights, street car switches, oil burner ignition, battery chargers, diathermy machines, high frequency apparatus, X-ray or violet-ray machines.

(5) RATTLES, MACHINE-GUN FIRE
 May be caused by: telephone dial systems, automobile ignition sys-tems, buzzers, vibrating rectifiers, sewing machine motors, dental laboratory motors, annunciators, doorbells.

(6) WHISTLES, SQUEALS
 May be caused by: defect in the receiver, heterodyning broadcast station signals, picking up radiations of an oscillating radio receiver nearby.

(7) BUZZING, HUMMING, WHINING, DRONING, WHIRRING
May be caused by: electric motor noise, may be on vacuum cleaner, electric fan, electric dryer, massage machine, hair dryer, motor generator set, small blower, farm lighting plant, electric refrigerator, oil burner, dental apparatus, cash register, sewing machine, etc.[4]

Offending objects could be found among:

A. GENERAL BUILDING EQUIPMENT

B. BUSINESS OFFICE EQUIPMENT

C. DOCTORS' OFFICES

D. DENTISTS' OFFICES

E. BEAUTY PARLORS AND BARBER SHOPS

F. SODA FOUNTAINS

G. DEPARTMENT STORES

H. RESTAURANTS, BAKERIES AND CONFECTIONARY STORES

I. GROCERY AND BUTCHERS' SHOPS

J. CLEANING ESTABLISHMENTS

K. SHOE REPAIR SHOPS

L. PRINTING SHOPS AND NEWSPAPER OFFICES

M. JEWELERS' AND OPTICIANS' STORES

N. GARAGES, BATTERY SHOPS AND FILLING STATIONS

O. DRESSMAKING, TAILORING, AND GARMENT SHOPS

P. LAUNDRIES

Q. MACHINE SHOPS

R. THEATRES

S. HOTELS, HOSPITALS, AND INSTITUTIONS

T. TELEGRAPH AND TELEPHONE OFFICES

U. STREET RAILWAY SYSTEMS

V. STREET RAILWAY STATION EQUIPMENT

W. POWER AND LIGHT COMPANIES

X. POLICE AND FIRE ALARM SYSTEMS

Y. TRAFFIC SIGNALS[5]

The loop antenna used was based on the same principle as direction-finding antennas used for navigation, for monitoring enemy movements during World War I, and for listening to whistlers and focusing in on the center of the galaxy. Wing loop and fuselage D/F antennas fitted into World War I aircraft used triangulated signals to direct bombing raids and guide the planes

back home but also to target specific radio transmissions. Loop antennas were a means to identify presence and locate direction and movement, not primarily to eavesdrop on the content of messages.

Collaborating objects could be a nuisance but they also threatened to collaborate with the enemy in real and paranoid ways. Home convenience devices might double as homing devices. Leading into World War II and during the Cold War, governments were concerned about certain appliances in their dominion conspiring in a much more active manner to leak information to the enemy or to be used as locator beacons to guide bombing. In Australia, an exchange of letters during 1940 alerted the attorney general that,

> In the manifold applications of modern electricity there is a wide range of apparatus in daily use which could, without much difficulty but with a suitable degree of technical knowledge, be converted for transmitting radio waves and particularly for sending messages in Morse code. Among these are:
>
> > Various electro-medical machines which are designed to generate high-frequency oscillations.
> > X-ray equipment.
> > Electric arc welding equipment.
> > Eddy-current heating equipment used, for instance, by dentists, metallurgists and in some manufacturing processes.
> > All automobile ignition systems.
> > Modern gas-tube electric signs, commonly known as "Neon" signs.
>
> Even the homely electric bell can be quite readily converted into a radio transmitter for short range communication and, of course, the household radio receiving set can also be converted.[6]

The Australian government decided that its methods for monitoring suspicious signals were preferable to registering new categories of professional equipment and domestic appliances; household radios were already registered.

Collaborating objects took on a whole new magnitude after the end of World War II; with nuclear weaponry, emanations from the electromagnetic spectrum had gone from being in the service of radio to broadcasting in gamma. Surreptitious signals of everyday objects were intensified because they could collapse two distant points on the spectrum together—radio frequencies and gamma—within a moment's notice to unheralded destructive effect: "The development of weapons of mass destruction has made the element of surprise—that is, the first blow—perhaps the most important phase of modern warfare."[7] Moreover, during World War II the Germans used "electromagnetic radiations emanating from the British Isles

as aids for air navigation. It is known that many German scientists are now working for the USSR."[8]

There was a recursive effect; what was once understood as transmission and radio began to be confused with radiation. In the United States, authority over radio communications during a national emergency depended on what was meant by radio communications; in 1950, it still meant "the transmission by radio of writing, signs, signals, pictures and sounds of all kinds." But that was not good enough because, according to a US Senate committee in session during 1951 investigating the emergency control of electromagnetic radiating devices, this definition did not account for "many new types of devices which emit electromagnetic radiations," which could pose a security threat.[9]

Major General Francis L. Ankenbrandt, director of communications for the Department of the Air Force, speaking for the Department of Defense, and an engineer, Mr. Plummer, presented the US Senate committee with a detailed list of transmitting and radiating devices that could be used primarily as homing devices: "There is evidence that potential enemies possess the atomic bomb and are diligently striving to develop long-range piloted aircraft and guided missiles for carrying the atomic bomb, or any other future type of weapon. Instruments utilizing electromagnetic radiations continue to be excellent means for solving navigational problems for piloted aircraft and guided missiles."[10] Such devices operated between "0.010 to 100,000 megacycles per second," with "the lower portion of the spectrum [being] most beneficial for 'initial guidance' for long-range navigation"; then higher frequencies could take over midcourse and terminal guidance functions. Therefore, many objects became suspect.[11]

Perhaps it was no accident that in the political paranoia of the time the first culprit discussed was "campus broadcast," since "electromagnetic emissions are all we are talking about," but such broadcasts eventually fell within a larger class of potential offenders, including all radio receiving sets (which can be reverse engineered), taxi cab radios, police radios, and commercial radio and television broadcasters.[12] Other suspect objects included remote-control devices, devices for testing vacuum tubes, burglar-alarm systems, industrial heaters ("Yes, if they are in fact radiators"), diathermy machines, "a vast variety of things used in our American scientific life . . . and medical life," neon signs, Pasteur ray lamps, mercury vapor sun lamps, motors and generators, electric razors ("An electric razor radiates"), elevator motors, substation switching gear, welders, X-ray equipment, and hot dog cookers.[13]

MR. PLUMMER: The idea is to cook food very quickly. They are small radio transmitters. I believe one manufacturer has about a 150-watt transmitter. It is around 2,400 megacycles.

SENATOR MAGNUSON: That is what they call the radar range.

THE CHAIRMAN: Do they have many of them in the city of Washington? I have seen one at the Statler Hotel.[14]

It was obvious that the chairman was getting anxious about objects within his own personal perimeter that could collaborate with the enemy. The nation's capital could be betrayed under the auspices of hot dogs.

According to the resulting Senate report, the existence of conspiring objects was monitored "mostly on the basis of interference complaints," which would not have been unfamiliar to a radio service man in the 1930s, before objects had become ensconced in a larger world of radiation.[15] Similarly, the interference heard on radio receivers would be tracked down using a direction-finding antenna: "We set a man down with a receiver and he just tunes through various frequencies looking for something that is unidentified or looks like it is giving interference, or trouble."[16] Obviously, there would not be enough men with enough time to listen to the increasing population of radiating objects to determine what was or was not interference, before it was too late. Moreover, if they tuned in to a radio program on electronic music, they would either get very confused or would not recognize it as being any different than what they were paid to listen to.

Not just objects but entire cities betrayed themselves electromagnetically. It was "theoretically possible to locate New York City by its electrical noise level—from sources of automobile ignition, defective light bulbs, arcing switches, and so forth."[17]

MR. PLUMMER: . . . *city noise*, electrical noise, dynamos contribute to an overall average noise that has a possibility of being used.

SENATOR MAGNUSON: You mean being picked up?

MR. PLUMMER: Yes, sir. I think it has actually been done.

THE CHAIRMAN: Suppose that you were in an airplane approaching the United States: Could you tell by the over-all electromagnetic noise whether it was a large city or a small city, that is, from the volume of the noise?

MR. PLUMMER: There is a possibility, yes.

THE CHAIRMAN: You could tell when you were approaching New
York or whether you were approaching—
SENATOR MAGNUSON: Washington?[18]

Just like the chairman, Senator Magnuson was becoming anxious about the possibility that the nation's capital, where he was seated, could be betrayed, not just by hot dogs, but by itself. And, as Mr. Plummer added, "The general noise level is rising all the time."[19] The lack of a feasible plan for the control of electromagnetic radiating devices led to CONELRAD, *control of electromagnetic radiation*, the emergency broadcasting channel associated with imminent and postnuclear attack.

· · ·

Among the broadcasts that a city makes are the constant hums of electrical grids. The basic frequency differs depending on the country, but it does not differ as much as the multitude of designs for electrical outlets (power points, electrical plugs) that are pasted on walls like little national flags. The widely held idea that electricity comes from these little holes in the wall is an occult belief best illuminated by Henry Adams's "Dynamo and the Virgin," the famous chapter from *The Education of Henry Adams* where he describes a metaphysics of energy extracted from the earth that occludes the destructive appetite of capital.

At the 1900 Paris Exposition, Adams visited an exhibit of dynamos, the industrial-strength electromagnetic generators of electricity that feed electrical grids. His encounter resulted in a remarkable meditation on the physics, metaphysics, and economics—that is, powers—of electricity and electromagnetism. He traced energies from brute force to ecstatic sublimity and then later applied this schema to the concept of an ephemeralization of all social existence. Brute force and sublimity were embodied in the dynamo itself, "this huge wheel, revolving within arm's-length at some vertiginous speed, and barely murmuring— scarcely humming an audible warning to stand a hair's-breadth further for respect of power—while it would not wake the baby lying close against its frame."[20] The spinning drove Adams toward rapture, who called the dynamo "a symbol of infinity," which in turn has driven countless commentators to interpret the encounter as an emblematic American adoration of force and technology. Indeed, in contrast to Henry David Thoreau, who wondered how anyone could ignore the din of sphere music torqued from the earth spinning around its axis and around the sun, for Adams the earth, with "its old-fashioned, deliberate, annual

or daily revolution," when compared to the humming speed at which the dynamo could spin, was "less impressive."[21]

The dynamo occasioned a larger discourse on energy, transcending the industrialized motors of Michael Faraday's electromagnetic fields to elicit reverie on the wirelessness of James Clerk Maxwell's electromagnetic waves. Adams hugged the dynamo, to be sure, and conceded he would have hugged two authors of electromagnetic wonders, Edouard Branly (the inventor of the coherer, an essential element in early wireless telegraphy) and Guglielmo Marconi, had they been present. Instead, he let himself be "wrapped . . . in vibrations and rays" of the "supersensual world" of wireless and X-rays, leading to "an indeterminable of universes interfused—physics stark mad in metaphysics."[22]

The term *supersensual* was used by others at the turn of the twentieth century to refer to the ability of clairvoyants and other occultists to perceive realms of reality beyond the material and sensory restrictions of science. However, Adams, a materialist with strong scientific interests, was interested in a different type of occultation. He had studied Karl Marx's writings but found them unhelpful in understanding these new forces; and mathematics were likewise unhelpful in trying to "figure out the equations between the discoveries and the economies of force."[23] He did, nevertheless, ground this occult in what capital attempts to keep hidden and mysterious: relations with labor and the environment. At the Paris Exposition, the display of the "barely murmuring—scarcely humming" of the dynamos was separated from what made the system spin: a coal-burning steam engine behind the wall. And behind that were the brute forces and labors of coal extraction, the massive routine fire of the engine's burning, and so on.

Hidden behind walls, in underground tunnels, and kept outside and out of sight, the ambient hum of the contemporary city grid operates in the same way, sustained by an "abysmal fracture" of the capitalist occult, the occlusion of an earth rendered "less impressive" through depletion of limited resources, pollution, and global warming.[24] But the grid has a less obvious relationship to electromagnetic nature. The alternating current of electricity oscillates at 50 hertz or 60 hertz, depending on the national system, meaning that it operates in the audio frequency range, just like natural radio. Thomas Watson took note of this fact when he observed that the sounds he heard in the telephone in Boston in 1876 were, not long afterward, no longer audible: "These delicate sounds could no longer be heard for they were completely drowned out when electric light and power dynamos began to operate."[25] One would have to leave the city and get away

from the grid to experience nature: in this way, electrification created a new electromagnetic wilderness.

Electromagnetic pollution in cities had long been conceived of as interfering with messages. However, as we have seen, telecommunications lived in a larger energetic context where, under the rare conditions of magnetic storms, their long metallic lines conducted enough energy from the environment to operate without the necessity of battery power (see chapter 4). What might have otherwise interfered (pollution) with a message instead provided power for its transmission. A larger energy leaked into the communicative priorities of telecommunications. This would now be called energy harvesting. The agrarian basis of the term is significant. Where once electrification in the city drove natural radio into a new wilderness, now farms are sprouting in the city. On the one side are server farms that epitomize ever-increasing demands on electrical generation; on the other is energy harvesting, epitomized by non-fossil-fuel means of generating electricity (solar, wind, waves, etc.). Objects are collaborating in new ways as they move from Cold War to Warm War; where once instant incineration was homing in on radiating devices, now it is a slow burn. Collaborating objects are no longer merely leaking information; they are also leaking energy.

19 **Joyce Hinterding**

Drawing Energy

Artists, musicians, and their audiences have many ideas about energies, about their significance and how they might work. The artist Robert Irwin once remarked how a nebulously defined energy contained in a small painting by Philip Guston overwhelmed much larger and bolder paintings in the same room, and how it helped move him toward light as a medium.[1] Many artists have moved toward sound for similar reasons. Musicians have long talked about generating, exchanging, and melding with energies, vibrations, and resonances in sounds, voices, instruments, psyches, bodies, spaces, the cosmos, and so on. Electronics have added another dimension, from ecstatic guitar feedback to the tightly controlled microcurrents that accompany computation.

In the 1970s, the composer John Bischoff was one of the first people to make music using a microcomputer (a personal computer) amid the experimental music scene at Mills College and the San Francisco Bay Area. Because the computer he used (KIM-1) was a glorified motherboard that had to be programmed in machine code keyed in using a hexadecimal pad, each and every sound was a labor of love. Because Bischoff intimately knew the code he authored and its relationship to each and every vibration in the speaker cone, he formed a palpable sense of everything between, that is, the signals coursing through the circuitry. He had always been "drawn to a music that sounded as if you were hearing the heart of electronics, of electricity as a material," and with the KIM-1 he was keyed in to where voltage differences pulse and oscillate through sound. Moreover, he understood that he had to conduct himself differently with this material. With acoustical music the performer is the initiator; with electronics one had to "step back one little half step and become an influencer" of something that was "already moving, already acting."[2]

Artist and media theorist Shintaro Miyazaki has described engineers' practice during the early period of mainframe computing of listening to "computational processes by using unsophisticated auditory interfaces."[3] What they heard were the raw electronic operations of computer code. In 1949 Louis Wilson, one of the engineers of BINAC,[4] happened to have a radio in the room while testing the computer; the radio picked up a pattern of static that correlated to the procedures under way in the computer. "So I installed a detector in the console and an amplifier and a speaker," he recalls, "so that you could deliberately listen to these things."[5] Other early main- frame engineers practiced this type of forensic listening and, as can be heard in the extant recordings, the compelling character of the raw electronic sounds has outlasted the little ditties held up as examples of "computer music" from the same period. For Miyazaki, the finely grained stutter-step rhythmic patterns of the computational algorithms are microtemporal emblems of a larger temporal, processual terrain of *algorhythmics* that, theoretically, derives from German media archaeology joining up with a *rhythmanalysis* whose tracks were most notably laid down by Gaston Bachelard and Henri Lefebvre. With artist Martin Howse in Berlin, Miyazaki has developed *Detektor* to monitor and analyze the microtempo- ral rhythms of voltage differences transmitted through informational channels in electromagnetic environments.[6]

The Australian musician and artist Peter Blamey performs directly on computer motherboards. Like many musicians, Blamey was introduced to electronic music through the electric guitar. Electricity adds something else (amplification and modulation, timbre, new sounds, circuits, currents, other devices) to musical instruments that can be configured in different assem- blages, decentered, rebalanced, and explored. Whereas an acoustical guitar has its resonating sound box attached, an electric guitar has distanced its sound box through electronics to a loudspeaker. Blamey was interested in repairing the rift between guitar (the place where the action takes place) and loudspeaker (the seeming source of the sound) in the form of feedback. The dynamical indeterminacy of what seems like howling and squealing in resistance is in fact a reunion of what was rent asunder.

Blamey later produced feedback from the enclosed space of a singular device—a mixing board, its outputs looped back into its inputs, a circuit fed back onto itself. These principles were turned inside out with Blamey's work *Forage*, where he performed with what he calls *open electronics*. Sending an audio signal through exposed motherboards, he lays on them loosely tangled skeins of fine copper wire from old speaker cables. The microscopically restrained complexity of the tightly controlled circuitry on

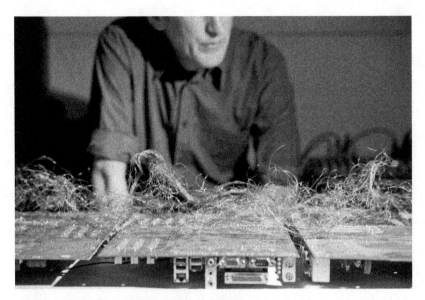

Figure 27. Peter Blamey, *Forage*, live performance at AV Union, Sydney, September 2012. Photograph by Lyndal Irons, courtesy of the artist.

the motherboard is met by the airy, rat's nest complexity of the jumbled copper wire: a chaotic caricature of connectivity. It is as though the usual infrastructure of copper has evaporated into an atmosphere hanging over the motherboard or, from the other direction, as though an inductive field has descended into conductivity. The copper skein drifts imperceptibly under its own weight, reconnecting with the circuits or within its own mass, or is prodded by Blamey gently moving it, or blowing on it, or picking the whole mess up and dropping it at a new place to hear what might happen next. What are heard are raw electrical connections never meant to be made; circuits bent, broken, and made; integrated circuits disintegrated. Like Bischoff, Blamey wants to hear the "heart of electronics, of electricity as a material," and, like Miyazaki, to hear the energetic heart of our informational appliances arhythmically pulsing code.[7]

Beginning in the early 1980s, the German artist and musician Christina Kubisch began making her "induction" installations: electrical cabling fixed to walls or hung in spaces within which sounds or music were routed and then received by individual handheld remote telephone amplifiers in the shape of small cubes. Similar telecoil technology has been used to enable people with hearing aids to listen without the interference of ambient noise directly to telephones or to public announcements at airports, to church

services, in taxis, and the like (and, as described in chapter 5, there was inductive radio at the inception of telephony). People move around the spaces in which she exhibits, listening and mixing the sounds according to their position within the electromagnetic fields.[8] In later works, specially engineered headphones replaced the handheld devices. Kubisch began using a newer generation of headphones with an installation in 1999. These headphones, she says, picked up "so many strange sounds: summing sounds, rhythms, and all kinds of things that, of course, disturbed me, because I didn't want them. Eventually, I realized that I no longer needed to put my sounds in cables because they were already out there."[9] From this realization she improved upon the headphones for what she calls *electrical walks* through the electromagnetic ambience of cities and all the devices within them.

Dancers too know that energies are ambient. Along with Bischoff, two other stalwarts of the Mills College and Bay Area scene in the 1970s were Tom Zahuranec and Jim Horton, both of whom died young. Horton was one of the first ardent proselytizers for using personal computers for music, whereas Zahuranec was known for making music from microcurrent responses of plants, which he attributed to communication with human sentiment.[10] Once, Horton and Zahuranec made music together by shaking apart a chain-link fence. On another occasion, as Horton recounted, "I saw Tom, on peyote, walk by a radio and it just slightly changed frequency. He noticed it immediately and began moving back and forth exploring the effect and an hour or so later he was running in patterns around the room changing the radio from one station to another."[11] Similarly to how hands are used in the inductive fields of a Theremin, Zahuranec danced in an energy field fluctuating due to his dancing (in fact, Theremin had already adapted his instrument to dancers with the Terpsitone). Surely it made sense for someone who explored plant sentience to tune to radio assisted by a small cactus, influencing something that was already moving.

· · ·

For over two decades the Australian artist Joyce Hinterding, often in collaboration with David Haines, has worked with sound, electricity, and electromagnetism, that is, energy. Her interest comes from a deep abiding curiosity. Once, when she was living in Sydney during the 1990s, Hinterding wondered about the possibility of cooking her meals on Channel 7, that is, of directing the energy of the television broadcast signal toward practical use. Of all the signals radiating in metropolitan areas at the time, those of broadcast television carried the most energy. Waterwheels used rivers and

streams to mill grain for bread; shouldn't antennas be able to sit alongside the blaring rush of broadcast television to make toast? With enough antennas, perhaps. But it might be difficult to generate an appetite for cheese melted by hot air from politicians.

Concentrating this atmospheric power would provide a spark that illuminated Nikola Tesla's dream of globally transmitted electricity, if not the reality. The mundane truth is that the capacity to flood television signals across large populations is marshaled by the power of corporate and state interests. Carrier waves carry consumerism and wave propagation channels propaganda. It made sense to redirect these transmissions toward something more useful, for instance, the preparation of meals. Unfortunately, doing this would not diminish the signal strength by much. The amount of energy that reaches an individual antenna is miniscule compared to that being transmitted, and even a huge tangle of antennas would only sap a tiny loss. For televisual food, perhaps a suspension bridge could be rigged to fry a fish.

Curiosity has its own logic of energy: it is something always moving, always acting. For Hinterding, it moves among salient intersections of different frequencies, materials, crafts, and artistic concerns, and it exists where the world of electronics meets up with hands-on approaches in amateurism and the arts. Take antennas, for instance. Antennas, in addition to any functionality, have for Hinterding important sculptural implications. Not only are they configurations of metal in the most conventional sculptural sense, but by resonating with an energetic environment they demonstrate via electromagnetic induction—"the most extraordinary concept"—that "everything is active; all materials are active."[12] This evokes a quantum cosmos where even the most inert object is a beehive of activity but also keeps reality terrestrially tied to a ground of lived electromagnetism.

At the metaphysical end, Hinterding's approach echoes the German romanticism of Goethe: "Electricity is the pervading element that accompanies all material existence, even the atmospheric. It is to be thought of unabashedly as the soul of the world."[13] Indeed, her artworks embody energetics much as Enlightenment electricity was investigated and demonstrated at the time of Goethe, that is, through beautifully crafted philosophical instruments. One such instrument was made of gold and leather; it emulated lightning, singeing the air, and sounded like thunder or, with equal rhetorical power, a pistol.

Over time, a natural philosophy of electricity became increasingly difficult to sustain amid the proliferation of technological devices during the nineteenth century. As Christoph Asendorf observed, "When electricity

begins to enter bourgeois daily life after 1880, it occasions confusion, which may have arisen out of the conflict between the profane technical utility, of a light bulb, for example, and the imaginative story of this invisibly flowing force."[14] In the twenty-first century, communications devices have become welded to souls far beyond any profane utility, and what flows through them is imagined by most to be entirely informational. Hinterding resists the societal conceit that humans "have authored electricity, like it is our invention," and opts instead for a broader, coalescent experience that includes "an electrical presence in the body, or that there is a natural electrical environment as well."[15]

Hinterding did not start out as an artist or sculptor but as a jeweler studying gold- and silversmithing. This was a craft that, in turn, led to working with copper, brass, and nickel to build drums and other devices used in music and performance art events. Then, through study of the musical physics of Hermann Helmholtz, she began to employ sound as a means to interrogate the materiality of objects, rather than refining the sound that came out of objects. Resonance and sympathetic vibrations also exemplified "what exists between things rather than things," so sound informed an attunement to movements of energies both within and between things, which extended to wave functions and fields of electromagnetism.[16] All the way through, subtending her evolution, were metals and other conductors.

Sound, for Hinterding, was passage to a larger field of energetics (much like it was for those who encountered electromagnetism in the nineteenth century). She built contact microphones "to amplify [the] interior activity" of things, and she soon dedicated herself to an electronics course at a technical school (TAFE, as such schools are called in Australia), where the properties of metals and other conductors took on a more precise meaning. But instead of steering her electronics skills to consumer goods and new gadgets, she circled back to the world of the handmade. Her interest in using simple antennas for natural radio was piqued by an article written by Tom Fox, "Build the 'Whistler' VLF Receiver," in the 1989 *Popular Electronics Hobbyist Handbook*.[17]

She remembered thinking at first that the article was about listening to lightning, which is true to a certain extent, since lightning is a source of whistlers. In the article, Fox recounts how the first sounds he heard after he built his antennas and solid-state VLF (Very Low Frequency) receiver were not the mysterious sounds of whistlers, but the sound of an Omega Navigation System beacon operating between 10 and 14 kilohertz (Omega beacons began closing down after a switch to satellite navigation systems

such as GPS). The real fun, he said, "starts when you pick up a whistler. That strange sound starts as a high-pitched whine, at about 20 kHz, and sweeps down in frequency to a pitch like that of a high-soprano singer; it lasts about a second."[18]

Fox decided to test a little low-tech hearsay. He "strung 125 feet of #22 wire along the top horizontal support of the wood fence [encircling his] children's play yard" and then listened with his headphone set. He heard weak Omega navigation signals and thus knew that he could conceivably hear whistlers. With his backyard in Michigan, Fox was hoping to hear sounds produced by lightning occurring at conjugate points located on the same geomagnetic line of force in the Southern Hemisphere. Just find the opposite latitude, add a few degrees to the longitude, and listen deep into the night. His fence made good neighbors with thunderstorms in the Southern Hemisphere.

There is a history of fences containing sound, ringing property with wires and posts, containing musical properties and establishing property rights. *Ringing* is appropriate, because it denotes both an enclosure and a resonance with surrounding space. Wind whipping through wire fences around the world rendered them Aeolian, and there were "ringing fences" with sounds produced by walking past picket fences—"a curious musical tone of initial high but rapidly lowering pitch . . . with a duration of perhaps a quarter second."[19]

Tales of radiophonic fences grew loud with the advent of *border radio*. In 1935, radio station XERA began blasting a directional signal of one million watts from across the Mexican border into the United States, often reaching into Canada. The broadcast signal was so strong that it was rumored that an unsuspecting bird flying too close to the antenna would be instantly bar-bequed, an early form of microwaved food. Historians Gene Fowler and Bill Crawford noted that "ranchers were startled to find their fences electrified by the high-powered broadcasts of hillbilly performers."[20] Country music singer June Carter agreed; hang a tin can off any barbed-wire fence, she said, and you could hear the Carter Family.[21] This would have made sense, because in the early twentieth century some communities in rural America used their barbed-wire fences to concoct their own telephone systems.[22]

In music, Alvin Lucier's *Music on a Long Thin Wire* (1977) took Pythagoras's monochord to a great length, where it began operating along chaotic principles rather than principles that organized the cosmos geo-metrically; the idea came from a dream Lucier had about a very long wire that went to the moon and back, which itself had a terrestrial analog: "I thought of the American West where we have those barbed wire fences that

go on for miles."[23] The violinists Jon Rose and Hollis Taylor have performed a truly large-scale work bowing fences across the Australian countryside.[24]

During 1992, Hinterding was in residence for four months in New York City at the Greene Street Studio of the Australia Council for the Arts. It was there that she built her first VLF antenna, the largest loop antenna described in the Tom Fox article. She hoped to hear the Omega navigation signal that would in turn let her know that she was at least in the right neighborhood for whistlers, but all she heard was the sixty-hertz hum of the US electrical grid. That was not all she heard. Quite unexpectedly, there was also a Christian fire-and-brimstone preacher instructing everyone through the hum to "Stand in front of the mirror. Repent! Repent!" She did not understand why there would be a regular radio broadcast at such a low frequency, apart from its ability to reach sinners wherever they might try to hide on the radio spectrum. Hinterding had met a person who had gone throughout the city to listen to stairwells and fire escapes in order to hear whether or not they were receiving radio; it made her wonder whether "Repent! Repent!" might also be pulsating just outside the window, resonating sympathetically in the conductive mass of the fire escape, and it made her wonder where else the call to repent might be in that big rat's nest of vibrating metal called a city.[25]

In New York she worked on a commission for the 9th Biennale of Sydney called *Electrical Storms* (1992), which used four custom-built high-voltage electrostatic loudspeakers: one pair were hooked up to a VLF antenna to listen in on ambient electromagnetism and the other pair to recordings of natural radio made on a visit to Walter De Maria's *Lightning Field*. The flat electrostatic speakers (as opposed to the cones in regular loudspeakers) lent an almost palpable three-dimensional spatiality to the sounds, and the low distortion transformed fields of noise into what seemed like distributed and defined particulate matter: "The sound was extraordinarily clear, as electrostatics have substantially greater fidelity with high frequencies and the VLF is mostly at the top end of the audio spectrum."[26] The presence of high voltage in the speakers fused the electromagnetic energies at the source of the sounds more closely than the acoustical principles of normal speaker cones would have, which are always involved in a broader range of representation. "The high voltage sound system is, in itself, a kind of an electrical storm," says Hinterding.[27]

Hinterding equipped *Electrical Storms* with a fifty-hertz notch filter to minimize the effects that the electrical grid in Sydney had on all other frequencies received on the VLF antenna. This made way for seasonal energies: the biennale was held from December to March, summer in the

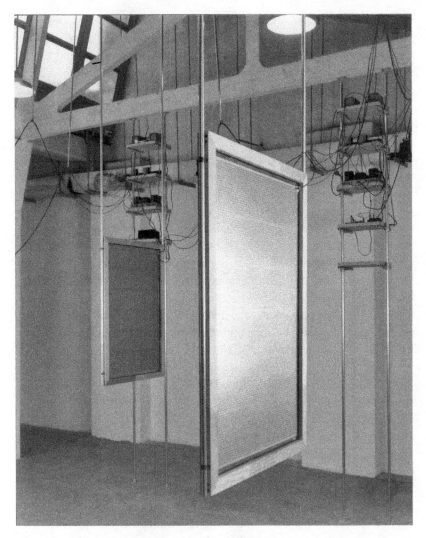

Figure 28. Joyce Hinterding, *Electrical Storms*, 1992. Installation view, 9th Biennale of Sydney, 1992. Photograph by Chris Fortesque, courtesy of the artist and Breenspace, Sydney.

Southern Hemisphere, a time when Sydney is prone to its own electrical storms. Thus, the work consisted of electrical storms resonating with electrical storms: "As soon as it would thunderstorm, you could hear it."[28] The recordings playing on the other speaker were made on October 13, 1992, when Hinterding visited De Maria's *Lightning Field* in New Mexico on her

way back from New York.[29] She was not there to watch lightning—it is not recommended to be too close to lightning while recording VLF, or any time for that matter; instead, she was there on an artistic pilgrimage and for the isolation that the site provided from any electrical grid. In the isolated reaches of New Mexico she followed Tom Fox's instructions, found the Omega navigation signal, and knew her antenna was working. She finally heard live the natural radio that New York City had overwhelmed.

The visit to De Maria's *Lightning Field* involved another part of the electromagnetic spectrum besides the audio frequency range. Apart from its sculptural beauty, natural setting, and natural radio recording opportunities, Hinterding considered *The Lightning Field* "a metaphysical work. It is about potential, about this thing that temps the sky. It's not a literal thing to do with seeing the lightning. . . . Clouds can feel the work from miles away—I think it's extraordinary that someone could make something that nature can respond to."[30] Equal parts conduction and seduction, De Maria's work was part of a larger "desire to experience massive energetic exchange between earth and sky" that came with the territory in the southwest United States, with its legacy of destruction exported to Japan.[31] The first atomic bomb that turned night into day was exploded less than seventy-five kilometers away, as the crow flies and dust settles, at the Trinity Test Site. David Haines and Hinterding were reminded of this fact after visiting *The Lightning Field* when, in a museum at Los Alamos the next day, their shoes set a Geiger counter clicking.

One of Hinterding's major works is the masterful *Aeriology* (1995), created for an exhibition at Artspace in Auckland and having many installations and variations since. It was inspired by a story she had heard about people in England who cooked their meals by television: "They lived in a house near a broadcast television tower and had TV antennas inside the house, on top of the house, all over their house, and were rectifying the signal to cook their dinner."[32] She thought of filling the gallery with antennas and sapping a little energy from Auckland's television transmissions, but the cost exceeded her budget; just as well—it may have not produced the desired results.

She decided instead to amplify the resonant principles of the VLF antenna she had built in New York by significantly increasing the scale. Instead of a loop wrapped around an aluminum or plastic frame, she would use the structural frame found in many art galleries: the four columns of a bay of a warehouse. *Aeriology* requires an enormous length of wire, anywhere from 20 to 30 kilometers depending on the installation, to wrap from floor to ceiling. Similar to the 21-kilometer telephone line running from

Figure 29. Joyce Hinterding, *Aeriology*, 1995. Installation view, Artspace, Auckland, August–September, 1995. Photograph by Ann Shelton, courtesy of the artist and Breenspace, Sydney.

the Sonnblick Observatory to the valley below it, *Aeriology* resonates with the long waves of VLF and the electromagnetic ambience.

Visually stunning, *Aeriology* has a presence you can see through. It cordons off the empty space of a bay, wire-fencing it with an impassable, diaphanous wall of gleaming metal, a suspended mineral. It marks off an ostensibly vacant volume that itself takes on quasi-object status, resonating in several energetic registers. There is a tensile energy: the entire work is held in suspension by the tension of its wrapping; in fact, a later installation was attempted using nonarchitectural supports and the structure collapsed under the pressure. It is taut but moves in the way it shimmers as you move, no matter how slightly. The shimmering itself is a reflection of the electromagnetic waves of visible light gathered, striated by the wires and splayed into rastered flaring fields. It is as though kilometers of wire have been spooled off the dynamo of a large electrical generator with the electricity still present.

The tension is also the product of a metabolic concentration of labor, not only in the kilometers traveled by people in a confined space, lapping the columns in the odd exertion of a tight marathon, but also in the spatial precision of putting each turn into place. This is where Hinterding's craft comes into play. Intentions in the arts are often produced through the euphemistic labor of gesturing, whereas what seems to be obsessive (20 to 30 km of wire wrapped around columns) is the immediate evidence of actual labor. Whereas Karl Marx described the presence of dead labor in capital intensivity, the fresh tracks of live labor intensivity are present in the tension that suspends Hinterding's work in air, the symbolic value of craft.

After Hinterding first wrapped and wound *Aeriology*, she found that it resonated in the VLF range as she had anticipated. There was no notch filter (as in *Electrical Storms*), so it let in all the ambient electromagnetism, most of it the sound of the electrical grid, beginning with the wires in the wall of the building and the lights that helped make *Aeriology* shimmer. Perhaps if *Aeriology* were installed in isolation, like De Maria's *Lightning Field*, then other signals could be heard. However, meaningful signals were indeed being heard: it was the sound leaking from an industrial centralization of power, the noise of excess amid a spectacle of control.

But *Aeriology* was not just an antenna or big inductive loop. It was also an energy scavenger. There is sound coming out of the speakers, but the sound equipment is not connected to an electrical outlet. All the power that the speakers needed to amplify and drive the sounds of *Aeriology* was available courtesy of the ambient energy accumulated by *Aeriology* itself. As Hinterding says, "It has enough energy because it's storing energy, and

that energy that it is storing becomes an amplifying element. It lifts the signal up."[33] In the way that telegraph operators in the nineteenth century disconnected their normal power sources and ran off the ambient energy of a magnetic storm, so too was *Aeriology* in-circuit with the urban electromagnetic environment.

This is the uncanny feature of *Aeriology*, one that reinforces all of its other manifestations of energy: the sound, tension on the wires, shimmering of light, and embodied labor. The work is freed from the electrical grid but resonates with it, with the city and beyond, transduces and accumulates energy and resonates acoustically with the room it occupies. It could never offset the mining, smelting, and manufacture of its copper wire with the minute energies gathered from the urban ambience but is instead a monument that, as Hinterding states, "explores technology in a very different way to mainstream thought: not looking so much for efficiency but simply possibility."[34]

During the 1990s, concurrently with *Electrical Storms* and *Aeriology*, Hinterding began exploring the artistic use of graphite. This in itself would not seem exceptional—pencils and powdered graphite are common in drawing—were it not for her use of its electrical properties. She encountered the possibility while first teaching herself about electronics. In the popular book *Getting Started in Electronics*, Forrest M. Mims III described the use of carbon in resistors: "'Carbon composition' is just a fancy way of describing powdered carbon mixed with a glue-like binder. This kind of resistor is easy to make. And its resistance can be changed from one resistor to the next simply by changing the ratio of carbon particles to binder. More carbon gives less resistance."[35] It was what he said next, under the heading "Do-It-Yourself Resistors," that piqued Hinterding's interest: "You can make a resistor by drawing a line with a soft lead pencil on a sheet of paper. Measure the resistance of the line or points along it by touching the probes of a multimeter [a device that measures electrical behaviors in a circuit] to the line. Be sure to set the multimeter to its highest resistance scale. The resistance of a single line may be too high to measure. If so, draw over the line a dozen or so times."[36] Ostensibly, any drawing using graphite will conduct and resist to a certain degree. Perhaps Sol LeWitt drawings could be amplified to hear what they are receiving and modulating. Hinterding's works using graphite are still, yet they are another example of "the most extraordinary concept [that] everything is active; all materials are active."[37] They are at an elemental crossroads of objects and energies, and that element is made of carbon.

Carbon in its different forms plays an important role not only in the history of drawing but also in the technical and metaphorical operations of

nineteenth-century inscriptive and transmissional media. In terms of inscription, *graphien* is writing and graphite the material form it takes; thus, carbon is the atomic element for writing, moving matter around in language, and the mimetic and expressive elaborations of drawing. Both nature and humans wrote themselves using phonautographs, phonographs, seismographs, et cetera.

The closest connection, of course, is photography and Henry Fox Talbot's *pencil of nature*, where silver replaced carbon and where the labors of a human hand tracing an image at a camera obscura were steadied by the hand of nature. The pencil of nature was not really the nature of the pencil. Sunlight was a feature of nature with Talbot's *sun-pictures*, heliographs, as it was with Lady Eastlake's *solar pencil* and *solar eye*. But in Talbot sunlight served the task of representing the things of nature other than itself. *Photo* as light and *graphien* as writing were the means by which nature wrote herself, and the sun was a handmaiden for writing, rather than writing its nonself. Within the photochemistry of class dynamics, Talbot's house in the country had more agency than the sun, for it was the first building "ever yet known *to have drawn its own picture.*"[38] Henry David Thoreau put photography on a larger plane when he said it was but one form in an "excess of informing light" that can break down such brute matter as "granite rocks and stone structures and statues of metal," an "influence of *actinism*, that power in the sun's light rays which produces a chemical effect."[39] These sentiments were, after all, coming from someone who went beyond his father's footsteps in the pencil-making business to himself becoming a writing implement in the recording of nature.[40]

Carbon was integral to the registration of the temporality of various energies by graphic recording instruments in the nineteenth century. The time of these energies was emulated in the rotary motion of a cylinder upon which the perturbations of a stylus inscribed a graphic representation of the original impulses. Instead of a pencil laying lead as in writing, a stylus etched its lines onto a surface of carbon distributed evenly over the cylinder, smoked with the carbon soot of lampblack. Étienne-Jules Marey used this method in the design of his scientific instruments, as did Édouard-Léon Scott's phonautograph, a precursor to Edison's phonograph.[41] But movement was involved, similar energies were fixed on surfaces, recorded and stored as a matter of memory, much like photography, rather than continuing to move. Lampblack moved from inscription to transmission with Edison's carbon button microphone in the telephone. He and his assistants collected lampblack from "the combustion of very light hydrocarbons, such as gasoline or naptha," and compressed it into the carbon disk. They

Figure 30. Joyce Hinterding, *The Oscillators*, 1995. Installation view, *Sound In Space: Australian Sound Art,* Museum of Contemporary Art, Sydney, 1995. Photograph by Ian Hobbs, courtesy of the artist and Breenspace, Sydney.

also used materials such as carbonized (burned) paper and wood and powdered graphite; they even tried lead (graphite) pencils for their electrical properties.[42] Forms of carbon, in other words, were used in transductive processes, allowing energies to move rather than being fixed.

Hinterding uses graphite in both fixed and moving ways. She uses it to draw and to draw energy. Sound in her work is the continuation of energy. She has used graphite since 1990, but her work took a distinct turn with *The Oscillators* (1995), where she used graphite and silver leaf to draw large circuits on 100 percent rag watercolor paper. Unlike Atsuko Tanaka's circuit drawings, the three drawings in *The Oscillators* are functioning circuits, phase-shift oscillators that synthesize simple sounds by creating electrical feedback. A solar panel is powered by the lighting in the room so, what we hear is a visible modulation of the work's own illumination; what we hear is what we see.

Although *The Oscillators* was circuitry writ large, Hinterding felt that the simple materials, basic operation, and forthright presentation moved the work from a technological device toward a natural entity or process.

The sound produced by the three drawings is reminiscent of crickets or cicadas, but if this circuit were built by conventional means, it would

have a pure sine wave sound that would be easily identifiable as synthesized. Ironically, the work sounds like nature—or, to put it differently, one is drawn to contemplate the system as a natural system. This may come in part form the absence of black boxes, but also comes from the fact that nearly all the materials employed are from the everyday world: paper, pencil, something that looks like aluminum foil, some cables and a solar panel. The work's tendency to elicit the powerful sensation of observing nature is interesting in light of the fact that many people do not tend to think of electrical synthesis as a natural process. A kind of challenge takes place: the challenge to see what we might call the synthetic world as part of what we might call the natural world.[43]

Over time, the electricity flowing through *The Oscillators* found more efficient paths, decreasing the resistance and raising the pitch. To keep it from going above the human audible range, Hinterding routinely maintained the drawings by removing graphite to raise the resistance and to reset the each drawing's balance of conductive and resistive properties. She also found out that pitch would be lowered the closer a person was, the body itself becoming an electrical component in the field of the work.

Hinterding returned to using graphite with *Earth Field* (2008), in collaboration with David Haines, and with her series *Aura* (2009–10), a number of complex figures that pack long-distance lines into small spaces to better resonate in lower frequency ranges. Unlike *The Oscillators*, the *Aura* drawings do not receive their power patched from a solar panel but instead, like *Aeriology*, resonate directly with the energetic environment. They do, however, change sound when approached and touched; they grow louder, which also means that certain harmonics can be heard more clearly. Bringing the body as a conductive medium into the artwork relates to her interest in Wilhelm Reich's ideas about energies in the body and environment. Hinterding encouraged interaction with the drawings by onlookers (ontouchers) as a continuation of the drawing process. So, of course, soon the graphite was streaked and smeared, and the sound changed in response. This was an acknowledgement not merely of interactivity per se but of the electrical potential of bodies.

In 2010 she began her series *Loops and Fields: Induction Drawings*. The largest work in the series is titled *Large Ulam VLF Loop* (2011), and it was completed for an exhibition in New York City. Instead of copper wire wrapped around a frame or spiraling up columns in a warehouse, the conductive material is liquid graphite and the spiral is applied directly onto a wall.[44] Graphically, the work is a maze that runs off the edge or into the center, where it retreats perspectively to a white void that itself is offset by

Figure 31. Joyce Hinterding, *Large Ulam VLF Loop (graphite)*, 2011. Image courtesy of the artist and Breenspace, Sydney.

the black square of the speaker. The plus or minus of the visual contrast of white square and black square is accompanied by the transduction of electromagnetic and acoustical states.

The speaker projecting the sounds of the signals and fields drawn into the drawing is as an ultrasonic device that demodulates into a focused beam of sound. Robert Barry used an ultrasonic beam for sculptural purposes but it remained inaudible and conceptual, whereas the speaker in Hinterding's work uses ultrasonic principles to narrow the spatial field in which a sound is heard. One is better able to hear the work amid a general hubbub of ambient sound, but it requires moving into position to do so. Consequently, within the energetic tactics of the work, to hear the work means moving into an interactive proximity that may inductively influence the sound. It brings the person's body into the transductive mix.

Large Ulam VLF Loop uses the mathematically derived square spiral made famous by Stanislaw Ulam, the mathematician whose work was at the center of the development of nuclear weaponry and computation. The square spiral was used by Ulam as a means for visualizing patterns among the apparent linear randomness of prime numbers. *Large Ulam VLF Loop* has nothing to do with prime numbers; rather, it is a conjecture or improvisation about what else the figure may pattern. A field of primes serves as an allegory for an environment of mysteriously complex energetic phenomena.

Hinterding wanted to hear what else Ulam's figure may be capable of enfolding in its large spiral. The work will ostensibly resonate in a specific manner based on a crude measure of its length, but because of the material duplicity of graphite as both conductor and resistor and the complex responsiveness to the environment, the functioning will be unpredictable. If Hinterding were in the actual antenna-building business, she would have pursued other means to achieve predictable results. But, then again, antenna builders know ahead of time what they want to receive; they are already locked into a loop of transmission and reception.

Hinterding wanted to hear what a large Ulam spiral would receive; she was surprised. Unlike her smaller graphite antennas and induction coils that pick up the 50- or 60-hertz hum of the electrical grid, the *Large Ulam VLF Loop* produced an unusual set of sounds. The exhibition was eleven floors up in the skyscraper canyons just opposite the Empire State Building, with dozens of Wi-Fi networks jumping from one frequency to another spread over the spectrum, amid the general electromagnetic density of the urban environment. Nearly two decades earlier, Hinterding had built her first VLF antenna and had heard the density of electromagnetic energies moving through and saturating the urban environs of Manhattan. Now, a stately graphite spiral was squealing and squeaking.

Recently, she has used graphite on glass. Thus, the electromagnetism of the sun or anthropic light mixes with the radio range of the spectrum; a larger environment becomes apparent beyond the plane of the work; and the work becomes scalable to an architectural level. And Hinterding wonders about the use of graphene, a mono-atomic ("two-dimensional") layer of graphite with remarkable properties at the center of major new advances in electronics. After all, the scientists who lead the research into graphene sourced their supply from a block of graphite using yet another vernacular object on a desk sitting next to a pencil: adhesive tape. Moreover, she has fundamental ideas on several other fronts, which means that the past will be reshaped in a struggle to keep up. Her curiosity and work keep everything moving through energetics.

20 Earth-in-Circuit

During the nineteenth century, communication went underground—nothing necessarily secretive or subaltern, even the most common telegraph and telephone messages followed a technological circuit that was returned and completed through the earth. Other aspects of the earth besides the ground have been called upon to serve signal propagation in telecommunications, the ionosphere being the most common. For over a century and a half there have been large cycles in which the earth has been *in-series* or *in-circuit* with an open *earth circuit* or excluded by a closed *metallic circuit*. The manner in which the earth was put in-circuit and taken out is a constituent if forgotten part of communications history that can, in turn, be observed as a strategy in music and the arts, and as an ecological allegory with programmatic implications.

The terms *in-series* or *in-circuit*, widespread during the eighteenth century in the vernacular of electrical research, with its "philosophical instruments," made their way into the engineering jargon of telegraphy and telephony throughout the nineteenth century. As John Joseph Fahie wrote, "The power of the earth to complete the circuit for dynamic electricity has been known for a very long time."[1] Many things were brought in-circuit; while most were recognizably "technological," others were not. A frog's leg, a cat, or Lord Kelvin's tongue tasting the signals of the transatlantic cable could all be brought in-series, in-circuit.[2]

Carl August von Steinheil proposed using an *earth return* for telegraphy in 1838 as a way to cut costs by doing away with a metallic return line. Also called an earth circuit, or grounded circuit (at times bodies of water were used), the principle was also applied to telephony, that is, until the cumulative interferences from too many competing messages, electrical systems, and other environmental noises forced recourse to the *metallic circuit* of a second wire, or multiplexing.

Whatever else the mysterious noises were, they were a nuisance. The poor little telephone business was plagued almost out of its senses. It was like a dog with a tin can tied to its tail. . . . "We were ashamed to present our bills," said A.A. Adee, one of the first agents, "for no matter how plainly a man talked into his telephone, his language was apt to sound like Choctaw at the other end of the line." . . . There was no way to silence these noises. Reluctantly, they agreed that the only way was to pull up the ends of each wire from the tainted earth, and join them by a second wire. This was the "metallic circuit" idea. It meant an appalling increase in the use of wire.[3]

An *earth circuit* was open to the sounds of the earth and to other, non-natural sounds, whereas a *metallic circuit* was closed onto its own techno-logical loop. Most often the sounds in an open circuit were thought of as noises, but they were also listened to aesthetically and observed and mea-sured as scientific phenomena.

After the earth returns of telegraphy and telephony, the next major phase of the earth being in-circuit began during the 1920s with radio. As Chen-Pang Yeang reminds us, "A particular feature of radio consists exact-ingly in the fact that immaterial open space between transmitter and receiver is an indispensable element of the technology."[4] Wireless had always used the intervening space, but at a certain point it began to system-atically incorporate ionospheric reflectivity for long-distance communica-tion, thus bringing the ionosphere into a technological circuit. In fact, because wireless was used to empirically establish the existence of the ion-osphere and to map its constitution and behavior, it participated in the development of its own circuit. Signals were sent straight up at different frequencies, just off the zenith, reflecting back from different layers of the ionosphere, and then vectors were lowered and sent over the horizon. In this way ionospheric reflectivity was instrumentalized as part of long-distance communications technologies.

The ionosphere proved in its own way to be as open to interferences as the earth return. It was given to daily and seasonal unpredictability, acting differently in the night than in the day, disturbed by solar storms and tem-peramental at the best of times, with signals fading in and out and crossing with other signals. The equivalent of a metallic circuit arrived with the advent of communications satellites, in effect, stable metallic patches of ionospheric reflection. Communications satellites have not been an entirely closed circuit, since their signal paths are subject to conditions surrounding the earth and to space weather from the sun's coronal mass ejections, the source of the same "magnetic storms" that wreaked havoc on telegraph

systems in the nineteenth century. There were other, more esoteric forms of putting the earth in-circuit, many of them early exercises in the same militarized field of "survivable communications" that produced the Internet.[5]

As we have seen, the fin whales remind us that, when they are "*not postulating meaningful communication*," they may engage in a "simple signaling of place": *there is a fin whale here*.[6] How *there is the earth here* might be signaled is open to question among media systems closed in loops of sociality. The metallic circuit is an allegory for the contemporary notion that communications technologies are for communications. It should be clear by now that the term *communications technology* is something of a misnomer in that it lacks precision and is too narrow.

The etymological root of *communications* (being *common to many*) carries an equation with the social (unless *many* could mean a proliferation of nonhuman entities), whereas the earlier obscured meaning of *imparting things material* might accommodate our concerns better (if *material* remains consistent with energies). Obscured functions tied more closely to earth observation and sensing could be called *commune technologies* or *natural media* if it were possible to shed trivializing connotations, even as the redundant term *social media* enjoys vernacular usage.

Historically, any sense of terrestrial materiality and connectedness in the *earth-in-circuit*—with its earth returns, earth circuits, grounds, and earth currents—that may have attended earlier telecommunications have over time given way to tropes of the *annihilation of space and time*, a phrasing that admittedly takes a destructive turn that on its face is not awfully ecofriendly. Having once described long-distance travel by sea, the *annihilation of space and time* was accelerated in the early nineteenth century by railway travel that, as Wolfgang Schivelbusch has written, was first of all an annihilation of a space-time continuum of existing technologies of transport.[7] Schivelbusch goes on to say that the way in which people were aesthetically transported moved into media; the "*devaluation* of landscapes by their exploitation for mass tourism" correlated to the destruction of the aura that Walter Benjamin described as the effect of mechanical reproduction on works of art.[8] Instead of trekking from town to country, the window of the train framed a hitherto hard-earned nature in a mobile screen of comfort; instead of visiting the sacrosanct hold of a painting, one of thousands of copies was bound to come to you.

While image quality and exercise were lost in this give-and-take, the same lines of transport and communication were valuing rather than devaluing distant land and seascapes. As reported in *Nature* in 1887, "The

electric telegraph has so changed the conditions of existence as to become indispensable to the same, and we could almost as soon do without food and clothing as dispense with the power that has annihilated distance."[9] Much of the change was driven by accelerated flows of capital, greater distribution of labor exploitation, increased resource extraction, and expanded military mobilities of command and control, and this acceleration, what David Harvey has described as "time-space compression," went into overdrive at the speed of light as telegraph lines pulled away from rail lines, and wireless pulled away from the lines of communication.[10]

Crucially, there was also a *dilation* of space and time, as one writer in 1873 commented about telegraphy: "It is commonly said that it has annihilated time and space—and this is true in a sense; but in a deeper sense it has magnified both, for it has been the means of expanding vastly the inadequate conceptions which we form of space and distance, and of giving a significance to the idea of time which it never before had to the human mind."[11] Amid our contemporary legacies of annihilations of space and time—with global warming and other forms of ecological destruction accelerated with the millisecond, metallic circuits of capital, and globally distributed Internet communities with no apparent natural habitat—it is clear that circuits need to be opened up to many earth returns in an evolving sense of planet.[12] As we live within this panorama, the energetics and earth scaling of artists, musicians, scientists, and engineers become increasingly crucial.

Notes

INTRODUCTION

1. Edmund Russell et al., "The Nature of Power: Synthesizing the History of Technology and Environmental History," *Technology and Culture* 52 (April 2011): 246–59.

2. The occasion was a panel titled "Data Atmospheres," convened by Frances Dyson at the annual conference of the Society for Literature, Science and the Arts, University of Texas, Austin, 2003. I discussed *Whistlers* and *Sferics* by Lucier and *Electrical Storms* and *Aeriology* by Hinterding. The way in which these works required a different approach is characteristic of a larger problem that composers and artists responsive to contemporary conditions can face: such composers and artists are often not well served by prevailing criticism or existing histories. Working from the integrity of single works or bodies of work has the advantage of engaging the theorization already embodied in artistic practice rather than importing it. Ideally, such an approach can counter normative cycles of history and criticism with a notion of artistic possibility from which such works arise in the first place.

3. Linda Dalrymple Henderson, *Duchamp in Context: Science and Technology in the "Large Glass" and Related Works* (Princeton, NJ: Princeton University Press, 1998).

4. Michael Heumann recognized the implications of Watson's sounds in his PhD dissertation, "Ghost in the Machine: Sound and Technology in Twentieth-Century Literature" (University of California at Riverside, 1998), http://thelibrary.hauntedink.com/ghostinthemachine/ (accessed October 2005). Avital Ronell discusses Watson in a calls-and-affect manner fixed on Watson's spiritism in *The Telephone Book: Technology, Schizophrenia, Electric Speech* (Lincoln: University of Nebraska Press, 1991).

5. Hillel Schwartz, *Making Noise: From Babel to the Big Bang and Beyond* (New York: Zone Books, 2011).

6. From a 1983 interview in the documentary *Richard Feynman—The Last Journey of a Genius*, BBC TV production in association with WGBH Boston, 1989.

7. Richard Feynman, *The Feynman Lectures on Physics*, vol. 2, *Mainly Electromagnetism and Matter* (Philadelphia: Basic Books, 2011), 20–09. Feynman continues: "But nevertheless, in some sense the fields are real, because after we are all finished fiddling around with mathematical equations—with or without making pictures and drawings or trying to visualize the thing—we can still make the instruments detect the signals from Mariner II and find out about galaxies a billion miles away, and so on" (20–10).

8. James Clerk Maxwell's equations get subsumed under Albert Einstein's electrodynamics, while the more quotidian fields of Hans Christian Ørsted and Michael Faraday and the empirical waves of Heinrich Hertz are ignored. Everyday media could serve as philosophical instruments, having rendered sub-atomic quantum activity audible in the noise floor of electronics and dispatches from the cosmos visible in the static of analog television. R. Buckminster Fuller was perhaps the most up front about how much of the cosmos is electromagnetic, how little is known about it, and how much the collective ignorance is ignored—although he went off the deep end imagining the eyes to be akin to dish-transceiving antennas from which thoughts could be "eye-beamed" into the cosmos and back and also suggesting that what is called intuition may be caused by remote cosmic transmission. And that was before he began entertaining the viability of body teleportation. See Bruce Clarke, "Steps to an Ecology of Systems: *Whole Earth* and Systemic Holism," in *Addressing Modernity: Social Systems Theory and U.S. Cultures*, edited by Hannes Bergthaller and Carsten Schinko (Amsterdam: Rodopi, 2011), 259–88.

9. "Electricity and Its Relation to the Senses, *Electrical World* 1, no. 9 (May 5, 1883): 277.

10. As Laura Bruno notes, the "models of the dispersion and accumulation patterns of radioactive fallout isotopes provided the basis for our understanding of pathways of persistent chemicals in the environment. The pathways of pesticides were compared to the dissemination model of strontium-90 in [Rachel Carson's] *Silent Spring*, the first bestseller about environmental destruction." Laura A. Bruno, "The Bequest of the Nuclear Battlefield: Science, Nature, and the Atom During the First Decade of the Cold War," *Historical Studies in the Physical and Biological Sciences* 33, no. 2 (2003): 237–60.

11. Leslie Groves, "General Grove's Report on 'Trinity,' July 18, 1945," in *The American Atom: A Documentary History of Nuclear Policies from the Discovery of Fission to the Present*, edited by Philip L. Cantelon et al. (Philadelphia: University of Pennsylvania Press, 1991), 55. "With the assistance of the Office of Censorship we were able to limit the news stories to the approved release supplemented in the local papers by brief stories from the many eyewitnesses not connected with our project. One of these was a blind woman who saw the light" (55).

12. One of Erik Satie's cephalophones, a class of musical instruments designed to exist in the head alone, had a "range of thirty octaves" but was, he conceded, "completely unplayable." An amateur tried, but "the instrument burst, snapped his spine & completely scalped him." Erik Satie, *A Mammal's*

Notebook, edited by Ornella Volta, translated by Antony Melville (London: Atlas Press, 1996), 148.

13. Very Low Frequency waves dominate but do not completely cover this range. *VLF* is shorthand. When most people talk about "radio," they are referring to the device within which higher frequencies must be stepped down or demodulated to become audible. For example: "In a Radio Nature receiver all demodulation operations, the separation of the carrier from the modulating signal, are unnecessary. The signal that will be received is already in base band. You just have to receive it with an antenna, and then transform the radio frequency wave into an electric signal, and amplify it enough to drive a loudspeaker or headphones." Renato Romero, *Radio Nature: The Reception and Study of Naturally Originating Radio Signals* (Potters Bar: Radio Society of Great Britain, 2008), 17–18. Shorter waves carry more information in a given amount of time, so VLF is used for special purposes where not much information, relatively, is needed; however, as we shall see, VLF has played a big historical role in location and navigation.

14. Robert A. Helliwell, *Whistlers and Related Ionospheric Phenomena* (1965) (Mineola, NY: Dover Publications, 2006).

15. Ursula K. Heise, "Unnatural Ecologies: The Metaphor of the Environment in Media Theory," *Configurations* 10, no. 1 (Winter 2002): 149–68 (164).

16. See Nadia Bozak, *The Cinematic Footprint: Lights, Camera, Natural Resources* (New Brunswick, NJ: Rutgers University Press, 2012), 17–52, for a treatment that includes poetics within a green media frame.

17. For a brief introduction to vibration, inscription, and transmission relating to technologies and tropes of sound, see my introduction to *Wireless Imagination: Sound, Radio and the Avant-Garde,* edited by Douglas Kahn and Gregory Whitehead (Cambridge, MA: MIT Press, 1992). My book *Noise, Water, Meat: A History of Sound in the Arts* (Cambridge, MA: MIT Press, 1999) focused primarily on phonography, graphical sound, rhetorical lines of demarcation, cinema sound, cellular inscription, and other inscriptive concerns, rather than vibration or transmission.

18. Optical telegraphy was an intermediary system. Having light at its physical core, it too was technically electromagnetic, and compared with other contemporary systems it was considerably faster. Still, as Alexander Field has calculated, a thirty-five-signal message from Paris to Lille on the most sophisticated system in the world in the early nineteenth century would require relays between twenty-two stations, each staffed with its own telegrapher, and would require a total transmission time of approximately eighteen minutes. Alexander J. Field, "French Optical Telegraphy, 1793–1855: Hardware, Software, Administration," *Technology and Culture* 35, no. 2 (April 1994): 315–47. Therefore, although the optical telegraphic system transmitted at the speed of light when enough light was available—with visual impediments like fog, rain, and snow permitting—electromagnetic speeds went in and out of circuit with the slower, metabolically based energies of the human body. Electrical

telegraphy placed the metabolic switches (telegraphers) at either end of the transmission and allowed the intervening space to aspire to the speed of light. As opposed to the expenses involved with optical telegraphy, general communication became affordable and diffusion began to be joined with transmission, a union that has become increasingly sophisticated to the present day.

19. For use of the telephone, microphone, and phonograph for scientific purposes, see Count Du Moncel, *The Telephone, the Microphone and the Phonograph* (New York: Harper & Brothers, 1879).

20. Friedrich Kittler, *Gramophone, Film, Typewriter* (Stanford, CA: Stanford University Press, 1999); Friedrich Kittler, *Discourse Networks 1800/1900* (Stanford, CA: Stanford University Press, 1990).

21. Friedrich Kittler, "Media Wars: Trenches, Lightning, Stars," in *Literature, Media, Information Systems* (Amsterdam: Overseas Publishers Association, 1997), 117–29. In "There Is No Software" (in the same book, pp. 147–55), this trajectory is extended; the physical limits of computing are tested by "digitalizing the body of real numbers formerly known as nature" (152) and there encounter, finally, a noisy energetics of electron diffusion and quantum-mechanical tunneling in the environment of the chip, suggesting an erogenous and cosmic union where computers can stop talking with each other and enter "that body of real numbers originally known as chaos" (155).

1. THOMAS WATSON

1. Charles Süsskind, "Observations of Electromagnetic-Wave Radiation before Hertz," *Isis* 55, no. 179 (March 1964): 32–43 (33).

2. Ibid.

3. See the chapter "Wireless before Marconi," in *History of Wireless*, by Tapan K. Sarkar et al. (Hoboken, NJ: John Wiley & Sons, 2006), 247–66.

4. Alexander Graham Bell, "Researches in Electric Telephony," *Journal of the Society of Telegraph Engineers* 6, no. 20 (October 31, 1877): 385–421.

5. John Joseph Fahie, *A History of Wireless Telegraphy: 1838–1899* (Edinburgh: William Blackwood and Sons, 1899).

6. Thomas A. Watson, *Exploring Life: The Autobiography of Thomas A. Watson* (New York: D. Appleton and Company, 1926), 62. I am indebted to George Kupczak at the AT&T Archives and History Center and also William Winternitz and Susan Cheever for their assistance on Thomas Watson.

7. Watson here refers to the machine shop of Charles Williams on the third floor and attic of 109 Court Street, Boston, where he had worked for almost four years. The shop built a limited range of electrical devices used during the day (telegraph apparatuses, fire alarms and other bells, batteries, etc.). Later, there was another line connecting the Exeter laboratory with an office on Pearl Street that itself was connected with a telegraph line receiving a time signal from the Harvard Observatory in Cambridge. "At night, when the signal wire was not in use, we could connect up the circuit to Cambridge for our experiments." Watson, *Exploring Life*, 80–82, 105.

8. As Robert Helliwell writes, "Some whistlers are very pure gliding tones; others sound 'swishy'—much like air escaping from a punctured balloon tire." Robert A. Helliwell, *Whistlers and Related Ionospheric Phenomena* (1965) (Mineola, NY: Dover Publications, 1993), 1–2. However, the incongruity of Watson's description of the grating sound lasting two to three seconds, whereas whistlers usually last about half that time, may be attributable to his memory fifty years after the fact. Helliwell provides a general description of tweeks: "The radiation from the lightning stroke travels at approximately the speed of light in the space between the earth and the lower edge of the ionosphere, called the earth-ionosphere waveguide. At times when the reflection efficiency of the ionosphere is high this radiation may echo back and forth between the boundaries of the waveguide many times before disappearing into the background noise. Then the received disturbance consists of a series of impulses, which produces a faintly musical or chirping sound. This particular type of atmospheric is usually called a 'tweek'" (2).

9. William F. Channing, "Overheard by Telephone. The Music in Providence," *Journal of the Telegraph* 10, no. 24 (December 16, 1877): 376–77. "Similarly, the first hearing of electric sounds from the aurora by telephone is due to Prof. John Peirce (Emeritus Professor of Brown University)." Letter from William F. Channing to Alexander Graham Bell, July 16, 1877, Alexander Graham Bell Family Papers, Library of Congress, http://rs6.loc.gov (accessed 2005).

10. *Annual Report of the Chief Signal-Officer to the Secretary of War for the Year 1877* (Washington, DC: Government Printing Office, 1877), 482.

11. Ibid.

12. Analysis and further observations of whistlers were made again from the Sonnblick Observatory in 1902 by Victor Conrad, and again in 1928 and 1954 by Josef Fuchs. Josef Fuchs, "Die Sende- und Empfangsverhältnisse für drahtlose Telegraphie am Sonnblick," in *XXXVII Jahresbericht des Sonnblick-Vereines, für Das Jahr 1928*, edited by Wilhelm Schmidt (Vienna: Julius Springer, 1929), 31–37; Josef Fuchs, "Report on Some Observations on Atmospheric Electricity," in *Proceedings on the Conference on Atmospheric Electricity (Held at Wentworth-by-the-Sea, Portsmouth, New Hampshire, May 19–21, 1954)*, edited by Robert E. Holzer and Waldo E. Smith (Hanscom Air Force Base, Bedford, MA: Air Force Cambridge Research Labs, 1955). Fuchs mentioned this research during discussions at the Twelfth General Assembly of URSI (International Scientific Radio Union), August 22–September 5, 1957, Boulder, CO, proceedings published as *A Report to the National Academy of Sciences—National Research Council*, Publication 581 (1958), including his own observations at the Sonnblick Observatory in 1928, when he heard "a short whistle of decreasing musical frequency, lasting about 0.2 seconds, with irregular intervals between two whistlers often up to several seconds. This phenomenon sounds somewhat similar to the whistle produced by a flick with a whip" (105). The journal *Science* reported observations from the Sonnblick Observatory in 1896 but explanation was framed in terms of "atmospheric

electricity" and "earth currents." "Current Notes on Meteorology: Atmospheric Electricity and Telephones," *Science* 4, no. 96 (October 30, 1896): 650–51. The telephone line at Sonnblick was a primitive version of the research antenna at Siple Station, Antarctica, a 21.2-kilometer dipole antenna for reception and transmission of VLF signals. R.A. Helliwell and J.P. Katsufrakis, "Controlled Wave-Particle Interaction Experiments," in *Upper Atmosphere Research in Antarctica*, edited by L.J. Lanzerotti and C.G. Park, Antarctic Research Papers 29 (Washington, DC: American Geophysical Union, 1978), 100–129.

13. E.T. Burton and E.M. Boardman, "Audio-Frequency Atmospherics," *Proceedings of the Institute of Radio Engineers* 21, no. 10 (October 1933): 1476–94 (1488). See also Rush F. Chase, "Occurrence of 'Tweeks' on a Telephone Line," *Proceedings of the Institute of Radio Engineers* 26, no. 11 (November 1938): 1380–84.

14. Watson, *Exploring Life*, 80–82.

15. Ibid., 121.

16. Charles Fourier, *The Passions of the Human Soul, and Their Influence on Society and Civilization*, vol. 1, translated by Hugh Doherty (London: Hippolyte Bailliere, 1851), 151ff; Nikola Tesla, "Talking with the Planets," *Collier's Weekly* (February 19, 1901): 4–5.

17. Daniel Gethmann, "Visual (Ec)Static: On National Radio Silence Day," in *Sound Art: Schriftenreihe für Künstlerpublikationen*, edited by Anne Thurmann-Jajes et al. (Cologne: Salon Verlag, 2005), 105–31.

18. E.C. Baker, *Sir William Preece, F.R.S.: Victorian Engineer Extraordinary* (London: Hutchinson & Co., 1976), 281–82.

19. Thomas A. Watson, *From Electrons to God: A New Conception of Life and the Universe* (Boston: Privately printed, 1933), 10.

20. Watson, *Exploring Life*, 80–82.

21. Ibid.

22. Ibid., 14–15.

23. Watson, *From Electrons to God*; Thomas Watson, "The Religion of an Engineer" (May 15, 1930), 18-page unpublished typescript, and Thomas Watson, "The Earth, a Vast Orchestra" (October 1, 1932), three-page unpublished typescript, both in "Articles written by Thomas Watson, 1892; 1909–1933," Box 1068, AT&T Archives and History Center, Warren, NJ.

24. Gustav Fechner, *The Little Book of Life after Death*, with an introduction by William James (Boston: Little, Brown & Company, 1912).

25. Watson, "The Earth, a Vast Orchestra," 1.

26. Watson, *From Electrons to God*, 3.

27. Watson, "Religion of an Engineer," 3.

2. MICROPHONIC IMAGINATION

1. "Microphone," *Telegraphic Journal* 6, no. 134 (September 1, 1878): 369.

2. "An Introduction Essay to the Doctrine of Sounds, Containing Some Proposals for the Improvement of Acousticks; As It Was Presented to the

Dublin Society November 12, 1683, by the Right Reverend Father in God Narcissus Lord Bishop of Ferns and Leighlin," *Philosophical Transactions of the Royal Society* 14 (1684): 472–88.

3. John Joseph Fahie, *A History of Wireless Telegraphy: 1838–1899* (Edinburgh: William Blackwood and Sons, 1899), 79.

4. James Clerk Maxwell, "The Rede Lecture," *Nature* 18, no. 343 (June 6, 1878): 159–63.

5. John G. McKendrick, "Laboratory Notes," *Nature* 18, no. 452 (June 27, 1878): 240–41.

6. M. d'Arsondal, "The Telephone as a Galvanoscope," *Journal of the Franklin Institute* 105, no. 6 (June 1878): 423. "The amount of current which will actuate a telephone receiver so as to make an audible sound is extremely small, a mere fraction of a milliampere, and for this reason it is one of the most delicate galvanoscopes that we have." George T. Hanchett, "Use of the Telephone as a Galvanoscope," *Electrical Engineer* 24, no. 503 (December 28, 1897): 596–97, cited in Sidney H. Aronoson, "The *Lancet* on the Telephone: 1876–1975," *Medical History* 21 (1977): 69–87. See also George Forbes, "The Telephone: An Instrument of Precision," *Nature* 17, no. 343 (February 28, 1878): 343.

7. D. E. Hughes, "On the Action of Sonorous Vibrations in Varying the Force of an Electric Current," *Proceedings of the Royal Society of London* 27 (1878): 362–69.

8. Ibid., 366.

9. Ibid.

10. Ibid.

11. "The Microphone," *New York Times* (August 31, 1878): 2.

12. Crookes, cited in "Microphone," *Journal of the Franklin Institute* 106, no. 1 (July 1878): 63; "The Phones of the Future," *New York Times* (June 9, 1878): 6; "The Microphone," *Littell's Living Age* 137, no. 1775 (June 22, 1878): 764–65; "Wonders of the Microphone," *Christian Advocate* 69, no. 48 (November 29, 1894): 791; Count Du Moncel, *The Telephone, the Microphone and the Phonograph* (New York: Harper & Brothers, 1879), 146 ("trumpeting of an elephant" and "asthmatic elephant"); Francis Jehl, *Menlo Park Reminiscences* (Dearborn, MI: Edison Institute, 1937), 140. The fly's intrepid descendants marched their way into experimental music when one critic for *Newsweek* magazine, reviewing John Cage's *Williams Mix*, stated that he heard a sound "like a fly walking on paper, magnified," whereas Cage himself knew that "sounds like ants walking in the grass" could be enlarged and heard using "new techniques" unimaginable to Goethe's Young Werther, and said that it would be "quite reasonable to imagine that we will have a loudspeaker that will be able to fly through space." Robert Dumm, "Sound Stuff," *Newsweek* (January 11, 1954): 76; Michael Kirby and Richard Schechner, "An Interview with John Cage," *Tulane Drama Review* 10, no. 2 (Winter 1965); 54, 65–66. This would be realized when Walter Murch's sound film technique of "worldizing," that is, recording a sound played back on set or in another space, was taken

into the insect world by Skip Livesay using a small speaker to wave the sound of a mosquito around in *Barton Fink*.

13. D.E. Hughes, "On the Physical Action of the Microphone," *Philosophical Magazine* 6, no. 34 (July 1878): 44–50 (46).

14. Maxwell, "The Rede Lecture," 162. George Prescott disagreed with the analogy of the microscope and its indexical capabilities and instead attributed the effect to a mediation of the device: "The sound that is heard in the receiving instrument of the microphone, when a fly is walking across the board on which the transmitter is placed, is not the sound of the fly's footsteps, any more than the stroke of a powerful electric bell, or sounder, is the magnified sound of the operator's fingers tapping lightly and, it may be, inaudibly upon the key." George Prescott, *Bell's Electric Speaking Telephone* (New York: D. Appleton & Company, 1884), 140.

15. "The Microphone," *Littell's Living Age*, 764–65.

16. McKendrick, "Laboratory Notes," 240–41.

17. "Dermatophony," *Medical News* 37 no. 437 (May 1879): 78.

18. Prescott, *Bell's Electric Speaking Telephone*, 140; W.H. Preece, "On Some Physical Points Connected with the Telephone," *Journal of the Franklin Institute* 105, no. 4 (April 1878): 278.

19. Hughes, "On the Action of Sonorous Vibrations," 365.

20. "The Microphone," *New York Times*, 3.

21. *Telegraphic Journal and Electrical Review* (July 1, 1878): 274, cited in Frederick Leland Rhodes, *Beginnings of Telephony* (New York: Harper & Brothers, 1929), 78. "The microphone affords another instance of the unexpected value of minute variations—in this case of electric currents; and it is remarkable that the gist of the instrument seems to lie in obtaining and perfecting that which electricians have hitherto most scrupulously avoided, *viz*, loose contact." *Telegraphic Journal and Electrical Review* (August 15, 1878): 340.

22. Such sounds only compounded the existing problems: "that a conversation over a wire of considerable length has, as it were, to run the gauntlet among the scraps of talk imparted from neighboring lines, the crackling and hammering due to induction from telegraph and electric light wires, and the vague murmur compounded of an infinite number of lesser disturbances; and it is not surprising that it is soon overwhelmed by so many adverse influences." "Telephonic Defects," *Manufacturer and Builder* 5, no. 7 (July 1883): 159.

23. "Telephone Sounds," *Scientific American* 47, no. 10 (September 2, 1882): 153.

24. "The Phones of the Future," *New York Times* (June 9, 1878): 6.

25. Ibid.

26. P.C.B., "Phonomime, Autophone, and Kosmophone," letter to the editor, *New York Times* (June 11, 1878): 5. I am indebted to Professor Paul Israel of Rutgers University, director and general editor of the Thomas A. Edison Papers Project, for kindly providing information regarding Bliss.

27. "The Microphone," *Littell's Living Age*, 764–65.

3. THE AEOLIAN AND HENRY DAVID THOREAU'S
SPHERE MUSIC

1. Carl Engel, "Aeolian Music," *Musical Times* 23, no. 4 (August, 1882): 436. The essay concludes in issue no. 5 (September 1882): 479–83.

2. Engel, "Aeolian Music," 432–33.

3. Eduard Hanslick, "The Relations of Music to Nature," in *On the Musically Beautiful: A Contribution towards the Revision of the Aesthetics of Music* (1854), 1891 edition translated by Geoffrey Payzant (Indianapolis: Hackett, 1986), 72, 73. For a long view of the music of the dead, see E. K. Borthwick, "The Riddle of the Tortoise and the Lyre," *Music and Letters* 51, no. 4 (October 1970): 373–87.

> The fact is that a voiceless creature, such as the tortoise, or inanimate materials, such as wood or gut, may be used to engender musical sound when the life of the creature, or the growth of the material, is terminated. The earliest literary reference to this paradox is in fact the famous myth of the lyre made by the god Hermes from the shell of a dead tortoise . . . in the Homeric Hymn to Hermes, composed probably in the sixth century B.C.: "For it was Hermes who first made the tortoise a singer." Addressing the tortoise before he dismembers it and fits "two horns and seven strings of sheep gut" to its empty shell, Hermes says: "Living you will become a charm against mischievous witchcraft, but if you die you sing most beautifully." (373–74)

4. Hanslick, "The Relations of Music to Nature," 68.

5. Ibid., 71.

6. Engel, "Aeolian Music," 433.

7. Ibid.

8. Ibid., 434.

9. Ibid., 435.

10. John Muir, *The Wilderness World of John Muir* (Boston: Houghton Mifflin, 1954), 193–94, 185–86.

11. The quotation is from Thoreau's December 28, 1851, journal entry, in *Journal, Volume 4: 1851–1852*, edited by Robert Sattelmeyer (Princeton: Princeton University Press, 1990), 227.

12. Thoreau, journal entries, March 15, 1842, and March 6, 1838, *Journal: Volume 1; 1837–1844*, edited by Elizabeth Hall Witherell et al. (Princeton, NJ: Princeton University Press, 1990), 332, and 34–35.

13. Thoreau, journal entry, December 28, 1852, *Journal: Volume 4*, 412–13.

14. Charles Ives, "Essays before a Sonata," in *Three Classics in the Aesthetic of Music* (New York: Dover Publications, 1962), 142.

15. Thoreau, journal entry, September 22, 1851, *Journal: Volume 4*, 90.

16. Thoreau, journal entry, January 3, 1852, *Journal: Volume 4*, 238.

17. Thoreau, journal entry, September 22, 1851, *Journal: Volume 4*, 90–91.

18. Ken Beauchamp, *History of Telegraphy* (London: Institution of Electrical Engineers, 2001), 57–58.

19. Paul Gilmore, "The Telegraph in Black and White," *ELH* 69, no. 3 (2002): 805–33.

20. Thoreau, journal entry, June 13, 1851, *Journal: Volume 3; 1848–1851*, edited by John C. Broderick (Princeton, NJ: Princeton University Press, 1990), 260.

21. Henry David Thoreau, *Walden* (Princeton, NJ: Princeton University Press, 2004), 304–5.

22. Thoreau, journal entry, September 19, 1850, *Journal: Volume 3*, 119.

23. Thoreau, journal entry, March 15, 1852, *Journal: Volume 4*, 388.

24. Thoreau, journal entry, January 23, 1852, *Journal: Volume 4*, 280.

25. Thoreau, journal entry, October 28, 1852, *Journal: Volume 5; 1852–1853*, edited by Robert Sattelmeyer (Princeton, NJ: Princeton University Press, 1990), 386–87.

26. Thoreau, journal entry, September 22, 1851, *Journal: Volume 4*, 89–90.

27. Charles Burchfield, journal entry, January 18, 1915, *Charles E. Burchfield's Journals*, vol. 23, 30–31, quoted in Nancy Weekly, "*Song of the Telegraph:* An Interpretation," in the exhibition program for *Charles Burchfield: Song of the Telegraph*, Burchfield Penney Art Center, May 14–June 14, 2009, www.yournewburchfieldpenney.com/pdf/songOfTheTelegraph.pdf (accessed November 5, 2010). The journals are part of the Charles E. Burchfield Archives at the Burchfield Penney Art Center, Buffalo State College, New York. All Burchfield quotations are taken from Weekly's "*Song of the Telegraph:* An Interpretation." I am indebted to Nancy Weekly for her assistance and my understanding of Burchfield's painting.

28. Burchfield, journal entry, January 29, 1915, 45–46, quoted in ibid.

29. Weekly, "*Song of the Telegraph:* An Interpretation."

30. Ernestine Hill, *The Territory* (1951) (Sydney: Walkabout Pocketbooks, 1970), 111.

31. Ibid., 118.

32. James H. Bunn, *Wave Forms: A Natural Syntax for Rhythmic Languages* (Stanford, CA: Stanford University Press, 2002), 33.

33. William Henry Hudson, *Nature in Downland* (1900) (London: Longmans, Green, 1906), 197–98. On Hudson, see Simon Naylor, "Discovering Nature, Rediscovering the Self: Natural Historians and the Landscapes of Argentina," *Environment and Planning D: Society and Space* 19 (2001): 227–47.

34. "There remains, you may say, the wire itself: but the wire, obsolete from the day of its completion, hung down from poles never replaced when they go to rot and tumble to the ground. (Sometimes the termites attack them, and sometimes the Indians, who mistake the humming of the telegraph wires for the noise of bees on their way to the hive)." Claude Lévi-Strauss, *Tristes Tropiques* (New York: Atheneum, 1975), 262.

35. Hudson, *Nature in Downland*, 197–98.

36. "The Telegraph," *Harper's New Monthly Magazine* 47, no. 279 (June–November 1873): 332. The author of this formidable essay was not listed.

37. T. Mellard Reade, "Vibration of Telegraph Wires during Frost," *Nature* 23, no. 588 (February 3, 1881): 314. See also F.T. Mott, "Vibration of Telegraph Wires during Frost, *Nature* 23, no. 589 (February 10, 1881): 338.

38. "The Telegraph," *Harper's New Monthly Magazine*, 332.

39. For the role of telegraphy in meteorology, see the chapter "Weather by Wire" in Mark Monmonier, *Air Apparent: How Meteorologists Learned to Map, Predict, and Dramatize Weather* (Chicago: University of Chicago Press, 1999).

40. Wm. H. Babcock, "Do Telegraph-Wires Foretell Storms?" *Science* 5, no. 119 (May 15, 1885): 396–97. The journal editors appended an explanation, saying that the sounds were produced by "simple transverse vibrations and longitudinal waves such as occur on every stretched cord that gives out a musical note. These vibrations are ultimately caused by the wind. . . . Sometimes rapid alternations of sunshine and shade, by heating and cooling the wire, cause it to elongate and contract rapidly, and maintain an additional series of musical notes." See also "The Telegraph and the Weather," *Scientific American* 12, no. 7 (February 11, 1865): 100: "We thus see that it is possible by merely observing whether the disturbance increases or decreases, to determine when a storm is approaching us or passing in the opposite direction."

41. E.T.A. Hoffmann, "Automata" (Whitefish, MT: Kessinger, 2004), 29. See also Mitchell Clark, "Aeolian-Bow Kites in China," *Experimental Musical Instruments* 14, no. 3 (March 1999); 41–45; and Mitchell Clark, "The Wind Enters the Strings: Poetry and Poetics of an Aeolian Sounding of the *Qin*," unpublished manuscript (personal correspondence). Any respectable collection of large-scale harps needs to include the mountain slopes that Erik Satie describes as harboring "monstrous Harps with special toboggan for glissandos." Erik Satie, *A Mammal's Notebook*, edited by Ornella Volta, translated by Antony Melville (London: Atlas Press, 1996), 148.

42. Timothy Morton, "Of Matter and Meter: Environmental Form in Coleridge's 'Effusion 35' and 'The Eolian Harp,'" *Literature Compass* 5, no. 2 (2008): 310–35 (313).

43. Vladimir Mayakovsky, "Open Letter to the Workers" (1918), quoted in Anatolii Strigalev, "The Art of the Constructivists: From Exhibition to Exhibition, 1914–1932," in *Art into Life: Russian Constructivism, 1914–1932* (New York: Rizzoli, 1990), 27.

4. THE AELECTROSONIC AND ENERGETIC ENVIRONMENTS

1. John Hollander, *The Untuning of the Sky: Ideas of Music in English Poetry, 1500–1700* (Princeton, NJ: Princeton University Press, 1961).

2. Friedrich Nietzsche, *The Gay Science* (1882), translated by Walter Kaufmann (New York: Vintage, 1974), 167–68.

3. From "The Lamentations of Edison," in *Tomorrow's Eve* (1886), by Villiers de l'Isle-Adam, translated by Robert Martin Adams (Urbana: University of Illinois Press, 1982), 9–11.

4. This schema provisionally excludes many other meanings of transduction, of course, yet has relevance for the trade between acoustics and electromagnetism, sound and signal, and for the operations of the two major "public senses" (sight and hearing) and for audiovisual media. The emphasis is on energy, mechanisms, and media, especially as they might locate what goes on in the grey area of black boxes. Gilbert Simondon is the main source for philosophical uses of the term *transduction:* "By transduction we mean an operation—physical, biological, mental, social—by which an activity propagates itself from one element to the next, within a given domain, and founds this propagation on a structuration of the domain that is realized from place to place: each area of the constituted structure serves as the principle and the model for the next area, as a primer for its constitution, to the extent that the modification expands progressively at the same time as the structuring operation." Gilbert Simondon, "The Position of the Problem of Ontogenesis," *Parrhesia,* no. 7 (2009): 4–16.

5. For a good introduction, see Jonathan Ashmore, "Hearing," in *Sound,* edited by Patricia Kruth and Henry Stobart (Cambridge: Cambridge University Press, 2000), 65–88. In 2007, the Danish artist Jacob Kirkegaard created a performance and installation titled *Labyrinthitis* utilizing otoacoustic emissions. Commissioned by the Medical Museion in Copenhagen and issued on CD by Touch in 2008 (Touch, Tone 35), it nicely counters Marcel Duchamp's dictum that "one can look at (see) seeing, one cannot hear hearing." From *Box of 1914,* in Marcel Duchamp, *Salt Seller: The Writings of Marcel Duchamp,* edited by Michel Sanouillet and Elmer Peterson (New York: Oxford University Press, 1973), 32.

6. See Jonathan Sterne, *The Audible Past: Cultural Origins of Sound Reproduction* (Durham, NC: Duke University Press, 2003).

7. Edward E. Clement, "Anthropomorphic Telephony," *Telephony* 5, no. 5 (May 1903): 272–73; Laura Otis, "The Other End of the Wire: Uncertainties of Organic and Telegraphic Communication," *Configurations: A Journal of Literature, Science, and Technology* 9, no. 2 (2001): 181–206.

8. Francis Jehl, *Menlo Park Reminiscences,* vol. 1 (Dearborn, MI: Edison Institute, 1937), 134–42, 184; Thomas A. Edison, *The Papers of Thomas A. Edison,* vol. 3, *Menlo Park: The Early Years, April 1876–December 1877,* edited by Robert A. Rosenberg et al. (Baltimore: Johns Hopkins University Press, 1994), 258–59, 269–71.

9. Alexander Graham Bell, "Researches in Telephony," *Proceedings of the American Academy of Arts and Sciences,* vol. 12, *May 1876 to May 1877* (Boston: Press of John Wilson and Son, 1877), 3; C.G. Page, "The Production of Galvanic Music," *Silliman's Journal* 32, no. 2. (1837): 396–97.

10. D.E. Hughes, "On the Action of Sonorous Vibrations in Varying the Force of an Electric Current," *Proceedings of the Royal Society of London* 27 (1878): 365.

11. C.F. Volney, *A View of the Soil and Climate of the United States of America* (Philadelphia: J. Conrad & Co., 1804), 198.

12. M.J. Fournet, "Electrical Countries and Their Action on the Weather," in *The Intellectual Observer: A Review of Natural History, Microscopic Research and Recreative Science*, vol. 12 (London: Groombridge and Sons, 1868), 134–36.

13. Edward C. Pickering, "Introduction," *Annals of Harvard College Observatory* 22 (1889): xi.

14. Fournet, "Electrical Countries," 134–35.

15. Ibid., 135.

16. Ibid., 412.

17. Ibid., 414.

18. "Eccentric Electricity," *Electrical World* 8, no. 20 (November 13, 1886): 239.

19. "Electrified Lily," *Journal of the Franklin Institute* 114, no. 5 (November 1882): 392.

20. David Livingstone, *Missionary Travels and Researches in South Africa* (New York: Harper & Brothers, 1858), 137.

21. Richard Stothers, "Ancient Aurorae," *Isis* 70, no. 1 (March 1979): 85–95.

22. Samuel Hearne, *Journey from Prince of Wales's Fort in Hudson Bay, to the Northern Ocean* (1795) (Toronto: Champlain Society, 1911), 235. See also Lane Cooper, "A Dissertation upon Northern Lights," *Modern Language Notes* 21, no. 2 (February 1906): 44–46.

23. S.M. Silverman and T.F. Tuan, "Auroral Audibility," in *Advances in Geophysics*, vol. 16, edited by H.E. Landsberg and J. Van Mieghem (New York: Academic Press, 1973), 252–53.

24. Silverman and Tuan summarize the theories as they stood in the early 1970s: "such possibilities as psychological origin, physiological, meteorological, direct transmission of sound, conversion of electromagnetic waves to pressure at the ear, infrasonic waves, and electric side effects, both directly as well as indirectly through brush discharges." Silverman and Tuan, "Auroral Audibility," 156. The authors privileged point and brush discharge of electrical fields. Still, more recently, Neil Bone states, "The occurrence or otherwise of auroral sound is likely to remain contentious for some time to come." Neil Bone, *Aurora: Observing and Recording Nature's Spectacular Light Show* (New York: Springer, 2007), 168.

25. The descriptions of sounds are primarily from Silverman and Tuan, "Auroral Audibility," 155–266. A few are from S. Chapman, "The Audibility and Lowermost Altitude of the Aurora Polaris," *Nature* 127, no. 3201 (March 7, 1931): 341–42, and "Aurora Sounds," *Journal of the Franklin Institute* 121, no. 6 (June 1886): 467.

26. "The Telegraph," *Harper's New Monthly Magazine* 47, no. 279 (June–November 1873): 332–60 (332).

27. Ibid., 332.

28. Ibid., 334.

29. Peter J. Smith, "Pre-Gilbertian Conceptions of Terrestrial Magnetism," *Techtonophysics* 6, no. 6 (1968): 499–510.

30. See "Magnetic Storms," *Scientific American* 8, no. 23 (June 6, 1863): 418: "Magnetic storms are always accompanied by aurorae and earth magnetic currents. The latter are known to telegraph operators. . . . They traverse the surface of the earth, and a portion of magnetism is taken up by the line-wires, seriously disturbing communications. It has been found that aurorae and great earth currents recur at intervals of about ten years, with the spots on the sun's surface. . . . The mysterious force 'magnetism' seems to pervade the entire solar system, and perhaps the whole universe."

31. W.H. Barlow, "On the Spontaneous Electrical Currents Observed in the Wires of the Electrical Telegraph," *Philosophical Transactions of the Royal Society of London* 139 (1849): 61–72.

32. O.H. Gish, "Natural Electric Currents in the Earth's Crust," *Scientific Monthly* 32, no. 1 (January 1931): 5–21.

33. George Wilson, *Electricity and the Electric Telegraph* (London: Longman, Brown, Green, Londmans, & Roberts, 1859), 58.

34. D.H. Boteler, "The Super Storms of August/September 1859 and Their Effects on the Telegraph System," *Advances in Space Research* 38, no. 2 (2006): 159–172; "The Great Auroral Exhibition of August 28th to September 4th, 1859," *American* 29 (May 1860): 92.

35. Boteler, "Super Storms," 163. This was for a message from Philadelphia to Pittsburgh. See also Gish, "Natural Electric Currents in the Earth's Crust," 7; and "Telegraph Lines and the Aurora Borealis," *Scientific American* 20, no. 23 (June 5, 1869): 357.

36. "The Disturbances Elsewhere," *New York Times* (November 18, 1882): 1.

37. W.H. Preece, compiling the reports of others, in "Earth Currents, and the Aurora Borealis of 4th February," *Journal of the Society of Telegraph Engineers* 1, no. 1 (1872): 102–4.

38. Ibid., 103.

39. "Earth Currents, and the Aurora Borealis of 4th February.—No. 2," *Journal of the Society of Telegraph Engineers* 1, no. 2 (1872): 250–56.

40. G.K. Winter, "On Earth Currents, and on Their Bearing upon the Measurement of the Resistance of Telegraph Wires in Which They Exist," *Journal of the Society of Telegraph Engineers* 2, no. 1 (1873): 89–102.

41. Fournet, "Electrical Countries," 134–36.

42. Ibid.

43. "A Thunder-Storm in the City," *New York Times* (February 22, 1882): 5.

44. "Influence of Atmospheric Electricity and Induced Earth Currents in Telegraphy," *Journal of the Telegraph* 10, no. 3 (February 1, 1877): 83–84.

45. "The Aurora Borealis and Telegraph Cables," *Scientific American Supplement* 11, no. 288 (July 9, 1881): 287.

46. "Influence of Atmospheric Electricity," *Journal of the Telegraph*, 83–84; "The Telegraph and the Weather," *Scientific American* 12, no. 7 (February 11, 1865): 100; "Special Report on Earth Currents," *Journal of the Society of Telegraph Engineers* 2, no. 1 (1873): 81–123.

5. INDUCTIVE RADIO AND WHISTLING CURRENTS

1. "The power of the earth to complete the circuit for dynamic electricity has been known for a very long time." See "Discovery of the Earth Circuit," in J.J. Fahie, *A History of Electric Telegraphy to the Year 1837* (London: E. & F.N. Spon, 1884), 343–48 (343).

2. Carl August von Steinheil, quoted in ibid., 348.

3. Herbert N. Casson, *The History of the Telephone* (Chicago: A.C. McClurg & Co., 1910), 120–22.

4. Testimony of John J. Carty before the Public Service Commission, State of New York, Albany, March 15, 1922, cited in Frederick Leland Rhodes, *Beginnings of Telephony* (New York: Harper & Brothers, 1929), 90. The capacity of one line to audibly detect activity in another fostered a proposal to use the telephone as a means to investigate defects in submarine telegraph lines. "Laboratory Notes," *Nature* 22, no. 555 (June 17, 1880): 157. This difficulty was noticed very early: "Great care is necessary in erecting lines for [Bell's articulating] telephone, for if the wire comes in close proximity to, or is carried on the same poles as, other lines, other currents are induced, producing confusion. Part of the line we are now working on is carried on the poles of the city lines, and you can hear distinctly the click of the various Morse instruments operating them." Secretary's report at the meeting of the Franklin Institute, September 19, 1877, in "Bell's Articulating Telephone," *Journal of the Franklin Institute* 104, no. 4 (October 1877): 219–22.

5. "Balance on Telephone Lines" (translation from *L'Electricien*, Paris), *Telephony* 6, no. 1 (July 1903): 54–55.

6. W.H. Preece, "The Telephone," *Nature* 16, no. 410 (September 6, 1877): 403–4.

7. Elisha Gray, *Experimental Researches in Electro-harmonic Telegraphy and Telephony: 1867–1878* (New York: Russell Brothers, 1878), 62, reprinted in *The Telephone: An Historical Anthology*, edited by George Shiers (New York: Arno Press, 1977).

8. "Exhibition of the Telephone," *Journal of the Telegraph* 10, no. 7 (April 2, 1877): 102; "Telephone Music by Induction," *Journal of the Telegraph* 10, no. 9 (May 1, 1877): 131. See also "Telephone Music by Induction," *Journal of the Telegraph* 10, no. 8 (April 16, 1877): 115.

9. "Albany Telegraphic Notes," *Journal of the Telegraph* 10, no. 19 (October 1, 1877): 293–94.

10. Ibid., 293.

11. William F. Channing, "Eavesdropping by Telephone," *Journal of the Telegraph* 10, no. 20 (October 16, 1877): 307.

12. William F. Channing, "Overheard by Telephone: The Music in Providence," *Journal of the Telegraph* 10, no. 24 (December 16, 1877): 376–77. Not only was music heard over the lines, "still more strikingly . . . Prof. E.W. Blake, of Brown University, talked with a friend for some distances along a railroad, using the two lines of rails for the telephonic circuit. At the same time

he heard the operating on the telegraph wires overhead, caught by the rails, probably by induction" (376).

13. C.E. McCluer, "Telephonic Reminiscences," *Telephony* 15, no. 1 (January 1908): 42–45. McCluer states that he made his telephones in the fall of 1876 based on an illustrated article of Bell's invention in an issue of *Scientific American,* but that article did not appear until February 10, 1877.

14. Ibid., 42–43.

15. John G. McKendrick, "Laboratory Notes," *Nature* 18, no. 452 (June 27, 1878): 240–41.

16. Casson, *The History of the Telephone,* 114.

17. McCluer, "Telephonic Reminiscences," 42–43.

18. W.H. Preece, "Recent Progress in Telephony," *Nature* 26, no. 673 (September 21, 1882): 516–19.

19. Channing, "Overheard by Telephone: The Music in Providence," 376–77. "The sound produced in the telephone by lightning, even when so distant that only the flash can be seen in the horizon, and no thunder can be heard, is very characteristic, something like the quenching of a drop of melted metal in water, or the sound of a distant rocket. The most remarkable circumstance is that this sound is heard just *before* the flash is seen—that is, there is probably a disturbance (inductive) of the electricity overhead, due to the distant concentration of electricity *preceding* the disruptive discharge" (377).

20. "The Java Earthquakes and the Telephone," *Scientific American* 44, no. 19 (November 10, 1883): 294.

21. One "Mr. Fay," speaking at the 1883 meeting of the National Telephone Exchange Association, quoted in in J.E. Kinsbury, *The Telephone and Telephone Exchanges* (London: Longmans, Green and Co., 1915), 418.

22. Alexander Graham Bell, "Researches in Electric Telephony," *Journal of the Society of Telegraph Engineers* 6, no. 20 (October 31, 1877): 385–421.

23. T.D. Lockwood, *Practical Information for Telephonists* (New York: W.J. Johnston Co., 1893), 66.

24. Ibid., 66–67.

25. J.E. Taylor, "Characteristics of Electric Earth-Current Disturbances and Their Origin," communicated by Sir Oliver Lodge, F.R.S. (received December 16, 1902; read January 22, 1903), *Proceedings of the Royal Society of London* 71, no. 471 (June 1903): 225–27.

26. See Robert W. Schunk and Andrew F. Nagy, *Ionospheres: Physics, Plasma Physics and Chemistry* (Cambridge: Cambridge University Press, 2000), 5.

27. W.H. Preece, "Letters to the Editor: Earth Currents," *Nature* 49, no. 1276 (April 12, 1894): 554. Preece was confident that the workers were able to distinguish such sounds from "ordinary inductive disturbances on telephone circuits" (554). Preece chronicled auroral activity on telegraph lines much earlier but without the benefit of the telephone. W.H. Preece, "Earth-Currents and the Aurora Borealis of February 4, 1872," *Nature* 5, no. 122 (March 7, 1872): 368. John Peirce, William Channing's associate at Brown University, listened to

the "electric sounds" during an auroral display but did not bother to describe them. Channing, "Overheard by Telephone: The Music in Providence," 376–77. See also letter from William F. Channing to Alexander Graham Bell, July 16, 1877, Alexander Graham Bell Family Papers, Library of Congress, http://rs6.loc.gov (accessed 2005).

28. Preece, "Letters to the Editor: Earth Currents," *Nature,* 554. Two of the most prominent whistler scientists from the second half of the twentieth century split on whether or not whistlers were actually heard. L.R.O. Storey said that Preece's "description is too vague to make the identification [of whistlers] certain," whereas Robert Helliwell was more convinced: "The descriptions suggest that the observers had heard tweeks and possibly whistlers and dawn chorus." L.R.O. Storey, "An Investigation of Whistling Atmospherics," *Philosophical Transactions of the Royal Society of London: Series A; Mathematical and Physical Sciences* 246, no. 908 (July 9, 1953): 113–41 (114); Robert Helliwell, *Whistlers and Related Ionospheric Phenomena* (1965) (Mineola, NY: Dover Publications, 2006), 11.

29. A review of the scientific literature up to the late 1950s is available in the history chapter of Helliwell, *Whistlers and Related Ionospheric Phenomena,* 11–22.

30. Walter Benjamin, "One-Way Street," in *Selected Writings,* vol. 1, *1913–1926* (Cambridge: Harvard University Press, 1996), 486–87. The English translation of *Rausch* as "ecstatic trance" may lend too much of a Dionysian trance 'n' dance inflection to the term, whereas it is also associated with the more sedate term *oceanic.*

31. Ibid., 486.

32. Heinrich Barkhausen, "Two Phenomena Discovered with the Aid of the New Amplifier," *Phys. Zeits* 20 (1919): 401–3, quoted in Heinrich Barkhausen, "Whistling Tones from the Earth," *Proceedings of the Institute of Radio Engineers* 18, no. 7 (July 1930): 1155–59 (1156).

33. Ibid., 1156.

34. Ibid., 1155. In 1919, Barkhausen knew the sounds were geophysically related; however, anything else was "inexplicable." By the time he revisited the topic in 1930, there was greater knowledge of the reflective properties of the ionosphere, and he was able to conjecture that whistlers were related to the powerful electromagnetic impulse of lightning. His biggest problem remained explaining the duration of the whistler, since, if the Heaviside layer was reflecting at 100 kilometers above the earth, and the signal was traveling at nearly 300,000 kilometers per second, then a whistler lasting one second would require 1,000 reflections, which was not plausible. Ibid., 1157.

35. On the importance of D/F, see David Kahn, "In Memoriam: Georges-Jean Painvin," *Cryptolgia* 6, no. 2 (1982): 120–27.

36. "The intelligence picture on the evacuation from Sinai and the redeployment of troops was also enhanced by D/F fixing and the familiarity gained by experienced operators with the electronic 'signatures' left by their German and Ottoman counterparts." Yigal Sheffy, *British Military Intelligence in the*

Palestine Campaign, 1914–1918 (London: Frank Cass, 1998), 225. Although it is understood that it was not until the mid-1920s that the ionosphere was identified by Appleton, Eckersley wrote a report "sent to the War Office in 1916 [that] probably formed the first scientific discussion of this subject." J.A. Ratcliffe, "Thomas Lydwell Eckersley, 1886–1959," *Biographical Memoirs of Fellows of the Royal Society* 5 (February 1960): 70.

37. T.L. Eckersley, "A Note on Musical Atmospheric Disturbances," *Philosophical Magazine, and Journal of Science* 49, no. 5 (1925): 1250.

38. T.L. Eckersley, "Electrical Constitution of the Upper Atmosphere," letter to the editor, *Nature* 117, no. 2954 (June 12, 1926): 821.

39. W.H. Eccles and H. Morris Airey, "Notes on the Electrical Waves Occurring in Nature," *Proceedings of the Royal Society of London: Series A; Containing Papers of a Mathematical and Physical Character* 85, no. 576 (April 11, 1911): 145–50.

40. Captain H.J. Round, T.L. Eckersley, et al., "Report on Measurements Made on Signal Strength at Great Distances during 1922 and 1923 by an Expedition Sent to Australia," *IEEE Journal* 63, no. 346 (October 1925): 933–1001.

41. E.T. Burton and E.M. Boardman, "Audio-Frequency Atmospherics," *Proceedings of the Institute of Radio Engineers* 21, no. 10 (October 1933); 1476–94. See also Everett T. Burton, "Submarine Cable Interference," *Nature* 126, no. 3167 (July 12, 1930): 55; Everett T. Burton and Edward M. Boardman, "Effects of Solar Eclipse on Audio Frequency Atmospherics," *Nature* 313 no. 3299 (January 21, 1933): 81–82; and A.M. Curtis, "Discussion of Whistling Tones from the Earth," *Proceedings of the Institute of Radio Engineers* 19, no. 1 (January, 1931): 145.

42. Burton and Boardman, "Audio-Frequency Atmospherics," 1479. Burton and Boardman's paper had been read by John N. Dyer, an engineer with the Columbia Broadcasting System, before he departed on the Second Byrd Antarctic Expedition in 1934. As chief radio engineer, Dyer worked with scientists on the expedition and was responsible for a weekly commercial radio broadcast to the United States, sponsored by the General Foods Corporation. CBS supplied him with recording-cutting lathes and aluminum recording disks to spice up the weekly broadcasts with penguins, dogs, and other sounds of the local environment. On his own time he investigated and recorded long-distance radio echoes, the auroras, the radio signatures of meteors, atmospherics, and whistlers using a 1.6-kilometer wire as an antenna, as well as what he called a class of "whish, which last for a second or longer—sound like a rope whirled through the air, usually very loud—the louder ones followed by a whistle of decreasing frequency which sounds like an approaching artillery shell." Unfortunately, upon his return he never published his findings, primarily because they were irrelevant to his work at CBS. See C. Stewart Gillmor, "The Early History of Upper Atmospheric Physics Research in Antarctica," in *Upper Atmosphere Research in Antarctica,* edited by L.J. Lanzerotti and C.G. Park (American Geophysical Union) (Baltimore:

Waverly Press, 1978), 236–62 (paraphrase of Dyer is on pp. 246–51; quotation is on p. 248).

43. W.H. Eccles, *The Electrician* (London) 69 (1912): 75, cited in L.W. Austin, "The Present Status of Radio Atmospheric Disturbances," *Proceedings of the Institute for Radio Engineers* 14, no. 1 (February 1926): 133–38.

44. Helliwell, *Whistlers and Related Ionospheric Phenomena*, 83. Interestingly, the 1951 paper cited as being most responsible for this shift from auditory to visual thinking was written by Ralph K. Potter, who at the time was an ardent champion of "audiovisual music" and abstract film and of providing "scientific tools for the arts." See Ralph K. Potter, "Analysis of Audio-Frequency Atmospherics," *Proceedings of the Institute of Radio Engineers* 39, no. 9 (September 1951): 1067–69. In *Whistlers and Related Ionospheric Phenomena*, Helliwell commented on the turn of events: "As is so often the case in scientific research, advances in one field are frequently made as a result of techniques and devices developed in another. Potter's paper described the application of a 'sound' spectrograph, developed for studies of speech and noise, to the visual portrayal of whistlers" (16). Like Burton and Boardman, Potter was employed by Bell Laboratories and had a long-standing interest in atmospherics; see his "High-Frequency Atmospheric Noise," *Proceedings of the Institute of Radio Engineers* 19, no. 10 (October 1931): 1731–65. In this way, his work was closely related to that other Bell Labs researcher, Karl Jansky, who used D/F to identify a persistent high-frequency noise in the atmosphere that turned out to be extraterrestrial, emanating from the center of the galaxy. Potter was also active in top-secret ciphony and the Sigsaly system, and he held patents for secret telephony. He is primarily remembered for his work on "visible speech" and sound spectrography, and he used Burton and Boardman's recordings in "Analysis of Audio-Frequency Atmospherics." For Potter's involvement in the arts, see his "Audiovisual Music," Hollywood *Quarterly* 3, no. 1 (Autumn 1947), 66–78; and "New Scientific Tools for the Arts," *Journal of Aesthetics and Art Criticism* 10, no. 2 (December, 1951): 126–34.

45. Helliwell, *Whistlers and Related Ionospheric Phenomena*, 206.

46. Ibid., 135–37.

47. Benjamin, "One-Way Street," 486.

6. ALVIN LUCIER: BRAINWAVES

Epigraph: Alvin Lucier, interview with Ev Grimes, Middletown, CT, June 6, 1986, p. 54, American Music Series, Oral History of American Music, Yale University Library, New Haven, CT.

1. Alvin Lucier, *Reflections: Interviews, Scores, Writings* (Cologne: Edition MusikTexte, 1995), 28. For an account of American experimental music in West Germany, see Amy C. Beal, *New Music, New Allies: American Experimental Music in West Germany from the Zero Hour to Reunification* (Berkeley: University of California Press, 2006).

2. Alvin Lucier, "Ostrava Days 2001—Transcript of Alvin Lucier Seminar," seminar organized by Petr Kotik, www.ocnmh.cz/days2001_transkript_lucier_ htm (accessed July 2008).

3. Ibid.

4. Lucier, *Reflections*, 300. Following Lucier's *Music for Solo Performer* there were many works by others using brainwaves, biofeedback, and other internal body-monitoring (interoceptive) techniques. Lucier's work was similar to James Tenney's *Metabolic Music* (1965; it was never performed), which was composed about ten weeks after Lucier's *Music for Solo Performer:* "It was one of those independent coincidences. I hadn't heard about Alvin's piece until after I did my own." Douglas Kahn, "Interview with James Tenney: Toronto, February 1999," *Leonardo Electronic Almanac* 8, no. 11 (March 2001): n.p. Brainwaves were also used in John Cage's *Variations VII* and Alex Hay's *Grass Fields* at *9 Evenings: Theatre and Engineering* (October 1966). The cybernetic foundation of *Music for Solo Performer* was evident also in Nam June Paik's desire for a DIRECT-CONTACT-ART:

> Medical electronics and art is still widely apart, but these two fields can also change each other's fruits, e.g., various signals can be fed to many parts of head, brain, and bodies, aiming to establish completely new genre of DIRECT-CONTACT-ART, and this artistic experiment can bring some scientific product for this young science in electro-anesthesia, electro-visual tranquilizer, electronic hallucination through the film for closed eyes, electro-sleep and other electro-therapy. Electro-magnetic vibration of the head might lead the way to electronic zen.

Paik's statement was written in 1966; see *Nam June Paik: Videa 'n' Videology, 1959–1973*, edited by Judson Rosebush (Syracuse, NY: Everson Museum of Art, 1974), n.p. Paik mentions that the "essay was written in winter and copies were sent to Max Mathews, Mike Noll, James Tenney and Lejaren Hiller, Jr. It was printed in *Fylkingen Bulletin* (Stockholm) in 1967." Works closer to a countercultural sensibility include *Environetic Synthesis* by Peter Crown and Richard Lowenberg, in *Radical Software* 2, no. 1 (1972): 44; and works in David Rosenboom, ed., *Biofeedback and the Arts: Results of Early Experiments* (Vancouver, BC: Aesthetic Research Centre of Canada, 1976); and they reached a zenith on the nationally televised *Mike Douglas Show* in 1972, when the composer David Rosenboom appeared with Kurt Munkacsi, on synthesizer, with Mike Douglas, John Lennon, and Yoko Ono in the production of brainwave music. Chuck Berry was also present but did not apply the electrodes. On Manfred Eaton's "biomusic," see Branden Joseph, "Biomusic," *Grey Room*, no. 45 (Fall 2011): 128–50. Notable examples during the period outside the United States include Pierre Henry's *Mise en Musique du Corticalart de Roger Lafosse* (1971) and Erkki Kurenniemi's *Electroencephalophone* (1973).

5. Andrew Pickering writes eloquently about how cybernetics as a whole "stages for us a nonmodern ontology in which people and things are not so

different after all." Andrew Pickering, *The Cybernetic Brain: Sketches for Another Future* (Chicago: University of Chicago Press, 2011), 18. His notion of ontological performance is also applicable to *Music for Solo Performer*, once distance from a countercultural motive has been granted.

6. Feedback in a cybernetic sense should not be confused with audio feedback. There was no audio feedback in Lucier's *Music for Solo Performer*; in fact, measures were taken to prevent it from occurring. Audio feedback was used in American experimentalism by Dick Higgins in *Loud Symphony* (1958), by David Tudor in his 1961 realization of John Cage's *Variations II*, and most famously by Jimi Hendrix. Lucier traces his own engagement with audio feedback proper back to *Bird and Person Dying* (1975), a composition in which I played a role by sending Lucier a gift, purchased from a discount department store, of an electronic Christmas tree ornament that emitted a bird sound. See Alvin Lucier, "My Affairs with Feedback," *Resonance* (a publication of the London Musicians' Collective) 9, no. 2 (2002): 24–25.

7. Lucier, "Ostrava Days 2001."

8. John Cage, *Conversing with Cage*, edited by Richard Kostelanetz (New York: Limelight Editions, 1988), 69–70. On Cage's *o′oo″*, see William Fetterman, *John Cage's Theatre Pieces: Notations and Performances* (Amsterdam: Harwood Academic Publishers, 1996), 84–90; and James Pritchett, *The Music of John Cage* (Cambridge: Cambridge University Press, 1993). See also Alvin Lucier, "Notes in the Margins: Collaborations with John Cage," in *Reflections*, 498–510.

9. Calvin Tomkins, *The Bride and the Bachelors: Five Masters of the Avant-Garde* (New York: Penguin, 1976), 139.

10. John Cage, "The Future of Music: Credo" (1937), in *Silence* (Hanover, NH: Wesleyan University Press, 1961), 6.

11. For further discussion of John Cage and the anechoic chamber, see my "Let Me Hear My Body Talk, My Body Talk," in *Re:Live—New Directions in Media Art Histories*, edited by Sean Cubitt and Paul Thomas (Cambridge, MA: MIT Press, 2013).

12. The pursuit of "small sounds" was part of a larger history of sensing *weak signals* that first jumped off the page when nerve impulses in a dissected frog's leg were detected by a galvanometer and then used as a galvanometer itself. Other early galvanometers, as we have seen, included the tongue and telephone but, as Norbert Wiener pointed out, the energy in the nerve of a frog was "excessively minute." Norbert Wiener, *Cybernetics: Or Control and Communication in the Animal and the Machine* (Cambridge, MA: MIT Press, 1961), 182. Small sounds and weak signals were common to both *o′oo″* and *Music for Solo Performer*, since signals on the scalp register at fifty millionths of a volt. Indeed, the historical evolution of *noise* could be written in part as a growing cultural and energetic strength of weak signals.

13. Lucier, "Ostrava Days 2001."

14. Robert M. Voss, "The Brandeis University Electronic Music Studio," *Journal of the Audio Engineering Society* 13, no. 1 (January 1965): 65–68.

15. Alvin Lucier, "Notes in the Margins," in *Reflections*, 510. A hotfoot is an adolescent prank where a match is inserted in a person's shoe and lit.

16. Alvin Lucier, "Statement On: *Music for Solo Performer*," in Rosenboom, *Biofeedback and the Arts*, 60–61.

17. Robert Ashley, "Landscape with Alvin Lucier," *Music with Roots in the Aether: Interviews with and Essays about Seven American Composers*, ed. Gisela Gronemeyer and Reinhard Oehlschlägel (Cologne: Edition MusikTexte, 2000), 83.

18. Lucier, "Statement On: *Music for Solo Performer*," 61.

19. Pauline Oliveros, correspondence with the author, July 2009.

20. Lucier, "Ostrava Days 2001."

21. Tony Gnazzo, telephone interview with the author, August 26, 2008.

7. EDMOND DEWAN AND CYBERNETIC HI-FI

1. Edmond Dewan, telephone interviews with the author, June and August 2008, and email correspondence with Brian Dewan during the same period.

2. Quoted in David A. Mindell, *Between Human and Machine* (Baltimore: Johns Hopkins University Press, 2002), 287.

3. Edmond Dewan, "'Other Minds': An Application of Recent Epistemological Ideas to the Definition of Consciousness," *Philosophy of Science* 24, no. 1 (January 1957): 70–76 (71). Dewan cited W. Grey Walter's popular text, *The Living Brain* (New York: Norton, 1953), and Walter's contribution to the Macy conference on cybernetics, "Studies on Activity of the Brain," *Cybernetics: Circular Causal and Feedback Mechanisms in Biological and Social Systems*, Transactions of the Tenth Conference, April 22–24, 1953, edited by Heinz von Foerster, sponsored by the Josiah Macy Jr. Foundation (New York: Corlies, Macy & Company, 1955), 19–31.

4. Dewan, "'Other Minds,'" 74.

5. Ibid., 75.

6. Regarding his dissertation, see Edmond M. Dewan, "Generalizations of the Saha Equation," *The Physics of Fluids* 4, no. 6 (June, 1961): 759–63; and Edmond M. Dewan, "Unusual Propagation of Satellite Signals," *Proceedings of the IRE* (November 1959): 2020. His later work included research on gravity waves and other atmospheric turbulences. One classified document he saw before it was released showed photographs of a spy balloon array that his friend Charlie Moore had worked on. The balloon would become famous for being mistaken for a UFO that crashed near Roswell, New Mexico, when the pattern of the fabric that Moore bought from a storefront vendor was confused with extraterrestrial writing.

7. Wiener himself was interested in brainwaves since at least 1948 with the publication of *Cybernetics*. He acknowledged personal communication with Grey Walter, whose "Central Effects of Rhythmic Sensory Stimulation" appeared the following year in *Electroencephalogy and Clinical Neurophysiology* 1 (1949): 57–86. The 1961 edition of Wiener's book included

as its last chapter "Brain Waves and Self-Organizing Systems" (181–204), an investigation into the process of how "highly specific frequencies are formed in brain waves." *Cybernetics: Or Control and Communication in the Animal and the Machine* (Cambridge, MA: MIT Press, 1961), xv.

8. Edmond M. Dewan, "Occipital Alpha Rhythm Eye Position and Lens Accommodation," *Nature* 214 (June 3, 1967): 975–77. See also Shel Michaels, "Letters," *Science News* 156, no. 17 (October 23, 1999): 259. "A subject remained motionless while voltages from electrodes placed on the scalp were amplified and filtered, then sent to a computer. The subject attempted to control his alpha waves while listening to computer feedback of both alpha-wave content and the computer's interpretation in Morse code. The first communication transmitted by this method, direct from brain to computer, was the word *cybernetics.* I know about the experiment firsthand, as I was the programmer who developed the program" (259).

9. Henri Poincaré, *Science and Method* (1908), translated by Francis Maitland (London: T. Nelson, 1914), 22. Also see Edmond M. Dewan's report, *Nonlinear Oscillation and Neuroelectric Phenomena, Part 1* (June 1963), Accession no. AD0411851, Defense Technical Information Center (DTIC); and his *Nonlinear Oscillation and Electroencephalography* (August 1963), Accession no. AD0421980, DTIC.

10. See papers from the US Air Force School of Aviation Medicine: Charles A. Berry and Herbert K. Eastwood, "Helicopter Problems: Noise, Cockpit Contamination and Disorientation," *Aerospace Medicine* 31, no. 3 (March 1960): 179–90, and "Disorientation in Helicopter Pilots," in the same issue, 191–99; L. C. Johnson, "Flicker as a Helicopter Pilot Problem," *Aerospace Medicine* 34, no. 3 (April 1963): 306–10; and the earlier report, C. W. Watson, *Detection of Light Evoked Cerebral Electrical Abnormalities among Helicopter Flight Trainees,* Progress Report of Research and Development Division, Office of Surgeon General, Department of Army Contract no. DA 49–007, MD-734 (September 1959).

11. For Norbert Wiener on visual and electrical flicker, see his *Cybernetics,* 198–99. On flicker in the arts, see John Geiger, *Chapel of Extreme Experience: A Short History of Stroboscopic Light and the Dream Machine* (Brooklyn, NY: Soft Skull Press, 2003). And on Tony Conrad's 1966 film *The Flicker,* see chapter 6 of Branden W. Joseph, *Beyond the Dream Syndicate: Tony Conrad and the Arts after Cage* (Brooklyn, NY: Zone Books, 2008).

12. Timothy Leland, "Brainwave Spells Out Morse Code Message," *Boston Globe* (January 17, 1965): 3.

13. William MacLaurin, "Talk via Brain Waves," *Science News Letter* 86, no. 18 (October 31, 1964): 275.

14. Howard Simons, "Man's Brain Waves Can 'Talk,' Overcoming Speech Barriers," *Washington Post* (October 21, 1964): A1.

15. See James Wierzbicki, *Louis and Bebe Barron's "Forbidden Planet": A Film Score Guide* (Lanham, MD: Scarecrow Press, 2005), 32–37. Caught on an island between the avant-garde and commerce, some electronic music composers

felt that the Barrons' efforts stigmatized electronic music for years to come as a caricature of "outer space" sounds, while others argued that it was a perfectly competent work that developed a wider audience for their own work and the genre as a whole.

16. Martin Caidin, *The God Machine* (New York: Dutton, 1968). Caidin's best known novel was *Cyborg*, the inspiration for the 1970s television series, *The Six Million Dollar Man*.

17. US Patent 6529773.

18. Alvin Lucier, interview with Ev Grimes, Middletown, CT, June 6, 1986, p. 54, American Music Series, Oral History of American Music, Yale University Library, New Haven, CT (OHAM).

19. Ibid., 117. The idea of inaudible music can be found in Michel Magne's *Symphonie Humaine* (1955), the first part of which is below audibility and then transposed for the benefit of the audience. The technological suggestion of transpositions to and from audibility and inaudibility was everywhere in evidence with the distribution of the tape recorder and its ability to slow down and speed up recorded events, whether an earthquake in seismological research or a musical track in the multitracking of Les Paul. Subaudible frequencies were commonly used in electronic music during the 1960s to create a causal ephemerality of overtones with no apparent fundamental.

20. Alvin Lucier, "Ostrava Days 2001—Transcript of Alvin Lucier Seminar," seminar organized by Petr Kotik, www.ocnmh.cz/days2001_transkript_lucier_htm (accessed July 2008).

21. Gordon Mumma, "Alvin Lucier's Music for Solo Performer 1965," *Source: Music of the Avant-Garde* 1, no. 2 (July 1967): 68–69, reprinted in *Source: Music of the Avant-Garde, 1966–1973*, edited by Larry Austin and Douglas Kahn (Berkeley: University of California Press, 2011), 80.

22. Ibid.

23. Gordon Mumma, correspondence with the author, August 18, 2008. Mumma compared Lucier's use of physically resonating systems to subsequent compositions by himself *(Hornpipe)* and David Tudor *(Rainforest)*.

24. Mumma, "Alvin Lucier's Music for Solo Performer 1965," 81. Mumma built specialized components under the brand Cybersonics for Lucier's performances of *Music for Solo Performer* and for his own performances of the composition. Cybersonics was a small and short-lived business of Mumma and William Ribbens. Lucier mentions using Cybersonics gear for the first time at the Fylkingen Congress of Technology and Art in Stockholm, September 21, 1966. The Cybersonics components were lighter and more portable than the Tektronix gear given to him by Dewan. See Malcolm Troup, ed., *Review 1972* (London: Guildhall School of Music and Drama, 1972), 23–24.

25. Robert Ashley, "Landscape with Alvin Lucier," in *Music with Roots in the Aether: Interviews with and Essays About Seven American Composers*, edited by Gisela Gronemeyer and Reinhard Oehlschlägel (Cologne: Edition MusikTexte, 2000), 80.

26. Alvin Lucier, *Reflections: Interviews, Scores, Writings* (Cologne: Edition MusikTexte, 1995), 50.

27. Ibid., 32.

28. Ibid., 48.

29. Lucier, interview with Ev Grimes, June 6, 1986, p. 59, OHAM.

30. Alvin Lucier, quoted in Joel Chadabe, *Electric Sound: The Past and Promise of Electronic Music* (Upper Saddle River, NJ: Prentice Hall, 1997), 97.

31. Lucier, *Reflections*, 96: "the space acts as a filter."

32. Gordon Mumma, correspondence with the author, August 18, 2008.

33. In his essay "Music for Solo Performer," reprinted in *Review 1972* from the Guildhall School of Music and Drama, Lucier was more specific: "In choosing loudspeakers for a performance of this work only those with good bass response are usable and cone-type speakers are preferable to horn-type speakers for purpose of resonating the percussion instruments. The reason is simply that the air pressure from the cone excursions will cause the grill cloth to bump in reaction to the bursts of alpha. This bumping effect is an efficient means for resonating these instruments. The composer has found that the KLH Model 4 loudspeaker is fine for this purpose" (23–24).

34. I am grateful to Eric D. Barry for his guidance on the hi-fi industry and loudspeaker design in the Boston area during the 1950s and 1960s. See his essay on audiophilic spectacle and Emory Cook, "High-Fidelity Sound as Spectacle and Sublime, 1950–1961," in *Sound in the Age of Mechanical Reproduction*, edited by David Suisman and Susan Strasser (Philadelphia: University of Pennsylvania Press, 2010), 115–38.

35. Amar Bose, "On the Design, Measurement, and Evaluation of Loudspeakers," *Audio Engineering Society*, Preprint no. 622 (H-3) (New York: Audio Engineering, 1968), 5. See also Amar G. Bose, "Relative Effects of Normal-Mode Structure of Loudspeakers and Rooms on Reproduction of Sound," *Journal of the Acoustical Society of America* 36, no. 10 (October 1964): 2011. Like much science at the time, this research was conducted under contract by the US Army, US Navy, and US Air Force, among other sources of funding.

36. Bose, "On the Design, Measurement, and Evaluation of Loudspeakers," 4, presented at the 35th Convention of the Audio Engineering Society, October 21–24, 1968. He set the problem in this way: "It would perhaps be possible to achieve a consensus on the objective of providing the home listener with the same auditory sensation that he would receive at the live performance. If we did not pause to consider some practical constraints we would immediately move in the direction of a larger number of channels with an even larger number of speaker systems and time delays, all installed in an anechoic environment. Very effective experiments of this type have been conducted for research purposes. An excellent demonstration of such a system is provided by the Laboratories of Philips Gloielampenfabrieken in Eindhoven Netherlands. However, if we introduce the practical constraints that limit us to two channels and to rooms the size of those found in average homes, it is safe to say that sound reproduction is at best a compromise with numerous shortcomings" (2).

37. Edmond Dewan, telephone interviews with the author, June and July 2008.

38. Amar G. Bose, correspondence with the author, August 22 and September 17, 2009. Bose gave the same demonstration several times throughout the Boston area, and people key to the Cambridge high-end audio community remember it to this day. The owner's manual for the KLH 6 loudspeaker system that Lucier used in *Music for Solo Performer* offers its own accommodation to actual rooms, as the manual reads, "To account for different room characteristics and different personal tastes, the high-frequency response of the Model Six may be adjusted by means of the three-position switch on the back of the cabinet."

39. Lucier, "Ostrava Days 2001."

40. See my "Alvin Lucier: I Am Sitting in a Room, Immersed and Propagated," *OASE Architectural Journal*, no. 78 (2009): 24–37.

41. "Interview with William Duckworth" (1981) in Lucier, *Reflections*, 322. Lucier later performed *Music for Solo Performer* at the Kitchen in New York while also sending his brainwaves over a telephone line to another set of instruments at a performance space in Los Angeles. Alvin Lucier, interviewed by Michael Parsons, "Beats That Can Push Sugar," *London Musicians Collective* (May 27, 1995), www.l-m-c.org.uk/texts/lucier.html (accessed July 11, 2003).

8. ALVIN LUCIER: *WHISTLERS*

Epigraph: "Interview with William Duckworth" (1981), in Alvin Lucier, *Reflections: Interviews, Scores, Writings* (Cologne: Edition MusikTexte, 1995), 322.

1. There is some confusion about the dating of *Whistlers*. I have chosen to prioritize Lucier's use of whistlers in performance rather than trying to locate a specific time of naming. As will be noted later, in a letter to David Tudor in preparation for *Variations VII*, John Cage mentioned Lucier's use of sounds of "outer space," and so the year can be stated as 1966. David Vaughan, the archivist at the Merce Cunningham Dance Company, brought to my attention a note in the archives that says that "Lucier performed for two Studio Events on 5 and 6 April 1974: the title of the music was Whistlers (1966–1974)." David Vaughn, correspondence with the author, March 17, 2008. The work appears to have survived until at least 1975, "as accompaniment to numerous performances in public spaces by the Viola Farber Dance Company, most notably the Sneakers series, 1975, throughout the five boroughs of New York City." Liner notes, Alvin Lucier, *Sferics; Music for Solo Performer*, Lovely Music CD 5013, 2010.

2. Air Force Cambridge Research Labs sponsored the Conference on Atmospheric Electricity, held at Wentworth-by-the-Sea, Portsmouth, NH, May 19–21, 1954, proceedings edited by Robert E. Holzer and Waldo E. Smith (Hanscom Air Force Base: Air Force Cambridge Research Labs, 1955). Josef Fuchs's "Report on Some Observations on Atmospheric Electricity" first appeared in these proceedings. See also C.B. Kalakowsky and E.A. Lewis, *VLF*

Sferics of Very Large Virtual Source Strength, Report 0479646, Air Force Cambridge Research Labs, L.G. Hanscom Field, MA (September 1966), 29.

3. "Earthquakes and Cosmic Music for Sale on Disks," *New York Times* (April 4, 1955): 31, reprinted in Meyer Berger, *Meyer Berger's New York* (New York: Random House, 1960), 136–37.

4. L.R.O. Storey, "An Investigation of Whistling Atmospherics," *Philosophical Transactions of the Royal Society of London; Series A, Mathematical and Physical Sciences* 246, no. 908 (July 9, 1953): 113–41. Whistler research became widespread after the important meeting of the International Union of Radio Science (URSI) in Australia in 1952.

5. L.R.O. Storey, "Whistlers," *Scientific American* 194, no. 1 (January 1956): 34–37 (34).

6. Daniel Lang, "Profiles: Ear Driven 1," *New Yorker* (March 3, 1956): 39–60. See also "Profiles: Ear Driven 2" (March 10, 1956): 45–69, an indispensable profile of Emory Cook.

7. Correspondence between Grainger Morgan, son of Millett Morgan, and the author, May 11, 2008.

8. Transcribed from *Out of This World,* Cook Laboratories 5012, 1953, LP.

9. Liner notes, *Ionosphere,* Cook Laboratories 5013, 1955, LP. "The record is intended for playing binaurally, simultaneously with two pickups on the same or separate arms" on the turntable. The channels were registered after the fact through the presumed conjunction of "bonks." For an early survey of the literature, see Eugene M. Wescott, "Magnetoconjugate Phenomena," *Space Science Reviews,* no. 5 (1966): 507–61.

10. Alvin Lucier, conversation with the author, Middletown, CT, February 2003. Speculation that whistlers connect with deep space signals can be found in the the last paragraph of Millett Morgan's liner notes to the *Out of the This World* LP: "It is not even necessarily certain that all of the signals recorded here originated on 'earth' or were transduced here into audio/radio signals from the impingement of particle energy from the outside. Amid the swishes and chorus there may also be radio sounds of a certain mode from outer space, tangentially trapped by free electrons or on a magnetic line, then guided to us through the ionospheric mask."

11. Liner notes, Lucier, *Sferics; Music for Solo Performer.*

12. Richard Lerman, correspondence with the author, August 26, 2008 (on bandpass filters), and August 26, 2008, and August 7, 2009 (on Winterfest). In one article, Gordon Mumma makes it appear as though live reception of VLF took place: "In 1966 Alvin Lucier composed *Whistlers,* in which, with special VLF radios, the sounds of electromagnetic disturbances were received from the ionosphere and electronically processed by an ensemble of live performers." Gordon Mumma, "Live-Electronic Music," in *The Development and Practice of Electronic Music,* edited by Jon H. Appleton and Ronald C. Perera (Englewood Cliffs, NJ: Prentice-Hall, 1975), 286–335.

13. Tony Gnazzo, correspondence and telephone interview with the author, August 2008.

14. Will Johnson, "First Festival of Live-Electronic Music 1967," *Source: Music of the Avant Garde*, no. 3, reprinted in *Source: Music of the Avant-Garde, 1966–1973*, edited by Larry Austin and Douglas Kahn (Berkeley: University of California Press, 2011), 117.

15. Ibid. Neither Stan Lunetta nor Larry Austin, editors of *Source* at the time, remember writing the note; nor can they think of whom among the editorial staff would have possessed this type of knowledge.

16. Radio reflections off missile vapor trails were, of course, relevant to monitoring missile tests and tracking missiles, while the larger field of scattering was relevant to radar detection and evasion (stealth). Radio amateurs were active in monitoring signals and reflections off satellites starting with *Sputnik*, as many articles in *QST* reveal, especially volumes 41 to 43, and were enlisted to register the effects of nuclear tests conducted at the Nevada Test Site. See "Radio Propagation and Atomic Bomb Tests: Amateur Observations Wanted," *QST* 41, no. 1, 10. Radio amateurs were also enlisted in Operation Smoke-Puff to monitor "artificial ionospheres" produced by high-altitude rocket release of chemicals from launches at Alamogordo, New Mexico. See O.G. Villard Jr., "Operation Smoke-Puff," *QST* 1, no. 5 (March 1957): 11–15. Coincidentally, Calvin R. Graf submitted a letter to *QST* reporting that he had heard about a quarter second "meteor ping" signal reflected from *Sputnik II. QST* 42, no. 3 (March 1958): 47. Graf wrote the amateur book that Lucier used to design the VLF antenna for his composition *Sferics* (1981).

17. Whistler research developed rapidly during the 1950s amid the scientific and military exigencies of VLF research generally arising from nuclear testing by the United States, Soviet Union, and the United Kingdom and for submarine communications. Research grew during the 1950s toward the International Geophysical Year (IGY), a year and a half actually, known for its most famous geophysical-geopolitical offspring: the *Sputnik* and *Explorer* satellites. The US IGY response to *Sputnik—Explorer 1*—conducted magnetospheric research under the aegis of James Van Allen, whose researches had benefited from L.R.O. Storey's analyses of whistler activity in the magnetosphere. See James Van Allen, *Origins of Magnetospheric Physics* (Iowa City: University of Iowa Press, 2004), 2; and C. Stewart Gillmor and John R. Spreiter, eds., *Discovery of the Magnetosphere* (Washington, DC: American Geophysical Union, 1997). Continued geopolitical military motives from 1950 through 2000 centered on submarines: "This need for navigation and communications with submarines and the need for reliable global military communications was the indirect driving force behind most of the developments in VLF and ELF radio wave propagation theory and experiment over the last 50 years." R. Barr et al., "ELF and VLF Radio Waves," *Journal of Atmospheric and Solar-Terrestrial Physics* 62, no. 2 (November 2000): 1689–1718 (1689).

18. Robert A. Helliwell, *Whistlers and Related Ionospheric Phenomena* (1965) (Mineola, NY: Dover Publications, 2006). The section "Explosion-Excited Whistlers" is on pages 135–37. It should be noted that Helliwell was integrally involved in tracking the whistler activity produced by one of the most remark-

able of nuclear tests, Starfish Prime (July 9, 1962). The yield was 1,400 kilotons, and detonation occurred at an altitude of 400 kilometers over Johnston Island, creating an electromagnetic pulse that shut down street lights and electronics in Hawaii 1,400 kilometers to the east. It was known as the rainbow bomb for the artificial aurora it produced. Helliwell reported on the particularly intense whistler recorded over the equator at Wellington, New Zealand. Many of Edmond Dewan's colleagues from the Air Force Cambridge Research Labs were involved in different aspects of monitoring the blast, as were researchers from Sandia National Laboratories. See Robert Helliwell and D.L. Carpenter, "Whistlers Excited by Nuclear Explosions," *Journal of Geophysical Research* 68, no. 15 (1963): 4409–20. For the political fallout on telecommunications of upper atmosphere testing, see James Schwoch, *Global Media: New Media and the Cold War: 1946–1969* (Urbana: University of Illinois Press, 2009), 129–35. Calvin Graf reported on changes in sferics that occurred with Starfish Prime. See "High-Altitude Explosion Effects on 2400–2500 c/s Sferics," *Proceedings of the IEEE*, 53, no. 5 (May 1965): 528.

19. Pauline Oliveros, "Alvin Lucier," *Software for People: Collected Writings, 1963–80* (Baltimore: Smith Publications, 1984), 192.

20. Pauline Oliveros, interview with the author, Berkeley, April 22, 2006.

21. Alvin Lucier, "The Future of Our Music," *Search Event IV,* University of California at San Diego, March 3, 2002, www.zsearch.org/text/lucier2.html (accessed July 11, 2003).

22. Oliveros, interview with the author, April 22, 2006.

23. Pauline Oliveros, "Alvin Lucier," in *Reflections: Interviews, Scores, Writings,* by Alvin Lucier (Cologne: Edition MusikTexte, 1995), 192.

24. Oliveros, interview with the author, April 22, 2006.

25. Lucier, "The Future of Our Music."

26. Calvin R. Graf, *Listen to Radio Energy, Light, and Sound* (Indianapolis: Howard W. Sams & Co., 1978), 3.

27. Alvin Lucier, "*Sferics:* Diary Notes (1981)," in *Reflections,* 474–82.

28. Ibid., 478.

29. Ibid, 480.

30. Alvin Lucier and Arthur Margolin, "Conversation with Alvin Lucier," *Perspectives of New Music* 20, nos. 1–2 (Autumn 1981–Summer 1982): 50–58 (56). In this interview, Lucier also explains how he composed *Sferics:* "My idea was to take samples from each hour and splice them. But my samples were so beautiful, and so richly representative of what actually occurred, that I had no real reason for splicing one section any more than another. I lost interest in 'composing' a chronology out of the material. So it occurred to me that I could do a multi-track overdubbing, choosing as much material as I wanted on each tape and laying that one over the other, so you'd hear a composite image. That seems like a richer idea than some artificial chronological ordering. And there's no story there except that of these lightning storms that are occurring all above the earth, that get caught on the magnetic flux lines and pop out of the ionosphere" (56).

31. Lucier, *Reflections,* 478.

32. Ibid., 264.

33. Liner notes, Arditti Quartet, *Alvin Lucier: Navigations for Strings, Small Waves* (1991), Mode Records 124, 2003, CD.

34. J.A. Pierce, "Omega," *IEEE AES Magazine* (July 1989): 4–13.

35. Liner notes, Arditti Quartet, *Alvin Lucier: Navigations for Strings*.

36. Ibid.

37. This simple means for producing complex results is akin to the phase-shifting tape loop compositions of Steve Reich, beginning with *It's Gonna Rain* (1965), to moiré patterns produced optically by superimposed sets of concentric circles slightly askew and other techniques in op art, and other artistic projects motivated by "maximum meaning with a minimal image . . . multiple implications through simple, even austere means." George Brecht, Robert Watts, and Allan Kaprow, "Project in Multiple Dimensions" (1957–58), in *Introduction to Book of the Tumbler on Fire*, by Henry Martin (Milan: Multhipla Edizioni, 1978), 126–27. For the role of beating patterns in the work of Lucier arising from the use of sine waves, starting with *Still and Moving Lines of Silence in Families of Hyperbolas* (1973–74), see the chapter "Hearing and Seeing the Shapes of Sounds: Alvin Lucier, 1973–1984," in "Sine Waves and Simple Acoustic Phenomena in Experimental Music—with Special Reference to the Work of La Monte Young and Alvin Lucier," by Peter Blamey (PhD dissertation, University of Western Sydney, 2008).

38. Lucier, *Reflections*, 268.

39. Graf, *Listen to Radio Energy, Light, and Sound*, 67.

9. FROM BRAINWAVES TO OUTER SPACE

1. Tony Gnazzo, telephone interview with the author, August 2008; Charles Shere, "New Music in the United States, 1950–1980," originally published (in Italian translation) in *Storia della Musica* (Milan: Arnoldo Mondadori Editore, 1982), www.shere.org/articles/newmusicus.html (accessed September 20, 2009). Shere, composer, writer, and stalwart of the San Francisco Bay Area new music community, was music director for the community radio station KPFA-FM from 1964 through 1967 and lectured at Mills College during the 1970s.

2. John Cage, letter to David Tudor describing plans for *Variations VII*, 1966. Letter kindly provided by Julie Martin from her personal collection of documents from Experiments in Art and Technology (E.A.T.).

3. On *Atlas Borealis* and its relationship to the thunderclaps of James Joyce's *Finnegans Wake*, see John Cage, *For the Birds: In Conversation with Daniel Charles* (1976) (Boston: Marion Boyars, 1981), 211–12.

4. John Cage, "*Variations VII*: 12 Remarks re Musical Performance," document provided by Julie Martin from her collection of documents from E.A.T.

5. In his own words, it was a composition using "transmission/transformation via system developed by David Tudor, Billy Klüver et al." that ruled out all recorded sound sources. John Cage, letter to David Tudor, 1966.

6. Ibid.

7. John Cage and Morton Feldman, *Radio Happenings: Conversations/ Gespäche* (Cologne: Edition MusikTexte, 1993), 11–13.

8. Ibid., 19.

9. My thanks to Gordon Mumma and David Vaughan, the archivist at the Merce Cunningham Dance Company, for helping me with the dates during this period.

10. Billy Klüver, DVD liner notes (text initially written 1988) for John Cage, *Variations VII*, E.A.T. and Artpik, 2008.

11. John R. Pierce, interview by Harriett Lyle, Pasadena, CA, April 16, 23, and 27, 1979, p. 19, Oral History Project, California Institute of Technology Archives, http://resolver.caltech.edu/CaltechOH:OH_Pierce_J (accessed February 21, 2006).

12. "New Radio Waves Traced to Centre of the Milky Way," *New York Times* (May 5, 1933): 1.

13. Karl G. Jansky, "Directional Studies of Atmospherics at High Frequencies," *Proceedings of the Institute of Radio Engineers* 20, no. 12 (December 1932): 1920–32.

14. The transcript of the WJZ program is in Jansky's papers, in possession of Professor Tony Tyson, physicist at the University of California at Davis. I am grateful to him for the archival material on Karl Jansky and for very helpful conversations on telegraphy, natural radio, and cosmology at the early stages of my research.

15. Klüver, DVD liner notes for Cage, *Variations VII*.

16. Henry Miller, "With Edgar Varèse in the Gobi Desert," in *The Air-Conditioned Nightmare* (London: Grafton, 1973), 113–14.

10. FOR MORE NEW SIGNALS

1. Gordon Mumma, "Live-Electronic Music," in *The Development and Practice of Electronic Music*, edited by Jon H. Appleton and Ronald C. Perera (Englewood Cliffs, NJ: Prentice-Hall, 1975), 286–35 (331).

2. Gordon Mumma, "Witchcraft, Cybersonics, and Folkloric Virtuosity," in *Darmstädter Beitrage zur Neue Musik* (Mainz: Musikverlag Schott, 1974), 71–77 (75).

3. The André Breton quotation is from his *What Is Surrealism?* (New York: Pathfinder Press, 1978), 17.

4. Dorothy Norman, "Edgard Varèse: Ionization-Espace," *Twice a Year*, no. 7 (Fall–Winter 1941): 259–60. On Antonin Artaud and Varèse, see the chapter "Celestial Telegraphies," in *Sounding New Media: Immersion and Embodiment in the Arts and Culture*, by Frances Dyson (Berkeley: University of California Press, 2009), 33–53. See also María Fernández, "*Estri-dentistas:* Taking the Teeth Out of Futurism," in *At a Distance: Precursors to Art and Activism on the Internet*, edited by Annmarie Chandler and Norie Neumark (Cambridge, MA: MIT Press, 2005), 342–71; and Douglas Kahn, "Radio Space," in *Radio*

Rethink: Art, Sound and Transmission, edited by Daina Augaitis and Dan Lander (Banff: Walter Phillips Gallery, 1994), 95–114. For an account of wirelessness and literature from an inscriptive basis, influenced by Friedrich Kittler, see Timothy C. Campbell, *Wireless Writing in the Age of Marconi* (Minneapolis: University of Minnesota Press, 2006).

5. Viktor Shklovskii, "The Monument to the Third International" (1921), in *Tatlin,* edited by Larissa Alekseevna Zhadova (New York: Rizzoli, 1988), 342–43.

6. Quoted in Edward J. Brown, *Mayakovsky: A Poet in the Revolution* (Princeton, NJ: Princeton University Press, 1973), 227–28. The ellipses are in the poem itself.

7. Ibid.

8. Velimir Khlebnikov, "Our Fundamentals," *Collected Works,* vol. 1, *Letters and Theoretical Writing* (Cambridge, MA: Harvard University Press, 1987), 387.

9. Ibid., 390. Van Gogh entertained star travel based on the mechanics of transport rather than transmission. The bright-light dots of stars in the night sky were inversely comparable to *black dots* on a map of French towns and villages. Whereas one could take a train to a town, only death could provide "celestial locomotion" of one's soul to a star, with "cholera, gravel, pleurisy & cancer" expediting the journey as if one were traveling on a steamboat, omnibus, or railway, instead of via the slow gait of dying of old age. Vincent van Gogh, "Letter to Theo van Gogh," Arles, ca. July 9, 1888, edited by Robert Harrison, no. 506, http://webexhibits.org/vangogh/letter/18/506.htm (accessed February 26, 2010).

10. James Joyce, *Finnegans Wake* (London: Penguin, 1982), 309.

11. F.T. Marinetti and Pino Masnata, *La Radia* (1933), translated by Stephen Sartarelli, in *Wireless Imagination: Sound, Radio and the Avant-Garde,* edited by Douglas Kahn and Gregory Whitehead (Cambridge, MA: MIT Press, 1992), 265–68.

12. Margaret Fisher, "'The Art of *Radia*': Pino Masnata's Unpublished Gloss to the *Futurist Radio Manifesto* Introduction," and "Excerpts from the Unpublished Manuscript of Pino Masnata: *Il Nome Radia,*" *Modernism/ Modernity* 19, no. 1 (January 2012): 155–58, 159–75 (168).

13. Stefan Themerson, "Letter to Henri Chopin," *Ou* 36–37 (1970): n.p.

14. Pauline Oliveros, "Valentine," in *Electronic Music,* by Elliott Schwartz (New York: Praeger, 1973), 246. The passage also states, "The same grandfather used to try to teach me the Morse Code with telegraph keys. I wasn't interested in the messages but I loved the dit da dit dit rhythms." Oliveros also listened to her parents' voices in the car, modulated by the engine vibrations, and the music on a wind-up Victrola when the drive mechanism wound down.

15. For a discussion of sources of sonic plenitude, see my "Ether Ore: Mining Vibrations for Modernist Music," in *Hearing Cultures: Essays on Sound, Listening, and Modernity,* edited by Veit Erlmann (London: Berg, 2004), 107–30.

16. "After all," he continues, "all music and indeed all art is based on physical agencies. Oils, pigments, chisels, mallets, clay, strings, pipes, needles, acids, felt, wood, steel, and brass are among the multitude of prosaic articles which we fashion into works of art or use in artistic creation. Why not that subtle fluid of greatest power—electricity?" Alfred Norton Goldsmith, "Electricity Becomes Music: Introducing the 'Emino,'" *Modern Music: A Quarterly Review* 15, no. 1 (November–December 1937): 17–23 (18).

17. Ibid., 20–23.

18. John Cage, "The Future of Music: Credo" (1940), in *Silence: Lectures and Writings* (Middletown, CT: Wesleyan University Press, 1961), 3–6. Although Cage's work is dated 1937 in *Silence*, Leta E. Miller has shown the accurate date to be 1940 in her "Henry Cowell and John Cage: Intersections and Influences, 1933–1941," *Journal of the American Musicological Society* 59, no. 1 (Spring 2006): 47–112.

19. Cage, "The Future of Music: Credo," 5. "Electrical musical instruments have attempted to imitate eighteenth- and nineteenth-century instruments . . . [and] imitate the past rather than construct the future" (4). Cage tempered his comments by saying that "most" inventors did so, making a distinction between the Theremin itself and performers who used the Theremin. "Although the instrument is capable of a wide variety of sound qualities, obtained by mere turning of a dial, Thereministes act as censors" (4).

20. E. D. Preston, reporting on a presentation at the Cosmos Club to the Philosophical Society of Washington by C. K. Wead, "Applications of Electricity to Musical Instruments," in "Societies and Academies," *Science* 9, no. 224 (April 14, 1899): 552–53.

21. John Cage, "For More New Sounds," *Modern Music* 19 (May–June 1942): 245, reprinted in *John Cage*, edited by Richard Kostelanetz (New York: Praeger, 1971), 64–66. The technical essay Cage cites is Harvey Fletcher, "Loudness, Pitch and the Timbre of Musical Tones and Their Relation to the Intensity, the Frequency and the Overtone Structure," *Journal of the Acoustical Society of America* 6, no. 2 (October 1934): 54–69. See also Vern O. Knudsen, "An Ear to the Future," *Journal of the Acoustical Society of America* 11, no. 1 (July 1939): 29–36.

22. Knudsen, "An Ear to the Future," 36.

23. Max Mathews, *The Technology of Computer Music* (Cambridge, MA: MIT Press, 1969), 2–4. Mathews joked that this could have been done with a phonograph: "If one had a minute chisel, grooves for new sounds could be cut by hand. However, the computer can accomplish an equivalent result by a much easier process" (3). In the competition within computing, Mathews pointed out, "We were the only ones in the world at the time who had the right kind of digital-to-analog converter hooked up to a digital tape transport that would play a computer tape. So we had a monopoly, if you will, on this process." Curtis Roads, "Interview with Max Mathews," in *The Music Machine*, edited by Curtis Roads (Cambridge, MA: MIT Press, 1989), 6.

24. James Tenney, personal notes, August 8, 1965, in "James Tenney Fonds, 1978—018/005," file no. 4, Scott Library Archives and Special Collections, York University, Toronto. Note that Tenney makes no distinction here between "computer" and "electronic" music.

25. Ibid.

26. For a discussion of Tenney's *Metabolic Music* and other acts of artistic male interoception, see my "Let Me Hear My Body Talk, My Body Talk," in *Re:Live—New Directions in Media Art Histories,* edited by Sean Cubitt and Paul Thomas (Cambridge, MA: MIT Press, 2013).

27. Mumma, "Live-Electronic Music," 331.

28. Quoted in Howard Junker, "Electronic Music—'Wiggy,'" *Newsweek* (May 22, 1967): 98.

29. Pauline Oliveros, interview with the author, Berkeley, May 2006.

30. Junker, "Electronic Music—'Wiggy,'" 98.

31. Gordon Mumma, interview with the author, San Francisco, December 18, 2008.

11. SOUND OF THE UNDERGROUND

1. See Harry M. Hine, "Seismology and Vulcanology in Antiquity," in *Science and Mathematics in Ancient Greek Culture,* edited by C.J. Tuplin and T.E. Rihll (Oxford: Oxford University Press, 2002), 56–75; and Spyros Missiakoulis, "Aristotle and Earthquake Data: A Historical Note," *International Statistical Review* 76, no. 1 (2008): 130–33.

2. C.A. Lawson et al., *The California Earthquake of April 18, 1906: Report of the State Earthquake Investigation Commission, 1/I,* part 2 (Washington, DC: Carnegie Institution of Washington, 1908), 203. For a post-Aristotelian understanding of earthquake sounds, see David P. Hill et al., "Earthquake Sounds Generated by Body-Wave Ground Motion," *Bulletin of the Seismological Society of America* 66, no. 4 (August 1976): 1159–72.

3. A recording of the same earthquake was inadvertently made when a high school student from a different part of the Puget Sound area recorded his musical performance in a band room: "The earthquake sounds are mixed with a cymbal falling to the floor, then mixed with the band risers falling from storage, then mixed with the students leaving the building. The school's fire bell finally rings." Karl V. Steinbrugge, "A Catalog of Earthquake Related Sounds," *Bulletin of the Seismological Society of America* 64, no. 5 (October 1974): 1409–18 (1416).

4. Alexander von Humboldt, *Cosmos: A Sketch of a Physical Description of the Universe,* vol. 1, translated by E.C. Otté (London: Henry G. Bohn, 1864), 212.

5. Quoted in David Nye, *American Technological Sublime* (Cambridge, MA: MIT Press, 1994), 246.

6. Humboldt, *Cosmos,* 212.

7. John Muir, "Inyo Earthquake of March 26, 1872," in *Our National Parks* (1901), in *Eight Wilderness-Discovery Books* (Seattle: The Mountaineers Books, 1992), 563.

8. Ibid., 563–64.

9. Andrew Thomson, "Earthquake Sounds Heard at Great Distance," *Nature* 124, no. 3131 (November 2, 1929): 687–88.

10. Charles Davison, *A Study of Recent Earthquakes* (London: Walter Scott Publishing, 1905), 229–31; Charles Davison, "Earthquake Sounds," *Bulletin of the Seismological Society of America* 28, no. 3 (July 1938): 147–61.

11. Davison, "Earthquake Sounds," 147–48.

12. Ibid., 150–51.

13. See Ari Ben-Menahem, "A Concise History of Mainstream Seismology," *Bulletin of the Seismological Society of America* 85, no. 4 (August 1995): 1202–25; Ernst von Rebeur-Paschwitz, "The Earthquake of Tokio, April 18, 1889," *Nature* 40, no. 1030 (July 25, 1889): 294–95; and James Dewey and Perry Byerly, "The Early History of Seismology (to 1900)," *Bulletin of the Seismological Society of America* 59, no. 1 (February 1969): 183–227.

14. Harold Allen, "RE: VLF.RXs," on discussion forum for the online magazine *Antennex* (August 9, 1999), www.antennex.com/storage/general/_general/00000014.htm (accessed February 26, 2008).

15. Friedrich Kittler, "Lightning and Series—Event and Thunder," *Theory, Culture and Society* 23, nos. 7–8 (2006): 63–74.

16. Geoffrey Winthrop-Young, "Implosion and Intoxication: Kittler, a German Classic, and Pink Floyd," *Theory, Culture, and Society* 23, nos. 7–8 (2006): 75–91.

17. Dean S. Carder and Leslie F. Bailey, "Seismic Wave Travel Times from Nuclear Explosions," *Bulletin of the Seismological Society of America* 48 (October 1958): 377–98 (377). See also Ben-Menahem, "A Concise History of Mainstream Seismology," 1212, which states, "The use of underground nuclear explosions as point sources, each with accurately known location and time of origin, greatly enhanced the capabilities of seismic studies of the Earth's interior. The first event of this type from which data became available to seismologists was the underwater explosion near Bikini Atoll on 24 July 1946. Since then, data from over 1000 nuclear explosions have been analyzed and studied in research centers around the world."

18. B. Gutenberg, "Interpretation of Records Obtained from the New Mexico Atomic Bomb Test, July 16, 1945," *Bulletin of the Seismological Society of America* 36, no. 4 (October 1, 1946): 327–30.

19. William L. Laurence, *Dawn Over Zero: The Story of the Atomic Bomb* (New York: Alfred A. Knopf, 1946), 4.

20. Ibid.

21. James Joyce, *Ulysses* (New York: Modern Library, 1946), 768.

22. "Minutes of the Second Meeting of the Target Committee: Los Alamos, May 10–11, 1945," US National Archives, Record Group 77, Records of the Office of the Chief of Engineers, Manhattan Engineer District, TS Manhattan

Project file '42–'46, folder 5D Selection of Targets, 2 Notes on Target Committee Meetings, reproduced on the Manhattan Project Heritage Preservation Association website, www.mphpa.org/classic/HISTORY/H-07d.htm (accessed November 23, 2009).

23. Robert Jay Lifton, *Death in Life: Survivors of Hiroshima* (New York: Random House, 1967), 19. See also John Hersey, "A Noiseless Flash," chapter 1 in *Hiroshima* (New York: Modern Library, 1946), 3–23.

24. Fumiko Nonaka, "The Face of Another," in *Hibakusha: Survivors of Hiroshima and Nagasaki*, edited by Naomi Shohono, translated by Gaynor Sekimori (Tokyo: Kosei Publishing, 1987), 89–92 (89).

25. Gene Sherman, "Coliseum Throng Views Tableau of War Scenes," *Los Angeles Times* (October 28, 1945): 2.

26. Carder and Bailey, "Seismic Wave Travel Times from Nuclear Explosions," 377–98.

27. Ibid.

28. Charles Richter, interviewed by Ann Scheid, February 15–September 1, 1978, California Institute of Technology Archives, Pasadena, CA http://resolver.caltech.edu/CaltechOH:OH_Richter_C (accessed October 6, 2009).

29. T.N. Burke-Gaffney and K.E. Bullen, "Seismological and Related Aspects of the 1954 Hydrogen Bomb Explosions," *Australian Journal of Physics* 10 (1957): 130–36. Keith Bullen, of the University of Sydney, proposed in 1955 that atomic bombs be detonated for scientific purposes as part of the International Geophysical Year; although that never came to pass, in the late 1960s and early 1970s the Atomic Energy Commission fired seven shots for scientific purposes for Vela Uniform. See footnotes 34 and 35 in Kai-Henrik Barth, "The Politics of Seismology: Nuclear Testing, Arms Control, and the Transformation of a Discipline," *Social Studies of Science* 33, no. 5 (October 2003): 743–81.

30. Ronald E. Doel, "Constituting the Postwar Earth Sciences: The Military's Influence on the Environmental Sciences in the USA after 1945," *Social Studies of Science* 33, no. 5 (October 2003): 635–66.

31. Meyer Berger, "About New York: 2 Quakes, Blast and 'Atom Bomb'; Busy Night," *New York Times* (August 19, 1953): 31, reprinted in Meyer Berger, *Meyer Berger's New York* (New York: Random House, 1960), 34–35 (34).

32. Ibid., 35.

33. "Earthquakes and Cosmic Music for Sale on Disks," *New York Times* (April 4, 1955): 31, reprinted in Berger, *Meyer Berger's New York*, 136–37 (136).

34. Eric D. Barry, "High-Fidelity Sound as Spectacle and Sublime, 1950–1961," in *Sound in the Age of Mechanical Reproduction*, edited by David Suisman and Susan Strasser (Philadelphia: University of Pennsylvania Press, 2009), 115–38 (120). Thanks also to Mark Karney of the Yahoo Natural Radio VLF Discussion Group for his assistance with *Out of This World*, Cook Laboratories 5012, 1953, LP.

35. Liner notes, *Out of this World.*

36. Ibid.

37. Ibid.

38. Ibid. In explaining how the seismic recording equipment and the frequencies of earthquakes themselves related to one another, the liner notes pointed out that "the tape travels at .02 inches per second. But even during nearby earthquakes, the rate of motion is so slow in terms of *cycles per second* that the taped signals played back at original speed cannot be heard as sound. Therefore, they are played back here at the more conventional specs of 15, $7^1/_2$, $3^3/_4$/sec. It is somewhat as though we played a $33^1/_3$ rpm record at *12,000* rpm."

39. Ibid. Similar comparisons occurred in the general literature. C. L. Strong, the "Amateur Scientist" columnist for *Scientific American,* wrote in his essay "The Attractions of Amateur Seismology," that "a great shock such as the Japanese quake in December, 1946, has a magnitude of about 8.6; an atomic bomb explosion may produce a quake rated at 5.5, and a mild quake that causes dishes to rattle in the vicinity of the quake center has a magnitude of 2.5." C. L. Strong, *The Amateur Scientist* (New York: Simon and Schuster, 1960), 233–34.

40. Associated Press, "Quake Inspired Violin Invention: New Instruments, Developed by Dr. Hugo Benioff on Seismograph Principles; Are Played in California Concert," *New York Times* (June 13, 1938): 3. I am grateful to Martha Benioff for her kind assistance.

41. Hugo Benioff, "Stringed Musical Instrument," US Patent no. 2,222,057, submitted April 2, 1938, granted November 19, 1940.

42. Ibid.

43. Hugo Benioff, "Global Strain Accumulation and Release as Revealed by Great Earthquakes," *Bulletin of the Geophysical Society of America* 62, no. 10 (April 1951): 331–38 (335). See also Hugo Benioff, "Seismic Evidence for the Fault Origin of Oceanic Deeps," *Bulletin of the Geological Society of America* 60, no. 12 (December 1949): 1337–66.

44. Benioff, "Stringed Musical Instrument," US Patent no. 2,222,057.

45. Sheridan Speeth curriculum vitae (ca. 1986). I am indebted to Christopher Eric Speeth and Lauren Speeth for their assistance with documents and memories regarding Sheridan Speeth.

46. A better picture is painted by Susan Hough, who points out that 2 percent of the US funding ($900,000) represented direct expenditure and did not include the expenses of the US military, especially those of moving seismologists and their equipment to remote locations and maintaining such operations, which could have totaled up to $1 billion in 1958 dollars. Susan E. Hough, "Seismology and the International Geophysical Year," *Seismological Research Letters* 79, no. 2 (March–April 2008), www.seismosoc.org/publications/SRL /SRL_79/srl_79–2_hs.html (accessed January 6, 2010). Still, as Hough restates, "Between 1960 and 1963, Vela Uniform received $110.7 million, 30% of which was earmarked for basic research."

47. Carl Romney, "Amplitudes of Seismic Body Waves from Underground Nuclear Explosions," *Journal of Geophysical Research* 64, no. 10 (October 1959): 1489–98.

48. The source for this aspect of Speeth's life is Philip G. Schrag, "Scientists and the Test Ban," *Yale Law Journal* 75, no. 8 (July 1966): 1340–63. Speeth joined the liberal organization Committee for a Sane Nuclear Policy and, after returning from a visit to Cuba in 1960, joined the New York chapter of Fair Play for Cuba and served on its executive committee before it was commandeered by Communists in 1961. He also was a member of the Society for Social Responsibility in Science, contributed to the Committee for Non-Violent Action, audited a course by the historian Herbert Aptheker, who belonged to the CPUSA, and was arrested for protesting an air-raid drill in New York City.

49. "One day in the spring of 1962, he was called into the office of his superior and told that he would not be able to get even the lowest grade of security clearance, and therefore he would not be able to see the improved recordings. He was also told that since he could not see the recordings, he would not be able to make much of a contribution, and therefore he was being taken off of the Vela Uniform project. Speeth had once before requested Bell to put in an application for 'confidential' clearance for him, but he had been told that it was so certain that he could not get it, that it would be a waste of money to conduct a security review." Schrag, "Scientists and the Test Ban," 1360.

50. Sheridan Dauster Speeth, "Seismometer Sounds," *Journal of the Acoustical Society of America* 33, no. 7 (July 1961): 909–16.

51. Ibid. See also B.P. Bogert, "Seismic Data Collection, Reduction and Digitization," *Bulletin of the Seismological Society of America* 51, no. 4 (October 1961): 515–25.

52. On Speeth's musical skills, see Professor George Sperling, Speeth's fellow graduate student at Harvard and colleague at Bell Labs, correspondence with the author, January 8, 2011. On his preference for cellists, see Lauren Speeth and Christopher Speeth, correspondence with the author, April 5, 2009.

53. Christopher Speeth, correspondence with the author, April 2, 2009.

54. *Music from Mathematics*, released by Bell Laboratories in 1960 and by Decca Records, DL 9103, in 1962.

55. Liner notes to *Music from Mathematics*, Decca Records DL 9103, 1962, LP.

56. As Tenney recounted, "He [Speeth] loaned me the *Selected Writings* of Reich. Carolee and I thought that it was very very interesting." James Tenney, interview with the author, published as "James Tenney at Bell Labs," *Leonardo Electronic Almanac* 8, no. 11 (February 2001): n.p. Schneemann remembered Speeth's "passionate interest in sexuality and the connections Reich's research made to fascism. He often had lunch with us in the house on the hill where we lived briefly during Jim's time at Bell Labs. He was so knowledgeable, ardent and politically astute. He inspired our intensive research into all that Reich wrote." Carolee Schneemann, correspondence with the author, January 10, 2011.

57. Carla Bley thought that Speeth's neologism *chronotransduction* meant "walking through life without effort." Jack Bruce, *Composing Himself* (London: Jawbone Press, 2010), 140–41. See also Carla Bley, "Accomplishing 'Escalator Over the Hill,'" www.angelfire.com/jazz/jm3/eoth_notes_accomp.html (accessed December 30, 2010), originally from *Impetus* (June–July 1976). But the word *chronotransduction* may have come from Speeth's engineering language (e.g., the liner notes to *Music from Mathematics* stated that all the music was "played by IBM 7090 COMPUTER and DIGITAL TO SOUND TRANSDUCER"), applied to Haines's lyrics, whereby the *chronos* of memory and history move in and out of the states of the present. Such time manipulation would have made sense for someone who had used the IBM 7090 with its digital-to-analog transducer to time-compress global and historical events for trained musicians. Sheridan Speeth and his wife, Susan Alexander Speeth, made a large donation toward the production of *Escalator Over the Hill*. Susan Speeth's tragic murder in Philadelphia in 1975 was an impetus for Take Back the Night.

58. Gordon Mumma, correspondence with the author, August 18, 2008.

59. "He [Speeth] hated his job designing weapons and refused to design anything that would cause permanent damage to the 'enemy.' This is why he eventually left that area of investigation but not before [working on] a variety of devices. . . . He was upset that a device to temporally blur vision was applied to pilots in the air." Christopher Speeth, correspondence with the author, February 16, 2005. See also Sheridan Dauster Speeth, "The Rational Design of Toys," *Journal of Creative Behavior* 1, no. 4 (1967): 398–410.

60. Gordon Mumma, interview with the author, December 18, 2008. Unless otherwise noted, information from Mumma is from this interview.

61. See G.E. Frantti and L.A. Levereault, "Auditory Discrimination of Seismic Signals from Earthquakes and Explosions," *Bulletin of the Seismological Society of America* 55, no. 1 (February 1965): 1–25 (7). The paper was based on the 1964 report *Investigation of Auditory Discrimination of Seismic Signals from Earthquakes and Explosions*, Report: AD-437784, filed by VELA Seismic Information Analysis Center at University of Michigan, Ann Arbor.

62. David Willis, telephone interview with the author, December 5, 2008.

63. D.E. Willis and J.C. Johnson, "Some Seismic Results Using Magnetic Tape Recording," *Earthquake Notes* 30, no. 3 (September 1959): 21–25 (22).

64. The pro forma paragraph placed on reports by Project Michigan stated that the project consisted of a "continuing research and development program for advancing the Army's long-range combat-surveillance and target-acquisition capabilities." After describing the role of Willow Run and University of Michigan researchers, it continued, "The emphasis of the Project is upon basic and applied research in radar, infrared, acoustics, seismics, information processing and display, navigation and guidance for aerial platforms, and systems concepts. Particular attention is given to all-weather, long-range, high-resolution sensory and location techniques, and to evaluations of systems and equipments both through simulation and by means of laboratory and field tests."

65. Gordon Mumma, correspondence with the author, April 19, 2009.

66. See the chapter "The Rise and Fall of *Grammophonmusik*," in *Capturing Sound: How Technology Has Changed Music*, by Mark Katz (Berkeley: University of California Press, 2010), 109–23.

67. Gordon Mumma, correspondence with the author, September 30, 2008. As Mumma said with regard to one *Mograph*, "The time-travel patterns of the P- and S-waves are different, but have similarities to the complex sound-reflection characteristics of musical performance spaces." Gordon Mumma, "*Medium Size Mograph 1962*," *Leonardo Music Journal* 21 (2011): 77–78 (77).

68. In their use of geophysical data in music, the *Mographs* predate the popular success of Charles Dodge's *Earth's Magnetic Field* (1970).

69. Michelle Fillion, liner notes to *Gordon Mumma: Music for Solo Piano* (*1960–2001*), New World Records 80686, 2008, CD.

70. "Does anyone want to say that the piano is near the end of the road? Except for how it is played, nothing of significance has happened to it in almost a century. Few machines survive as long as the piano with so little overhaul. Performance innovations tax the instrument to the limit. Some of those who established the innovations, like David Tudor, are moving to other ground. Others of us are still rigging the beast with accessories and cramming it with electronics. Those who take offence can no longer seek refuge behind your shouts of 'desecration.' Age is not enough to make an object sacred. We live with a vast new literature which, though threatening the mechanism, is its viable repertoire. The mechanism must change to accommodate the music. At the end of the road we might make it fly." Gordon Mumma, statement about *Mographs* and pianos in a letter to Udo Kasemets, September 23, 1967, provided to the author by Mumma.

71. Gordon Mumma, correspondence with the author, April 19, 2009.

72. Gordon Mumma, program notes to *Medium Size Mograph 1963*.

73. Gordon Mumma, correspondence with the author, April 19, 2009.

74. Richard Schmidt James, "ONCE: Microcosm of the 1960s Musical and Multimedia Avant-Garde," *American Music* 5, no. 4 (Winter 1987): 359–90 (374).

75. Udo Kasemets, *CANAVANGARD: Music of the Nineteen Sixties and After Series* (Don Mills, ON: BMI Canada, 1967), 84.

76. See *United States Nuclear Tests: July 1945 through September 1992*, Report 209-REV 15, US Department of Energy, Nevada Operations Office (December 2000).

77. Gordon Mumma, interview with the author, December 18, 2008. A number of artists, musicians, and scientists have incorporated seismic phenomena into their works and public demonstrations, including Juan Geurer *(Al Asnaam)*, Trimpin *(Seismophone)*, Matt Rogalsky *("When he was in high school in Texas Eric Ryan Mims used a similar arrangement to detect underground nuclear tests in Nevada")* (see reference to Ryan's father, Forrest Mims III, in chapter 19), Mark Bain *(Portable Earthquake* and *StartEndTime*, the latter based on the seismics of the World Trade Center destruction), D. V. Rogers *(Parkfield Interventional EQ Fieldwork)*, John T. Bullitt *(Earth Sound)*, and the

work of Florian Dombois and of Ben Holtzman. To keep things in perspective, entire nations and their arts communities can be transformed by seismic events, as occurred over a short period of time in 2011 with the Christchurch, New Zealand, and Tohoku, Japan, earthquakes. My only lecture on seismology and music was given at the Physics Room in Christchurch on December 15, 2010, just prior to the devastating earthquake.

12. LONG SOUNDS AND TRANSPERCEPTION

1. "Telephoning Extraordinary," *New York Times* (March 17, 1887): 2.

2. Marin Mersenne, *Harmonie Universelle* (1636), cited and discussed in Frederick Vinton Hunt, *Origins in Acoustics; The Science of Sound from Antiquity to the Age of Newton* (New Haven, CT: Yale University Press, 1978), 87.

3. Ibid., 86–87.

4. "Mistpouffer, Uminari, Atmospheric Noises, *Monthly Weather Review* 43, no. 7 (July 1915): 314–15. *Seefahrts* would also be German for sounds associated with "seafaring." See also "Seismic Noises," *Monthly Weather Review* 25, no. 9 (September 1897): 393; and "Seismic Noises," *Monthly Weather Review* 26, no. 12 (December 1898): 562.

5. J. Scherer, "Notes on Remarkable Earthquake Sounds in Haiti," *Bulletin of the Seismological Society* 2, no. 4 (December 1, 1912): 230—32 (231).

6. Ibid., 231.

7. Simão de Vasconcelles, cited in *The Quarterly Review* (London) 12 (October 1814 and January 1815): 343–44.

8. R.D.M. Verbeek, "The Krakatoa Explosion," *Nature* 30, no. 757 (May 1, 1884): 10–15 (11). Another anecdotal report placed the sound as far away as nearly 3,000 miles (4,800 km). Simon Winchester, *Krakatoa* (New York: HarperCollins, 2004), 259–61. See also T. Simkin and R. Fiske, *Krakatau 1883— The Volcanic Eruption and Its Effects* (Washington, DC: Smithsonian Institution Press, 1983); and G.J. Symons, ed., *The Eruption of Krakatoa: Report of the Krakatoa Committee of the Royal Society* (London: Trübner & Co., 1888), 78–88.

9. Symons, *The Eruption of Krakatoa*, 79–80.

10. Ibid, 81.

11. Ibid, 83.

12. Ibid.

13. Verbeek, "The Krakatoa Explosion," 11.

14. Walter Munk et al., *Ocean Acoustic Tomography* (Cambridge: Cambridge University Press, 1995), 329.

15. From a boat near Heard Island, underwater projectors transmitted sound at a continuous rate at 57 hertz with a source level of around 220 decibels (160+ dB at 1 km, 137+ dB at 72 km at depth 80 m, and 120+ dB at 100–1,000 km) into the deep sound channel. Munk, *Ocean Acoustic Tomography*, 337–39. "Heard Island was chosen for two reasons: the relatively shallow channel depth (200m)

at that high-latitude location, and the unobstructed great-circle pathways into may parts of the Atlantic, Pacific and Indian oceans." W. John Richardson et al., *Marine Mammals and Noise* (San Diego: Academic Press, 1995), 66–67.

16. "Changes in behavior of pilot whales and sperm whales provided unequivocal evidence of behavioral effects of the transmissions." Ann E. Bowles et al., "Relative Abundance and Behavior of Marine Mammals Exposed to Transmissions from the Heard Island Feasibility Test," *Journal of the Acoustical Society of America* 96, no. 4 (October 1994): 2469–84 (2483). See also Munk, *Ocean Acoustic Tomography*, 334–39; and Richardson, *Marine Mammals and Noise*, 65–67, 155. "The operation has been put largely on hold, due to opposition from environmental and ecological groups, who feared harm to the animal species in the ocean." Robert T. Beyer, *Sounds of Our Times: Two Hundred Years of Acoustics* (New York: Springer-Verlag, 1999), 384. However, high-decibel active sonar arrays injurious to marine mammals are being deployed for submarine detection by the United States under the auspices of the "homeland" security state.

17. Munk, *Ocean Acoustic Tomography*, 339.

18. Roger S. Payne and Scott McVay, "Songs of Humpback Whales," *Science* 173, no. 3997 (August 13, 1971): 585–97.

19. *Songs of the Humpback Whale*, Communication Research Machines, CRM Records SWR 118, 1970, LP.

20. Roger Payne and Douglas Webb, "Orientation by Means of Long Range Acoustic Signalling Baleen Whales," *Annals of the New York Academy of Sciences* 188 (December 1971): 110–41 (110).

21. Ibid.

22. Alvin Lucier, *Reflections: Interviews, Scores, Writings* (Cologne: Edition MusikTexte, 1995), 326–31.

23. Ibid., 110–12.

24. Ibid., 326.

25. The ocean acoustical origin of *Quasimodo* and *I am sitting in a room* have something else in common: "A range of objects, from tiny dust particles and bubbles to the myriads of aquatic life, as well as the roughness of the surface, especially in stormy weather, and the irregularities of the bottom, all contribute to the scatting of any sound signal traveling through the medium. The totality of such scattering is known as reverberation, and is a counterpart to the phenomena involved in room acoustics." Beyer, *Sounds of Our Times*, 255.

26. Lucier, *Reflections*, 326.

27. Alvin Lucier, interview with Ev Grimes, June 6, 1986, p. 104, American Music Series, Oral History of American Music, Yale University Library, New Haven, CT (OHAM).

28. Alvin Lucier, interview with Vivian Perlis, April 28, 1993, pp. 1–3 (2), OHAM.

29. Ibid., 2.

30. Lucier, *Reflections*, 328.

31. Ibid. Lucier tried more vociferous forms, but they "sounded awkward and grotesque. They sounded too psychological; the upward and downward sweeps sounded like moaning" (106).

32. Transnational Ecologies I: Sounds Travel project, www.transnationale-cologies.net (accessed February 22, 2012).

33. Matt Rogalsky, email correspondence with the author, March 6, 2012.

34. Henry David Thoreau, journal entry, May 1, 1851, *Journal: Volume 3; 1848–1851* (Princeton, NJ: Princeton University Press, 1990), 212.

35. Thoreau, journal entry, October 12, 1851, *Journal: Volume 4; 1851–1852* (Princeton, NJ: Princeton University Press, 1990), 143.

36. Ibid., 142–43. A variation of this passage appears in the "Sounds" chapter of *Walden*.

37. Ibid., 143.

38. Ibid.

39. "Telephoning Extraordinary," *New York Times*.

40. Nam June Paik, piece from a 1961–62 series of works, published at Kalendar '63, Düsseldorf, Everson Museum of Art, Syracuse, NY.

41. Christopher Bartlette et al., "Effect of Network Latency on Interactive Musical Performance," *Music Perception* 24, no. 1 (September 2006): 49–62 (49).

42. My thanks to Chris Chafe of Stanford University for assisting me with matters of network latency; correspondence with the author, March 22, 2012.

13. PAULINE OLIVEROS

1. See Pauline Oliveros, "Auralizing in the Sonosphere: A Vocabulary of Inner Sound and Sounding," *Journal of Visual Culture* 10, no. 2 (August 2011): 162–68.

2. Pauline Oliveros, "Improvisation in the Sonosphere," *Contemporary Music Review*, 25, nos. 5–6 (October–December 2006): 481–82. Oliveros's usage of the term *technosphere* is informed by the New Age writer José Argüelles in his book *Time and the Technosphere: The Law of Time in Human Affairs* (Rochester, VT: Bear and Company, 2002). Argüelles is best known for the "Harmonic Convergence" in 1987 and his role in a New Age appropriation of Mayan cosmology.

3. Pauline Oliveros, interview with the author, Berkeley, April 22, 2006.

4. Ibid.

5. Pauline Oliveros, "Quantum Listening: From Practice to Theory (to Practice Practice)," n.d., www.deeplistening.org/pauline/writings/quantum_listening.html (accessed April 16, 2006).

6. Pauline Oliveros, "Quantum Improvisation: The Cybernetic Presence," keynote address at the Improvisation Across Borders conference, University of California at San Diego, April 11, 1999, www.deeplistening.org/pauline/writings/quantum.html (accessed April 8, 2005). This talk was influenced by technofuturist Ray Kurzweil and his book *The Age of Spiritual Machines* (New York: Penguin, 1999).

7. Oliveros's notion of the biosphere derives from Vladimir Vernadsky; see his *Biosphere* (New York: Copernicus, 1997).

8. Oliveros, "Improvisation in the Sonosphere," 481.

9. Alvin Lucier, "'There are all these things happening': Thoughts on Installations," in *Reflections: Interviews, Scores, Writings* (Cologne: Edition MusikTexte, 1995), 524.

10. Pauline Oliveros, paraphrased by Lucier in "Interview with William Duckworth" (1981), in *Reflections*, 322. Oliveros included brainwaves on another occasion when she listened to insects "singing in the supersonic range," hearing "their combination tones while the insects probably hear the radio frequency sounds created by motor drones, but not the fundamentals. If we could hear the micro-world, we would probably hear the brain functioning." Pauline Oliveros, "Some Sound Observations" (1968), reprinted in *Source: Music of the Avant-Garde, 1966–1973*, edited by Larry Austin and Douglas Kahn (Berkeley: University of California Press, 2011), 137.

11. Oliveros, "Improvisation in the Sonosphere," 481–82.

12. Gordon Mumma, "Witchcraft, Cybersonics, and Folkloric Virtuosity," in *Darmstädter Beitrage zur Neue Musik* (Mainz: Musikverlag Schott, 1974), 71–77 (74).

13. Oliveros, interview, April 22, 2006.

14. Ibid.

15. H.P. Blavatsky, *The Voice of the Silence, Being Chosen Fragments from the "Book of the Golden Precepts"* (London: Theosophical Publishing Company, 1889), 89.

16. Benjamin Silliman, *Principles of Physics, or Natural Philosophy, Designed for the Use of Colleges and Schools* (Philadelphia: T. Bliss & Co., 1863), 252.

17. C.W. Leadbeater, *The Hidden Side of Things* (1913) (Adyar, Madras, India: Theosophical Publishing House, 1948), 210. My thanks to Luciano Chessa, who directed me to this passage.

18. See Hiroo Kanamori, "Shaking without Quaking," *Science* 279, no. 5359 (March 27, 1998): 2063–64; Naoki Suda, Kazunari Nawa, and Yoshio Fukao, "Earth's Background Free Oscillations," *Science* 279, no. 5359 (March 27, 1998): 2089–91; and Junkee Rhie and Barbara Romanowicz, "Excitation of Earth's Continuous Free Oscillations by Atmosphere-Ocean-Seafloor Coupling," *Nature* 431, no. 7008 (September 30, 2004): 552–56.

19. Gregg Braden, *Awakening to Zero Point: The Collective Initiation* (Questa, NM: Sacred Spaces, 1994), 113. In 2002, the composer David First was researching a sound installation using brainwaves when he discovered that Schumann resonances intersected with the same frequency range. This put him in a predicament caught between magical New Age thought, with its "outsider science," and hard science proper. He rejected claims that the Schumann resonance could fundamentally change but remained intrigued with the correlation of brainwaves. This conforms to his insight of the artist as "someone who draws upon the unexplainable but who does not wish to share the credit." David First,

"The Music of the Sphere: An Investigation into Asymptotic Harmonics, Brainwave Entrainment and the Earth as a Giant Bell," *Leonardo Music Journal* 13 (2003): 31–37 (32).

20. Brian Greene, *The Elegant Universe: Superstrings, Hidden Dimensions, and the Quest for the Ultimate Theory* (New York: Vintage, 2003), 135.

21. Joseph Eger, *Einstein's Violin: A Conductor's Notes on Music, Physics, and Social Change* (New York: Tarcher/Penguin, 2005), 144, 211–12.

22. Andrew Deutsch, correspondence with the author, May 27, 2008.

23. Ibid.

24. Ibid.

25. Oliveros, interview, April 22, 2006.

26. Pauline Oliveros, "Valentine," in *Electronic Music*, by Elliott Schwartz (New York: Praeger, 1973), 246.

27. Pauline Oliveros, "Some Sound Observations," 136.

28. Oliveros, interview, April 22, 2006.

29. Scot Gresham-Lancaster, correspondence with the author, September 30, 2006.

30. Pauline Oliveros, "Echoes from the Moon: Notes," www.deeplistening .org/pauline/writings/moon.html (accessed April 16, 2006).

31. Gresham-Lancaster, correspondence, September 30, 2006.

32. "In Electricity's Field," *Los Angeles Times* (July 1, 1895): 3.

33. John DeWitt Jr., quoted in Andrew J. Butrica, *To See the Unseen: A History of Planetary Radar Astronomy* (Washington, DC: NASA History Office, 1996), 8, published online as publication SP-4218, http://history .nasa.gov/SP-4218/sp4218.htm (accessed April 24, 2008). See also John H. DeWitt Jr. and E. K. Stodola, "Detection of Radio Signals Reflected from the Moon," *Proceedings of the I.R.E.* 37 (March 1949): 229–42; and James H. Texler, "Lunar Radio Echoes," *Proceedings of the I.R.E.* 46, no. 1 (January 1958): 286–92.

34. A recording of Nixon's speech can be heard at NASA's Human Space Flight website, http://spaceflight.nasa.gov/gallery/video/apollo/apollo11 /html/lunar_activities.html (accessed February 10, 2012).

35. *New York Times* (July 25, 1969), quoted in David E. Nye, *American Technological Sublime* (Cambridge, MA: MIT Press, 1994), 250.

36. Nam June Paik, "Preparing for my first entry to U.S.A. This letter to John Cage . . . ," in *Nam June Paik: Videa 'n' Videology, 1959–1973*, edited by Judson Rosebush (Syracuse, NY: Everson Museum of Art, 1974), n.p. See also Paik's installation, *Moon is the Oldest TV* (1965–76).

37. Lucier, "'There are all these things happening,'" *Reflections*, 526.

38. Nicholas Alfrey, "Transmission, Reflection and Loss: Katie Paterson's *Earth-Moon-Earth (Moonlight Sonata Reflected from the Surface of the Moon),*" in *Earth-Moon-Earth*, exhibition catalog (Nottingham: Djanogly Art Gallery, Lakeside Arts Centre, 2009).

39. Oliveros, "Echoes from the Moon: Notes"; For her discussion of tape delay techniques, see Pauline Oliveros, "Tape Delay Techniques for Electronic

Music Composers," in *Software for People: Collected Writings, 1963–1980* (Baltimore: Smith Publications, 1984), 36–46.

40. Oliveros, interview, April 22, 2006.

14. THOMAS ASHCRAFT

1. Exhibition notes to *Thomas Ashcraft,* CUE Art Foundation, New York, December 9, 2004–January 29, 2005.

2. David Dunn, "The Liminal Worlds of Thomas Ashcraft," unpublished essay, courtesy of Dunn.

3. Louis Grachos, ed., *Ashcraft,* exhibition catalog (Santa Fe, NM: SITE Santa Fe, 1998), n.p.

4. Vivian Endicott Barnett, "Kandinsky and Science. The Introduction of Biological Images in the Paris Period," in *Kandinsky in Paris, 1934–1944* (New York: Solomon R. Guggenheim Museum, 1985), 61–87; Maura C. Flannery, "Images of the Cell in Twentieth-Century Art and Science," *Leonardo* 31, no. 3 (1998): 195–204.

5. Thomas Ashcraft, correspondence with the author, May 2009.

6. See the Papers of Grote Reber, 1910–99, National Radio Astronomy Observatory Archives, www.nrao.edu/archives/Reber/reber.shtml (accessed June 1, 2009).

7. Ashcraft, correspondence, June 2009.

8. Thomas Ashcraft, "Jumpering Wild Electricities from Outer Space," radio documentary commissioned by Aether Fest 1: Festival of International Radio Art, broadcast by KUNM, Albuquerque/Santa Fe, June 26, 2003.

9. A different military, scientific, and amateur configuration occurred on November 6, 1957, when Calvin Graf, living in San Antonio, Texas, recorded a meteor "ping" lasting about a quarter of a second that had been scattered by the signal transmitted from *Sputnik II.* He reported this single ping in *QST,* the amateur journal of the American Radio Relay League. Calvin R. Graf, "Meteor *Ping* from Sputnik II," *QST* 42, no. 3 (March 1958): 47. Graf would unwittingly influence American experimental music as the author of the book *Listen to Radio Energy, Light and Sound* (Indianapolis: Howard W. Sams & Co., 1978), which Alvin Lucier used to finally build a successful VLF antenna for his piece *Sferics.*

10. "Hey! Use My Nervous System," interview with Thomas Ashcraft, *Santa Fe New Mexican* (June 27, 2008): 24.

11. The quotations are transcriptions from Ashcraft's recordings of the radio scattered (reflected) off the space shuttle.

12. Posting on the Google group for the Society of Amateur Radio Astronomers, May 4, 2008, http://groups.google.com/group/sara-list.

13. Gerrit L. Verschuur, *The Invisible Universe: The Story of Radio Astronomy,* 2nd ed. (New York: Springer, 2007), 29.

14. Ashcraft Web site, www.heliotown.com/CCA_Event.html (accessed June 12, 2009).

15. Ashcraft, correspondence, May 2009.
16. Ashcraft Web site, www.heliotown.com/CCA_Experiments_Ashcraft.html (accessed June 12, 2009).
17. Ashcraft, "Jumpering Wild Electricities from Outer Space."
18. "Hey! Use My Nervous System," interview with Ashcraft.

15. BLACK SUN, BLACK RAIN

1. Harry Crosby, "I Climb Alone," in *Revolution of the Word: A New Gathering of American Avant-Garde Poetry, 1914–1945*, edited by Jerome Rothenberg (New York: Seabury Press, 1974), 126–27.
2. My deep appreciation for their assistance with this section on Karl-Birger Blomdahl goes to Jesper Olsson, Ingvar Loco Nordin, Christina Tobeck, Ludwik Liszka, Pelle Snickars, and the Swedish National Archive of Recorded Sound and Moving Images.
3. Ludwik Liszka, correspondence with the author, September–October 2009.
4. Ibid.
5. Liszka and Blomdahl became close friends, with Blomdahl the godfather to Liszka's younger son.
6. Blomdahl worked closely with the sound technician Berndt Berndtson, special effects technician Béla Thinsz, and the composer and photographer Ralph Lundsten. The use of data as imagery in an audiovisual relationship is a precursor to the contemporary work of Ryoji Ikeda and others.
7. Quoted in Matts Rying and Karl-Birger Blomdahl, "Fågelstrupar och rymders svalg" (Birds' throats and chasms of spaces), *Röster i Radio* 49 (1966) (Swedish National Radio program magazine), reprinted in the anthology *"Facetter" av och om Karl-Birger Blomdahl* (Stockholm: P.A. Norstedt & Söner, 1970), 127. My thanks to Christina Tobeck for providing this text and to Jesper Olsson for its translation.
8. Liszka, correspondence, September–October 2009.
9. Johannesson's novel was published in English as *The Great Computer: A Vision* (London: Victor Gollanz, 1968).
10. Ruth K. Inglefield, "Karl-Birger Blomdahl," *Musical Quarterly* 58, no. 1 (January 1972): 77.
11. Semiconductor (Ruth Jarman and Joe Gerhardt), interview with the author, Berkeley, April 2006.
12. *Brilliant Noise*, www.semiconductorfilms.com/root/Brilliant_Noise/BNoise.htm (accessed September 24, 2009).
13. Jarman and Gerhardt, interview, April 2006.
14. See Greg Siegel, "Radiating Emergency: The Perils and Promise of the Broadcast Signal in the Atomic Age," *Communication and Critical/Cultural Studies* 8, no. 3 (September 2011): 286–306.
15. "Statement by the President Announcing the Use of the A-Bomb at Hiroshima" (August 6, 1945), Harry S. Truman Library and Museum, http://

trumanlibrary.org/calendar/viewpapers.php?pid=100 (accessed September 20, 2012).

16. *Hiroshima-Nagasaki: A Pictorial Record of the Atomic Destruction* (Tokyo: Hiroshima-Nagasaki Publishing Committee, 1978), 66.

17. Paul DeMarinis, "The Boy Mechanic—Mechanical Personae in the Works of Jim Pomeroy," in *For a Burning World Is Come to Dance Inane: Essays by and about Jim Pomeroy*, edited by Timothy Druckrey and Nadine Lemmon (New York: Critical Press, 1993), www.jim-pomeroy.org/demarinis. html (accessed March 12, 2003).

18. Erkki Huhtamo, "Excavating Sounds: On the Art of Paul DeMarinis," in *Excavated Sounds: The Media Art of Paul DeMarinis*, edited by Päivi Talasmaa (Helsinki: Otso Gallery, 2000), 10–15; "T(h)inkering with Media: The Art of Paul DeMarinis," in *Resonant Messages: Media Installations by Paul DeMarinis*, exhibition catalog (Pasadena, CA: Alyce de Roulet Williamson Gallery, Art Center College of Design, 2000), n.p.; "Thinkering with Media: On the Art of Paul DeMarinis," in *Paul DeMarinis: Buried in Noise*, edited by Ingrid Beirer et al. (Berlin: Kehrer Verlag, 2010), 33–46.

19. Paul DeMarinis, statement on his installation *An Unsettling Manner*, Ars Electronica, Linz, Austria, September 1991.

20. Ibid.

21. "Doppler Effect—Information Derived from It," track 4, *Voices of the Satellites*, Smithsonian Folkways FW06200, 1958, LP.

22. Paul DeMarinis, notes to *Rome to Tripoli* (2006), in *Paul DeMarinis: Buried in Noise*, edited by Ingrid Beirer et al. (Berlin: Kehrer Verlag, 2010), 182–85.

23. Frantz Fanon, "This Is the Voice of Algeria," in *A Dying Colonialism* (New York: Grove Press, 1994), 69–120.

16. STAR-STUDDED CINEMA

1. John Tyndall, "Life in the Alps" (1887), in *New Fragments* (New York: D. Appleton and Co., 1898), 307–8, alluding to Tennyson.

2. Remarks of Alexander Graham Bell on the paper by Mr. W.H. Preece, "The Photophone and the Conversion of Radiant Energy into sound," read before the Society of Telegraph Engineers, London, December 8, 1880, Alexander Graham Bell Family Papers, Library of Congress, http://rs6.loc.gov (accessed September 15, 2008).

3. Ibid.

4. Alexander Graham Bell, "Application of the Photophone to the Study of the Noises Taking Place on the Surface of the Sun," *Science* 1, no. 25 (December 18, 1880), 304.

5. Klaus Hentschel, *Mapping the Spectrum: Techniques of Visual Representation in Research and Teaching* (Oxford: Oxford University Press, 2002), 102.

6. See Laurent Mannoni, *The Great Art of Light and Shadow: Archaeology of the Cinema* (Exeter: University of Exeter Press, 2000), 299–303.

7. Thomas A. Watson, *Exploring Life: The Autobiography of Thomas A. Watson* (New York: D. Appleton and Company, 1926), 80.

8. Bell, "Application of the Photophone to the Study of the Noises Taking Place on the Surface of the Sun," 304.

9. Linda Dalrymple Henderson, *Duchamp in Context: Science and Technology in the Large Glass and Related Works* (Princeton, NJ: Princeton University Press, 1998).

10. Marcel Duchamp, *Salt Seller: The Essential Writings of Marcel Duchamp*, edited by Michel Sanouillet and Elmer Peterson (London: Thames and Hudson, 1973), 26.

11. Ibid., 120.

12. Masaki Kobayashi, Daisuke Kikuchi, and Hitoshi Okamura, "Imaging of Ultraweek Spontaneous Photon Emission from Human Body Displaying Diurnal Rhythm," *PLoS ONE* 4, no. 7 (2009): e6256, doi:10.1371/journal. pone.0006256.

13. Quoted in Pierre Janet, "The Psychological Characteristics of Ecstasy," in *Raymond Roussel: Life, Death and Works*, edited by Alastair Brotchie et al. (London: Atlas Press, 1987), 40–41.

14. Ibid., 39.

15. *Marcel Duchamp, Notes*, edited and translated by Paul Matisse (Boston: Exact Change, 2003).

16. Frances Dyson, "Circuits of the Voice: From Cosmology to Telephony," *Musicworks*, no. 53 (Summer 1992): 5–15.

17. *The Writings of Marcel Duchamp* (New York: Da Capo Press, 1989), 26. The Jura–Paris road notes are extensively discussed in Henderson, *Duchamp in Context*, 37–39.

18. Camille Flammarion, quoted in Brian Mackrell, *Halley's Comet over New Zealand* (Auckland: Reed Methuen, 1985), 124. See also, "Comet's Poisonous Tail: Yerkes Observatory Finds Cyanogen in Spectrum of Halley's Comet, *New York Times* (February 8, 1910): 1.

19. Richard Whittaker, "Greeting the Light: An Interview with James Turrell," *Works + Conversations*, no. 2: n.p., www.conversations.org/99–1-turrell .htm (accessed November 7, 2003).

20. Roland Barthes, "Upon Leaving the Movie Theatre," in *Apparatus: Cinematographic Apparatus: Selected Writings*, edited by Theresa Hak Kyung Cha (New York: Tanam Press, 1980), 1–4 (2).

21. Anthony McCall, "*Line Describing a Cone* and Related Films," *October* 103 (Winter 2003): 43.

22. Ibid.

23. For spotlights, from blinding lanterns to anti-aircraft searchlights, see Friedrich Kittler, "A Short History of the Spotlight," in *Light Art from Artificial Light*, edited by Gregor Jansen and Peter Weibel (Ostfildern, Germany: Hatje Cantz, 2006), 76–84.

24. Craig Adcock, *James Turrell: The Art of Light and Space* (Berkeley: University of California Press, 1990), 6.

25. Ibid., 1.

26. Robert Morris, "The Art of Existence: Three Extra-Visual Artists: Works in Progress," *Artforum* 9, no. 5 (January 1971): 28–33 (30). Morris's statement on Traub/Turrell begins, "After having worked with high-frequency sound perception in anechoic chambers for some two years" (30). He is referring to Turrell's collaboration with Robert Irwin and Ed Wortz during the Art and Technology Program organized by Maurice Tuchman for the Los Angeles County Museum of Art. On anechoic perception and Turrell's relationship to John Cage, see my "Let Me Hear My Body Talk, My Body Talk," in *Re:Live— New Directions in Media Art Histories,* edited by Sean Cubitt and Paul Thomas (Cambridge, MA: MIT Press, forthcoming).

27. James Turrell, interview with Esa Laaksonen, Blacksburg, VA, 1996, reprinted in *ARK: The Finnish Architectural Review,* http://home.sprynet.com/~mindweb/page44.htm (accessed November 11, 2003).

28. James Turrell interview in Richard Andrews and Chris Bruce, *James Turrell: Sensing Space* (Seattle: Henry Art Gallery, University of Washington, 1992), 47–48.

29. Alison Sarah Jacques, "There never is no light . . . even when all the light is gone, you can still sense light: Interview with James Turrell," *James Turrell: Perceptual Cells,* edited by Jiri Svestka (Stuttgart: Edition Cantz, 1992), 61–63.

30. Andrews and Bruce, *James Turrell: Sensing Space,* 48.

31. Ibid.

32. Whittaker, "Greeting the Light: An Interview with James Turrell," n.p.

33. Turrell, interview with Laaksonen, 1996.

34. Adcock, *James Turrell,* 176.

35. Ibid., 178.

17. ROBERT BARRY

1. John Cage, *Empty Words* (Middletown, CT: Wesleyan University Press, 1979), 179.

2. John Cage and Daniel Charles, *For the Birds* (New York: Marion Boyars, 1981), 220–21.

3. Mikhail Larionov, "Rayonist Painting" (1913), in *Russian Art of the Avant-Garde: Theory and Criticism, 1902–1934,* edited by John E. Bowlt (New York: Viking, 1976), 91–100 (98). "We do not sense the object with our eye, as it is depicted conventionally in pictures and as a result of following this or that device; in fact, we do not sense the object as such. We perceive a sum of rays proceeding from a source of light; these are reflected from the object and enter our field of vision" (98).

4. Ursula Meyer, "Conversation with Robert Barry, 12 October 1969," in *Conceptual Art* (New York: E. P. Dutton, 1972), 36–38 (38).

5. *January 5–31, 1969,* exhibition catalog, curated by Seth Siegelaub (New York: Self-published), n.p. The show included three other artists: Douglas Huebler, Joseph Kosuth, and Lawrence Weiner.

6. Ibid.

7. Raimundas Malasauskas, "'You never know where it goes': Interview with Robert Barry (March 3, 2003)," *newspaper*, no. 36 (March–April 2003), www.janmot.com/newspaper/barry_monk.php (accessed June 5, 2005).

8. *January 5–31, 1969*, n.p.

9. Vius H. Weh, "Conversation with Robert Barry," *KünstlerInnenporträts 28*, Museum in Progress, www.mip.at/attachments/180 (accessed March 24, 2008). The powerful masking of Moscow Radio transmissions without modulation/information was different than Richard Feynman's acknowledgment of the "information from Moscow Radio that's being broadcasted at the present moment," mentioned in this book's introduction.

10. Buckminster Fuller, foreword to *Projections: Anti-materialism*, exhibition catalog (La Jolla, CA: La Jolla Museum of Art, 1970), n.p., quoted in Lucy Lippard, *Six Years: The Dematerialization of the Art Object from 1966 to 1972* (New York: Praeger, 1973), 165. In the same foreword Fuller also stated, "Today's epochal aesthetic is concerned almost exclusively with the invisible, intellectual integrity manifest by the explorers and formulators operating within the sensorially unreachable, yet vast, ranges of the electro, chemical and mathematical realms of the physical and metaphysical realities" (n.p.).

11. Susan Sontag, *Against Interpretation and Other Essays* (New York: Picador, 2001), 301–2.

12. "Robert Barry: May 30, 1969," in *Recording Conceptual Art: Early Interviews with Barry, Huebler, Kaltenbach, LeWitt, Morris, Oppenheim, Siegelaub, Smithson and Weiner by Patricia Norvell*, edited by Alexander Alberro and Patricia Norvell (Berkeley: University of California Press, 2011), 89.

13. Lucy Lippard and John Chandler, "The Dematerialization of Art" (1967), *Art International* 12, no. 2 (February 1968): 31–36, reprinted in *Conceptual Art: A Critical Anthology*, edited by Alexander Alberro and Blake Stimson (Cambridge, MA: MIT Press, 1999), 46–50.

14. Lippard, *Six Years: The Dematerialization of the Art Object*.

15. Terry Atkinson, "Concerning the Article 'The Dematerialization of Art,'" (March 23, 1968), reprinted in Alberro and Stimson, *Conceptual Art*, 52–58.

16. "Robert Barry: May 30, 1969," in Alberro and Norvell, *Recording Conceptual Art*, 89.

17. Ibid, 90.

18. "Four Interviews with Arthur Rose," *Arts* (February 1969), quoted in Lippard, *Six Years: The Dematerialization of the Artwork*, 71–72. "Arthur Rose" was a fictitious person who collaborated in the self-interviews of conceptual artists. In the realm of radio, Luxembourg invokes the *Luxembourg effect*, a term for the propensity of the powerful transmissions of Radio Luxembourg to interact with the ionosphere, cross-modulate with other frequencies, and supplant distant weaker stations with its signal. See also Robert Barry, "Untitled Statement," in *Art Povera*, by Germano Celant (New York: Praeger, 1969), 115,

reprinted in *Theories and Documents of Contemporary Art,* edited by Kristine Stiles and Peter Selz (Berkeley: University of California Press, 1996), 839.

19. Meyer, "Conversation with Robert Barry, 12 October 1969," 37.

20. Robert Barry, *"Ultrasonic Wave Piece,"* in *Software—Information Technology: Its New Meaning for Art,* edited by Judith Root Burnham (New York: Jewish Museum, 1970), 29–30.

21. Meyer, "Conversation with Robert Barry, 12 October 1969," 36–38. Barry sourced the barium-133 from a store used by university science labs; the low level of radioactivity in the small amount used posed no risk to users of the park.

22. Lippard and Chandler, "The Dematerialization of Art" (1967), 46–50 (50).

23. Meyer, "Conversation with Robert Barry, 12 October 1969," 39.

24. "Robert Barry: May 30, 1969," in Alberro and Norvell, *Recording Conceptual Art,* 90. It is unclear whether Jack Burnham had Barry in mind when he wrote that "conceptual art's ideal medium is telepathy." Jack Burnham, "Alice's Head: Reflections on Conceptual Art," reprinted in Alberro and Stimson, *Conceptual Art,* 215.

18. COLLABORATING OBJECTS RADIATING ENVIRONMENTS

1. Ursula Meyer, "Conversation with Robert Barry, 12 October 1969," in *Conceptual Art* (New York: E. P. Dutton, 1972), 36–38 (37).

2. Hugh G. J. Aitken, *Syntony and Spark: The Origins of Radio* (New York: John Wiley and Sons, 1976), 68.

3. Alfred A. Ghirardi, *Modern Radio Servicing* (New York: Murray Hill, 1935), 1076.

4. Ibid., 1063.

5. Ibid., 1065–69.

6. Letter from Sir Ernest Fisk, director of economic coordination, to W. M. Hughes, attorney general, July 31, 1940, State Library of New South Wales, Sydney, Australia.

7. US Senate, *Emergency Control of Electromagnetic Radiating Devices,* Hearings Before the Committee on Interstate and Foreign Commerce, 82nd Congress, 1st Session on S. 537: A Bill to Provide for the Greater Security and Defense of the United States against Attack (February 21 and 22, 1951), 11. For a discussion of this document in relation to CONELRAD, see Greg Siegel, "Radiating Emergency: The Perils and Promise of the Broadcast Signal in the Atomic Age," *Communication and Critical/Cultural Studies* 8, no. 3 (September 2011): 286–306.

8. US Senate, *Emergency Control of Electromagnetic Radiating Devices,* 9.

9. Ibid., 8.

10. Ibid., 9.

11. Ibid.

12. Ibid., 12.

13. Ibid., 12–17.

14. Ibid., 17.

15. Ibid.

16. Ibid., 18.

17. Ibid., 10.

18. Ibid., 15.

19. Ibid.

20. Henry Adams, "The Dynamo and the Virgin," in *The Education of Henry Adams: An Autobiography* (Boston: Houghton Mifflin, 1918), 379–90 (380).

21. Ibid., 380.

22. Ibid., 381–82.

23. Ibid., 381.

24. Ibid.

25. Thomas A. Watson, *Exploring Life: The Autobiography of Thomas A. Watson* (New York: D. Appleton and Company, 1926), 80–82 (82).

19. JOYCE HINTERDING

1. Robert Irwin, interview with the author, San Diego, July 19, 2004.

2. Douglas Kahn, "A Musical Technography of John Bischoff," *Leonardo Music Journal* 14 (2004): 77. Bischoff was particularly influenced in this regard by the music and thinking of David Tudor, with whom he worked. For a discussion of the arts and music of microcomputing at Mills College and in the San Francisco Bay Area, see my "Between a Bach and a Bard Place: Productive Constraint in Early Computer Arts," *MediaArtsHistory*, edited by Oliver Grau (Cambridge, MA: MIT Press, 2007), 423–52.

3. Shintaro Miyazaki, "Algorhythmics: Understanding Micro-Temporality in Computational Cultures," *Computational Culture*, no. 2 (September 12, 2012), http://computationalculture.net/article/algorhythmics-understanding-micro-temporality-in-computational-cultures (accessed May 1, 2013).

4. The Binary Automatic Computer, or BINAC, was an early electronic computer produced in 1949 by the Eckert-Mauchly Computer Corporation for the Northrop Aircraft Company.

5. UNIVAC Conference, oral history (OH 200) conducted May 17–18, 1990, by Charles Babbage Institute, University of Minnesota, Minneapolis, http://purl.umn.edu/104288 (accessed November 14, 2012), quoted in Miyazaki, "Algorhythmics." In the UNIVAC Conference oral history, Albert Tonik, a programmer working on UNIVAC in 1949, remembers the maintenance crew putting a program in the computer, and "it would go *grrrrroooo, rrrrroooooo*. You know, the loudspeaker would allow you to hear what was going on." As Paul Doornbusch has written, sound from a loudspeaker (hooter) "was commonly used for warnings, often to signify the end of the program and sometimes as a debugging aid. With many of the earliest computers, owing to the lack of visual feedback (there was no display as is customary today), it was common to include

a 'hoot' instruction at the end of a program to signal that it had ended, or elsewhere if a signal was needed for the operator." Paul Doornbusch, "Computer Sound Synthesis in 1951: The Music of CSIRAC," *Computer Music Journal* 28, no. 1 (Spring 2004): 10–25 (12). The early operators of the CSIR Mk 1 mainframe computer took these tones and shaped them into familiar songs. A similar thing happened in early microcomputing when, in 1975, Steve Dompier heard the computer program on his Altair 8800 as he was listening to a weather broadcast on his transistor radio. After testing a number of programs for their sound-producing capabilities, he was able to reconstruct the melody of "The Fool on the Hill" by the Beatles. See Steven Levy, *Hackers: Heroes of the Computer Revolution* (New York: Penguin, 1994), 204–5.

6. On rhythmanalysis, see the chapter of the same name in Gaston Bachelard, *The Dialectic of Duration* (Manchester, UK: Clinamen Press, 2000), 136–55; and Henri Lefebvre, *Rhythmanalysis: Space, Time and Everyday Life* (London: Continuum, 2004). See also the artists' *Detektors* project website, http://detektors. org (accessed November 14, 2012); and Martin Howse and Shintaro Miyazaki, "Detektors: Rhythms of Electromagnetic Emissions, their Psychogeophysics and Micrological Auscultation," *Proceedings of the 16th International Symposium on Electronic Art ISEA 2010 RUHR* (Berlin: Revolver, 2010), 136–38.

7. Peter Blamey, liner notes for *Forage*, Avant Whatever, Whatever 011, 2012, CD. The term *forage* pertains equally to the way Blamey scavenges parts from the rubbish and the way that signals seek out their paths of conductivity on the microterrain of the motherboard.

8. Early works by Kubisch include *Écouter les murs* (1981), *Il respire del mare* (1981), and *Murmures en sous-sol* (1982). See Christina Kubisch, *KlangRaumLichtZeit: Arbeiten von 1980 bis 2000* (Heidelberg: Kehrer Verlag, 2000). A conceptual use of induction loops and receivers can be found in *Loop* (1967), by Art & Language members David Bainbridge and Harold Hurrell; the setup served as an earlier armature for the more rhetorically elaborate *Lecher System* (1970), based on a late-nineteenth-century Hertzian spark gap device, for which Bainbridge and Hurrell were joined by Terry Atkinson and Michael Baldwin.

9. Christoph Cox, "Invisible Cities: An Interview with Christina Kubisch," *Cabinet*, no. 21 (Spring 2006), www.cabinetmagazine.org/issues/21/cox.php (accessed May 1, 2013).

10. In a 1972 KPFA radio broadcast, Zahuranec set up personal/botanical interactions with a philodendron. See the Radio Other Minds archive, http:// radiom.org/detail.php?omid=RE.1972.10.18 (accessed May 1, 2013). This was the type of plant sentience popularized in the book *The Secret Life of Plants* (1973); walking down the same mystical garden path much earlier was the founder of modern experimental psychology, Gustav Fechner, and his book on the soul-life of plants, *Nanna oder über das Seelenleben der Pflanzen* (1848). His writings, as we have seen, were important to Thomas Watson.

11. Jim Horton, *The History of Experimental Music in Northern California*, www.mcs.csueastbay.edu/~tebo/history/LongDur/JimHorton/jh-music1.html (accessed May 1, 2013).

12. Joyce Hinterding, interview with Josephine Bosma, Amsterdam, August 24, 1998, www.nettime.org/Lists-Archives/nettime-l-9808/msg00074.html (accessed May 1, 2013). With respect to antennas, early in the second half of the twentieth century the Greek artist Takis created his *Signaux*, resembling antennas, much as the artists who addressed electromagnetism through representational means in the early part of the century. These objects were thematic rather than operative, and many visual artists incorporated radios-as-devices within their works, as did Jean Tinguely and Robert Rauschenberg. On Takis, see Melissa Warak, "Made to Music: Interactions of Music and Art, 1955–1969" (PhD dissertation, University of Texas at Austin, 2013).

13. Goethe, "Versuch einger Witterrungslehre" (1825), quoted in Christoph Asendorf, *Batteries of Life: On the History of Things and Their Perception in Modernity*, chapter 11, "Nerves and Electricity," 153–77 (153) (Berkeley: University of California Press, 1993).

14. Ibid., 153.

15. Hinterding, interview with Bosma, August 24, 1998.

16. Ibid.

17. Tom Fox, "Build the 'Whistler' VLF Receiver," *Popular Electronics: Electronics Hobbyist Handbook* (July 1989): 107–11.

18. Ibid., 107.

19. S.W. Robinson, "Ringing Fences," *Science* 2, no. 75 (December 3, 1881): 573. The professor from Ohio State University wrote, "This sketch is mainly of a simple fact of observation. My attention was one day suddenly arrested while walking on a hard road alongside a picket fence by the peculiarity of the sound which reached my ear immediately following each step. This sound was first noticed to be very different from that perceived at other parts of the sidewalk ... when opposite a picket fence the noise following each footstep was prolonged into a curious musical tone of initial high but rapidly lowering pitch, and with a duration of perhaps a quarter of a second" (573). Similar phenomena were observed with "stairs, under proper conditions," including "the steps in front of the State House at Columbus, O" (573).

20. Gene Fowler and Bill Crawford, *Border Radio: Quacks, Yodelers, Pitchmen, Psychics and Other Amazing Broadcasters of the American Airwaves* (Austin: Texas Monthly Press, 1987), 34.

21. Charles K. Wolfe, *Classic Country: Legends of Country Music* (New York: Routledge, 2001), 10.

22. Alan Krell, *The Devil's Rope: A Cultural History of Barbed Wire* (London: Reaktion Books, 2002), 88–89.

23. Alvin Lucier, "'There are all these things happening': Thoughts on Installations," in *Reflections: Interviews, Scores, Writings* (Cologne: Edition MusikTexte, 1995), 526.

24. See Hollis Taylor, *Post Impressions: A Travel Book for Tragic Intellectuals* (Portland, OR: Twisted Fiddle, 2007).

25. Ibid.

26. Joyce Hinterding, interview with the author, Riga, Latvia, August 27, 2006.

27. Ibid.

28. Ibid.

29. Hinterding counts Walter De Maria's *Lightning Field* as one of her few influences or, rather, licenses. The most important precursor for energetics in Australia was the work of the poet and artist Joan Brassil. See Rita Joan Brassil, "The Poetic Vision," thesis for a doctorate of creative arts, School of Creative Arts, University of Wollongong, 1991. Hinterding has found artistic license for openness to energies in the work of John Cage, R. Murray Schafer, Alvin Lucier, and Joseph Beuys. The connection with sound among these composers is self-evident. Beuys's identification with energy is varied: his *Fonds* are stacked like voltaic piles, alternating material layers in a battery, a theme that he made explicit in *Fat Battery* (1963), with its associations of metabolic biotic energies (fat, like fossil fuels, is an energy storage substrate), and trench warfare transmissions; the same holds for his *Capri Battery* (1985), with its school science project use of a lemon as a power source. "Beuys' *Capri-Batterie* is a streamlined metaphor for civilization's ecological balance. It shows an interdependence between artifice and substance, technological artifacts and organic entities. The terms it provides demonstrate the fusion of culture with nature, culture become nature, nature as fuel source. The light bulb doesn't exhaust itself because it never goes on, but the lemon 'battery' requires periodic replacement when it shrivels up. The symbiosis of the two elements is false, in a practical sense, and true, in an artistic one." Gary Indiana, *Village Voice* (November 12, 1985), quoted in *Joseph Beuys: The Multiples; Catalogue Raisonné of Multiples and Prints*, edited by Jörg Schellmann (Munich: Edition Schellmann, 1997), 499. In terms of the earth circuits and telephonic currents, Beuys's *Erdtelephon* (Earth telephone, 1967) is particularly relevant. As Beuys states, "The communication can still be made but there is also a lump of earth there. That's more of a declaration about the nature of electricity: the fact that it is a phenomenon that runs underground and has altogether an energy quality that one could characterize with a minus sign." Joseph Beuys, interviewed June 1977, in Schellmann, *Joseph Beuys: The Multiples*, n.p. See also Dierk Stemmler, "On the Multiples of Joseph Beuys," in Schellmann, *Joseph Beuys: The Multiples*, 512.

30. Joyce Hinterding, quoted in Catherine Lumby, "Joyce Hinterding: Systemic Murmurs," *Art + Text*, no. 46 (September 1993): 48–53 (49).

31. Hinterding, interview with the author, August 27, 2006.

32. Ibid.

33. Ibid.

34. Hinterding, interview with Bosma, August 24, 1998.

35. Forrest M. Mims III, *Getting Started in Electronics* (Fort Worth, TX: Radio Shack, 1984), 28.

36. Ibid.

37. Hinterding, interview with Bosma, August 24, 1998.

38. Henry Fox Talbot, "Some Account of the Art of Photogenic Drawing," *Philosophical Magazine,* series 3, vol. 14, no. 88 (1839): 196–211 (206). See also Henry Fox Talbot, *The Pencil of Nature* (London: Longman, Brown, Green and Longmans, 1844); and Lady Elizabeth Eastlake, "Photography," *London Quarterly Review* (April 1857): 442–68.

39. Henry David Thoreau, journal entry, February 18, 1851, *Journal: Volume 3; 1848–1851* (Princeton, NJ: Princeton University Press, 1990), 196. This mineralist approach to media materialism is beautifully realized in the works of Dove Bradshaw, for example, *Radio Rocks* (1999).

40. See Sean Ross Meehan, "The Pencil of Nature: Thoreau's Photographic Register," *Criticism* 48, no. 1 (2006): 7–38.

41. Robert M. Brain, "Representation on the Line: Graphic Recording Instruments and Scientific Modernism," in *From Energy to Information: Representation in Science and Technology, Art, and Literature,* edited by Bruce Clarke and Linda Dalrymple Henderson (Stanford, CA: Stanford University Press, 2002), 155–77.

42. Thomas A. Edison, *The Papers of Thomas A. Edison: The Wizard of Menlo Park,* vol. 4 (1878), edited by Paul B. Israel et al. (Baltimore: Johns Hopkins University Press, 1998), 111–15.

43. Joyce Hinterding, *"The Oscillators," Leonardo Music Journal* 6 (December 1996): 113–14.

44. Using a two-meter-square vinyl stencil, Hinterding applied the colloidal graphite (Aquadag) directly onto the wall and then removed the stencil. The spiral is from a demonstration from Wolfram's *Mathematica* software, "Square Spiral for a Given Number of Divisors." The speaker is a Holosonics "audio spotlight."

20. EARTH-IN-CIRCUIT

1. J.J. Fahie, "Discovery of the Earth Circuit," in *A History of Electric Telegraphy to the Year 1837* (London: E. & F.N. Spon, 1884), 343–48 (343). I am using "complete" instead of "closed" for how the earth is in-circuit, open to other influences.

2. Hermann von Helmholtz, "The Recent Progress of the Theory of Vision," in *Science and Culture: Popular and Philosophical Essays* (Chicago: University of Chicago Press, 1995), 150.

3. Herbert N. Casson, *The History of the Telephone* (Chicago: A. C. McClurg & Co., 1910), 120–22. This was not the only instance of comparing a Native American language to noise; the irony in this instance is that Choctaw "code talkers" were used by the United States in World War I as a secure "noise" in military communications.

4. Chen-Pang Yeang, "Characterizing Radio Channels: The Science and Technology of Propagation and Interference, 1900–1935" (PhD dissertation, history and social study of science and technology, MIT, 2004), 26.

5. As with ionospheric reflection, radio signals were bounced off the moon, off the ionized trails of meteors, off auroras, and to complete the circuit, through

an aurora off the moon. See R. P. Ingalls, J. C. James, and M. L. Stone, "A Study of UHF Space Communications through an Aurora Using the Moon as a Reflector," *Planetary and Space Science* 7 (July 1961): 272–85. The ionosphere itself was heated up to reradiate "stimulated electromagnetic emissions," and the use of entire islands as VLF and ELF transmitting antennas was entertained. See P. Stubbe, H. Kopka, et al., "Ionospheric Modification Experiments in Northern Scandinavia," *Journal of Atmospheric and Terrestrial Physics* 44, no. 12 (1982): 1025–41. We have already seen the *earth speech device* that was used in World War I; in 1904, George O. Squier, best known for his role in the industrial music of Muzak, submitted a patent for using trees as antennas in wireless communication.

6. Roger Payne and Douglas Webb, "Orientation by Means of Long Range Acoustic Signalling Baleen Whales," *Annals of the New York Academy of Sciences* 188 (December 1971): 110–41 (110).

7. Wolfgang Schivelbusch, "Railroad Space and Railroad Time," *New German Critique*, no. 14 (Spring 1978): 31–40.

8. Ibid., 38.

9. "The Jubilee of the Electric Telegraph," *Nature* 36 (August 4, 1887): 326–29.

10. David Harvey, *The Condition of Postmodernity* (Cambridge: Blackwell, 1990). Indeed, for the second half of the nineteenth century it was clear among many writings in technical journals and popular publications alike that the telegraph could make the world a smaller place, and that place would be called the British Empire.

11. "The Telegraph," *Harper's New Monthly Magazine* 47, no. 279 (June–November 1873): 359.

12. Ursula K. Heise, *Sense of Place and Sense of Planet: The Environmental Imagination of the Global* (Cambridge: Oxford University Press, 2008).

Index

Text: 10/13 Aldus
Display: Franklin Gothic
Compositor: IDS Infotech, Ltd.
Indexer: Peter Blamey

Printed in the USA
CPSIA information can be obtained
at www.ICGtesting.com
JSHW081532210823
46934JS00001B/2